The Middle Ages

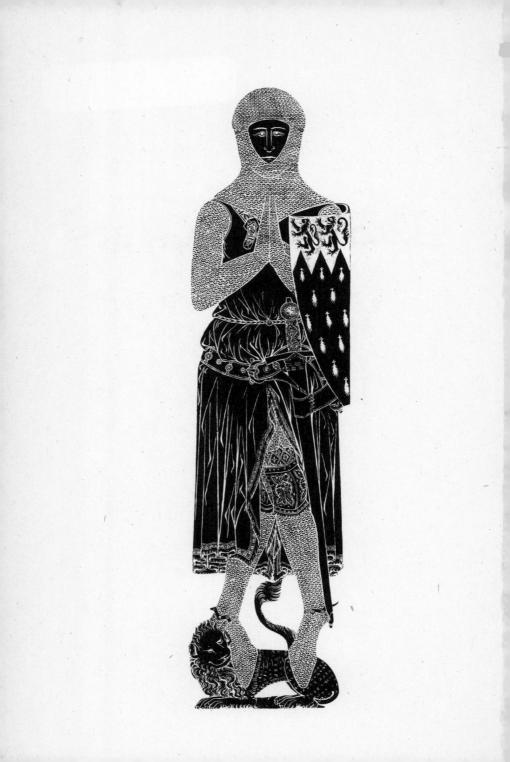

The Middle Ages Morris Bishop

A MARINER BOOK HOUGHTON MIFFLIN COMPANY BOSTON • NEW YORK First Mariner Books edition 2001

Copyright © 1968, 1996 by American Heritage Inc.

All rights reserved

An American Heritage Book

For information about permission to reproduce selections from this book, write to Text Permissions, American Heritage Inc., Forbes Building, 60 Fifth Avenue, New York, New York 10011.

AMERICAN HERITAGE is a registered trademark of American Heritage Inc. Its use is pursuant to a license agreement.

Library of Congress Cataloging-in-Publication Data is available.

ISBN 0-618-05703-X

Printed in the United States of America

DOC 20 19 18 17 16 15

Table of Contents

I	The Long Dark	6
п	The High Middle Ages	40
III	Knights in Battle	76
IV	The Noble's Life	108
v	An Age of Faith	142
VI	Towns and Trade	176
VII	The Life of Labor	208
VIII	The Life of Thought	236
IX	The Artists' Legacy	268
x	End of an Era	294
Picture Credits		329
Index		331

I The Long Dark

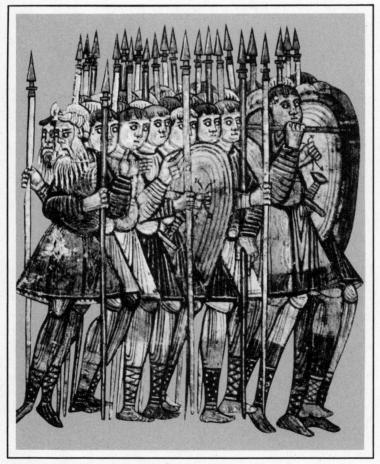

This eleventh-century illustration depicts a troop of spear-bearing warriors.

The Middle Ages is an unfortunate term. It was not invented until the age was long past. The dwellers in the Middle Ages would not have recognized it. They did not know that they were living in the middle; they thought, quite rightly, that they were time's latest achievement. The term implies that the Middle Ages were a mere interim between ancient greatness and our modern greatness. Who knows what the future will call it? As our Modern Age ceases to be modern and becomes an episode in history, our times may well be classed as the later Middle Ages. For while we say time marches forward, all things in time move backward toward the middle and eventually to the beginnings of history. We are too vain; we think we are the summit of history.

The Middle Ages of Europe were a *continuation* and a *formation*. They were a continuation of old Rome in race, language, institutions, law, literature, the arts. They were also a continuation of cultures independent of Rome. The Franks and the Saxons, the Greeks and the Arabs, contributed their own civilizations to western Europe to help make the new civilization that we inherit. The English language, formed in the Middle Ages and drawn from every source, from Sanskrit to Icelandic, is a symbol of our blended culture.

In a deeper sense the Middle Ages were a continuation of the ancient peasant culture that goes back ten or twenty thousand years, to the Stone Age. This depended on settled agriculture and the raising of domestic animals for food, clothing, and service; it possessed few tools beyond a crude plow and harrow, but it learned to adapt itself and to survive and attain a rude well-being. This peasant culture scarcely changed from millennium to millennium. It remains even to our own times. A highland farmer in Macedonia, a shepherd in the Auvergne mountains, live a life more medieval than modern. An American pioneer of the last century, setting out with oxcart, axe, plow, and spade to clear a forest farm, was closer to the Middle Ages than to modern times. He was self-sufficient, doctoring himself and his family with herbs, raising his own food, pounding his own grain, bartering with rare peddlers, rejoicing in occasional barn dances for all the world like medieval karoles.

But the Middle Ages were not merely a continuation; they

7

were the formation of our world. A modern school of historians contends that the so-called Dark Ages were a period of ascent rather than of decline, that with the withering of the pagan classic civilization came the first budding of a new culture that was to develop into our modern civilization.

When did these Middle Ages begin? When Rome fell. But when did Rome fall? No one knows. Historians have proposed many dates. A common one is A.D. 476, when the last emperor of Roman blood, Romulus Augustulus, was deposed by a barbarian Goth, Odoacer. That date will do if we remember that the transition from ancient to medieval was slow, that at some time in the fourth or fifth or sixth century the old Roman system of organization and behavior and thought was replaced, more or less, by another; then it can be said that Rome had indeed quietly fallen.

But why did Rome fall? We have far too many answers. There is the intellectual answer: Montesquieu said that the Romans conquered the world with their republican principles, they changed their principles to fit an empire, and the new principles destroyed it. There is the moral answer: license, luxury, and sloth, a decline in character and in discipline. The Christian answer of Saint Augustine: sinful Rome fell to prepare for the triumph of the City of God. The rationalist answer of eighteenth-century freethinkers: Christianity, teaching nonresistance, otherworldliness, disarmed the Romans in the face of the barbarians. The political answer: Caesarism, loss of public spirit, the failure of the civil power to control the army. The social answer or answers: the war of classes and the institution of slavery, which suppresses incentives toward change and progress. The economic answer: trade stagnation, low productivity, scarcity of gold and silver. The physical answer: soil depletion, deforestation, climatic change, drought. The pathological answer: plague and malaria, or even lead poisoning from cooking pots and water pipes. The genetic and racial answers: the dwindling of the old Roman stock through war and birth control and its mingling with Oriental and barbarian breeds. And the biological-cyclical-mystical answer: an empire is an organism, and like a living creature, it must pass through stages of growth, maturity, and decline, to death.

Whatever the cause, the later days of the empire were marked by discouragement and fear, by what has been well termed "a failure of nerve." The Roman Empire was like a declining business, whose program is retrenchment and retreat, whose ventures are desperate, whose employees can only shrug their shoulders and hope that the old enterprise will last out their time.

Most of the old Roman magnificence remained—the great stone walls, temples, baths, aqueducts, theatres, and mansions. But the cities shrank in size and population; for instance, Autun in France dwindled from an area of five hundred acres to less than twenty-five. With the shrinkage came the abandonment of municipal services—street lighting, running hot water for the public baths, sewage systems. Weeds and bushes grew in the aqueducts, prying the stones apart. Roofs fell in, pavements heaved, refuse lay where it was thrown. Vacant houses were torn down for material to strengthen the walls. The cities had a battered, hopeless look. In the countryside the population diminished, the old Roman slave-operated estates disintegrated, and farm land reverted to waste and marsh.

Depopulation had begun in Italy and Greece in the third century B.C., and before long even Gaul was affected. The Roman army was kept to strength only through the recruitment of barbarians—a practice that was destined to bring disaster. The emperors invited immigrants from beyond the frontiers to colonize Italy, and even the uninvited joined them.

Economically the old system contracted or gave way. It had depended too much on conquest, tribute, slavery, and had fostered a fatal scorn for productive labor. Towns, in their subsidence, overspent their resources; transport became dangerous and expensive; wars, being mainly defensive, brought in no booty. As money lost its meaning, there began a gradual shift toward a natural economy. Communities reduced their wants, their scale of living, and learned to be almost self-sufficient. Still, there are always the smart and the lucky, even in disastrous days. The generals did well, and the high officials, and the sycophants, and clever Syrian and Jewish traders, and especially the large landowners. Some landowners fortified their mansions and kept private armies. They built their estates through imperial gifts or through purchasing the holdings of small landowners, who received in return protection against the taxing government and against marauders, native or foreign. These men were bound to the soil as coloni and were soon to become serfs. But their way of life was not much changed, and if they lost freedom, they gained security, a fair bargain in a tottering world. Here one sees the cell-like movements that were to develop into the feudal system.

This age of mournful endings was marked by a great beginning: the rise of the Christian church in the West. Christianity, with its beauty, its lofty ethics, its universal appeal, and its glorious promise of immortal bliss, was eagerly welcomed. Its triumph was assured by the conversion of the Emperor Constantine. Before his battle at the Milvian Bridge in Rome in A.D. 312, he saw in the sky a blazing cross, with the words, in Greek: "By this conquer." He vowed that if he should win the battle for control of the empire, he would become a Christian. Indeed he won, and indeed he became a Christian, although an uncommonly bloodthirsty one. Thus Christianity became the official religion of Rome while paganism lingered on in the countryside and among conservatives with antiquarian tastes.

The success of the faith demanded its efficient organization as a church. Natural leaders gave it their full time and their zeal, and became priests and bishops. Like the empire, the church was organized into provinces, with the bishops as administrators. As the powers of the government decreased, they became the leaders, the tribunes of the people, took over the empire's civil and social functions, cared for the poor and sick.

In the West the first among bishops was the bishop of Rome. He did not become pope until the fifth century; previously all bishops were called *papa*. The pre-eminence of Rome was due in part to the prestige of the city, in part to Christ's pledge of primacy to Saint Peter, in part to the vigor of certain great bishops of Rome, such as Gregory the Great (509–604), who defended the city against the barbarians, established social services, promoted missionary work, and wrote much and well.

The early age of Christianity was the age of the monks. Monasticism flourished first in the East, especially in Egypt, lending itself to a somewhat grotesque exhibitionism, with pillar sitters and browsers, who grazed on all fours. Saint Benedict of Nursia in Italy (c. 480-c. 543) brought common sense to monastic practice. His famous Rule encouraged asceticism and otherworldliness, without leading to excess. It prescribed, in reasonable proportions, prayer, praise, study, and labor in the

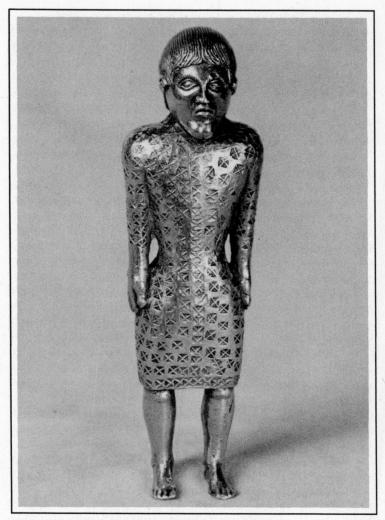

This gold figure of a warrior, found in France, probably represents a barbarian. Following the decline of the ancient Roman Empire, barbarian tribes plundered the Continent, occupying and looting towns. fields. The Rule is still the guide for many monasteries.

From the sixth to the tenth centuries, during the times of cultural and economic stagnation that followed the fall of Rome, the monks held the Western world together. They provided most of the great missionaries. Reasonably secure, they preserved the ancient culture in their libraries, copying old books, making new ones, conducting almost the only schools. Monastery walls sheltered men with the impulse to escape the world, to seek virtue, to reflect on man's soul and his destiny. The monasteries were often compared to little paradises, refuges in an evil wilderness.

Many of the church's institutions began during these years. The practice of pilgrimage was frequent from the third century on. The cult of relics appeared early out of the East and led to unprincipled rivalries, holy souvenir collecting. The system of penance and penalty was codified. Saint Columban, about A.D. 600, prescribed six lashes for a monk who forgot to say *Amen*, ten for one who notched a table with his knife, six for one who sang out of tune. The liturgy took form; great hymns were written; confraternities, or laymen's associations, were formed. The cult of the Virgin Mary gained popularity; the first Western church dedicated to her was Santa Maria Maggiore in Rome.

But the early church was riven by doctrinal dissensions. The most acute was caused by Arius in the early fourth century. His chief contention was that Jesus Christ, being created by the Father, must be inferior to him, hence only semidivine. Under the leadership of Athanasius, at the Council of Nicaea in 325, the church ruled this to be a damnable heresy. Nonetheless, Arianism spread afar and was carried by ardent missionaries to the barbarian tribes, especially to the Goths, Vandals, Burgundians, and Lombards. Here was a mighty source of conflict.

These barbarian tribes had long dwelt outside the Roman pale and had long been filtering through the borders of the empire. Barbarian slaves, soldiers, gladiators, trod the streets of Roman cities. Whole areas of the Roman domain had been set aside for settlement by "allied" tribes. Thus a powerful fifth column prepared for the eventual irruption.

The first invaders were the Germans, who occupied central Europe. East of them were the savage Slavs, and farther east, the still more savage Huns. The marauding Huns, balked by China's Great Wall, turned toward Europe and harried their western neighbors, inducing pressures that culminated with thrusts against the Roman defenses.

The Germanic Visigoths crossed the lower Danube in 376. They were a people on the march, a mounted army with women, children, and elders riding in carts. The horsemen destroyed the imperial infantry near Constantinople and killed the emperor. Under their famous leader, Alaric, they swept through Greece and then turned west and captured Rome in 410. The Goths found Italy too poor a country to support them; they moved across Gaul and into Spain, to establish a Visigothic kingdom that lasted until it was submerged by the Moslems early in the eighth century.

Then came the Vandals, whose reputation for wanton destruction is perpetuated in our common noun. The Vandals drove through Gaul and Spain, and built a robber kingdom on the site of ancient Carthage. They came by ship to sack Rome in 455. They plundered for two weeks, stripping the roof off the Capitol because they thought it was gold. They carried off even statues, probably valuing the bronze more than the art.

And then came the Huns, a people of Mongol origin. Westerners shuddered at their hairless yellow faces, deliberately scarred in babyhood, their beady malignant eyes, their rank smell. Under their remarkable leader, Attila, "the Scourge of God," they invaded Gaul in 451. The Romans, the Visigoths, and various German tribes united against them and threw them back in a decisive battle near Troyes. The Huns then galloped into Italy and reached the walls of Rome, where Pope Leo the Great stood strong against them. When Attila suddenly died, they raised the siege and left Italy.

The German Franks, who had been nibbling at the empire in what is now Belgium, advanced southward, and the Burgundians crossed the upper Rhine and entered the land that was to be known thereafter as Burgundy. The dwindling Roman army, forced to defend its lines on the Continent, gradually withdrew from Britain during the early fifth century. To the inhabitants who protested and pleaded for help, the Roman emperor replied that they must learn to take care of themselves. The Picts poured over Hadrian's Wall in the north; Scottish tribes harried the coasts from their homes in northern Ireland. The Saxons, or Anglo-Saxons, came from the coast of Denmark and Germany to ravage England's eastern shores, and finding the land good,

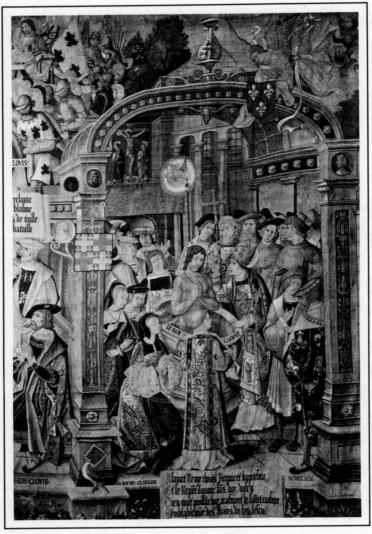

Bishops and nobles gather to watch as Clovis, king of the Franks, is baptized. The dove, a symbol of God's approval, descends, bringing ceremonial oil. Not long after his conversion, Clovis embarked on a holy war against the Arian Visigoths in Germany.

established permanent settlements. They wondered at the Roman remains, regarding them as the "cunning work of giants." The native population, part Briton, part Roman, fought the Saxons long and well through two centuries, and even won a major victory in 571. One of their early leaders was King Arthur—in fact a British chieftain who fought against the invaders, in legend a noble chivalric monarch with his Knights of the Round Table. By the end of the sixth century the Saxons were firmly established. The Britons who refused foreign domination retreated to the west, to Wales and Cornwall, and to Brittany across the Channel.

There were two kinds of barbarian invasions: raids for booty and irruptions of settlers. The raiders for booty, such as the Huns, wanted what they could carry off on their horses: money and jewels, which were to be found only in the churches and in the homes of the rich. The spoilers might in high spirits commit a few atrocities and set fires, but the stone-built cities were not very flammable. In the countryside the raiders might burn a smallholder's barn and drive off his animals for food; they would not pause to trample his wheat and cut down his vines and fruit trees. The invasions for settlement were quite different. The newcomers wanted domination, not destruction. Their numbers were relatively small; their hordes are estimated at from 20,000 to 120,000, including women and children. The fighting men were only a fifth of the total. These were nations on the march, like the Israelites seeking the Promised Land. They committed atrocities by the way, but extermination did not serve their purpose.

The barbarian invasions were not a calamity to all dwellers in the empire. It made no difference to the ground-grubbing *colonus* whether his master was Roman or German if only he was kindly. And there must have been many who never even heard of the barbarians. Off the track of the invasions, they led their changeless lives from day to day and from year to year, unconscious of the dooms that loom so big in history.

Much of old Rome persisted under barbarian domination the language, the forms of respect and worship, the institutions, the law, even the imperial ideal of unity. The cultures fused, intermarriage became general, the stocks blended. Learning faded to be sure. The old Roman culture was literary; hence its appeal to writers of the past and present. But it had lost its creative force. Barbarian culture was one of action and power, not of record and tradition. It was unable for the most part to make reasoned reports on itself for our instruction, but it was busy transforming its world.

In some ways the newcomers made ordinary life better and easier. They brought with them new kinds of clothing, felt and furs, and above all the precious trouser. (The old Gauls had known the trouser, but had abandoned it for the fashionable Roman toga. Mongolian trousers conquered the world, reaching even the Eskimos and the Iroquois.) The barbarians introduced their dietary tastes, such as for rye bread and butter, and barrels and staved tubs—though these perhaps should be credited to the Gauls—and the wooden-framed saddle, and, apparently, the wheeled plow, which permitted the cultivation of the heavy rain-sodden soils of the north.

And in the realm of the spirit, the barbarians restored the heroic ideals of the warrior to a discouraged world.

Of all the barbarians it was the Franks who most determined the character of the age to come. It was their country of Frankland, or France, that became the type and center of medieval civilization.

The Franks, a Germanic tribe, are first to be discerned in the Low Countries and along the course of the Rhine. In 481 fifteenyear-old Clovis succeeded to the kingship of half the tribe. He invaded Gaul and gradually extended his power over the northern and western regions of the country, reaching as far as the Pyrenees. To do so he had to subdue not only the Gallo-Romans but also rival Germanic groups, the Alamanni, the Burgundians, and the Visigoths. At some time in the process he was converted to Athanasian Christianty. His conversion and that of his people, which automatically followed, established in the West a stronghold of Christian orthodoxy.

Clovis, whose name was later gallicized to Louis, stands glorious in France's history as the country's first king, the first of nineteen Louis. Every French child knows the great words of the Bishop Remigius of Reims at the baptism: "Bow thy head, proud Frank; adore what thou hast burned; burn what thou hast adored." Clovis died in 511, after partitioning his kingdom among his four sons, in accordance with the Frankish tradition of inheritance. The realm would soon have been subdivided into numerous tiny principalities had not the excess of heirs been diminished by illness (poison) and accident (murder). These rulers were called the Merovingian kings, after Merowig, grandfather of Clovis. For ample reason the later ones are also termed the *rois fainéants*, the "Do-Nothing Kings."

The Merovingian government, feeble as it was, made an effort to find solutions to new problems. The Roman system of centralized administration and taxation had proved unworkable; the old civil service had disappeared. Effective power resided in the local magnates, new men, most of them Franks. The kings therefore appointed the magnates to be *comites*, counts, charging them with defense, administration, and the judgment of disputes according to local customs. The counts had to provide little armies; they enlisted them from among their subordinates, who were named knights and endowed with land. These armies were subject to call for the king's purposes, offensive or defensive. The counts paid no money to the king, for there was little money in circulation. The king was expected to support himself with the products of his royal, or private, domain. The system developed, in time, into feudalism.

From the point of view of the king it was a very poor system. He received almost no revenues. He had nothing to give but land, and land once given never returned to him. He became poorer and poorer, more and more a do-nothing. By the midseventh century these pathetic kings gave up any serious effort to rule and contented themselves with outings in the royal oxcart, driven by a plowman. Such monarchs always find to hand a sharp, unscrupulous familiar, a minister or an executive secretary. The effective master of the Merovingian state, in peace and war, was the major-domo, the mayor of the palace, who eventually became strong enough to pass his office on to his sons. We should call him a hereditary prime minister. Naturally the major-domos were not long content to be king in all but name.

A twentieth-century tourist going back to visit France around the year 750 would have deemed it a crude and backward land like the rest of western Europe. He would find the Eastern Empire much more congenial. "A modern traveler would feel more at home in medieval Constantinople than anywhere else in Europe," says the scholar Christopher Brooke. "It was a world in which many men were moderately well educated, knew their Bible and their Greek classics, could talk sensibly about God and earthquakes and rising prices; a world in which money consisted in small change and large, with shops and commercial houses and factories—the nearest thing one could meet in Europe to an industrial city; a world in which the gentlemen banded together in guilds and clubs." The visitor would be astounded by the emperor's magnificence, by his throne, which could be elevated high into the air, by his roaring artificial lions and his mechanical caroling birds. He would be impressed by the art and architecture, by the church of Santa Sophia, one of the world's noblest structures. If he had scholarly tastes, he would admire the flourishing literature of the city, the general concern with theology and law.

He might extend his journey to the realms of Islam. During the seventh and eighth centuries the Arabs, inspired by Mohammed, conquered half the Western world. Their empire extended from India to Spain, threatening the Eastern Roman Empire and France and Italy. Commerce followed conquest. Islam controlled the seas; its fleets and caravans traded with China. Magnificent new cities arose in eastern deserts. In the year 712 the Arabs crossed the Pyrenees and briefly held the French coast of the Mediterranean. They mounted a great invasion of France in 732, burned churches at Bordeaux and Poitiers, and were thrown back near Tours by the Franks under the leadership of Charles Martel, "the Hammer," mayor of the palace. Tours marks the high point of Islam's tide. The Arab Empire was torn by the rivalries and dissensions that are the price of success. A hundred years of conquest had sapped its zeal. The conquerors demanded their reward-peaceful enjoyment of their gains.

When our traveler quitted the lands of Islam and the East, he would find himself in barbarous Europe, where life was hard, hungry, and dangerous. By and large, rule was exercised by strong men, mostly Germans, their hands always at the sword hilt. For survival small landowners put themselves under the protection of the chiefs. Cities, providing few means of livelihood, became for the most part merely shelters for farmers or disappeared entirely.

As central governments weakened, the church and its bishops took over many governmental functions. Bishops administered justice, undertook public works, defended their flocks, at need buckled on their swords and rode to war against foreign invad-

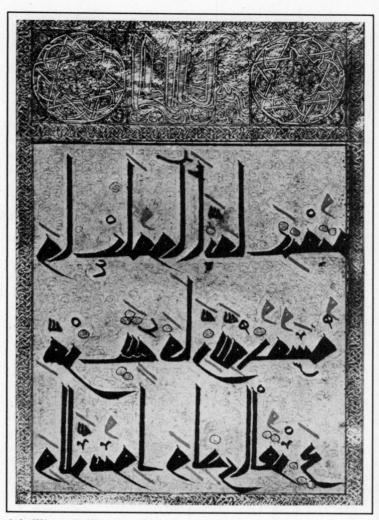

A brilliant civilization flourished in Islamic lands throughout the Middle Ages. The delicate calligraphy of the illumination shown here comes from a Koran of the eleventh or twelfth century.

ers or local aggressors. Laymen, from kings to serfs, feared the church's material and spiritual weapons and respected its rights, such as the right of sanctuary.

The church was animated with missionary zeal. Early in the fifth century Saint Patrick, a Christian Briton who had learned the Irish language as a captive of Irish pirates, began the conversion of their barbarous island. The Irish church developed a special character. It was independent of Rome; it was entirely monastic in organization; its clerics sought the most remote and uncomfortable retreats, even, by some mysterious means, founding houses in uninhabited Iceland. They cultivated learning in their wildernesses; many read Greek when that tongue was hardly known in Rome. They copied busily and beautifully the sacred texts and adorned them in a style of their own. The eighth- or ninth-century Book of Kells, now in Trinity College, Dublin, draws visitors as to a holy shrine.

The Irish monks repaid Saint Patrick by attempting the conversion of Scotland and Saxon Britain. In the sixth century Saint Columba proclaimed the faith from his headquarters on the bleak island of Iona, off the western Scottish coast. His disciple, Saint Columban, invaded the Continent and planted the seeds of the spirit in pagan parts of France and present-day Switzerland.

In the year 596 Pope Gregory the Great was inspired to send a missionary band of Benedictine monks to England. Their success brought them into conflict with the Irish monks, who followed certain minor religious practices unacceptable to Rome. The conflict was resolved in favor of the Romans, and Anglo-Saxon England was incorporated into the Roman Catholic system. English monks in their turn carried the faith to the Germanic peoples of the Continent. The great English missionary Saint Boniface (680–755) founded, in what is now Germany, many monasteries, some of them still existent.

Ere long nearly all of western Europe was Christianized. The Christianization, to be sure, often did not go very deep. A chief would embrace the faith for personal advantage and would decree the mass baptism of his uncomprehending people. They could not forget their familiar woodland gods; they continued to offer prudent sacrifices to the spirits of trees, stones, and springs. Pagan rites were transposed to Christian purposes; the festivals of the changing seasons found their way into the Christian year, where they remain. But the Christian God had conquered, and the old gods had no recourse but to become goblins, devils, the enemies of man.

In the secular world, trade slowly diminished. Until about 600 there was still a good deal of traffic with the East. Merovingian graves yield magnificent products of Eastern art, and English soil has disclosed shells, beads, and bronze vessels from Egypt, and a goblet with a Greek inscription from the Mediterranean. But much of this trade ceased with the growing insecurity of the seas and roads. The West suffered from an unfavorable balance of trade. It had very little to export other than slaves and Frankish swords and raw materials, such as timber and metals, which were too bulky to be profitably transported.

Inland trade of course continued. Peddlers visited the settlements on foot or with pack animals. But they had much to contend with: high traffic tolls, and brigands, and scarcity of money, and the drying up of their sources of supply. Throughout the West, there was a steady dwindling of the commercial class—which is to say the middle class, the bourgeoisie.

Movement on the old Roman roads did not entirely cease. Benedict Biscop, abbot of Wearmouth, England, in the late seventh century made five overland journeys to Rome, returning with books, pictures, vestments, and relics for his monastery, and with the archchanter of St. Peter's, to teach his monks proper music. Pilgrimages became very popular, particularly with the English, who inaugurated their folkway of taking a Continental holiday with a view to self-improvement. They went even to Jerusalem, undeterred by the dangers of Alpine snows, shipwreck, piracy, and brigands and thievish landlords by the way. There were moral dangers also, especially for stranded women pilgrims. Saint Boniface, in the early eighth century, proposed to forbid pilgrimages for women "because for the most part they are lost, few remaining pure. There are indeed few cities in Lombardy or in France or in Gaul in which there is not an adulteress or harlot of the English race."

The period from the sixth to the eighth centuries was a time of endings and forgettings. In most of the West an architect could no longer build a dome, or a shipbuilder a war galley, or a wheelwright a chariot. No written manuals were handed down; artisans in later times had to begin anew. But with all the endings and forgettings, it was a time of obscure beginnings. We vaguely call the years from about 500 to about 1000 the Dark Ages, and they do generate little light to illumine our investigations. But perhaps the darkness is in our own perceptions. We can still discern in the gloom a new barbarian vigor, a youthful energy and capacity to learn.

During the fourth quarter of the first millennium, there was nothing dark in the Byzantine civilization radiating from Constantinople. Islamic culture was also at its apogee, reforming agriculture, promoting industry, encouraging the sciences, philosophy and literature, art and architecture, and building great cities, such as Córdoba, with most of the amenities of modern life. And in the West there was a brief resurgence under the leadership of the Franks and their great ruler Charlemagne.

The rise of the Frankish kingdom began in 751, when Charles Martel's son, Pepin the Short, sent messengers to the pope to inquire if it was right that powerless, incompetent monarchs like the Merovingians should bear the title of "king." The pope replied that it was not right. Pepin then held an election, which proclaimed him King Pepin I. In 753 or 754 Pope Stephen journeyed to Gaul and anointed him. Pepin in return made a visit to Italy and defeated the Lombards, enemies of the papacy. He also presented the pope with a belt of territory in central Italy, to be known for a thousand years as the papal domain. The present brought the popes little comfort and much woe until it was reduced to the area of Vatican City.

The papacy justified its landholding with the aid of a remarkable document, the Donation of Constantine, supposedly written by the Emperor Constantine around A.D. 312. Therein Constantine declared that he had been smitten by leprosy. Following the advice of pagan priests, he set up a font on the Capitoline Hill and assembled a group of innocent children, in whose blood he proposed to bathe. But upon hearing the cries of the victims' mothers, he recoiled at the idea. After a dream in which he was told he would be healed by Bishop Sylvester of Rome, he appealed to the bishop, who dipped him three times in a font of sanctified water, by way of baptism. A hand from heaven seized his, and he rose clean of his leprosy. In gratitude the emperor then transferred all Italy to be the property of the pope and removed to his city of Constantinople, leaving the manuscript recording his donation on the embalmed body of Saint Peter. "Alas, Constantine, how much evil didst thou mother!"

exclaimed Dante. This is unfair to Constantine; the evil was mothered by some ingenious clerical zealot, who contrived probably the most momentous forgery in history. The donation was accepted as authentic until the fifteenth century, when the humanist scholar Lorenzo Valla challenged it on historical and linguistic grounds.

King Pepin and his queen, Big-foot Bertha, Berthe au grand pied, had a son, Charles, who came to the throne in 768. We call him Charlemagne, Charles the Great. Great he was by every reckoning-great in physique, in prowess, in purpose, in intelligence, in industry. His skeleton shows his height to have been six feet four inches; he towered above the little men of his time. His hair was flaxen, his head round, his eyes large and vivacious, his neck thick and short. He wore a drooping Frankish moustache, not the flowing beard of legend. Though normally temperate in eating and drinking, he developed a paunch in later life. His voice was high-pitched; he was inclined to sputter in his speech. He loved hunting and violent games, and pursued the bison and the auroch in the eastern forests. He was said to be the best swimmer in his kingdom; he had a great marble pool at his palace in Aachen that would hold a hundred bathers. He was extremely amorous. He hated pomp, ceremonies, and banquets. He was hearty and informal, and invited everyone, no matter what his rank, to dinner. He was accessible to all; anyone seeking justice was invited to ring a bell at his palace gate. According to legend, an abandoned horse once did so, and the emperor sought out the heartless owner and punished him for discarding a faithful servant. He ordinarily spoke German, but he was fluent in Latin and knew a little Greek. He was fond of music and took pride in his boys' choir. The first folklorist, he collected old Frankish ballads, which unfortunately were destroyed by his pious son. He even began compiling a grammar of his native language. "He also tried to write, and used to keep tablets and blanks in bed under his pillow, that at leisure hours he might accustom his hand to form the letters; however, as he did not begin his efforts in due season, but late in life. they met with ill success." So says his friend and biographer, Einhard.

He consolidated and enlarged his Frankish kingdom, conquered the Lombards in northern Italy and the Bavarians and savage Saxons to the east, and everywhere he imposed his

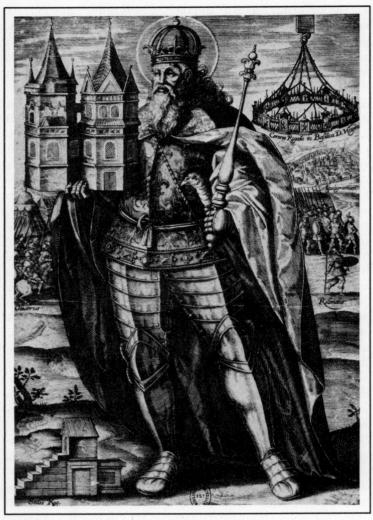

In this engraving the emperor Charlemagne (Charles the Great) is shown holding a scepter in one hand, a model of the church in Aachen in the other. At his beloved palace there, the monarch entertained all ranks of guests, at hearty banquets and around the great marble swimming pool. Roman Catholicism. He invaded Moslem Spain, but there he had slight success. That campaign remains in Western memory, thanks to the immortal *Song of Roland*. "O, for a blast of that dread horn/On Fontarabian echoes borne/That to King Charles did come!"

Charlemagne became the dominant force in Europe. The weak are always eager to avail themselves of the strength of the strong. Pope Leo III was very weak and very unhappy. In 799 some Roman nobles assaulted him in the street, beat him, started to cut out his tongue and gouge out his yes, and then contented themselves merely with slashing at his eyes with a knife. (Later he regained his sight, though he always bore the scars on his eyelids.) Pope Leo fled to Charlemagne's dominions and besought him to restore order in Italy. Charlemagne, though much annoyed by the whole business, invaded the country and put down the rebels with his usual efficiency.

On Christmas Day, 800, Charlemagne and his army attended mass in St. Peter's, with Pope Leo officiating. Charlemagne wore the long Roman tunic and cloak, a golden belt, and jewelstudded sandals. On the shining altar reposed a magnificent crown. Charlemagne rose from his knees; the pope took the crown from the altar and placed it on the monarch's head. All the Romans, obviously well drilled, shouted three times: "Long life and victory to Charles Augustus, crowned by God the great and pacific emperor of the Romans!" Pope Leo knelt at Charlemagne's feet and kissed the hem of his garment, adoring him, according to Byzantine custom. Thus was made the first Roman emperor in the West in more than three hundred years.

What did it all mean? Apparently Charlemagne did not take the coronation very seriously. He continued to style himself "king of the Franks and Lombards." He never again visited Rome or wore Roman dress. But the coronation looms immense in history. It marks the shift of power from the East to the West. Until the eighth century Italy had developed culturally as a satellite of Byzantine civilization. The Franks and Charlemagne bound Italy to northern Europe rather than to an east Mediterranean bloc. The coronation implied that a new *Europa* was in formation. It was also the beginning of the papal claim to make and rule the emperor, and through the emperor the world. The coronation has been alleged even to mark the birth of western European civilization. Not the least of Charlemagne's achievements was his organization of an efficient government. He combined the German system of semi-independent chiefs or dukes, responsible only to the great chief, with the Roman tradition of centralization, which had been preserved in the church. He devised a scheme of royal inspectors, *missi dominici*, who traveled in pairs, judging, decreeing, and reporting to the king. Like Napoleon, he was forever dictating capitularies, ordinances, and commentaries on the greatest and smallest subjects. He held an annual convention, or congress, of nobles and high churchmen, who had not much to do but listen and applaud. He ruled church and state and the private lives of his subjects. He was the model of the good Christian prince and became the ideal of other good Christian princes.

When home from his foreign wars, he spent most of his time traveling, inspecting his kingdom, and consuming the credits due him in food and entertainment. He was accompanied, after 802, by an elephant presented to him by Caliph Harun al-Rashid. Harun also sent silks, brass candelabra, perfume, salves, balsam, ivory chessmen, a colossal tent with many-colored curtains, and a water clock that marked the hours by dropping bronze balls into a bowl, as mechanical knights—one for each hour—emerged from little doors, which shut behind them. The presents may have influenced Carolingian art.

Charlemagne's favorite residence was Aachen, or Aix-la-Chapelle, which is now in Germany, just over the Belgian border. There he built his octagonal chapel, one of the finest relics of his age. It still glitters austerely; it must have glittered more when Charlemagne's bishops assembled in council, wearing silk gowns with gold baldrics, begemmed daggers, and spurs. He encouraged building, civil and ecclesiastic. We should like to know more of his half-mile-long wooden—or perhaps pontoon—bridge over the Rhine at Mainz, and more of his canal from the Danube to the Main.

Following Germanic custom, Charlemagne made his close associates vassals, granting them enormous territories with life tenure. (But when they died, their heirs scarcely ever returned the property to the king or to his heirs.) The vassals usually divided their lands among subvassals, and both owed their immediate overlords obedience, war service, and a fixed number of soldiers, foreshadowing the great age of feudalism. Charlemagne's world was organized in great domains, or manors, descendants of the large estates or villas of the later Roman Empire. At the center of a domain, usually, was the master's house, in a cluster of outbuildings—church, grain mill, forge, bakery, stables, barns, fishpond, perhaps a cloth-working shop for women, and the peasants' rude cottages standing in rows. The manor was practically self-sufficient.

Charlemagne conceived of himself as the father of his country. He thought it his duty to provide for the material, spiritual, and intellectual welfare of his subjects. This was a new concept of the duties of a Christian king. The emperor appointed his bishops and supervised them as well as the lower clergy. He was very high-principled, imposing the death penalty for breaking fast in Lent, for eating meat on Friday, for refusing baptism. He fostered the great abbeys, many of which grew to be enormous. The lands of St. Martin of Tours were worked by 20,000 serfs. The monks were fully occupied with celebration of the liturgy and with prayer. At Centula St. Riquier 300 monks and 100 clerks prayed continually for Charles's health and salvation, working in three shifts, day and night, and employing 30 altars, 12 bishops, 15 bells, and the relics of 56 martyrs, 34 confessors, 14 virgins, and 14 other saints.

Charlemagne sought to impose a new culture on his empire, a combination of Roman, German, and Christian elements. He thought to begin with general education; he found, as do the counselors of today's emergent nations, that he must first make teachers. Of these he had few, only the products of elementary cathedral schools.

He sent a summons throughout his realm and beyond, and invited the most eminent educators alive, headed by the celebrated Alcuin of York, to his court. They taught at his Palace School, occupying themselves with instruction and with scholarly research, as it was then understood. Charlemagne took an active interest in the Palace School; he personally whipped a boy who made a mistake in Latin grammar. The palace scholars and members of the court formed a club, in which everyone took more or less funny false names. Alcuin was Flaccus; Charlemagne, King David.

The school did noble work in teaching sound Latin and in preparing a literate aristocracy for government service. It also restored respect for the classics, which the church had been inclined to discountenance as pagan. Charlemagne sent a circular to all religious houses, ordering them to cultivate humane letters as an introduction to the sacred Scriptures. Everywhere monks were set to work copying the old manuscripts in their archives. We must thank the patient monks—and the imperious commands of Charlemagne—for our possession of most of the Latin classics. Ninety percent of our earliest examples of Latin classical writings are Carolingian copies.

For the immense task of copying, the scribes developed their own handwriting style—the Carolingian minuscule. This contrasts with the majuscule, or capital letters, of the Romans, and with the slipshod cursive of Merovingian days. The minuscule, compact, legible, "lower-case" lettering, is perfectly familiar to our eyes, and with good reason. In the fifteenth century Italian humanists tried to escape from the current Gothic style of handwriting and to return to the style of Roman antiquity. What they took to be Roman was in fact Carolingian. This became the humanist hand, the "Roman" style of the first Italian printers. It is the style in which this book is printed.

Charlemagne's educational and cultural campaign was momentous for its preservation of the classical past and for its effects on medieval society. The level of literacy never again sank as low as it had in pre-Carolingian times. But his cultural revival hardly deserves the pompous name of the Carolingian Renaissance. There was very little original writing, and that little is of small interest today. Most of the productions were textbooks, anthologies, encyclopedias. When Charlemagne's driving impulse passed, his Renaissance faded. For two hundred years after his death, there is not much to record in western Europe in the way of creative thought.

Nor did Charlemagne's empire have a better fate. It soon fell a prey to internal rivalries and disorders and to attacks from without. Charlemagne left, however, a memory of achievement, an example of the power of a great and good king to inspire a people, to make a world. He left a legend, a name that is a battle cry and a magic.

Even in Charlemagne's lifetime his empire was threatened. New terrors to the settled world arose in the east. The Slavs, turned bold and fierce, occupied the Balkans, Macedonia, a good part of Greece, Russia, and eastern Germany. The nomadic Magyars were poised ready to seize present-day Hungary. Even-

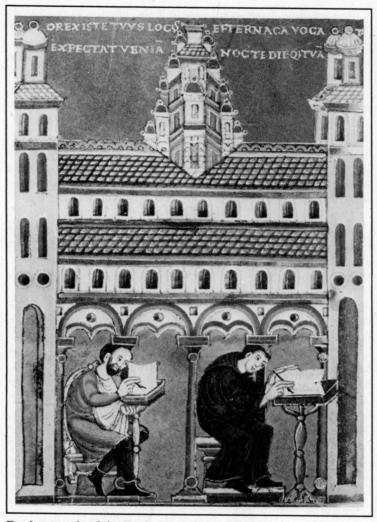

During much of the Dark Ages, monasteries were western Europe's only centers of scholarship. In this eleventh-century German illustration two industrious monks are busy at work, copying manuscripts at their desks beneath a cloister's arches.

tually they raided northern Italy and the Rhine valley. By 925 they had brought fire and sword into Lorraine and Burgundy. But in 955 they were defeated by Otto the Great of Germany. They settled down to farming the rich Hungarian plain and found tillage more rewarding than pillage.

In the south the Arabs controlled the Mediterranean, thanks to their possession of the great islands, including the Balearics. From Sicily they invaded mainland Italy, often with the connivance of bargaining nobles, even bishops. In 846 they reached Rome, sacked St. Peter's, and violated the Tomb of the Apostle. They established bases once again in southern France, raiding north as far as Burgundy. They climbed the Alpine passes, robbed merchants, and seized for ransom high prelates on their way to Rome.

And from the north came the dread Vikings. They were a Germanic people, farming the thin soil of Scandinavia during the brief northern summers. Some impulse stirred within them, driving them seaward. Perhaps it was a famine, perhaps a sudden rise in population, coinciding with a realization of their own power and with a new achievement in shipbuilding. Trading and taking, they moved east and south, up the Dvina and the Volkhov, down the Dnieper and the Dniester to the Black Sea. They attacked Byzantium in 865. They brought back wealth to Scandinavia, including great hoards of Byzantine and Islamic coins. A group of them ruled an obscure empire in Russia from a capital in Kiev; there, in time, they became as Russian as their subjects.

Venturing into the mysterious seas to north and west, the Vikings colonized Iceland in the ninth century and Greenland soon after, and even reached America. But it was western Europe that most lured them. They began their raids on England and then descended in force on Ireland. In 810 they began to probe the Frankish heartland. Charlemagne is said to have wept, seeing the Viking sails like black birds in the Channel. He ordered the building of a fleet and the erection of watchtowers along the coast. But the defenses were far from adequate. The Vikings ventured farther every summer, looting and devastating. In 859 they rounded Gibraltar and entered the Mediterranean. A few years later they were threatening Rome.

The Vikings developed a technique of plundering. They would seize an offshore island or even a walled coastal city as a

base. They would push up a river in their shallow-draft boats to a convenient point, then commandeer horses from the inhabitants, and attack a city or monastery. What they wanted was gold, silver, and jewels; they could not transport goods in bulk. Chalices and reliquaries - the treasures of the monastery churches-were chiefly prized. The Vikings' best weapon was terror. When they could, they would extort a mighty ransomprotection money-and then move on to the next town. If they encountered opposition, they would teach the countryside a lesson, exterminating all resisters. Their ferocity appalled even those ferocious times. A new verse was inserted in the Litany: "From the fury of the Northmen, good Lord deliver us!" They were terrible men, tall and vellow-bearded, wearing red cloaks over ring mail. They fought with bloodthirsty frenzy, like mad dogs or wolves, says one of their own chroniclers; they believed that their god Odin would strike their enemies deaf and blind, turning their swords into sticks. They went "berserk," to use their own word. It has been suggested that they were dosed before battle with a hallucinogenic mushroom. But it is also suggested by their partisans that their ferocity was a myth concocted by monkish writers, horrified by the Vikings' pagan sacrileges.

The Northmen ranged at will through France, taking what cities there were. In forty years Paris was besieged four times, pillaged three times, burned twice. Nearly all the great accessible monasteries from Hamburg to Bordeaux were raided.

The invaders' extraordinary success was due to the Vikings' spirit of boldness, ruthlessness, endurance, and to their mystical admiration for their own racial virtues. Their spirit was served by an extraordinary capacity for careful military planning. Particularly it was served by their ability as boatbuilders and navigators.

Some of their *drakken*, dragon ships, have happily been preserved, thanks to their ceremonial burial in swamps, which has kept them almost intact. They were about sixty feet long, with a single straight tree trunk for a keel. Cross-ribs held firm the sides, which were clinker-built; they were fastened to the frame with thongs tied through cleats or with wooden pins. The shell was very thin and flexible. A single mast was set amidships, with a sail made of varicolored strips of coarse woolen cloth. Oars were used only in emergencies. Not more than thirty-five

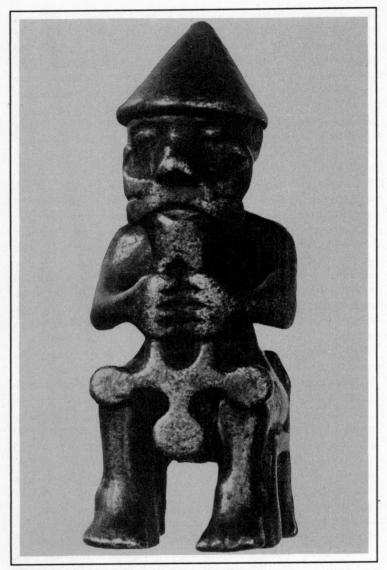

The bold and ruthless Vikings emerged from northern Europe by boat, their colonizing armies invading the Continent's coastlines. The bronze statue shown here depicts Thor, the Norse god of war.

men could be carried on a long journey. They lived and slept on the open deck, with no shelter from sun, wind, and storm. They could transport only a minimum of food, and, of course, no cooking could be done on board. They were hardy men indeed, and they were great navigators. They set forth from Norway or the Faeroes and sailed over foggy northern seas, without compasses, guided by dead reckoning and the flight of birds, to hit Iceland square. Often, to be sure, they did not reach their landfall; they missed Iceland and landed on the icy coast of Greenland, or they landed only on the ocean's bottom.

Little by little the fury of the Northmen abated. Their operations became more difficult as resistance was organized and the rich monasteries retreated to the interior. The men of the Viking garrisons turned into merchants; in the grave of one chief a pair of scales was found beside the longsword. They turned also into farmers, raising their own supplies. After all, most of them were farmers back home, and they loved the good land. They also loved the French women and made alliances that had a way of becoming permanent. The children of the pirates became settlers, Christians, speaking only French. They accepted Romance culture in preference to that of their fathers. Their presence was formally recognized in 911, when King Charles the Simple made a pact with the Viking chief Rollo. The chief did homage to the king as his vassal and promised to accept Christianity; the king made Rollo duke of all that country known thenceforth as Normandy.

In Britain the Vikings, whom the Anglo-Saxons called inaccurately the Danes, first arrived in 787. They rounded the north of Scotland, descended on Ireland, and settled there, living on tribute from the natives. In 853 they set up a proper kingdom, with its capital in Dublin. At first they came to England with the spring's easterly breezes and returned with their loot before the autumn gales began. Then they began to winter in England, and then to make England their home. Their territory—the northeast, Yorkshire, Norfolk, the Midlands—was called the Danelaw. From the rest of the country they exacted tribute, the Danegeld, tons of silver annually. They treated the natives with noble contempt. Englishmen had to call any member of the master race Lord Dane. If an Englishman and a Dane met on a narrow bridge, the Englishman waited for Lord Dane to cross.

The opposition to the Viking Danes was led by King Alfred

of Wessex (849-899), fittingly termed the Great, for his spirit was so great that it inspired a country to turn the course of history. (No other English king is called the Great: greatness is reserved for English queens.) Alfred drove the Danes from most of their English conquests in a long and desperate war. He was a wise and good king as well as a great one. He was always busy. He made little inventions, lanterns of transparent oxhorn, candles marked to tell the time. Distressed at the ignorance of his clergy and the illiteracy of his people, he established a court school like that of Charlemagne and imported teachers from abroad. He was more literate than his great model. He translated works of piety and instruction into Anglo-Saxon. He concluded one of his books with the words: "He seems to me a very foolish man and very wretched, who will not increase his understanding while he is in the world, and ever wish and long to reach that endless life where all shall be made clear." His heaven would not be the home of idle bliss but of knowledge.

By the end of the first millennium Anglo-Saxondom comprised most of the territory of England. Its population was somewhat over a million. Anglo-Saxon England would seem to us a lonely, ragged land. Forests, some of them primeval, covered much of the country. They supplied the people with fuel and game and with acorns and beechmast for the pigs. The arable was poorly tended, the pastures mostly scrub. Solitary farms were rare. Most people lived in small villages that straggled along a main street or surrounded a large green or square, perhaps originally designed to protect the cattle—wretched little wild creatures—against marauders and wolves. The villagers shared with their beasts their one-room chimneyless thatchroofed cottages of wattle and daub or of logs.

Towns were few and much diminished since Roman times. They were still trade centers, but the extent of their trade is debatable. Probably it was small. Necessities, such as salt, fish, and grain, were transported and exchanged. English wool, cheese, slaves, embroidery, were shipped abroad to pay for luxuries, such as wine, silk, jewels, glass. There was some industry, in textiles, wood, and metals. Local smiths made weapons and tools.

A man's social standing was distinguished, in part, by his wergild, the set price to be paid by his killer in case he should be murdered. In Kent the wergild of an earl was three hundred oxen, three times the wergild of an ordinary man. A slave had no wergild at all, but his killer had to recompense the owner for his value, usually a pound. Noblemen were few, but there was a large class of thanes, landed proprietors, often well-to-do, possessing gold, jewels, tapestries, fine houses, and rich clothing.

Englishmen wore a mantle, fastened by a brooch, over a kneelength tunic and trousers. Their women wore a full-length kirtle and mantle, and rings, amulets, necklaces, and even diadems. A woman's duty was supervision of household routine and attendance on guests. She had considerable legal liberty and could hold land in her own right and dispose of it freely. The ordinary man was the churl, a free man, not bound to the soil. but able to own land and sell it. Most churls were farmers, but some became specialists: fowlers, sailors, smiths, carpenters, fishers, tailors, bakers, cooks. Below the churls were the serfs. bound to the land and usually bought and sold with it. Though a serf was not much worse off than the poorest freeman, he would often escape to the Danes, or be freed by his master, or find the means to buy release. Lowest of all were the slaves, children of slaves, prisoners of war, condemned men unable to pay their fines. Desperate poor men sometimes sold themselves or their children into slavery, presenting themselves in church with a rope round their necks and a penny on their heads.

The peasant was governed by Anglo-Saxon law, which was hardly more than a collection of unwritten tribal "customs." An aggrieved person could bring a suit to the folkmoot, a local public assembly, whose procedure was not so much the determination of the facts as testing the reliability of the parties to the case. Accuser and defendant swore to their own innocence and the other's guilt; if the contestants were rich or noble, they were supported by oath helpers, or compurgators, in effect character witnesses. The court, if confused by conflicting judgments of character, might proceed to an ordeal to find who was telling the truth. In one ordeal the accused carried a red-hot iron for nine feet; in another he plunged his hand into boiling water to take out a stone. If the wound healed in three days without festering, his veracity was proved. If not, his burned hand was the least of his troubles.

Spirituality and culture had their refuge in the monasteries. There, manuscripts were copied and illuminated, the decorative arts fostered, particularly the sculpturing of crosses and tombstones. Lay artisans produced fine metal- and jewelwork and textile art, especially embroidery. Early in the Middle Ages, English literature began with the poet Caedmon and with *Beowulf*, composed with conscious artistry in a demanding poetic form. Thus in England men strove to constitute an orderly realm, properly governed and policed, and adorned with the blooms of art and literature.

But if one contemplates the total European scene during the two centuries after Charlemagne's death, one recognizes that it cannot allure even the romantic imagination. Life was normally short and brutish. Most babies took a brief look at the world and died. Skeletons, now rudely disinterred, show the effects of chronic undernourishment. Old age came soon, and death was often welcome. Cruel masters oppressed; Vikings and Saracens robbed and burned while the savage Magyars descended from the east. When the scourge passed, local nobles were likely to seize smoking monasteries and their lands, well knowing that deeds and charters had perished in the blaze. Strong men ruled bloodily; weak men gladly exchanged freedom for protection, for freedom is meaningless in a world of anarchy. The empire crumbled. The papacy was powerless and almost comically corrupt. One pope's mistress, Marozia, made her bastard son and grandson popes in their turn, and is said to have arranged the murder of another pontiff. John XII, her grandson, was deposed by Emperor Otto I in 963 on the grounds that he had ordained a deacon in a stable at an improper season, turned the papal palace into a brothel, castrated a cardinal, drunk the devil's health, and invoked the aid of Jupiter and Venus while playing at dice. Pontificates were quickly fatal; three in succession lasted, respectively, four months, one month, seventeen days. Within a century six popes were assassinated and two were starved to death in prison. The French bishops declared at a council in 991: "We seem to be witnessing the coming of Antichrist, for this is the falling away of which the Apostle speaks."

Nevertheless, all was by no means lost. In bad times Christianity itself gained ground, for it alone could offer men solace and hope. The monastic order of Cluny was founded, setting an example of zeal and devotion. "Christendom" became conscious of itself. The very word was first used by Pope John VIII around the year 880; it suggested a solidarity of Europe against

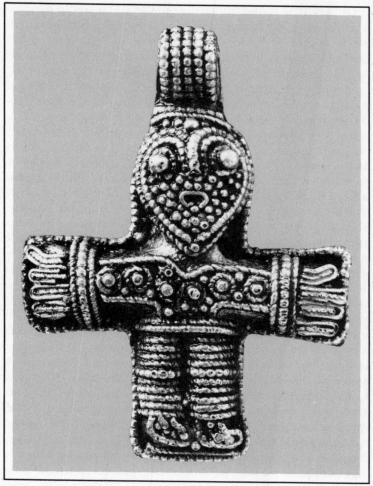

As the fury of Nordic invasions subsided and the battles ended, many Vikings found themselves marrying French wives and settling down to farm work. In exchange for the dukedom of Normandy, the Viking chief Rollo pronounced his acceptance of Christianity to King Charles the Simple. This item is an early Viking depiction of the crucified Christ. the infidel. The converted Vikings and Magyars settled down to relative tranquility in their newly won territories. Intellectual life did not entirely disappear. Such great monasteries as St.-Germain-des-Prés in Paris and St. Gall in Switzerland continued copying manuscripts, cultivating scholarship and poetry.

Modern researchers have discovered important technical advances during these dark years. Call man in the mass apathetic, tradition-bound; nevertheless, if someone discovers a better way of doing work, others will imitate him. The barbarians were inventive, by nature or necessity. The three-field system of rotation of crops became standard; one field was sown to winter wheat or rye, another to legumes or spring grains, while a third lay fallow and rested. Our familiar fruits, most of which came originally from the East, were improved by selection. Stone Age tools of wood and stone were replaced by metal ones. The crank makes its first recorded appearance in Europe in ninth-century representations of rotary grindstones and is seen next in a primitive hurdy-gurdy. Water mills became common. Only a dozen are reported in sixth-century Gaul; but the Domesday Book lists 5,624 mills in England in 1086. The most momentous advance was in animal traction and harness. In ancient times the traces were attached to a yoke on a horse's withers or on an ox's horns; the yoke was anchored by a strap around the animal's breast. This strap constricted the beast's windpipe; the harder he pulled the more he choked himself. Many old pictures and sculptures show a horse tossing back his head in the effort to get air. Then sometime around A.D. 900 appeared the great invention, possibly derived from central Asia, the rigid horse-collar, which puts the strain on the horse's shoulders and frees the windpipe. The horse's pulling power is thus multiplied four or five times. He began to replace the slow and clumsy ox.

Horses, carrying heavier burdens than nature appears to have foreseen, are particularly subject to hoof breakage and foot diseases. The Romans sometimes clothed horses' feet in a kind of glove or sandal, but the first firm evidence of nailed horseshoes in Europe dates from the end of the ninth century. Perhaps the innovation had to wait for a sufficient diffusion of standardized nails. The horseshoe was rapidly adopted throughout the West. The heavily armed cavalry of later days could not have functioned without the horseshoe. With it, the horse-collar, and a new method of harnessing beasts in tandem, economic life was transformed.

The history of the stirrup is a curious one. The Greeks and Romans rode on blankets; a horseman riding a thin, highbackboned mount must have been in torture. The Chinese early developed a wooden-framed saddle and passed it on to the Mongol Huns. One would think the next step inevitable-to devise a footrest depending from the saddle. But the stirrup was strangely long in coming. A rudimentary toe stirrup was found in India around A.D. 100, but the stirrup did not appear in China until the fifth century. The first specific record of it in the West is in the ninth century, when a rider depicted on a Milan altarpiece is shown using a pair. Around that time the use of the stirrup promptly became general. For the first time a mounted man could stand firm in his saddle and with his sword describe a moulinet, or circular sweep, without falling off, and he could withstand the shock of spear against shield. The stirrup extends the range, forward and sideways, of the horseman's sword. This technological advance was to have profound results in the future.

II The High Middle Ages

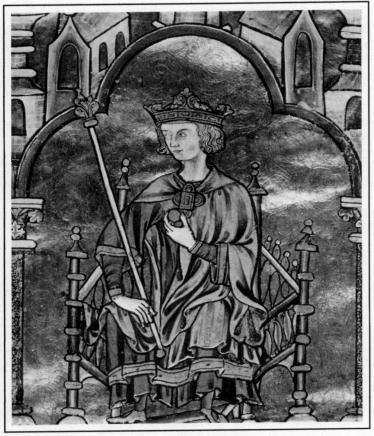

Medieval men considered Louis IX of France to be the ideal monarch.

he state of Christendom after a thousand years of Christianity may well have tested the believer's faith. Christ's homeland was held by the infidel. Holy Rome, the caput mundi, was a city of ruins, physical and moral. Only two hundred fifty miles from Rome lay the Moslem island of Sicily. Italy itself was not a nation; it was a collection of little principalities, each in perpetual conflict with its neighbors. France was, in effect, a coalition of mighty, landowning nobles, who elected the least of their number as king. Except for the northern mountain strongholds of Navarre and Leon, Spain was still dominated by Moslems. England maintained a precarious peace in an unstable compound of Anglo-Saxons and Danes. In Germany duchies, which were practically independent, no sooner elected a king than they rebelled against him. The Scandinavian kingdoms were pirates' nests, sending warriors abroad to assail and plunder peaceable weaklings.

Still, one could point to certain gains, to certain justifications for hope. The Western world, for all its troubles, was in a little better shape than it had been a century earlier. Many of the menaces from without and within had been checked. The period of disintegration had passed; there was a tendency for political units to coagulate, gaining strength in the process. One can readily perceive on a map of Europe in the year 1000 the outlines of the major modern states. All the fury and bloodshed of another thousand years have not changed them very much.

The year 1000 may be taken as a turning point. Around the time of the millennium a new era began with a population explosion that resulted in social and labor disturbances in both town and countryside and the reclamation of wild land throughout western Europe. In Spain the Christians began extending their conquests southward; the Germans continued absorbing Slavic territories in the east; and the knights of Normandy and northern France conquered England, southern Italy, and Sicily, and then—with the first crusade of 1099—the Holy Land as well. Towns and cities grew to keep pace with rising commerce, attracting the surplus peasant population and creating markets for farm produce. New agricultural techniques increased the yield per acre, encouraging families to expand and consume the yield. Business, industry, art, letters, and scholarship prospered.

Western Europe took the initiative away from the lands of the east and south. The great High Middle Ages had begun.

The eleventh and twelfth centuries were a period of advance and innovation. Men built cities, castles, and cathedrals, created wealth, wrote poems, fought in crusades. By the thirteenth century they had become free to make life in Europe safer and more comfortable. The previous centuries had been creative; the thirteenth century was to be logical and legalistic. Scholars in the new universities proposed philosophical ideas and systems, as men of the Western world had not done since the Hellenistic age. Thomas Aquinas and his contemporaries ordered the affairs of God and of man. A spirit of optimism and self-satisfaction was widespread. People came to believe that their little cosmos had at last gained stable equilibrium.

The optimistic spirit of the thirteenth century was encouraged by rising material prosperity. Even the peasants could afford chimneys and tallow candles and metal kitchenware. The bourgeois lived in high houses, with fine wall hangings and bed furnishings, with solid chests fitted with hinges and locks, and with windows of glass instead of oiled linen. (In this period cash accounts of student banquets at the University of Bologna often include an item for broken windows—pro vitris fractis.)

The female sex gained status. Previously women had been merely unpaid domestic laborers or symbols of sin. Now they attained dignity and commanded respect. The concept of chivalry and the code of courtly love elevated women, or at least upper-class women. They had leisure to learn to read and to enjoy the long poetic romances that were written for them. Women's conversation was prized, their friendship sought, en tout bien tout honneur. Social life, as we know the term, really began in the thirteenth century. The well-to-do burgher's wife aped the aristocrats' manners and aided her husband's reputation by ostentatiously displaying her wealth. The petty bourgeoise was a real helpmeet, assisting in the shop, raising her children, supervising the household and the apprentices, who, according to their contracts, were entitled to her maternal care. The peasant woman changed little, however; she continued to labor daylong in the fields, unaware of any social evolution.

One mark of the transformation was the appearance everywhere of new towns and cities: Newtons, Newports, and Newburys in England, Villeneuves in France, Neustadts in Ger-

The crafts developed rapidly, and the number of artisans grew, during the eleventh and twelfth centuries. The bas-relief above, executed around 1200, depicts a carpenter or a barrel maker with tools of his trade. many. These towns purchased corporate rights and liberties from the feudal lords on whose lands they were located. Their enterprising burghers laid them out with regard for commerce and the amenities of life, and walled them against armed greed.

The new prosperity of these towns was based on commerce; commerce was based on industry, and industry on obscure developments in technology. Improvements in agricultural techniques created surpluses that fed the cities' growing populations. New tools and devices contributed to the development of smallscale manufacturing. The humble spinning wheel appeared in the thirteenth century-the first example of belt transmission of power. The same period saw the advent of the mechanical weight-driven clock, which altered people's conception of time by dividing day and night into twenty-four equal hours, making possible standardized measurements of time and modern science itself. (Previously there had been twelve hours from sunrise to sunset, and every day the length of the hour and minute varied.) Navigation was transformed by the introduction of the compass and the fixed rudder. We are ill informed about medieval technology, but we have only to regard the dizzy engineering of a cathedral or the wide arches of a seven-hundred-year-old bridge to recognize the skills of their builders.

To be sure, the commercial prosperity did not alter the lot of the lowest classes of society. The peasant had his constant enemies—warfare, taxation, epidemics, famine. During the reign of Philip Augustus of France (1180–1223), eleven famine years are recorded. People in the country ate roots, bark, and carrion, and died. The poor of the cities were no better off. They suffered from the added menaces of city diseases, fires (Rouen burned six times in twenty-five years), and the dismal and prolonged periods of unemployment.

The first two centuries of the new millennium saw the gradual rise of a few lands to nationhood. Of these the foremost was France, which gained an intellectual and cultural dominance that it has preserved almost continuously ever since. French achievements in philosophy and science, in literature, in art and architecture, and in the refinements of social life set the tone for feudal society throughout western and central Europe. By the end of the twelfth century the French language was spoken in every court and was the official tongue of the principalities that the crusaders had established in the eastern Mediterranean. The courtly life of French nobles was imitated everywhere. French literature, art, and architecture were taken as models. Paris was the great school of philosophy, attracting students from every part of the medieval world and sending them back to their own countries filled with new ideas.

In the northeastern corner of France and just beyond its borders lay the thickly populated county of Flanders and the neighboring provinces of Holland and Friesland. These Low Countries were the first lands to industrialize, the first to discover the joys and the miseries of commercial prosperity. The Frisians had been well known even in ancient times for their woolen cloth, which we still call frieze. To supplement the wool supply, they sent buyers to England, where the adaptable sheep had developed very long, silky fleece to protect themselves against the English climate. As European trade revived, Flanders benefited from being located at the junction of several trade routes. Roads from Paris, southern Germany, and Italy terminated in the county; barges descended the river Rhine to reach its ports, meeting coasting vessels from Scandinavia, England, and the rest of France.

Throughout the Low Countries new cities formed, accumulating wealth based on industry and trade. The young cities attracted two kinds of people: the energetic, ambitious, and dissatisfied, who became the bourgeoisie; and the desperate, landless outcasts, who became the industrial proletariat. Desires and opportunities created a primitive capitalism, which came into existence alongside a primitive state socialism. The city regulated everything—prices, wages, sales; it was concerned with public health; it built hospitals; it forbade the labor of children and women, not because it was inhuman, but because it competed unfairly with the labor of men. The businessmen, vain of their commonwealths (a significant word), erected fine public buildings; but in the back streets the haggard weavers sneered; they were at the mercy of the business cycle and of the interruptions of that cycle by weather and war.

Two great powers emerged in the Middle Ages: the Roman papacy and the German Empire. The papacy held that its responsibility for souls entitled it to supervise and direct the conduct of all people—even emperors. The scholars employed by kings and emperors replied that the monarch receives his

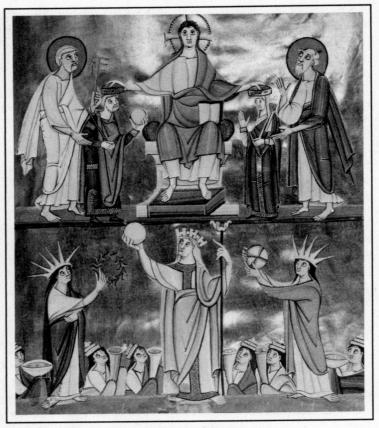

Medieval men and women believed that the Holy Roman Empire was established by God. In the illustration at top the eleventhcentury emperor Henry II and his wife receive Christ's blessing. Below them, several figures representing the provinces have come to pay homage. power directly from God and is answerable only to Him, and that the church's concern should be with the affairs of heaven rather than those of earth.

The High Middle Ages resounded with conflicts between the popes and emperors and other temporal rulers. Kings and emperors had their armies; the popes had none, but they possessed divine authority and spiritual weapons—excommunication, interdict, anathema. As a result the opposing forces were almost evenly balanced.

The rulers of Germany were descendants of tribal chiefs. The strongest, cruelest, and greediest among them survived, to become even kings. In the tenth century one of the tribal dynasties of northern Germany, the Saxon line, emerged as the strongest of the strong. From its ranks came Duke Otto of Saxony, who was elected king of Germany by his fellow dukes in 936. He took his title seriously, thus provoking a series of ineffectual insurrections by the nobles who had elected him. Otto campaigned against the Slavs and the Bohemians, and won a great victory over the Magyars in 955, ending forever their threat to western Europe. Pope John XII asked him for military aid against the Lombard king. Otto crossed the Alps, took the Lombard crown for himself, and in 962 had himself anointed imperator et augustus by the pope, who evidently had never learned one of the major lessons of history: one should never ask a mighty man for help against one's rival. Thus Duke Otto became Emperor Otto I, repeating the work of his ideal and idol, Charlemagne, and restoring the Roman Empire in the West, which eventually came to be known as the Holv Roman Empire-"holy" because of its consecration by the pope, and "Roman" in recollection of the time when Europe had enjoyed unity.

Otto's grandson Otto III is a very engaging figure, whose personality united German force with Greek sensitiveness, derived from his mother, a Byzantine princess. He had as tutor Gerbert of Aurillac, a scholar and scientist, who constructed astronomical instruments and reintroduced the abacus to the West. Gerbert became Pope Sylvester II in 999, and inspired in his former student the idealistic dream of an empire and papacy harmoniously ruling Christendom for the welfare of people and the glory of God. But the dream was shattered by the untimely death of the emperor in 1002 and of Gerbert a year later.

47

In 1053 the German princes elected as king Henry IV, heir of the Saxon line. Henry, who came to the throne as a young child, developed into an intelligent, even brilliant man. He was a competent king and attempted to revitalize the empire that he had inherited; he might have become a great emperor had he not come into conflict with an equally brilliant pope, Gregory VII, who was filled with a passionate zeal to make the papacy the effective ruler of Christ's kingdom on earth.

Gregory was a small man, fat and short-legged, and probably of common birth. Yet his spirit was colossal, demonic. He was consciously an Elijah, the defender of God's purposes against those of wicked kings. He was one of those mighty men of faith whose spiritual strength can change the world—though not always for the better. A single purpose possessed him: to cleanse the church of its abuses and restore the power of the apostles, divinely entrusted to the holy city of Rome. Since his church had the power to bind and loose, to punish and absolve, it must be superior to any human institution, including the Holy Roman Empire.

In the spring of 1075 Gregory issued a decree abolishing lay investiture—the formal appointment of a bishop or abbot by a lay ruler, who ceremoniously hands him his ring of office and crosier, or pastoral staff. The sophisticated might consider this ceremony merely an ancient formula. But the age had a powerful sense of symbols. The ring was the symbol of episcopal ordination, and the staff of pastoral care. Many regarded the investiture as clear proof of the monarch's right to choose and appoint prelates.

To Henry IV Gregory's decree came as a dangerous blow. The church held more than a third of German territory. High churchmen were governors of Henry's most loyal dominions; they served as directors of his political, financial, and administrative organization, and provided most of his revenues. They were a mighty bulwark against his perennially rebellious barons. The appointment of these great officers of state by the papacy would mean anarchy. Henry thought the pope had gone crazy. But for the moment he made no reply to Gregory's decree; he was busy putting down a revolt in Saxony.

Gregory threatened Henry with deposition and excommunication if he did not immediately promote the papal program of reform. Henry answered by calling a council of German bishops, which decided by vote that Gregory should be deposed from his holy office. Henry communicated the decision to the pope in a letter that concludes: "Thou, therefore, damned by this curse and by the judgment of all our bishops and ourself, come down and relinquish the apostolic chair which thou has usurped. Let another assume the seat of St. Peter, one who will not practice violence under the cloak of religion, but will teach St. Peter's wholesome doctrine. I, Henry, king by the grace of God, together with all our bishops, say unto thee: 'Come down, come down, to be damned throughout all eternity!'"

This was no way to talk to Pope Gregory. He immediately excommunicated Henry and declared him deposed. "I absolve all Christians from the oath they have taken to him, and forbid anyone to recognize him as king." Excommunication would not have disturbed Henry greatly if Germany had been united behind him. His bishops had begun to take fright, however, and the lay rulers of his empire piously accepted the pope's decree, for it provided them with a convenient authorization to rebel. The princes of Germany proposed a meeting in Augsburg in February 1077, to be held under the presidency of the pope, with the chief item on the agenda the dismissal of Henry and the election of a new king.

Henry had to admit defeat. His one chance to recoup his fortunes was to intercept Gregory while the latter was traveling to Germany and regain his favor. In January, with his wife and young son, Henry made the bitter journey across the Alps. The party zigzagged up the mule path of the Mont Cenis pass, met the ice-flecked wind at the summit, and slipped and stumbled down into Italy. Gregory, already on his way to the Augsburg council, received Henry at the castle of Canossa, a seat of his devoted supporter Countess Matilda of Tuscany.

Canossa stands on a mountaintop, not far from Parma. To reach it the visitor must climb a weary way, as up the Mount of Purgatory itself. Its ruined walls are still grim, still hostile, as they were to Henry. The gates were closed against him. At Gregory's order, Henry stood without in the January snows, barefoot, gowned in coarse penitent's garb, and stripped of all his regalia. Gregory kept him there for three days and two nights until at last the pope, in Christian charity, deemed the humiliation the emperor had suffered to be sufficient. The gates opened and Henry was admitted, to kiss the papal toe and beg forgiveness, which was granted.

Henry's surrender turned-as he had hoped it would-into political victory. The rebellious German princes thought that the pope had abandoned them. Their coalition disintegrated, and Henry regained his power. With his control over the empire restored, he promptly renewed his defiance; he could not long remain at peace with Gregory. He was excommunicated again and responded by leading an army into Italy and seizing Rome; only the papal fortress of Castel Sant' Angelo held out against him. Henry summoned Gregory, safe within the fortress, to crown him Roman emperor. Gregory refused, but offered, so they say, to lower the crown onto Henry's head by a rope. Unsatisfied with this compromise, Henry then appointed an antipope, who crowned and anointed him properly. Gregory begged the aid of Robert Guiscard, the Norman ruler of southern Italy. Robert appeared with an army that was largely made up of Saracens, drove Henry from Rome, and then subjected the city to a thoroughgoing pillage, selling thousands of Romans into slavery. Gregory, abandoned by most of his cardinals and execrated by the people, left Rome together with the Norman army and promptly died, broken-spirited, quoting the psalmist: "I have loved righteousness and hated iniquity," and adding, "therefore I die in exile."

The quarrel of investitures continued, with other champions. The point at issue was settled by the Concordat of Worms in 1122. The emperor surrendered his right to invest bishops with ring and staff, but he retained the privilege of pointing to the future bishop with his scepter before the pope would confer the sacred symbols. This was a mere compromise of form, however. Who actually won the war of investitures?

Some say the lay rulers won. The king continued to choose prelates as landholders and administrators, and to invest them with the insignia of temporal rule. Others say that the church won. According to the historian Christopher Dawson: "The Church was the primary and fundamental social reality, and the State was merely a subordinate institution charged with the office of preserving peace and order." Some say the result was a stalemate; after it became evident that neither pope nor emperor could prevail completely, the issue was allowed to die down. Some assert that the conflict resulted in a world revolution comparable with the Protestant, liberal, and communist revolutions of the sixteenth, eighteenth, and twentieth centuries. It destroyed the old systems, freed the church from secular control, and made of it a superstate. The great quarrel of investitures has been transformed into a quarrel of historians.

I taly, the country that witnessed the drama of Canossa, rendered real allegiance to neither emperor nor pope. The old Lombard kingdom in the northern regions of the peninsula had come under German overlordship, but the Germans were unable to rule effectively beyond the Alpine barrier. The Lombard cities, virtually independent, grew in wealth and power. Time after time the citizens of Milan repulsed the armies that the emperors sent against them. Pavia became a great trading center. Caravans arrived there from the far north, after having crossed the Alps, with horses, slaves, wool, linen, and armor, to meet merchants who came from the Italian seaports with silks, spices, jewelry, Eastern reliquaries, and crucifixes.

The cities of northern Italy invented the commune, which has been defined by one scholar as "an association in which all the inhabitants of a town, and not the merchants alone, bound themselves by oath to keep the common peace, to defend the common liberties, and to obey the common officers." The maritime communes of Genoa and Pisa, and the republic of Venice came to dominate Mediterranean trade. Venice's greatness began about the year 1000, with the expansion of its power along the Adriatic coast. Venetian vessels came to supply Byzantium with wheat, wine, wood, salt, and slaves, and brought back the Eastern luxuries that the West craved. In 1085 Venice was granted its own quarter in Byzantium, and exemption from customs duties in the Eastern Empire.

Southern Italy and Sicily had traditionally maintained closer ties with Constantinople than with Rome. In the ninth century the links with the Eastern Empire were weakened when the Saracens invaded Sicily and took it from its Byzantine overlords. Many traces of the Arab occupation can still be seen in Sicily, in the island's art, architecture, language, and traditions. The Arabs introduced irrigation, and with it oranges, mulberries, sugar cane, date palms, and cotton. They descended on the mainland, still nominally Byzantine territory, and established themselves here and there among the quarreling nobles.

In 1016 forty Norman knights, returning from a pilgrimage to the Holy Land, stopped at Salerno, and were invited by the city to join in repelling a Saracen attack. Their prowess was such that they were urged to stay. They did so, and sent back word of their happiness to their friends in Normandy. Among those who responded by coming to join them were six of the twelve stalwart sons of Tancred de Hauteville, who was rich in offspring but poor in land. The brothers aided the Byzantines against the Saracens and seized part of Apulia for their pay. In 1046 they were joined by a seventh brother, Robert Guiscard, or "the Weasel." By plundering a papal city Robert aroused the anger of Pope Leo IX, who went out to war against him at the head of a large army. Robert Guiscard captured the pope and humbly begged his forgiveness for routing his army; during the meeting he managed to confirm his own title to all conquests he had made or might make. Robert seized Byzantine Apulia and Calabria, and proposed to conquer the whole of the Byzantine Empire. He began by taking Corfu and Durazzo on the eastern coast of the Adriatic: but he was interrupted by an appeal from Gregory VII for aid against Emperor Henry IV, who had just conquered Rome. Robert returned to Italy and rescued the pope, but he died before he could effectively resume his great project of eastern conquest.

Meanwhile, Robert Guiscard's younger brother Roger had taken Sicily from the Saracens. Roger's son Roger II united Sicily and southern Italy, and even added a considerable part of the African coast to his domain. This Roger, known as the Pagan, shocked Christendom by his good-fellowship with the Moslems. He spoke Arabic, patronized Moslem architects and poets, and had an Arabic inscription embroidered on his coronation mantle. The amenities of his capital, Palermo, dazzled the West. A visitor in 1180 describes the palace, where even the floors were tricked out with gold and silver. On a ship splendid with silver and gold the king basked with his women as they floated on an artificial lake in the royal gardens.

In the north the Normans conquered another island kingdom—England—a domain less splendid and much less wealthy than Sicily. The effects of the conquest still reverberate today. The Normans brought the isolated kingdom of England into the orbit of western Europe and helped create there a rich and vital civilization, one of the chief determinants of our own.

The English Parliament convenes before Edward I in this illustration. The darkrobed churchmen are at the left, barons at the right, and judges seated on woolsacks between them. Edward is enthroned above his vassals, the rulers of Scotland and Wales.

In the years before the Norman Conquest, England had been unfortunate in its Anglo-Saxon rulers. Ethelred the Unready, or the Ill-Advised, had been forced to pay tribute to Danish invaders. In 1013, under Danish pressure, he was forced to send his Norman wife Emma and his son Edward to the Continent for safety, and shortly thereafter joined them there. The Danes took over the entire country under King Canute, who turned out to be an excellent monarch. After Canute's two sons died, the English magnates conferred the kingship, in 1042, on Edward the Confessor, son of Ethelred. Edward was about forty years old, and he was childless; hence a conflict was bound to arise over the succession to his throne. Having spent most of his life in Normandy, Edward felt a stranger in England, and packed the government with his Norman friends. He received warmly at Westminster his second cousin William the Bastard, duke of Normandy, William later reported that Edward had offered to make him the heir to the English crown. Probably he had; but there were no witnesses, and anyway Edward had no right to name his successor.

At the time the most powerful man in England was Harold Godwinson, the son of the earl of Wessex and the brother of Edward's queen. He was very tall, mighty, blond, and typically Nordic; he was also honorable, hearty and gay, a sportsman, an English country gentleman, much beloved in his time. Edward sent Harold on a mission to Normandy, but owing to misadventures the earl arrived as a prisoner rather than as an ambassador. William and Harold immediately liked each other. They hunted, hawked, feasted, talked politics, and fought side by side in a little war against Brittany. But when the time came for Harold's return home to England, William would not let his dear friend go unless he swore to support William's succession to the English throne. Harold readily agreed, being well aware that an ordinary oath made under duress can be easily disavowed. To guarantee the validity of the oath. William had assembled the holiest relics of the dukedom, a great chestful of miraculous bones, and concealed them beneath the altar of Bayeux Cathedral. Once Harold had sworn faith and allegiance, William whipped off the altar cloth and revealed the hidden witnesses. With one stroke William had the feudal world, the church, and heaven itself on his side.

On January 5, 1066, Edward the Confessor died, having first

recommended Harold instead of William as heir to his kingdom. The English nobles approved of the choice; on the very day of Edward's burial in his new Westminster Abbey, Harold was crowned king by the archbishop of York. Nevertheless, William was still determined to be king of England. The pope blessed his enterprise and sent to Normandy a bull excommunicating Harold and his partisans, a consecrated battle banner, and a diamond ring containing a hair and a tooth of Saint Peter. Feudal society approved any action taken against the perjurer. William gave his gentlemen alluring promises of land, loot, rank, and feudal privileges. In the summer of 1066 he assembled his expeditionary force along the Norman coast; there were perhaps seven thousand combatants plus thousands of service troops.

The invasion was a brilliant logistical operation. William even had a prefabricated fort ready to set up when he arrived in England. About seven hundred transports were required to carry his men across the Channel; most of these were mass-produced to a common plan. William may have timed his invasion to synchronize with another from the north by the king of Norway, Harold Haardraade, "the Hard-Boiled," who sought the English throne for himself. The Norwegians landed near York and utterly defeated the local English army that was defending the coast.

When King Harold heard the news in London, he assembled his housecarls, or permanent picked troops, and what militiamen he could find. He hurried north at remarkable speed and met the Norwegian invaders at Stamford Bridge, east of York, on the twenty-fifth of September. In a great battle his saddlesore troops destroyed the enemy. The Norwegians, who had come in three hundred ships, went home in twenty-four.

Three days later, on the twenty-eighth, Duke William landed in the south. His expedition had embarked at St.-Valéry-sur-Somme on the previous afternoon. The crossing was a triumph of navigation, though the distance to the landing place at Pevensey is only sixty miles. Aided by a fair following wind, the pilots found their way by the stars and by intuition, for they had no compasses and there was no moon. Only two of the fleet's seven hundred vessels were lost. One of them carried the expedition's soothsayer. "No great loss," said William, "he couldn't even predict his own fate." Above Hastings he found a strong position for an entrenched camp. When Harold Godwinson, in the north, received news of William's invasion, he assembled his housecarls, still battle-sore, and rode at top speed to London. It was his second long forced march in a fortnight. Bands of the militia, the fyrd, joined him. The housecarls were picked men, oversized, thick-muscled, wearing leather jerkins reinforced with iron rings. Their characteristic weapon was the mighty battle-ax, five feet long and grasped with both hands. The militia, untrained, carried what weapons they could muster—spears, hatchets, slings, or even scythes. There was a deplorable lack of archers. Harold reached the high ground north of Hastings and found a strong position on a small hilltop, with his flanks protected. The advantages of his position were offset, however, by the exhaustion and disorganization of his troops.

On the morning of October 14 William advanced to the attack. At the alarm of his approach, the English rushed to take their posts, forming a shield wall, the housecarls in front, the fyrd behind. Before them the ground dropped away, not sharply but enough to wind an attacking foot soldier wearing a thirtypound suit of chain mail. Halfway up the slope William deployed, with his foot soldiers in the van. The banner blessed by the pope waved overhead. William, with a bag of relics hanging at his throat, rode to and fro giving orders.

The course of the battle has been much disputed. It was evidently a series of advances by the Normans against the firmstanding Saxon line. The action resolved itself into man-to-man, hand-to-hand conflicts, without decisive results. In the afternoon a Norman cavalry attack was thrown back with heavy losses. The English broke ranks to strip the dead and wounded of their expensive suits of chain mail. William seized his opportunity. His cavalry closed in on the isolated Englishmen. He then ordered a direct attack on the English command post. It is commonly said that Harold was wounded by an arrow in the eye, but this may be a misinterpretation of a scene in the Bayeux tapestry. The Normans, massed and fierce for victory, broke through the English defense. Harold and his two brothers were struck down by Norman knights. On the exact spot where Harold fell, William decreed that the altar of a great commemorative church, Battle Abbey, should stand.

October 14, 1066, was one of the decisive days of history. The battle itself was nip and tuck; the shift only of a few elements

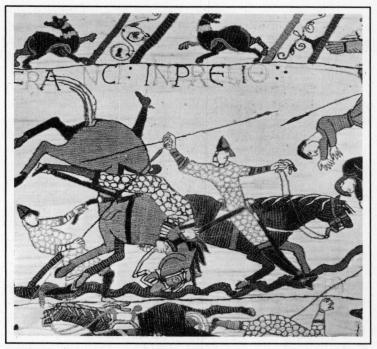

At the Battle of Hastings, King Harold's battle-weary English spearmen attempt to defend a hill against William the Conqueror and the invading Normans. In gritty handto-hand combat, and with a gift of luck in the final hours of combat, the Normans successfully trounced the British on the very memorable date of October 14, 1066. here or there, a gift of luck could have given the victory to the Anglo-Saxons. If Harold had won at Hastings and had survived, William would have had no choice but to renounce his adventure. There is little likelihood that anyone would have attempted a serious invasion of England during the next millennium—by water, at least. England would have strengthened its bonds with Scandinavia while remaining distrustful of the western Continent—even more distrustful than it is today. The native Anglo-Saxon culture would have developed in unimaginable ways, and William the Conqueror would be dimly known in history only as William the Bastard.

But as it was, the Normans won at Hastings, not only the battle but the war. With the death of Harold and his brothers, Anglo-Saxon leadership was lost, and William had no serious rival for the English crown. From then on it was all mopping up. A month after the battle William entered London, and on Christmas Day, 1066, was crowned king of the English.

The new king then proceeded to divide the spoils. His principle was a simple one: he owned all the soil of England, and he allotted certain portions of it to his deserving followers as tenants; if they had no lineal heirs, the land would revert to the crown. England was the perfect feudal state. The holders of the great fiefs were tenants-in-chief or barons. They provided for their retainers by subinfeudation, granting them land with the usual obligations of vassals. Thus there were about five thousand knights at the king's call. To enforce his rule, William decreed the immediate construction of royal castles throughout the kingdom.

A good and greedy businessman, William ordered a complete census and inventory of his kingdom, not only of every person but of every cow and pig. This extraordinary operation provoked riots and perjuries, for William's new subjects were certain that they would be taxed heavily for all the property that was registered. The disorders were cruelly punished in court sittings that were compared by the populace to Judgment Day. Hence the census report was and is called the Domesday, or Doomsday, Book. It is one of the world's most precious historical sources.

The conquest transformed the social structure of England. The old Anglo-Saxon aristocracy disappeared with hardly a trace, absorbed mostly into the ranks of the peasantry. By 1087 about two hundred thousand Normans and French had settled in England, dominating the native population of something over a million. Many of the newcomers were adventurous bachelors; they married local girls, and their children spoke English more readily than French.

William's iron rule brought England security and order. "A girl laden with gold could pass in safety from one end of England to the other," said a chronicler. But under weak successors the country slipped into anarchy. "The earth bare no corn; you might as well have tilled the sea, for the land was all ruined, and it was said openly that Christ and his saints slept."

Then in 1154 Henry II came to the throne. He was the first Angevin king, son of Geoffrey Plantagenet, count of Anjou. He was thickset, broad-shouldered, with mighty arms and legs. He had a large, round head, short neck, reddish hair, and freckled skin. Insatiably curious, he was fluent in several languages and never forgot a face or a useful fact.

Thanks to his mighty energy England prospered. In his time the never-to-be-forgotten appellation "Merrie England" was coined—Anglia plena jocis. The countryside, dotted with stone castles and flowered brookside hamlets, assumed the look that rural England still bears today. Great cathedrals rose—Canterbury, Ely, Oxford, Wells. Commerce increased, towns grew. London Bridge, the first stone bridge over the tidal Thames, was begun in 1176. To build the piers it was necessary to divert Thames waters with cofferdams—a considerable engineering feat.

Henry's great achievement was to lay the foundations of common law, on which English liberty and even the institution of limited monarchy rest. The common law is based on custom and usage, and is "common" to the whole kingdom. Earlier methods of determining innocence or guilt—by ordeal or by the combat of champions—had become obviously absurd and unjust, for all too often heaven's decisions appeared to be contrary to the evidence. Henry, therefore, devised a substitute the jury system. A group of responsible citizens (*jurati*, or "sworn men") were assembled and put on oath to tell the truth. They might act as a modern grand jury, making official accusation of notorious misdeeds, or as a petty jury, serving as expert witnesses in court trials. The jurymen reached their decisions on the basis of common local knowledge, not on evidence pro-

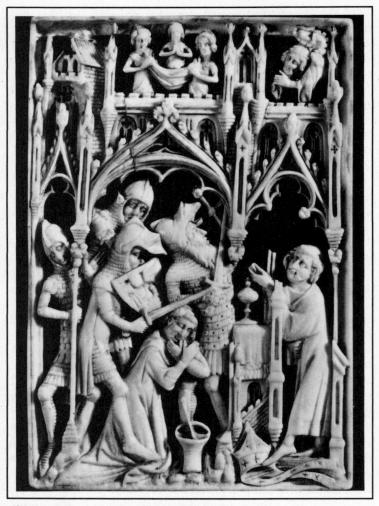

This ivory carving depicts the death of Thomas à Becket. Appointed archbishop of Canterbury by his friend Henry II, Thomas surprised and antagonized the king by asserting the primacy of the church. The controversy grew so fierce that Becket was forced to find refuge in France. Shortly after his return home, four of Henry's knights killed him in his cathedral. duced in court; but their verdict decided the case.

Henry's effort to establish a workable judicial system brought him into conflict with the church, which had its own courts, with jurisdiction over all clerics, or clerks. To prove himself a clerk and save his neck, a man had only to read aloud some Bible verses, called neck verses. In 1164 Henry issued the famous Constitutions of Clarendon, somewhat limiting the jurisdiction of church courts.

The archbishop of Canterbury, Thomas à Becket, King Henry's former playfellow, signed the Constitutions at first, but then he repudiated them. He demanded rights for the church that not even the pope asserted, among them exemption from capital punishment for all clerks, even those guilty of murder. After years of conflict the king was moved one day to exclaim: "What sluggish knaves I have brought up in my kingdom! Is there no one who will rid me of this turbulent priest?" Four of his gentlemen took the hint. They rode to Canterbury, found Becket in his cathedral, and struck down the still-defiant churchman before the Chapel of the Virgin Mary. The monks who prepared his body for burial discovered beneath his clerical garments a stiff hair shirt, verminous enough to prove his sainthood. He was canonized within two years; his shrine became one of the world's great pilgrimage centers, as indeed it still is, although the pilgrims today are less devout than of yore.

In Henry's reign the long subjection of Ireland to England began, as a result of an Irish chieftain's request for English aid against his rivals. A troop of Anglo-Norman knights responded to his plea, subdued the rivals, and went on to subdue the client chieftain as well. Henry could not permit an independent kingdom to take shape. He invaded Ireland and subjected both the Irish and the Anglo-Normans. Everywhere in the territory under his control arose fortified towers from which the English masters looked down on their subjects. Many of them still stand, symbols and reminders to the Irish of their age-long servitude.

Henry's relations with France were complicated. During his lifetime the French kings were gaining power and extending their domain. They reclaimed wasteland, fostered commerce, encouraged the growth of cities. A sentiment of French nationality, of common race, began to form. Henry of England had inherited the French county of Anjou; he was also the duke of Normandy, and thereby a vassal of the French king.

That monarch, Louis VII, was wedded to Eleanor of Aquitaine, suzerain of most of western and southern France. Because she had presented him with no sons, and had been unfaithful besides, Louis divorced her. Henry seized the opportunity for a conquest, both amorous and territorial. Two months after the divorce he married Eleanor and her lands, extending his rule from Flanders to the Pyrenees. For all this fair French estate he owed some feudal duties and homage to the king of France, but he was far more powerful than his nominal master.

Henry and Eleanor had four sons who reached maturity. Henry, the heir, called the Young King, was a scapegrace who led a band of highwaymen, even robbing monasteries of their relics and sacred vessels. He died in 1183 in abject poverty. His pallbearers, it is said, fainted from hunger. Henry's second son married the heiress to Brittany, and died shortly thereafter.

The third son. Richard the Lion-Hearted, or Richard Yeaand-Nay, became king of England in 1189. He did not like England and was there only twice in his life, once for his coronation and once to raise money. "I would sell London if I could find a bidder," he said. Richard was a romantic hero, a handsome warrior-poet, a brilliant military strategist and engineer. He went on a crusade to the Holy Land, gallantly stormed and captured the stronghold of Acre, but failed to take Jerusalem. As he was returning home he was shipwrecked in the Adriatic, seized as he was passing through Austria, and then held for ransom by Emperor Henry VI of Germany. King Philip Augustus of France and Richard's brother John tried to arrange for Richard to be kept in prison indefinitely, but England met the German emperor's ransom terms by heroic efforts (incidentally initiating the taxation of personal, as opposed to real, property). Released after more than a year's imprisonment, Richard carried on a ferocious war with Philip until he died of a gangrening crossbow wound in 1199, to be succeeded by his younger brother, John.

King John has been frequently condemned in English history and literature. He did have his good side, however; he was intelligent and occasionally generous, kindly, and energetic. But he was unreliable and subject to fits of fury, of savage cruelty, and of an apparently pathological lethargy. He was forever restless, traveling from one to another of his seventy-two castles and

In this manuscript illustration King John is shown pursuing deer near one of his many hunting lodges. Son of King Henry II and brother of King Richard the Lion-Hearted, John was much less heroic than Richard but was still a mighty hunter.

dozen hunting lodges. His train included an officer charged with drying his wet clothes, several hundred hunting dogs and their attendants, and a band of laundresses doubling as prostitutes or vice versa.

Shortly after his accession John quarreled and then went to war with his feudal overlord, Philip Augustus of France, who took most of John's lands in northern and western France and added them to his domains. As a result France became a great political power; England too benefited, for its king was no longer preoccupied with his French interests. Thenceforth the island kingdom was free to follow an independent course.

The pope during these years was the great Innocent III, who attempted to maintain papal supremacy, spiritual and temporal, over all earthly rulers. King John fell out with him; Innocent slapped an interdict on the country and released John's subjects from their oaths of allegiance to the king. John fought back, seizing all ecclesiastical property in England and taking over the revenues as well as the operations of the church, thus setting a precedent for Henry VIII's break with Rome. Under threat of a crusade against him by Philip Augustus, John was forced to back down. In 1213 he surrendered England as a papal fief to the Apostolic See, promising a yearly service of a thousand silver marks. The pope then handed England back to John, who was now his vassal. This arrangement did not last long.

John's defeats in war and diplomacy released the long-pent rebelliousness of the English barons. They summoned him to a conference at Runnymede, on the Thames below Windsor, and there presented for his signature a charter listing all their liberties. John squirmed but signed this Great Charter, or Magna Carta, on June 15, 1215.

The Magna Carta is primarily a statement of the barons' feudal rights in relation to their overlord—a reactionary statement, in fact. But to gain the support of other groups, the nobles inserted clauses favorable to the church, cities, merchants, the Welsh, and even the king of the Scots. The charter abolished burdensome taxes and made the king declare: "No free man shall be taken, or imprisoned, or deprived of his land, or outlawed, or exiled or in any other way destroyed, nor shall we go against him or send against him except by legal judgment of his peers or by the law of the land." This is an important statement of due process of law. Momentous also was the establishment by the Magna Carta of a requirement calling for the barons' consent before the king could impose extraordinary taxation on them.

The Magna Carta has become a sort of sacred icon, solemnly exhibited under bristling guard. It is taken as a symbol of British freedom, a declaration of independence of the common man. This is considerably more than the framers intended.

King John struggled for a year against his barons and solved his problems by dying, in 1216. He was succeeded by his son Henry III, a builder and art connoisseur, a man of peace. During Henry's fifty-six-year-long reign, the English Constitution that almost mystical concept—developed further. The guarantees of Magna Carta were reaffirmed, and the doctrine fixed that the king himself was subject to the nation's law. The Great Council, or feudal court of the realm, increased its powers and came to be called the Parliament, or Discussion Group, wherein representatives of the barons and the church freely criticized and checked the king's pretensions. The Parliament of 1258 forced the king to accept the famous Provisions of Oxford, which for a time put effective control of the kingdom's finances in its hands.

Edward I ("Longshanks"), who came to the throne in 1272, was a good king, a valiant, devout knight, and a crusader. He took seriously the motto that he later had carved on his tomb-Pactum serva, "Keep troth." He brought England fully under control of the common law, administered by royal courts. A privy council of specialized advisers, similar to modern cabinet ministers, advised the king and aided in the government. Edward cooperated with his Parliament, which he made a forum for airing grievances, so members would cooperate with him when he requested money and troops. To the Parliament of 1295, which has become known as the Model Parliament, the king invited not only the nobles but also two knights from each shire, two burgesses from each borough, and representatives of the lower clergy on the democratic principle that "what touches all must be approved by all." This group, continuing to meet, gained control of the country's finances and developed into the House of Commons.

In 1277 Edward invaded Wales with a powerful and wellorganized army. The country was quickly subdued and subjected to English rule. Little remains of Welsh independence beyond the title of "prince of Wales," bestowed on the heir to the English throne, and an ancient lingering resentment against the English. During the same period, independent Scotland suffered a period of anarchy. In 1290 Edward was asked to arbitrate among twelve claimants to the throne. His choice was rejected and a civil war broke out. Edward invaded Scotland and set up a government of his own. The Scots, aided by France, fought for years under the leadership of their heroes William Wallace and Robert Bruce. After a long and sanguinary war, they defeated the English at Bannockburn in 1314, and remained independent for three centuries more.

Throughout the High Middle Ages the history of France stood in strong contrast with that of England. England's road to national unification was relatively smooth; France's was agonizingly difficult. In the eleventh century the king of France, the theoretical but almost powerless feudal overlord of many mighty dukes, could rule effectively only in his own personal domain, which hardly covered the area from Paris to Orléans. The French kings struggled for centuries to acquire power over more territory, using all sorts of means: marriage, confiscation, war. Their program demanded constant aggressiveness. Even on his own domain the king had to exercise his rights in every village annually or lose them. For custom made law, and "twice made a custom."

The great dukes of France were practically independent; their deference to the king was merely social. The duchy of Aquitaine was five times the size of the royal domain. It had its own capital and court at Poitiers, its own Provençal language and culture. Old traditions, submerged in the north, persisted there. Indeed, Roman culture never quite died out in the south. Until quite recent times the people of Provence ate Roman food, played Roman games, built columned churches, carved sarcophagi, and ruled themselves by Roman law.

The French kings steadily pacified and unified their realm, extended royal power, reduced the independent nobles, promoted economic well-being. The greatest among them and the greatest agent of France's rise was Philip II, commonly called Augustus, who succeeded to the throne in 1180. Though he was bald, had one bad eye, and disliked extravagant display, Philip appeared sufficiently kingly. He was sagacious and unscrupulous, his constant occupation being the advancement of his own interests and those of his kingdom. He reorganized the French government, appointing commoners trained in law as administrators and providing them with fixed salaries, thus creating a civil service and an efficient bureaucracy responsible to the king alone. During Philip Augustus' long reign his wealthy and populous realm became a dominant power in Europe, politically as well as culturally. France's cultural importance was to increase, and its political effectiveness and unity were to continue for decades after Philip's death.

Philip Augustus' pious young grandchild Louis IX succeeded to the throne of France in 1226, at the age of twelve. His character contrasted markedly with that of his grandfather. There are so few good kings, so many bad kings! Louis IX, Saint Louis, is the only sainted monarch of France. The French love him still; after Joan of Arc he is the most popular character in their history. His personal charm captivated all who knew him, and thanks to his adoring biographer, Jean de Joinville, still wins French schoolchildren and their elders. He was temperate and chaste, faithful always to his rather forbidding wife, Margaret of Provence, who bore him eleven children. He was tall, thin, fair-haired, with blue eyes, "dove's eyes" according to one chronicler, who adds that he had the face of an angel and a mien full of grace. Though subject to painful attacks of skin disease, he was always cheerful.

His faith was deep. To the usual practices of attending mass, reading pious books, and confession, Louis added austerities. He wore a hair shirt, and even sent his daughter one, along with a discipline, or self-flagellator, for a Christmas present. He kissed lepers and once invited to dinner twenty poor people, whose smell revolted the soldiers of the guard. He thought of joining the Cistercians or the Franciscans, but was dissuaded by his wife. He tried to attain mystic ecstasies, and while praying could lose all contact with the external world. But faith, he held, should banish all tolerance of infidelity. He said that a layman, hearing the Christian religion abused by a Jew, "should not attempt to defend its tenets except with his sword, and that he should thrust into the scoundrel's belly as far as it will enter."

He had, nevertheless, a very pleasant whimsical way of speech. Joinville quotes him: "To restore [*rendre*] is such a hard thing to do that even in speaking of it the word itself rasps one's throat because of the r's that are in it. These r's are, so to speak,

67

Emperor Frederick II was a constant puzzle to the papal bureaucracy. His open-minded interest in the world, his intellectualism, his irritating distaste for crusades, earned him excommunication. Isolated from the church, he was content to travel to the Middle East, where his diplomacy resulted in an important truce. Here Frederick graciously greets the sultan of Egypt. like the rakes of the devil, with which he would draw to himself all those who wish to 'restore' what they have taken from others." (The remark indicates that the Parisian, or uvular, r was current in the thirteenth century.)

He was a good king. He loved and enforced justice, and carried as a part of his regalia not only a scepter but also a *main de justice*, a staff with an open hand upon it to symbolize fair dealing. He abolished trial by combat, insisting that guilt be proved by evidence alone. He tried to check private wars among nobles, imposing a forty-day cooling-off period and prohibiting crop burning and peasant killing. A corps of professional magistrates, forbidden to take fees, frequent taverns, or play at dice, was enlisted to administer justice; the group eventually developed into the *parlement de Paris*, the nation's supreme court. Louis employed a band of Franciscans to inquire into official injustices. He liked to sit under an oak tree at Vincennes, or stroll in a Paris public garden, to render immediate justice to any aggrieved person.

To his own and later times, Saint Louis was a perfect example of the Christian king. Europe recognized in him the embodiment of justice and proof that monarchs ruled by divine right. Saintly as he was, Louis was not, however, the most extraordinary ruler of the Middle Ages. That distinction must be reserved for the Emperor Frederick II, called *Stupor Mundi*, "the Marvel of the World."

Born in 1194, Frederick grew up in Palermo, poor, unregarded, though heir to the Sicilian throne. He associated by preference with low company, grooms, and Moslems. He was precocious, learning to speak half a dozen languages, notably Arabic. He had an insatiable curiosity about everything, including science, especially zoology. As a boy Frederick dreamed of restoring the empire, uniting Germany and Italy, and annexing the temporal possessions of the pope. He pushed his claims in Germany, and in 1220 was crowned emperor, having gained papal support in his campaign for the imperial post by offering to yield Sicily to the pope as fief. Despite his promise, he could never bring himself to fulfill his part of the bargain and surrender Sicily. He antagonized Rome further by vowing to go on a crusade, and then delaying his departure; finally Gregory IX excommunicated him.

In 1228 the excommunicated emperor embarked on the most

remarkable of all crusades, taking along a detachment of Arab troops and a Moslem teacher of dialectic for his instruction. Upon landing, he sent princely gifts to the Saracen leader, Sultan al-Kamil, a broad-minded scholar-poet like Frederick himself. The sultan responded with equally princely gifts, including an elephant. The two rulers concluded a ten-years' truce, which ceded Jerusalem, Bethlehem, and Nazareth to the Christians, along with a corridor from Jerusalem to the sea, and gave the Moslems full rights to retain their own shrines in the Holy City.

Frederick visited Jerusalem more as tourist than as a pilgrim. Out of regard for Christian sensibilities the sultan ordered the muezzin to omit the calls to prayer during his visit. Frederick protested; he had come to Jerusalem for the local color. Pope Gregory was enraged at the news of Frederick's pact. The excommunicate had liberated the Holy Sepulcher, but he had done it in the wrong way, without striking a blow, without shedding a drop of paynim blood. The pope proclaimed a crusade against the crusader, but this elicited little response, and eventually he was forced to revoke Frederick's excommunication.

Frederick returned to Europe, carried on long, indeterminate wars to unite his empire, and established a brilliant Oriental court at his castles in Sicily and southern Italy. There he had everything he loved-gardens, pools, woods, strange beasts, singing birds, dancing girls, and wise men of good conversation. Among the latter was Michael Scot, scientist, astrologer, translator of Aristotle and Averroës, something of a charlatan, and still legendary in Scotland and Italy for his wonder-working. Frederick's broad-mindedness shocked everyone. He gave a banquet commemorating Mohammed's hegira for some Moslem guests, and to their surprise sat them down beside bishops and Christian nobles. The pope once accused him of saying: "The world has been deceived by three impostors: Moses, Mohammed, and Christ." Like the eighteenth-century Frederick II of Prussia, the emperor liked best a supper with philosophes. Voltaire would have loved him, and he Voltaire.

Frederick was fascinated by mathematics and science. He made many experiments, some of them rather gruesome. On one occasion he fed two prisoners the same large dinner, sent one to bed and the other on a headlong hunt, then cut them open to see which had better digested the meal. (It was the sleeper.) He was very proud of his planetarium—a gift from the sultan of Damascus—a metal tent wherein jeweled astral bodies, moved by hidden mechanism, described their courses. In return for it, Frederick sent the sultan a white peacock and a polar bear, which delighted the sultan by jumping into the sea and catching fish. (One wonders who captured the polar bear, and where, and how it was transported to Syria!) He propounded a series of puzzling questions to the learned world of Islam. Why does a stick in water appear bent? What proof is there of the soul's immortality? Or that the world exists in eternity?

His own contribution to science is his book On the Art of Hunting with Birds. The magnificent illustrated copy that belonged to his son still exists. The book is a manual of falconry, and at the same time, a scientific study of ornithology, based on direct observation. In it Frederick discusses bird migration, nesting habits, and the mechanism of hummingbird flight, and advises falconers to create a conditioned reflex by singing an unvarying song while feeding them.

Frederick encouraged all branches of learning. He founded the University of Naples in 1224 to train lawyers, accountants, and civil servants. This was the first university founded and run by laymen. He is said to have been the first medieval man to appreciate classical sculpture. He was the father of Italian poetry, the first to write love songs in the vernacular. He even cared about spelling, a rare concern for a man of the Middle Ages. When a notary wrote his name Fredericus instead of Fridericus, he had the guilty thumb cut off.

Physically Frederick was short, stout, balding, nearsighted, with something snaky and demonic in his green eyes. A Moslem said that he wouldn't bring two hundred dirhems on the slave market. He was abstemious but fastidious; his one daily meal, in the evening, had to be good. His favorite dish was *scapace*, a combination of fish and vegetables, fried, then marinated in a white wine and saffron sauce. He was extremely libidinous and kept a harem, which traveled with him, even to war, in curtained palanquins guarded by eunuchs. He was enlightened, but he was not really a very nice man.

Frederick failed in his great aims of reducing the power of the popes, uniting Italy, creating a viable Holy Roman Empire with its capital in Rome. After his death in 1250, the empire ceased to be a functioning reality, and the power of the imperial line of

71

Hohenstaufen disintegrated. Modern people have been fascinated by Frederick because he was so modern. That was just his trouble; he would probably have been much more successful if he had been more medieval.

Like Frederick II, the popes failed to realize many of their aims: reducing the power of the emperors, uniting Europe and all Christendom under their leadership, discerning and combating widespread abuses in the church. The struggle of the papacy for political domination complicated and sometimes undercut church efforts to seek reform, but reformers were never silent, and often they were extremely effective. A problem never finally resolved was that of clerical celibacy. In the eleventh century clerical marriage seemed no more heinous than it does to most of the world today. Peasants certainly preferred a married priest to a lusty bachelor who was free to roam the village while they were at work in the fields. The trouble was that ecclesiastic fathers were inclined to pass on their posts to their sons, and church livings became, in effect, private property. Iceland even had hereditary bishoprics. Priests' wives and concubines were often dreadful troublemakers. In 1072 they lynched the archbishop of Rouen for preaching against them. The Second Lateran Council made celibacy mandatory in 1139. Though the decree helped purify the church, many clerics, high and low, simply substituted promiscuity for marriage. In the thirteenth century Bishop Henry of Liège had sixty-one children, fourteen of them within twenty-two months, setting perhaps a record of clerical philoprogenitiveness.

A more serious problem was posed by the church's wealth. Centuries of pious bequests had given the medieval church enormous holdings. Some bishops were great feudal lords, with establishments that outdid those of kings in luxury and display. The church's wealth and secular power brought corruption in their train, particularly the abuse, or sin, of simony—payment in one form or another for an ecclesiastical post. A king or noble who legally controlled the appointment to a rich bishopric or abbey might well feel justified in taking a commission from his appointee, as a modern state considers itself justified in leasing productive rights to the highest qualified bidder. Insofar as the cleric held and exploited land, he was a part of the feudal system. He owed certain obligations to his overlord in payment for protection; why should he not make an advance to the overlord against his future revenues. A simoniac cleric argued, moreover, that he was paying not for the spiritual function he would fulfill, but for the material property he would administer. Similarly, if he had paid for a living, he had a right to recoup his expenditure by selling the living to the next incumbent. Thus simony became nearly universal.

The church's efforts to reform were directed at laypeople as well as at churchmen. Dreaming of peace on earth at a time when warfare was the only honorable occupation for an aristocrat, clerics attempted to put an end to all fighting. In the year 989 a church council called on men to abstain voluntarily from attacking priests, churches, and peasants' livestock. Other exemptions were added later: mills, vines, merchants, and persons on their way to church. The movement was known as the Peace of God. Its aims were difficult for men to understand, and eventually it was extended, with its concept somewhat modified. In 1017 a ban was imposed on all fighting from the ninth hour on Saturday to daybreak on Monday. This primitive weekend vacation, called the Truce of God, was later extended to include the period from Wednesday evening to Monday morning, and all the seasons of Lent and Advent. There was evidently a party of outright pacifists in the church. In 1054 another council declared: "A Christian who slavs another Christian sheds the blood of Christ." But pacifism presented too many problems in a wicked world. Gregory VII often quoted with approval Jeremiah: "Cursed be he that keepeth back his sword from blood." Before long the church itself was the instigator of political wars, and its enemies were those who cried for peace.

The leaders of the reforming movements were generally monks, who labored within their own orders as well as within the organizational structure of the church in their efforts to purge abuses. Many new monastic orders were founded in hopes of returning to the pure monasticism—unsullied by material wealth—that had been so prominent a feature of early Christianity. One of the most important of these orders was the Cluniac, so called from its mother abbey at Cluny in Burgundy, which had been founded in 910, with a charter providing that it be responsible only to the pope. Under a series of remarkable abbots, Cluny begat a swarm of daughter and granddaughter houses-almost fifteen hundred of them-which based their practices on the Benedictine Rule, but made it even stricter.

Since human efforts to tread down triumphant evil had availed little, Cluny proposed to assail heaven with concentrated and continuous prayer and worship. On holy days the *Opus Dei*, God's work at the altar and in the choir, lasted from midnight to noon, or from dusk to dawn, allowing the monks little time to commit a sin, except in thought. But in time the Cluniacs relaxed their austerity as other orders had, and zealous souls began to demand more in the way of asceticism, self-castigation, and saintliness.

In 1084 Saint Bruno, a German, founded a monastic community in the French Alps. From this mother house—La Grande Chartreuse—the monks took the name of Carthusians, their homes the name of charterhouses. Their monasteries consisted of nothing but a church and a cluster of hermit cells, where the adepts lived, never or almost never speaking except to God, subsisting on a noisome vegetable platter pushed in at their doors, meeting in chapter only once a week. Their rule ("never reformed because never deformed") has changed little in nine hundred years, though pious donors have given them splendid churches and decent quarters.

In 1098 a group of Benedictine monks, bored with undemanding routine, sought spiritual adventure in a "desert." They found a satisfactory one about a dozen miles south of Dijon, at Citeaux, which has given their order the name of Cistercians. They resolved to follow Saint Benedict's Rule to the letter, "rejecting everything that was contrary to it." Because they did not read that Saint Benedict had "possessed churches, altars, oblations, burial rights or the tithes of other men, nor bakehouses, mills, villages or peasants, nor that he had buried any nuns there, saving only his sister, they rejected all these things." The monks were thus obliged to clear and farm their lands, to build their own homes. They did wonderful work in draining marshes, tilling wastelands, reclaiming good soil from the sea. They were chiefly famous as sheep and cattle raisers, selling the wool and cheese to inhabitants of the new cities. And before long they owned bakehouses, mills, villages, and even peasants.

The Cistercians spread very rapidly; by the thirteenth century they had about seven hundred houses, for both men and women. The Cistercian's existing abbey churches have the stark beauty of form. Ascetic principle forbade decoration and brilliant glass, even a sanctuary lamp, even rich vestments. Their crucifixes were of wood, their candelabra of iron, their thuribles of copper. Their dormitory was a row of coffinlike wooden boxes. Their diet was bread made of barley, millet, or vetch, with boiled roots or nettle leaves. But their austerity and their business success did not render them universally popular.

The greatest Cistercian was Saint Bernard of Clairvaux (1090– 1153), a mystic and statesman, who was personally responsible for the establishment of dozens of abbeys. In his sanctity as well as in his fervor, Bernard typified the spirit of medieval Christianity. His attentions were devoted to the next world—here, he wrote, men were but "strangers and pilgrims"—but he was completely at home in this world, exerting a profound political influence, appeasing the conflict of church and state, swaying papal elections, advising popes and the kings of France. Bernard labored to suppress doctrinal error and preached against heresy in sermons for which he was famous. Under his influence, the Cistercian order expanded rapidly. Bernard was cast in the eternal role of the militant saint, the upholder of the faith, the scourge of heresy and unbelief. He was an eternal type, indeed; but he was also medieval.

And what is *medieval*? In common parlance the word connotes a backward time, but the High Middle Ages were not backward; they were a forward time. They were a time of noble aspiration and of unexampled villainy. And they were a time of advance and discovery, of exploration. They were a time of progress.

If one compares the state of Europe in the century before Saint Bernard's death and the century after, one looks upon two different worlds, though we call both medieval. The aspect of the countryside had changed from half-wild to a cultivation not unlike that of today. Castles guarded the fields. Towns and villages emerged under exalted Gothic spires. Commerce was controlled by bankers and regulated by guilds. Universities flourished; scholars wrote their profundities; poets and novelists, their imaginations. The High Middle Ages had created that European civilization that was to become our own.

75

III Knights in Battle

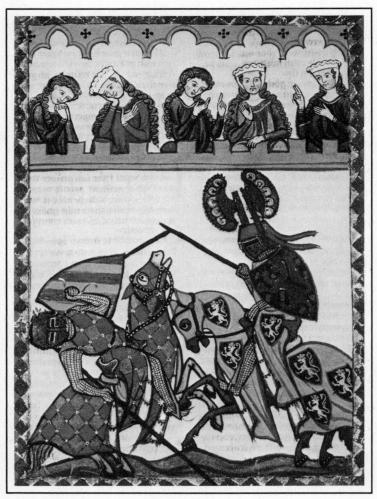

Tournament battle was a popular form of entertainment in the violent Dark Ages.

hat is the function of orderly knighthood?" wrote the twelfth-century English philosopher John of Salisbury. "To protect the Church, to fight against treachery, to reverence the priesthood, to fend off injustice from the poor, to make peace in your own province, to shed blood for your brethren, and if needs must, to lay down your life." This was a splendid ideal, often put into practice during the Middle Ages. It lingers still in the army-officer tradition of France and Germany, in the public-school tradition of England. To medieval men knighthood was more than a career; it was a spiritual and emotional substructure for an entire way of life.

The knight, the chevalier, was a man who owned a *cheval*, who served in the cavalry, and who guided his life by chivalry. His duty was to fight the enemies of his feudal lord. Said the fourteenth-century French chronicler Jean Froissart: "Gentle knights were born to fight, and war ennobles all who engage in it without fear or cowardice."

Fighting was the gentleman's trade. He had been bred to it from babyhood, with all his education directed toward toughening his body and spirit. His school was a guardroom in a military post; his home a castle, perpetually prepared against assault. As a vassal he was frequently summoned to wars of lord against lord, to be paid for his services with booty taken in the capture of an enemy castle or with goods plundered from merchants on the roads. Or he might receive a summons from his king, who found profit in making war. "Only a successful war could temporarily fill royal coffers and re-endow the king with fresh territory," writes the scholar Denys Hay. "Every spring an efficient king tried to lead his warriors on aggressive expeditions. With peace came poverty."

War was also the gentleman's joy. Peacetime life in a grim castle could be very dull, for the typical noble had almost no cultural resources and few diversions besides hunting. Battle was the climax of his career as it was often the end. The noble troubadour Bertrand de Born speaks for his class: "I tell you that I have no such joy in eating, drinking, or sleeping as when I hear the cry from both sides: 'Up and at 'em!', or as when I hear riderless horses whinny under the trees, and groans of 'Help me! Help me!', and when I see both great and small fall in the ditches

77

and on the grass, and see the dead transfixed by spear-shafts! Barons, mortgage your castles, domains, cities, but never give up war!" (It is true that Dante, in the *Inferno*, saw the bellicose Bertrand de Born in hell, carrying his severed head before him as a lantern.)

As Europe became more stable, central governments more efficient, and the interests of commerce more powerful, the warlike ideal faded. The military organization of society yielded to a civil structure based on legality. In the late Middle Ages knights found themselves out-of-date; war fell more and more into the hands of base ruffian mercenaries, sappers and miners, and artillerymen. The military traditions of the noble knight remained, but were transformed into the pageantry of which we read in Froissart. Commercialism altered the noble caste; around 1300 Philip the Fair of France openly sold knighthoods to rich burghers, who thereby gained exemption from taxes as well as social elevation. In our end of time the chevalier has become a Knight of Pythias, or Columbus, or the Temple, who solemnly girds on sword and armor to march past his own drugstore.

The knight was originally the companion of his lord or king, formally admitted to fellowship with him. Around the year 1200 the church took over the dubbing of the knight and imposed its ritual and obligations on the ceremony, making it almost a sacrament. The candidate took a symbolic bath, donned clean white clothes and a red robe, and stood or knelt for ten hours in nightlong silence before the altar, on which his weapons and armor lay. At dawn mass was said in front of an audience of knights and ladies. His sponsors presented him to his feudal lord and gave him his arms, with a prayer and a blessing said over each piece of equipment. An essential part of the ceremony was the fastening of the spurs; our phrase "he has won his spurs" preserves a memory of the moment. An elder knight struck the candidate's neck or cheek a hard blow with the flat of the hand or the side of his sword. This was the only blow a knight must always endure and never return. The initiate took an oath to devote his sword to good causes, to defend the church against its enemies, to protect widows, orphans, and the poor, and to pursue evildoers. The ceremony ended with a display of horsemanship, martial games, and mock duels. It was all very impressive; the more earnest knights never forgot their vigils or belied their vows. It was also a very expensive undertaking, so

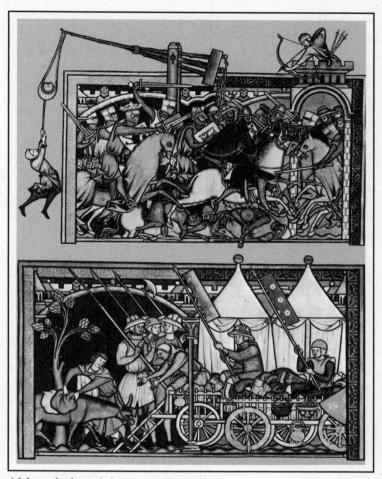

Although the miniature at top portrays an Old Testament battle, the artist who executed the work painted thirteenthcentury armor and siege weapons. The man at left is struggling with a trebuchet, a medieval weapon used to fling boulders against the walls of resisting cities. The miniature below it, from the same French manuscript, shows a military cart carrying armor and provisions.

79

much so that by the fourteenth century many eligible gentlemen preferred to remain squires.

The knight was bound to serve his master in his wars, though in the early period of feudalism for only forty days a year. Wars were, then, necessarily brief-raids rather than actual wars. Few pitched battles occurred unless one party sent a challenge to fight at a set time and place. The commander's purpose was not to defeat the enemy but rather to harm him by burning his villages, massacring his peasants, destroying his source of income, while he raged impotently but securely in his castle. "When two nobles quarrel," wrote a contemporary, "the poor man's thatch goes up in flames." A chanson de geste of the period happily describes such an invasion: "They start to march. The scouts and the incendiaries lead: after them come the foragers who are to gather the spoils and carry them in the great baggage train. The tumult begins. The peasants, having just come out to the fields, turn back, uttering loud cries; the shepherds gather their flocks and drive them toward the neighboring woods in the hope of saving them. The incendiaries set the villages on fire, and the foragers visit and sack them. The distracted inhabitants are burnt or led apart with their hands tied to be held for ransom. Everywhere alarm bells ring, fear spreads from side to side and becomes general. On all sides one sees helmets shining, pennons floating, and horsemen covering the plain. Here hands are laid on money; there cattle, donkeys, and flocks are seized. The smoke spreads, the flames rise, the peasants and the shepherds in consternation flee in all directions. . . . In the cities, in the towns, and on the small farms, wind-mills no longer turn, chimneys no longer smoke, the cocks have ceased their crowing and the dogs their barking. Grass grows in the houses and between the flag-stones of the churches, for the priests have abandoned the services of God, and the crucifixes lie broken on the ground. The pilgrim might go six days without finding anyone to give him a loaf of bread or a drop of wine. Freemen have no more business with their neighbors; briars and thorns grow where villages stood of old."

With the coming of large-scale wars, such as William's conquest of England, and with the crusades, the rudiments of strategy began. Military thinkers reflected on several questions: the role of cavalry and infantry, the choice of terrain, the use of archers, and the handling of reserve units.

The supreme cavalry tactic was the charge at full gallop against a defensive position. Terrified peasants would break and run before the oncoming menace of iron men on wild beasts. Nevertheless, the charge had its dangers for the attackers; in broken or swampy terrain it was ineffective, and a concealed ditch could bring it to naught. Stouthearted defenders could protect their position with rows of sharpened stakes planted at an angle between them and the enemy. In the face of such an obstacle the most intrepid steed will refuse. If the defense possessed a welldrilled corps of bowmen, they would greet the charging knights with a hail of arrows or bolts. But they had only a few moments. The effective limit of an arrow was only about one hundred fifty yards, and good armor would deflect all but direct hits. A sensible archer aimed at the horse, for a knight once dismounted was at a serious disadvantage.

Once the cavalry charge was over, the battle became a series of hand-to-hand engagements. As the armies engaged, the archers retired, leaving the battle to the knights. The issue was decided by the number killed and wounded on either side; the side with fewer casualties held the field. The number of knights killed in battle was remarkably small, however; prisoners of distinction were held for ransom. There was even a curious traffic in captives, who were bought and sold by merchants on speculation. Nonransomable prisoners were stripped of their precious armor, and then they were often finished off with a dagger to save the cost of maintaining them.

The medieval army, until the thirteenth century, consisted almost entirely of combatants, with very few of its men concerned with the auxiliary services and supplies. Medical services hardly existed, and soldiers had to forage for themselves, for the army was expected to live off the country. Usually about a third of the troops were mounted knights, although the proportion varied greatly with circumstances. Some of the infantry were professional soldiers, but the majority were peasants impressed for the campaign. They wore whatever armor they could provide, usually heavy leather jerkins reinforced with iron rings, and they carried shields, bows and arrows, swords, spears, axes, or clubs.

The knight's equipment represented a compromise between offensive and defensive demands, or between the need for

mobility and the need for self-protection. For offensive purposes the queen of weapons was the sword. The knight, who had received it from the altar after a night of prayer, could regard it with holy awe as the symbol of his own life and honor. Certain swords are celebrated in legend, Arthur's Excalibur, Roland's Durendal. The pommel of the sword was often hollowed, to contain relics: to take an oath one clasped one's hand on the sword hilt, and heaven took note. To suit individual tastes, there was much variation in the sword blade, grip, and guard. The most popular model had a tapering blade three inches wide at the hilt and thirty-two or thirty-three inches long. It was equally effective for cutting or thrusting. The steel blades were made of layered strips of iron, laboriously forged and tempered. Much learned discussion dealt with the relative merits of blades from Toledo, Saragossa, Damascus, Solingen, and Milan. Twohanded swords had their vogue, but the soldier who used one had to be very strong. Since neither arm was free to carry a shield, he was likely to be undone by an agile adversary while he was preparing his blow. These swords were best used for judicial beheading.

The lance or spear was the traditional weapon of the horseman, and it lingers to our own times as a symbol of the mounted knight. In 1939 the Polish cavalry, with ridiculous gallantry, carried lances into battle against German tanks. With a ten-foot steel-pointed spear a charging knight could overthrow a mounted enemy or reach over a shield wall and pin his victim. But his spear was nearly useless after the first clash; the knight had to throw it away and take to the sword or battle-ax, which could deal cruel blows even through armor, often driving the links of chain mail into the wound, where they would fester and cause gangrene. Some knights carried a mace, or club, the most primitive of weapons, made all the more fearsome by the addition of deadly spikes. The mace was the badge in battle of William the Conqueror and Richard the Lion-Hearted, and it was also, as the scholar William Stearns Davis points out, "the favorite of martial bishops, abbots, and other churchmen, who thus evaded the letter of the canon forbidding clerics to 'smite with the edge of the sword,' or to 'shed blood.' The mace merely smote your foe senseless or dashed out his brains, without piercing his lungs or breast!" By one of history's pretty ironies the mace survives as a sanctified relic, borne before the president at college commencements by the most ornate member of the faculty.

Arming a knight was a slow process. In time, as the weight and complexity of armor increased, the chevalier was unable to prepare himself for conflict unaided. He had to sit down while a squire or squires pulled on his steel-mailed hose, and stand while they fitted the various pieces, fastening them with a multitude of straps and buckles. First came an undershirt, made of felted hair or quilted cotton, to bear the coat of mail, or hauberk. This was an actual shirt, usually extending to mid-thigh or even below the knee and composed of steel links riveted together. If well made, it could be very pliable and springy and could even be cut and tailored like cloth. A superb hauberk in the Metropolitan Museum of Art in New York is composed of over two hundred thousand links and weighs only about nineteen pounds. Cruder coats of mail could weigh two or three times as much. Despite its strength, the hauberk did not fully protect the wearer against a mighty blow. It was also subject to rust: as a result very few early hauberks have survived to our own time. One method of derusting was to put the coat of mail with sand and vinegar into a leather bag and then toss it about for exercise like a medicine ball. Our museums have adapted this technique for cleaning hauberks by making powered tumbling boxes.

Defensive armor steadily became more elaborate, with coifs to cover the neck and head, elbow pieces, knee guards, and greaves. Because the face remained vulnerable, helmets increased in weight and covered more and more of the face until they came to resemble cylindrical pots with slits for the eyes. As usual, security was gained at a cost. The knight had to bandage his head, for if he took a fall, he might easily sustain a brain concussion. William Marshal, a famous English champion who lived at the end of the twelfth century, won a tournament, and afterward could not be found to receive the prize. He was finally discovered at a blacksmith's, with his head on the anvil and the smith hammering his battered helmet in an effort to remove it without killing the wearer. In a hot fight on a hot day one suffered indeed. The sun beat down on the helmet; perspiration could not be wiped away, one could not hear orders or messages or utter comprehensible commands, and if the helmet was knocked askew, one was blind. There are many examples

83

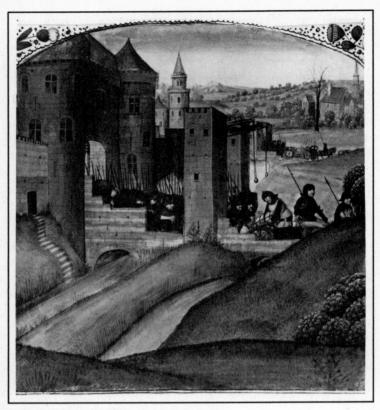

In this illustration men-at-arms cross a drawbridge over the castle's protective moat. Earlier fortresses generally served as great communal defenses, but the castles of the Middle Ages were, above all, private shelters, the symbols of feudal lordship. of death from heat stroke or from drowning after a fall into even a little stream. At Agincourt many French knights fell into the deep trampled mud and suffocated. Moreover, the pot helmet concealed one's identity; hence knights painted bearings on their helmets and shields. Thus heraldry began.

In the fourteenth century the hauberk yielded to plate armor, which was fitted to the figure and often magnificently decorated. A full suit of plate armor weighs sixty pounds or more. Just the helmet and cuirass of one French knight at Agincourt weighed ninety pounds. If properly articulated and well oiled, plate armor permitted much freedom of movement. A famous fifteenth-century French athlete could turn a somersault wearing all his armor but his helmet and could climb the underside of a scaling ladder using only his hands. But no matter how well equipped, the armored knight was still vulnerable. A base villein could stab his horse, a pikeman could hook him in the armpit and bring him down; and once dismounted he was in a sorry state. He moved clumsily. His buttocks and crotch were unprotected to permit him to hold his seat in the saddle. If he fell on his back, he had to struggle like a turtle to right himself. A lightfooted adversary could readily lift his visor, stab him in the eyes, and finish him off

The shield was generally made of stout wooden boards, nailed together, bound by casein glue, and covered with heavy hide surrounded by a metal rim. Often it had a metal boss in the center to deflect the opponent's sword blade. Foot soldiers carried round shields, but knights usually bore kite-shaped shields, which protected the legs.

To carry the steel-clad knight into battle or tourney, a heavy, powerful horse was needed. Such chargers were rare and costly in days when fodder was scarce and animals thin and small. Horse farmers bred them deliberately for size and strength. The Arabian strain was popular, and a white stallion the most prized of all. Riding a mare was considered unknightly. To sustain the clash of battle, the horse needed long and careful training. His rider, cumbered with sword, shield, and spear, usually dropped the reins and guided his mount by spurring, leg pressures, and weight shifting.

The great weapon of infantry—and of Mongol and Turkish cavalry—was the bow and arrow. The short bow is very ancient, the property of most primitive peoples the world over. As we see in the Bayeux tapestry, it was drawn to the breast, not the ear; at short range it could be lethal. The six-foot longbow, shooting a three-foot "clothyard" shaft, was apparently a Welsh invention of the twelfth century; it became the favorite weapon of the English. Only a tall, strong man with long training could use it effectively. There is a knack: the bowstring is kept steady with the right hand and the body's weight is pressed against the bow, held in the left hand—one pushes instead of pulling, using the strength of the body more than that of the arm. At short range the steel-headed arrow could penetrate any ordinary armor. A good archer could aim and deliver five shots a minute.

At the end of the twelfth century, with the general adoption of the crossbow as a weapon, the age of mechanized warfare began. The crossbow is a short instrument of steel or laminated wood, mounted on a stock. One draws it usually by setting its head upon the ground and turning a crank against a ratchet. A catch holds the drawn bow until one is ready to trigger the short, thick arrow, called the bolt or quarrel, which has great penetration at short range. The church deplored the use of this inhuman weapon, and many considered it to be unknightly. While a good longbowman could beat a crossbowman in range and rapidity of fire, with the new weapon the half-trained weakling could be almost the equal of the mighty archer.

The medieval art of war was centered upon the castle or stronghold, the nucleus for the control and administration of surrounding territory as well as the base for offensive operation. Within its walls a little army could assemble and prepare for a little war. It was designed to repel the attacks of any enemy and to shelter the neighboring peasants fleeing with their flocks and herds before a marauder. The earliest castles of medieval timessuch as those William the Conqueror built in England-were of the motte-and-bailey type. They were mere wooden structures with a watchtower, set on a mound, or motte, and surrounded by a ditch and palisade. Below the mound was a court, or bailey, within its own ditch and stockade, spacious enough to provide shelter for the domain's staff of smiths, bakers, and other workers, and refuge for peasants in time of alarm. The motte-andbailey castles were replaced by stone structures, many of which we still visit. The first datable stone donion, or keep, was built in France at Langeais, overlooking the Loire, in 994. Stone construction had to await the progress of technology, effective

stonecutting tools, hoisting devices, and winches. Once the techniques were mastered, castlebuilding spread fast and far. A census taken in 1904 lists more than ten thousand castles still visible in France.

One could see the castle from afar on its commanding hill, or if it was in flat country, perched on an artificial mound. Sometimes the building gleamed with whitewash. The visitor passed a cleared space to the barbican, or gatehouse, which protected the entrance. Receiving permission to enter, he surrendered his weapon to the porter and crossed the drawbridge over the dank, scummy moat, the home of frogs and mosquitoes. Beyond the drawbridge hung the portcullis, a massive iron grating that could be dropped in a flash. Such a portcullis was recently discovered at Angers. Although it had not been used for five hundred years, its chains and pulleys, when cleaned and oiled, still functioned. The castle's entrance passages were angled to slow attackers and were commanded by arrow slits, or "murder holes." in the walls above. At Caernarvon Castle in Wales the visitor has to cross a first drawbridge, then pass five doors and six portcullises, make a right-angled turn and cross a second drawbridge.

One traversed the enormous walls, sometimes fifteen or twenty feet thick, to reach the inner bailey. The walls were topped by runways, with crenelated battlements to protect defending archers and with machicolations, or projections with open bottoms through which missiles or boiling liquids could be dropped. At intervals the wall swelled out into bastions, which commanded the castle's whole exterior. If by some unlikely chance an attacker succeeded in penetrating the interior, he could not be sure of victory. The different sections of the parapets were separated by wooden bridges, which could be destroyed in a moment to isolate the enemy. In the winding stairways within the walls, there were occasional wooden stairs instead of stone ones; these could be removed, so that an unwary assailant, hurrying in the gloom, would drop suddenly into a dungeon.

The heart of the defensive system was the keep, a tower sometimes two hundred feet high and with walls twelve feet thick. Underground, beneath the keep, were the oubliettes, dungeons opening only at the top and used for prisons or for storing siege provisions, and enclosing, if possible, a well. Above were living quarters for the noble and his guardsmen, and at the top, a watchtower with a heraldic banner flying from it.

The stoutness of the castles is made evident by their survival on many a hilltop of Europe and Syria. During World War II some sustained direct hits by high-explosive and incendiary bombs, with little effect. At Norwich and Southampton the medieval walls were hardly harmed by bombardment, whereas most of the houses built against them were destroyed.

But the castles were not impregnable. Remarkable siege engines were invented, especially by the Byzantines-battering rams, catapults that hurled stone balls weighing as much as one hundred fifty pounds, arbalests, or gigantic crossbows. Miners would patiently and dangerously dig a tunnel under the moat. under the very walls. The tunnel was propped with heavy timbers and filled with combustibles. These were ignited, the props were consumed, and with luck, a section of the wall would fall into the moat. At the same time archers drove the defenders from the battlements. Soldiers ran forward with bales of hay, baskets of earth, or other material, to fill the moat. Others followed them across this causeway and hung scaling ladders against the walls, with shields held over their heads to deflect missiles. To climb a ladder holding the shield on one arm and keeping a hand ready to grasp the dangling sword is no small achievement. An alternative method of attack was to construct a wheeled wooden siege tower as high as the wall, with a commando party concealed on the top story. The tower was pushed up to the wall, and a drawbridge dropped, on which the gallant band of assailants crossed to the battlements. It was in this manner that the crusaders took Jerusalem.

The casualties in storming a castle were usually enormous, but lives were regarded as expendable. There are many examples of successful attacks on supposedly impregnable castles and towns. Richard the Lion-Hearted captured Acre with his siege machines in 1191. Edward, prince of Wales, "the Black Prince," took Limoges in 1370 by mining and direct assault. Irritated by the resistance, he commanded that more than three hundred men, women, and children be beheaded. "It was a great pity to see them kneeling before the prince, begging for mercy; but he took no heed of them," says Froissart, with hardly a hint of reprobation. In general, however, the defense of castles and walled towns was stronger than the offense. By far the best way

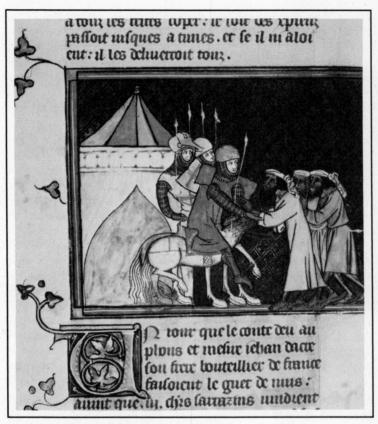

Mounted Christian knights embarked on holy wars in the Middle East. Knights enlisted, swept away by the power of the Christian rhetoric, mesmerized by promises of earthly riches and heavenly thanks. The crusaders in this manuscript illustration confront a band of bearded Saracen strangers. to reduce a stronghold was to find a traitor within the walls, and if one could not be discovered, then to starve out the garrison. But a prudent castellan kept his fort well stocked with a year's supply of food, drink, and fuel. Hence sieges could often be very long, lasting as much as two years, and were almost as exhausting to the besiegers as to the besieged.

The dwindling of feudalism and of the nobles' independence and the introduction of gunpowder and siege cannon in the fourteenth century made the castle obsolete. Gentlemen abandoned the discomforts of life in an isolated stone prison without regret. They much preferred a spacious manor house or a residence in town among their own kind.

War was waged on the high seas as well as on land. In time of need the monarch would simply commandeer his nation's merchant vessels. These might displace two hundred tons or more; by the fifteenth century we find even thousand-tonners. A crusader's ship could transport a thousand soldiers with their horses and equipment. The ingenious Frederick II built for his crusade fifty vessels, similar to modern landing craft, with doors at the waterline, so that knights could disembark on horseback. In the Mediterranean the Byzantines, Venetians, and Genoese favored long, narrow galleys, very maneuverable and with formidable beaks for ramming the enemy.

The admiral built on his merchant ships a forecastle and a sterncastle, from which his archers could fire down on the enemy's decks. His purpose was to sink his opponent by ramming, or if that did not work, to grapple and disable him by cutting his rigging and then boarding. For hand-to-hand combat he was likely to carry quicklime to blind the defenders, and soft soap mixed with sharp bits of iron to render their footing precarious. The Byzantines mounted catapults on their ships; they also introduced the West to Greek Fire, apparently a mixture of petroleum, quicklime, and sulfur. The quicklime in contact with water ignited the bomb, a primitive napalm.

The medieval art of war found its great exemplification, its test, its school, in the crusades. The organization of an expeditionary force calls into question familiar logistics; the prosecution of a distant war demands new strategies and tactics; out of battles with strange foes in far lands emerge new weapons, new techniques of warfare. The crusaders learned much from the Byzantines' well-drilled, professional infantry, from their advanced weaponry and engineering. The crusaders' vast castles in the Levant, giant monuments of courage and disaster, were constructed according to traditional Byzantine principles of fortification.

The crusades were a great historical novelty; they were the first wars fought for an ideal. Naturally the ideal was promptly corrupted and falsified. But the fact remains that the crusades were conceived as a service to the Christian God, and the crusaders thought themselves, at least intermittently, the consecrated servants of holy purpose. The crusades were many things, but originally they were a beautiful, noble idea.

The idea of a crusade owes something to the Old Testament, something to the Moslem example of a jihad, or holy war. It owes something, too, to the inflammatory preaching of illuminate monks, and a great deal to the beginning of the Christian reconquest of Spain from the Moors; this combined the triumph of the faith with the acquisition of rich properties. But the chief stimulation of the idea came in news from the East.

By the end of the first millennium the Near East had attained a kind of stability, with the Byzantine Empire and the Arabs holding each other at a standstill. The pilgrim route to Jerusalem was kept open and secure, and the Holy City, itself in Moslem hands, was operated as a sanctified tourist attraction for both Moslems and Christians. The comfortable balance was upset by the Seljuk Turks, who captured Jerusalem, defeated the Byzantine Empire in Asia Minor in 1071, and harassed the Christian pilgrims. Hard pressed by the Turks, the Eastern emperor, Alexius Comnenus, at length appealed to the pope and to the West for military aid against the paynim foe. He asked for a mercenary army that would recapture his territories in Asia Minor and pay itself from the proceeds. He was not much interested in the Holy Land.

The pope who launched the crusade was Urban II, a French noble who had humbled himself to become a Cluniac monk and then had been exalted to the papal throne. He was a vessel of holy zeal, wise in men's ways. Emperor Alexius' appeal stirred in him a vision of a gigantic effort by Western Christendom to regain the Holy Sepulcher. The union of military resources under the pope's control would end the wars of Europe's princes, would bring peace in the West, and in the East, Christian unity in spiritual purpose; it might even link—under papal leadership—Eastern and Western churches, long painfully at odds. The times were propitious for the realization of such a dream. Faith was ardent and uncritical. Europe's population was increasing, men were restless, looking for new lands, new outlets of energy. They seemed to be begging for a worthy use for their idle swords.

At the Council of Clermont in south central France in November 1095, Pope Urban, tall, handsome, bearded, made one of the most potent speeches in all history. He summoned the French people to wrest the Holy Sepulcher from the foul hands of the Turks. France, he said, was already overcrowded. It could barely support its sons, whereas Canaan was, in God's own words, a land flowing with milk and honey. Hark to Jerusalem's pitiful appeal! Frenchmen, cease your abject quarrels and turn your swords to God's own service! Be sure that you will have a rich reward on earth and everlasting glory in heaven! The pope bowed his head, and the whole assembly resounded with acclaim: "Dieu le veult!"-"God wills it!" Snippets of red cloth were crossed and pinned on the breasts of the many who on the spot fervently vowed to "take the cross." It was a spectacle to rejoice the heart of any revivalist. Astutely, Pope Urban had roused men's emotional ardor for the faith, and as if unaware, had tickled their cupidity. All his hearers had been bred on Bible stories of the rich fields and flocks and blooming meadows of Canaan; they confused the actual city of Ierusalem with the Heavenly City, walled in pearl, lighted by God's effulgence, with living water flowing down its silver streets. A poor crusader might find himself tempted by a fief of holy land; and if he should fall, he was assured, by papal promise, of a seat in heaven. The pope also offered every crusader an indulgence, or remission of many years in purgatory after death. Urban appealed, finally, to the strong sporting sense of the nobles. Here was a new war game against monstrous foes, giants and dragons; it was "a tournament of heaven and hell." In short, says the historian Friedrich Heer, the crusades were promoted with all the devices of the propagandist-atrocity stories, oversimplification, lies, inflammatory speeches.

The pope was taken aback by the success of his proposal. No plans had been made for the prosecution of the crusade. Several important kings of Christendom happened to be excommuni-

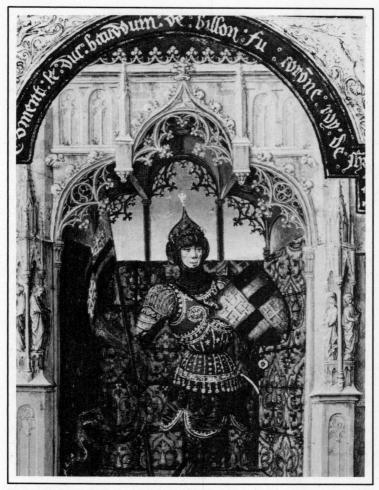

This illustration portrays Sir Godfrey of Bouillon in his elaborate crusading armor. Sir Godfrey, the chosen Christian ruler of Jerusalem, remained in the Middle East after most of his allied knights and infantrymen had returned home to Europe. Though the plundering had subsided, the crusaders' fanaticism would not be forgotten by their non-Christian victims. cated at the time. Urban placed the bishop of Le Puy in charge of the undertaking, and French nobles assumed military control. The church's entire organization was set to the task of obtaining recruits, money, supplies, and transportation. In some regions, under the spell of compelling voices, enthusiasm was extreme. Reports the chronicler William of Malmesbury: "The Welshman left his hunting, the Scot his fellowship with vermin, the Dane his drinking party, the Norwegian his raw fish. Lands were deserted of their husbandmen, houses of their inhabitants; even whole cities migrated." This is pious exaggeration, but exaggeration of facts. Proudly the dedicated wore their red crosses or exhibited scars in the form of the cross on their breasts.

The crusades began with grotesqueries, comic and horrible. A band of Germans followed a goose they held to be Godinspired. Peter the Hermit, a fanatic, filthy, barefoot French monk, short and swarthy, with a long, lean face that strangely resembled that of his own donkey, preached a private crusadeknown as the Peasants' Crusade-and promised his followers that God would guide them to the Holy City. In Germany Walter the Penniless emulated Peter. Motley hordes of enthusiastshaving plucked Peter's poor donkey totally hairless in their quest for souvenirs - marched through Germany and the Balkan lands, killing Jews by the thousands on their way, plundering and destroying. The Byzantine Emperor Alexius sent them with all haste into Asia Minor, where they supported themselves briefly by robbing Christian villagers. They were caught in two batches by the Turks, who gave the first group the choice of conversion to Islam or death and massacred the second group. Peter the Hermit, who was in Constantinople on business, was one of the few to escape the general doom.

The first proper crusade got under way in the autumn of 1096. Its armies followed several courses, by sea and land, to a rendezvous in Constantinople. The crusaders' numbers are very uncertain; the total may have been as low as thirty thousand or as high as one hundred thousand. At any rate, the Byzantine emperor Alexius was surprised by the multitude and was hard put to find food for them. He was also displeased by their character. He had asked for trained soldiers; but what he received was a vast and miscellaneous throng of undisciplined enthusiasts that included clergy, women, and children. Only the mounted knights made a good military show, and even they behaved arrogantly. One sat down comically on the emperor's own throne. Alexius, swallowing his anger, offered money, food, and troops to escort the expedition across Asia Minor. In return he asked an oath of allegiance for Byzantine territories the crusaders might recapture. This was given more than grudgingly. Mutual ill will and scorn were rife. Many highhearted Franks vowed that the Byzantine allies were as much their enemies as were the Turks.

In the spring of 1097 Alexius hustled his troublesome guests out of the capital on their way through Asia Minor toward the Promised Land. It was a dreadful journey. The Asian uplands were dry and barren; the few local peasants fled before the invader, carrying with them their goats and sheep and tiny stocks of grain. Hunger and thirst assailed the marchers. Accustomed to the abundant water supply of their homelands, many had not even provided themselves with water canteens. Knights marched on foot, discarding armor; horses died of thirst, lack of forage, and disease; sheep, goats, and dogs were collected to pull the baggage train. A part of the army crossed the Anti-Taurus range in a flood of rain on a muddy path skirting precipices. Horses and pack animals, roped together, fell into the abyss. Continually the Turks attacked the column. Their bowmen, mounted on fast little horses, discharged a hail of arrows at a gallop and fled before a counterattack could be organized. Their devices were ambush, feigned retreat, and the annihilation of the enemy's foraging parties. Such hit-and-run tactics, new to the Westerners, shocked their sense of military propriety.

The survivors came down to the Mediterranean at its northeastern corner and found some reinforcements that had come by ship. The fainthearts and the greedy revealed themselves. Stephen of Blois, brother-in-law of one English king and father of another, deserted; but when he got home he was sent back, reportedly by his high-spirited wife. Peter the Hermit, who had joined up, fled for good. Baldwin of Boulogne managed to establish himself as ruler of the county of Edessa and was lost for a time to the great enterprise.

The main body camped before the enormous stronghold of Antioch, which barred all progress south toward Jerusalem. An epic eight-month-long siege ensued, enlivened by such bizarre interludes as the appearance of the Byzantine patriarch hanging from the battlements in a cage. Because of treachery within the walls, Antioch was finally taken in June 1098. The Christian army then moved cautiously toward Jerusalem. By any modern standards it was a tiny force, numbering by then perhaps twelve thousand, including twelve hundred or thirteen hundred cavalry. The invaders were shocked to find Canaan a stony, barren land. There is an old Eastern story that at the Creation the angels were transporting the entire world's supply of stones in a sack, which burst as they flew over Palestine. No milk and honey flowed in the gray gullies, not even water. The blazing summer sun on the treeless plain came as a surprise. Men and horses suffered grievously from the lack of shade. The sun smote down on steel helmets, seeming to roast the soldier's dancing brains. Coats of mail blistered incautious fingers until the crusaders learned to cover them with a linen surcoat. Within the armor complaining bodies longed to sweat, but in vain, for there was no water to produce sweat. The soldiers were afflicted with inaccessible itchings, with the abrasions of armor, with greedy flies and intimate insects.

By the best of luck or by divine direction the Turks were at odds with the Arab caliphate in Baghdad, and the country was ill defended. The crusaders made their way south by valor and by threat and bribes to the Moslem garrisons. Finally on June 7, 1099, the army camped before the beetling walls of Jerusalem.

Let an eyewitness, Foucher de Chartres, tell the story of the assault: "Engineers were ordered to build machines that could be moved up to the walls and, with God's help, thus achieve the result of their hopes.... Once the engines were ready, that is the battering rams and the mining devices, they prepared for the assault. Among other contrivances, they fastened together a tower made of small pieces of wood, because large timber was lacking. At night, at a given order, they carried it piece by piece to the most favorable point of the city. And so, in the morning, after preparing the catapults and other contraptions, they very quickly set it up, fitted together, not far from the wall. Then a few daring soldiers at the sound of the trumpet mounted it, and from that position they immediately began to launch stones and arrows. In retaliation against them the Saracens proceeded to defend themselves similarly and with their slings hurled flaming brands soaked in oil and fat and fitted with small torches on the previously mentioned tower and the soldiers on it. Many therefore fighting in this manner on either side met ever-present

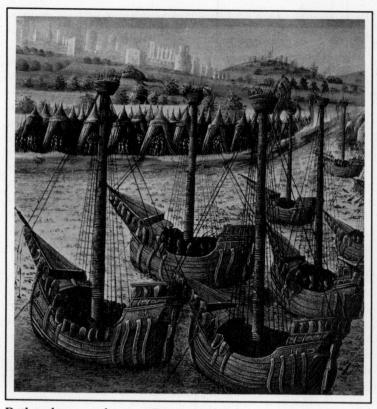

Rather than march across Europe and Asia Minor, many later crusaders traveled by sea to the Holy Land. One such expedition, which embarked from England in 1147 and sailed down the coast of France, paused long enough to capture Lisbon from the Moslems. The ships here, preparing for imminent departure, are headed for Constantinople. death.... [The next day] the Franks entered the city at midday, on the day dedicated to Venus, with bugles blowing and all in an uproar and manfully attacking and crying 'Help us, God!'..."

Once the crusaders had taken control of the city, they began to massacre the inhabitants. "Some of our men," wrote the twelfth-century chronicler Raymond of Agiles, "cut off the heads of their enemies; others shot them with arrows, so that they fell from the towers; others tortured them longer by casting them into the flames. Piles of heads, hands, and feet were to be seen in the streets of the city. It was necessary to pick one's way over the bodies of men and horses. But these were small matters compared to what happened at the temple of Solomon, a place where religious services are ordinarily chanted. What happened there? If I tell the truth, it will exceed your powers of belief. So let it suffice to say this much at least, that in the temple and portico of Solomon, men rode in blood up to their knees and bridle reins. Indeed, it was a just and splendid judgment of God, that his place should be filled with the blood of the unbelievers, when it had suffered so long from their blasphemies.

"Now that the city was taken it was worth all our previous labors and hardships to see the devotion of the pilgrims at the Holy Sepulcher. How they rejoiced and exulted and sang the ninth chant to the Lord. It was the ninth day.... The ninth sermon, the ninth chant was demanded by all. This day, I say, will be famous in all future ages, for it turned our labors and sorrows into joy and exultation; this day, I say, marks the justification of all Christianity and the humiliation of paganism; our faith was renewed. 'The Lord made this day, and we rejoiced and exulted in it,' for on this day the Lord revealed Himself to His people and blessed them."

Soon after the capture most of the army went home, having fulfilled their vows. Godfrey of Bouillon, who had been chosen ruler of Jerusalem, was left with only one or two thousand infantrymen and a few hundred knights to control a hostile land populated by Arabs, Jews, heretical Christians, and members of the Eastern Orthodox Church. Ill will smolders still. According to the great historian of the crusades Stephen Runciman, the massacre at Jerusalem is unforgotten. "It was this bloodthirsty proof of Christian fanaticism that re-created the fanaticism of Islam."

The crusaders set about strengthening their hold on the coun-

try, constructing those gigantic, practically impregnable castles that still fill us with awe. Little by little they acclimated themselves, learning Arabic, adopting the sensible Oriental dressburnoose and turban-and such congenial local institutions as the harem. They married Armenian and other local Christian women. Their children were brought up by Arab nurses and tutors. In Ierusalem and the coastal cities nobles and merchants lived in fine houses, with carpets, damask hangings, carved inlaid tables, dinner services of gold and silver. Their ladies were veiled against the enemy sun; they painted their faces and walked with a mincing gait. Before long a social class developed of the native-born, the Old Settlers, at home in the East. Like the Old China Hands of our own time, they too had their good friends among the native gentry and would hunt, joust, and feast with them. They took their religion easily, with a tolerant smile for the excessive devotions of other Christians newly arrived in the East. They set aside chapels in their churches for Moslem worship, and the Moslems reciprocated by installing Christian chapels in their mosques. After all, when one can see the Holy Places any day, one gets used to them.

To swell the ranks of the crusaders, mostly pious fighting men of gentle birth, newcomers kept arriving from Europe. A young gentleman, inspired for whatever motive to take the cross, had first to raise his passage money, often by mortgaging his land or by ceding some feudal rights. He heard a farewell sermon in his village church and kissed his friends and kinsmen good-bye, very likely forever. Since the road across Asia Minor had become increasingly unsafe, he rode to Marseilles or Genoa and took passage with a shipmaster. He was assigned a space fixed at two feet by five in the 'tween decks; his head was to lie between the feet of another pilgrim. He bargained for some of his food with the *cargador*, or chief steward, but he was advised to carry provisions of his own—salt meat, cheese, biscuit, dried fruits, and syrup of roses to check diarrhea.

For the devout young warrior willing to accept celibacy, a career opened in the military orders, which were the kingdom's main defenders against the Saracens. The Knights Hospitalers had already been established before the conquest as an order of volunteers caring for sick pilgrims in Jerusalem. They took monastic vows and followed the Benedictine Rule, adopting as their symbol the white Maltese cross. After the conquest they became the Knights of St. John of Jerusalem, owing obedience to the pope alone. Their hostel in Jerusalem could lodge a thousand pilgrims. Because they policed the pilgrim routes, their interests became more and more military. In later centuries they transferred the site of their operation and were known as the Knights of Rhodes and the Knights of Malta. Today their successors constitute a powerful Roman Catholic order of distinguished key men, and in England a Protestant offshoot, which still maintains a hospital in Jerusalem.

The Knights Templars, the valiant red-cross knights, were established in 1118, with their headquarters in the Dome of the Rock, which the crusaders believed to be Solomon's Temple. Their first duty was to protect the road to Jerusalem. Soon both Hospitalers and Templars were involved in almost every fray between the crusaders and the Saracens, acting as a kind of volunteer police. The rulers of the Christian states had no control over them; they had their own castles, made their own policy, even signed their own treaties. Often they were as much at odds with other Christians as with the Moslems. Some went over to Islam, and others were influenced by Moslem mystical practices. The order in France was all but destroyed in the fourteenth century by Philip IV, eager to confiscate the Templars' wealth. Today the Freemasons have inherited their name and ancient mysteries.

Another fighting monastic order was the Teutonic Knights, whose membership was restricted to Germans of noble birth. They abandoned the Holy Land in 1291 and transferred their activities to the lands of the eastern Baltic. There they spread the Gospel largely by exterminating the heathen Slavs and by replacing them with God-fearing Germans.

The active period of Christian conquest ended in 1144 with the recapture by the Turks of the Christian county of Edessa. Thereafter the Westerners were generally on the defensive. The news of the fall of Edessa shocked Europe. The great Saint Bernard of Clairvaux quickly promoted a new crusade—the second. At Easter in 1146 a host of pilgrims gathered at Vézelay to hear Bernard preach. Half the crowd took the crusader's vow; as material for making crosses gave out, the saint offered up his own gown and cowl to be cut to provide more material.

Inspired by Bernard, the French King Louis VII decided to lead his army to the Holy Land, and Louis's mettlesome queen, Eleanor of Aquitaine, determined to go along. Bernard went into Germany to recruit King Conrad III for the expedition. On their way to Constantinople both the French and the German expeditions found themselves as welcome as a plague of locusts. The cities along the route closed their gates and would supply food only by letting it down from the walls in baskets, after cash payment. Therefore the crusaders—especially the Germans burned and pillaged defenseless farms and villages, and even attacked a monastery. In Constantinople the Germans were received more than coolly by the emperor, who had come to the conclusion that the crusades were a mere trick of Western imperialism.

Somehow the crusaders made their way across Asia Minor, suffering heavy losses on the way. Although the armies and their monarchs were bitterly hostile to one another, they united to attack Damascus; but the attack was unsuccessful, and in their retreat the crusading armies were largely destroyed. The kings left the Holy Land in disgust, acknowledging that the crusade was a total fiasco. Only Queen Eleanor had made the best of things during the journey, carrying on a notorious affair with her youthful uncle, Raymond II, prince of Antioch.

The Moslems continued nibbling at the Christian holdings, and in 1187 they captured Jerusalem. Their great general, Saladin, refused to follow the Christian precedent of massacring the city's inhabitants. He offered his captives for ransom, guaranteeing them safe passage to their own lines. The news of Jerusalem's fall inspired yet a third crusade, led by Philip Augustus of France, Richard the Lion-Hearted of England, and Frederick Barbarossa of Germany, who was drowned on his way to the East.

Warring nations often have a pet enemy—in the first World War, Count von Luckner, in the second, General Rommel. To the crusaders Saladin was such a gallant foe. When he attacked the castle of Kerak during the wedding feast of the heir to Transjordania, the groom's mother sent out to him some dainties from the feast, with the reminder that he had carried her, as a child, in his arms. Saladin inquired in which tower the happy couple would lodge, and this he graciously spared while attacking the rest of the castle. He was fond of a joke. He planted a piece of the True Cross at the threshold of his tent, where everyone who came to see him must tread on it. He got some pilgrim monks drunk and put them to bed with wanton Moslem women, thus robbing them of all spiritual reward for their lifetime toils and trials. In a battle with Richard the Lion-Hearted, Saladin saw Richard's horse fall, generously sent him a groom with two fresh horses—and lost the battle. And when Richard came down with fever, Saladin sent him peaches, pears, and snow from Mt. Hermon. Richard, not to be outdone in courtesy, proposed that his sister should marry Saladin's brother, and that the pair should receive the city of Jerusalem as a wedding present. It would have been a happy solution.

Though Richard captured Acre in 1191 (with the aid of a great catapult known as Bad Neighbor, a stone thrower, God's Own Sling, and a grappling ladder, The Cat), he could not regain Jerusalem. He had to be content with negotiating an agreement that opened the way to the Holy City to Christian pilgrims. The third crusade marked on the whole a moral failure. It ended in compromise with the Moslems and in dissension among the Christians. The popes lost control of their enterprise; they could not even save their champion, Richard the Lion-Hearted, from imprisonment when he was taken captive by the duke of Austria, who resented an insult he had received from Richard during the crusade. Idealism and self-sacrifice for a holy cause became less common, and most recruits who went to the Holy Land were primarily looking for quick returns. People accused the men collecting taxes to pay for a new crusade and even the pope himself of diverting the money to other purposes.

In 1198 the great Innocent III acceded to the papacy and promoted another expedition, the lamentable fourth crusade. Its agents made a contract with the Venetians for the transport to the Holy Land of about 30,000 men and 4,500 horses. However, by embarkation day the expeditionaries had raised only about half the passage money. The Venetians, always businessmen, offered the crusaders an arrangement: if they would capture for Venice the rival commercial city of Zara in Dalmatia, which the Venetians described as a nest of pirates, they would be transported at a cheaper rate. Zara was efficiently taken, to the horror of Pope Innocent, for Zara was a Catholic city, and its Hungarian overlord was a vassal of the Apostolic See. Now that the precedent of a crusade against Christians was set, the leaders, at Venetian urging, espoused the cause of a deposed, imprisoned, blinded Byzantine emperor, Isaac Angelus. By restoring him to

The cruel crusaders were not inclined to extend any Christian charity to their Moslem enemies. After capturing the city of Acre, Richard the Lion-Hearted, pictured here at left, wearing a crown, watched calmly as his men massacred 2,700 Moslems. his throne they would right a great wrong, return the East to communion with the Roman church, and receive from their Byzantine protégé men and money for a later conquest of Egypt. The pope was persuaded to look on the project with favor, and the ships of the fourth crusade set sail for Constantinople.

The noble city was taken by storm on April 12, 1204. The three-day spree that followed is memorable in the history of looting. The French and Flemish crusaders, drunk with powerful Greek wines, destroyed more than they carried off. They did not spare monasteries, churches, libraries. In Santa Sophia they drank from the altar vessels while a prostitute sat on the patriarch's throne and sang ribald French soldiers' songs. The emperor, regarded as a wicked usurper, was taken to the top of a high marble column and pushed off, "because it was fitting that such a signal act of justice should be seen by everyone."

Then the real booty, the Eastern Empire, was divided. Venice somehow received all the best morsels: certain islands of the Aegean and seaports on the Greek and Asian mainlands. The Franks became dukes and princes of wide lands in Greece and in Macedonia, where one still sees the massive stumps of their castles. The papal legate accompanying the troops absolved all who had taken the cross from continuing on to the Holy Land to fulfill their vows. The fourth crusade brought no succor to Christian Palestine. On the contrary, a good many knights left the Holy Land for Constantinople, to share in the distribution of land and honors.

"There was never a greater crime against humanity than the fourth crusade," says Stephen Runciman. It destroyed the treasures of the past and broke down the most advanced culture of Europe. Far from uniting Eastern and Western Christendom, it implanted in the Greeks a hostility toward the West that has never entirely disappeared, and it weakened the Byzantine defenses against the rising power of the Ottoman Turks, to whom they eventually succumbed.

A few years later, the crusading spirit staged a travesty upon itself. Two twelve-year-old boys, Stephen in France and Nicholas in Germany, preached a children's crusade, promising their followers that angels would guide them and that the seas would divide before them. Thousands of boys and girls joined the crusade, along with clerics, vagabonds, and prostitutes. Miracle stories allege that flocks of birds and swarms of butterflies accompanied the group as it headed southward over the mountains to the sea, which, however, did not divide to let them pass. Innocent III told a delegation to go home and grow up. A few of the Germans managed to reach Palestine, where they disappeared. The French party fell into the hands not of angels but of two of the worst scoundrels in history, Hugh the Iron and William of Posquères, Marseilles shipowners, who offered the young crusaders free transport to the Holy Land, but carried them instead to Bougie in North Africa and sold them as slaves to Arab dealers.

The melancholy tale of the later crusades can be briefly told. Unable to recapture Jerusalem, the strategists tried to seize Egypt, one of the great bases of Moslem power. In 1219, after a siege of a year and a half, an expedition took Damietta, on one of the mouths of the Nile. But the Christians were able to hold on to the city for only a few years. Again in 1249 Saint Louis invaded Egypt, hoping to retake it, but he was unsuccessful.

There were numerous attempts to recapture Jerusalem after it had fallen to the Saracens. The Emperor Frederick II's rather comic expedition of 1228 resembled a goodwill tour rather than a crusade. The mood of the times had changed. It now suited almost everybody to maintain the status quo. The Moslems were threatened from the east by the Mongols under Genghis Khan and his equally formidable successors; they wanted no little wars in Palestine. The Christian Old Settlers had developed a thriving import-export trade in Oriental goods, with merchandise brought by camel caravan to the coastal cities to be shipped to Europe. They had enough of visiting zealots, who were eager to plunge into furious battle, commit a few atrocities, break the precarious peace, and then go home, leaving the Old Settlers holding the bag.

With want of enthusiasm, want of new recruits, want, indeed, of stout purpose, the remaining Christian principalities gradually crumbled. Antioch fell in 1268, the Hospitaler fortress of Krak des Chevaliers in 1271. In 1291, with the capture of the last great stronghold, Acre, the Moslems had regained all their possessions, and the great crusades ended, in failure.

Why? What went wrong? There was a failure of morale, clearly; there was also a failure in military organization and

direction. The popes were no commanders in chief; the various allied armies were riven by dissension; there was no unity of command or strategy in the rival principalities of Palestine and Syria. The military means available were insufficient to maintain the conquest; with the distance from European bases so great, supply problems were insuperable. The armies were over-officered, for the crusades were regarded as a gentleman's game, and poor men soon ceased to volunteer. And always there was the wastage caused by malaria, dysentery, and mysterious Oriental diseases.

As the historian Henri Pirenne has pointed out, the crusades did not correspond to any temporal aim. Europe had no need for Jerusalem and Syria. It needed, rather, a strong Eastern Empire to be a bulwark against the aggressive Turks and Mongols; and this empire the crusaders destroyed with their own swords. In Spain, on the other hand, the crusading spirit was successful because it matched a political need.

It is easy enough for us to see that the early enthusiasm of the crusaders was based on illusion. Long before the forms and phraseology of the crusades were abandoned, disillusionment had set in. The character of the later recruits changed. Many went out to the East to escape paying their debts; judges gave criminals their choice of jail or taking the cross. After the defeat of Saint Louis in 1250, preachers of a crusade were publicly insulted. When mendicant monks asked alms, people would summon a beggar and give him a coin, not in the name of Christ, who did not protect his own, but in that of Mohammed, who had proved to be stronger. Around 1270 a former master general of the Dominican order wrote that few still believed in the spiritual merit promised by the crusades. A French monk addressed God directly: "He is a fool who follows you into battle." The troubadours and the minnesingers mocked the church, and Walther von der Vogelweide called the pope the new Judas. There were countercrusades in France and Germany. The dean and chapter of the cathedral at Passau preached a crusade against the papal legate; in Regensburg anyone found wearing a crusader's cross was condemned to death. A pacifist party arose, led by the Spiritual Franciscans. "Don't kill the heathen; convert them!" was their cry. At first the crusades had strengthened the church, but eventually the papacy's sponsorship of warfare came to undermine its spiritual authority.

The effects of the crusades on the lay world were mixed. Troublesome younger sons were packed off to the Holy Land so they could not disturb the peace at home. The rising middle class benefited by lending money to the crusaders and selling them supplies. Many a peasant and serf bought his freedom from his master, who needed cash for travel expenses, and discovered a new trade in the swelling cities.

The crusades coincided more or less with the West's rediscovery of the East. Traders, of whom the best known is Marco Polo, found their way to the Mongol Empire in the Far East and organized a great international business, both overland and seaborne. Eastern products became common in the West—rice, sugar, sesame, lemons, melons, apricots, spinach, and artichokes. The spice trade boomed; the West learned to appreciate cloves and ginger and to delight in exotic perfumes. Eastern materials had a mighty vogue—muslins, cottons, satins, damasks, rugs, and tapestries; and new colors and dyes—indigo, carmine, and lilac. The West adopted Arabic numerals in place of the impossible Roman system. Even the rosary is said to have come to Christian Europe by way of Syria.

The crusades stimulated Europe's economy. Trade became big business as the new devices of banking and credit, developed during the period, came into common use. Europe's imagination was also stimulated, for the crusaders gave rise to a rich vernacular literature, epic poems, histories, memoirs. And the heroic ideal, however abused, possessed the Western imagination and still lives there as the great example of self-sacrifice for a holy cause.

IV The Noble's Life

In her fashionable headdress, this fifteenth-century duchess leads her personal retinue of ladies.

Final eudalism is one of those words that have taken on so many extended and figurative meanings that the original meaning has been obscured. Today any oppressive government, greedy landholder, or brutal exploiter of labor is called feudal—always with disapproval. This is unfair to feudalism. The word is also often confused with the manorial system, which tied peasants to the land they worked, and is sometimes applied to all medieval European governments. This is inexact; parts of Europe, such as Scandinavia and Ireland, were hardly touched by feudalism, and in Italy it was complicated by other political systems. On the other hand, Japan developed an organization that may well be called feudal.

Feudalism is a total organization of society. It specifies the status of the individual and his relations with his superiors and inferiors. It includes an economic system based on land; in general a man's rights to land correspond with his social rights. It is a scheme of political organization, legally based, overlapping the social and economic organization. In medieval feudalism the overlord was, in theory, socially, economically, and politically supreme. He granted some part of his rights to his vassals, his noble companions and servants. The granted rights took the form of rule over a unit of land, a fief. An implicit bargain was struck: the lord offered maintenance and protection; the vassal promised military aid to his lord.

Feudalism was, then, a military, political, social, economic, and legal system emerging from the breakup of Carolingian society. It suited a time when communications were difficult, when society was governed through personal relations rather than correspondence, when scarcity of money precluded a salaried officialdom. Feudalism was a system of rights and duties; more than that, it was a way of life and a mystique.

As a system of government, feudalism was simple and logical. The king kept a part of his realm as his own demesne, which he farmed and administered for his own support. The rest he entrusted to his faithful companions in the form of fiefs, to enjoy and administer. In theory the fief was revocable and would revert to the monarch at the holder's death, but in practice the monarch was seldom strong enough to remove a gift once made, and feudal holdings became hereditary. In return for his land the noble became his lord's vassal, owing to him services, particularly the provision of a fixed number of armed horsemen for his lord's wars. The noble, vassal of his king, was also a lord, empowered to grant a share of his land, with its accompanying rights and duties, to a vassal of his own; this is subinfeudation.

The feudal lord usually exercised justice on his estate, except for major cases reserved to his monarch. He collected tolls and other taxes, and was supposed to maintain roads, bridges, and defenses, and to protect the poor, orphans, and widows. The lord and his vassals together formed the nobility, in distinction to the mass of peasants, the clergy, and the townspeople, although the distinctions were not completely formalized until the twelfth century. The nobles were fighting men, the descendants of fighting men. They were proud of their vassalage, a word we have tinged with derogation. But today most of us are, have been, or will be employees; no employee has the right to look down on a vassal.

The feudal contract rested upon land because land was, in the early days, the only capital or means of support. The French law said: "No lord without land; no land without a lord." A fief, however, was more than land; it represented the whole complex of the vassal's rights and obligations. The bond between lord and vassal was affirmed or reaffirmed by the ceremony of homage. The vassal knelt, placed his clasped hands within those of his master, declared, "Lord, I become your man," and took an oath of fealty. The lord raised him to his feet and bestowed on him a ceremonial kiss. The vassal was thenceforth bound by his oath "to love what his lord loved and loathe what he loathed, and never by word or deed do aught that should grieve him."

The vassal rendered to his lord certain services in addition to supplying his quota of armed knights. He had to attend his lord's court when summoned to be a judge in a case against another vassal, for everyone had the right to be tried by his peers. If the judges could not reach a decision, appeal was sometimes taken to God, with an ordeal by battle. According to thirteenth-century Norman procedure, the plaintiff and defendant, or their champions, met at noon, wearing padded jerkins and iron caps and carrying staves. Each swore that he bore no charms and had drunk no magic potion and would invoke no demons for aid. The contestants fought all afternoon. If the defendant was undefeated by nightfall, he was acquitted and his accuser jailed; but if he was disabled or forced to cry "craven," he was usually hanged. (As late as 1818 a young Englishman invoked his right to a judicial duel, but the law was hurriedly annulled.)

The vassal was obliged to entertain the overlord and his large and hungry suite. He was liable also for certain "reliefs" or "aids." When an heir received his father's fief, he was usually required to pay the lord the first year's revenue from it. The lord chose a new husband for a vassal's widow; he was guardian, profitably, of a minor who inherited a fief. He received contributions from his vassals when he gave his eldest daughter in marriage, when his eldest son was knighted, or when, as a prisoner, he required a ransom. Some of the feudal services were peculiar. A Kentishman was required to "hold the king's head in the boat" when he should cross the Channel. Even more peculiar was the case of a certain vassal obliged every Christmas to make before his lord *unum saltum et siffletum et unum bumbulum* ("a leap, whistle, and an audible gaseous expulsion").

There was a distinction made between the feudal system, defining the relation of lord and vassal, and the manorial or seigneurial system, which determined the relations of the vassal or subvassal and the tenants on his manor. The manor commonly consisted of a village with its surrounding lands. This farming unit was older than the military unit or fief. Ideally it was selfsufficient, but even in the darkest of Dark Ages it needed some imports—salt, millstones, metals for tools and weapons. The workers were bound to the land as subjects of the seigneur, or lord of the manor. They received an allotment of land to work on their own in return for a share of the produce. Such "sharecropping" still exists in the American South.

An essential part of the manor was the demesne, that part of the land that the seigneur reserved for his own use. The villagers were required to work on the demesne usually two or three days a week, with the other days free for tending their own holdings. The peasants were bound by innumerable ancient customs and duties. "On certain days," writes the historian Marc Bloch, "the tenant brings the lord's steward perhaps a few small silver coins or, more often, sheaves of corn harvested on his fields, chickens from his farmyard, cakes of wax from his beehives or from the

111

swarms of the neighboring forest. At other times he works on the arable or the meadows of the demesne. Or else we find him carting casks of wine or sacks of corn on behalf of the master to distant residences. His is the labor that repairs the walls or moats of the castle. If the master has guests the peasant strips his own bed to provide the necessary extra bed-clothes. When the hunting season comes round, he feeds the pack. If war breaks out he does duty as foot soldier or orderly, under the leadership of the reeve of the village."

The lord had also certain valuable monopolies. He alone could operate the gristmill, the wine press, the bakeoven, the dovecot. He took his large share of everything, even the fish from the village fishpond. His rights were varied and vexatious, such as the fine he imposed for provoking the incontinency of a female serf. (She was his chattel, and anyone who deteriorated her value must pay.) There was heriot and mortuary, by which at a serf's death, the lord of the manor claimed his best beast, the rector his second-best. If he had no beasts, his best clothes were seized, or a brass caldron, or the bed on which he had died. The erudite scholar G. G. Coulton reports a curious case of heriot: "In the later nineteenth century Lord Rothschild bought an estate of which part was copyhold under New College, Oxford. The Warden and Fellows, therefore, were in that respect his lords, and he had to redeem the freehold in all haste lest, at his death, these overlords should claim as a heriot his 'best beast' which, in the case of so distinguished a racing man, might have been worth twenty thousand pounds or more."

Some of the medieval specifications cited by the incomparable Professor Coulton are no less surprising. "A tithe-hen, rejected by the lord as sickly, must be accepted if, when frightened, she can clear the garden fence or jump upon a stool.... The miller must not let the water in his dam mount so high above the stake as to prevent a bee from standing on the top and drinking without wetting his wings.... "Fallen wood delivered as a duty to a German count could be packed so loosely that a hare "could run through it with his ears erect." A bondman who wished to marry a bondwoman from a certain manor "must give the lord a brass pan in compensation; and the pan must be of such capacity that the bride should be able to sit in it without undue compression."

Feudalism was a balance of needs and forces, arising out of

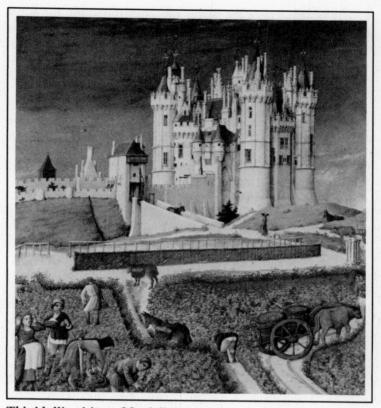

This idyllic vision of feudalism portrays peasants peacefully working the fields surrounding their lord's castle walls. The castle belongs to the duke of Berry, at Saumur, in France. Seen in its best light, feudalism served the needs of both the peasant and the landholder—the first in need of protection, the second in need of labor. the strong man's urge for power and possessions and the weak man's need for protection and survival. It was a class system; it maintained that nobles and villeins were born to their state by divine disposition and that they would remain forever what they were born to be. The blood of noble and commoner was believed to be different in composition.

The church, as the greatest of landholders, was necessarily within the feudal system. Throughout the West the church came to possess as much as a third of the land. Bishops and abbots of the great monasteries entered the feudal hierarchy, adopting its duties and exercising sovereign rights. Some even fulfilled their military obligations. Three bishops fought the English at Poitiers in 1356; the archbishop of Sens died at Agincourt. Until the French Revolution the bishop of Cahors had the right to lay on the altar his helmet, cuirass, and sword when he said mass in state.

Feudalism began, in part, as a system by which weak kings could transfer to strong agents the tasks of administration and defense. It established a swarm of local rulers, turbulent and savage. Its patterns of loyalty were obscure and marred by frequent breaches of faith. Its justice was capricious; its financial system, incompetent. Its raison d'être was the exchange of land for military service, but by the fourteenth century the feudal army became obsolete, and the mercenary army replaced the levée en masse. The growth of commerce, based on money, weakened land-based feudalism. In the late Middle Ages the nobility, hard hit by rising costs, were obliged to sell land, to discontinue their manorial workshops in the face of competition from the towns, and to sell serfs their freedom. In England freed serfs began to lease their own farms or work for wages. The lord made indentures with his workers. The terms of agreement were written twice on a single sheet, one copy for each party; as a check against future forgery, the two parts were cut apart on a jagged line resembling a great bite, hence indenture.

As the historian J. J. Bagley has noted, the fourteenth century "marked the end of the true feudal age and began paving the way for the strong monarchies, nation states, and national wars of the sixteenth century. Much fourteenth-century 'medievalism' had become artificial and self-conscious. Already men were finding it a little curious. It was acquiring an antiquarian interest and losing its usefulness. It was ceasing to belong to the real world of practical living." Feudalism had begun as a bargain the exchange of service for protection. The bargain was not kept; in the end one party continued to render service while the other failed to provide protection.

The definition of a noble or gentleman and the character of his life varied from time to time and from place to place. In Venice and indeed throughout Italy the aristocrat was likely to be a rich tradesman or banker. In many Italian cities he lived within the walls in a high fortress. Florence in the mid-thirteenth century contained two hundred seventy-five such towers, some over two hundred feet tall. But normally the gentleman was a feudal warrior, or a descendant of feudal warriors, who lived in a country castle.

There was indeed some social movement up and down. Here and there little men became big through astuteness, prowess, or royal favor. Valiant fighters were knighted on the field of battle; rich merchants bought country estates and married into the gentry. On the other hand, German knights sank into the peasantry or lived as robbers, and in thirteenth-century Siena some aristocrats were seen begging their bread. But in general class distinction was presumed to be dictated by Providence and fixed to eternity. The fifteenth-century Lady Juliana Berners, author of a treatise on hunting, records the common conviction that Seth and Abel, sons of Adam and Eve, were gentlemen, but Cain a churl and ancestor of the churls of the world. Christ, she says, was a gentleman on his mother's side.

In feudal society gentlemen and ladies formed a kind of club, the members recognizable by dress and speech. Their class loyalty transcended their national patriotism, and in France it sometimes did so up to the seventeenth century. Nobles played the game of menial service to their king, supervising his hunting dogs and his wardrobe, handing him his silver cup on feast days, and then receiving the cup as a present. Their occasional humility justified them in requiring greater humility from inferiors.

Their life was precarious and had to be lived fast and hard. To balance the high incidence of infant mortality, women had to marry when barely nubile and bear three times as many children as they do today. The genetic effects of the mating of twelveyear-olds can only be guessed at. Polluted water, tainted foods, the rheumatic, pneumonic damp of stone-walled rooms, mistreatment of wounds, epidemics of typhoid, dysentery, smallpox, influenza, and the plague took a heavy toll. The nobles consumed too much meat and alcohol, and in the winter no vitamin C, for lack of which, says Aldous Huxley, they were subject to visions, holy or diabolical.

Noble life was organized with the family as a base. The individual was subordinate to family interests. The great families declared private wars; the lesser ones involved all their kinsmen in feuds. Younger married couples usually lived with the groom's parents and bands of relatives clustered about the head of the clan. Marriage was a family alliance, and individual preferences had little to do with it. It was a union of feudal holdings; the heiress was identified with her fief. She was betrothed and often even married in infancy by two greedy fathers, and usually she submitted docilely to her destiny.

The wedding of the two families was symbolized by the groom's passing a ring to the bride. The witnesses would sometimes hit one another to impress the occasion on their memories since, in the absence of formal records, they might be called upon to attest the marriage. The couple was covered by a marriage pall; if either party happened to possess any natural children, these were huddled under the pall and thus legitimized. During mass bride and groom shared a piece of bread and a sip of wine; then the bride might take a distaff and demonstrate her skill in spinning. Afterward, friends crying, "Plenty! Plenty!" showered them with seeds, a fertility symbol that has been succeeded by rice or innocuous confetti. Then dancing; and then the vicar, with holy water and incense, blessed the nuptial couch; and so to bed.

The newly married couple lived in a crowded turmoil that would offend a present-day recipient of relief. Few nobles possessed more than two or three rooms, and these swarmed with family and retainers. Even the English king was known to hold royal court in his bedroom, with his queen sitting on the bed for lack of other retreat. All ate together in the hall. Waifs lived under the stairs, and at dinner stood in "beggars' row," disputing their pittance with the dogs. Children slept with their parents or with the servants on the floor of the hall. Privacy is one of the greatest of modern inventions.

The noble lady had her importance in the scheme of things, for she retained feudal rights over her dower land, and she could

Isabella, queen of France, holds court in a lavishly decorated bedchamber. Regal tapestries bear the arms of France and Bavaria. In the scene here the royal retinue presents the queen with a volume of poetry.

possess and administer a seigneury or rule an abbey. In her lord's absence she was mistress of the castle, defended it at need, rode to rousing hunts with the men. Her duties were exacting since everything had to be planned long in advance; no hasty shopping was possible. But she was legally a minor, in the custody of her husband. He was permitted, nay, encouraged, to beat her for her own good. He was likely also to support one or more concubines and to bring his bastards into the castle for their education. Accepting the general code of behavior, the noble lady dealt generous blows and slaps to her companions and inferiors. She was very often a virago. And sometimes she loved her husband and was loved by him.

When the lady was brought to bed, the bells of the village church rang clangorously to invoke the aid and favor of the saints. After a happy delivery the midwife washed the babe in a tub of warm water and worked the fingers and limbs to chase any evil humors. She rubbed him with salt and honey to dry and comfort his members, and laid him on a bed of rose leaves mashed with salt. She dipped her finger in honey and cleaned therewith the infant's palate and gums. She filled her mouth with wine and expelled a few drops into the little complaining mouth. Then she wrapped the newcomer in the softest and warmest materials in the castle's wardrobe — silk, furs, or ermine. For obvious reasons these were very soon replaced by swaddling clothes of linen.

The christening took place at the earliest possible moment, for fear that the devil might carry off the tiny, undefended soul. At the font one godparent held the body, two others each took one leg. The priest immersed the child completely to allow the Evil One no handhold. The godparents vowed to keep him seven years from water, from fire, from horse's foot, and from hound's tooth.

Most gentlewomen breast-fed their babies since it was thought that a common nurse's milk would contaminate noble blood. Blanche of Castile, mother of Saint Louis, found a woman of the court giving such to a royal infant; she held up the baby by the heels until he vomited.

The life of noble children was that of all infants since the world began. They were caressed, reproved, and taught by parents and nurses; they played ancient games of chasing, hiding, and fighting; they had their dolls, wooden soldiers, toy windmills, jumping jacks, and as they grew older, little bows for killing birds and mice. They played with castle pets—lap dogs, tame squirrels, magpies, parrots. (Cats were regarded askance as witches' familiars.) They might learn their letters from the chaplain, who had also the duty of reading the mail and composing fine answers in Latin. Girls and little boys lived mostly with the women of the castle, learning household tasks, such as bedmaking and waiting on table, and therewith the elements of polite behavior.

For fear that the boys would be softened by feminine care, they were often sent off, as early as in their eighth year, to be pages in another castle, generally that of the overlord or of a maternal uncle. There they learned social duties and graces, carving meat, kneeling to present the winecup, dancing, playing chess and backgammon. At this time their military training began. They fenced with blunt swords, tilted against manikins, hawked, rode to the hunt, and practiced killing.

Girls likewise were often sent to another castle, as though to a finishing school. Hence the bevy of beautiful maidens who appear as a chorus in the romances of chivalry. The girl learned embroidery, weaving, and music. If her tastes were domestic, she might practice cooking and sewing. She prepared for handling castle finances, selecting and controlling servants, supervising the cooking and housecleaning, the making and care of clothes, the choosing and tending of wines, the planting and upkeep of the kitchen garden. She learned also the elements of hygiene, first aid, and household remedies, for she was likely to become the castle's doctor and pharmacist, as the mistress of the house was to be on the plantations of the American South. If her tastes so inclined, she might learn to read and write. A literature of poetic romance developed, directed toward bored ladies whose husbands were far away at the wars, or, perhaps, nearby, pursuing comely wenches in their villages.

This literature expressed the ideals of courtesy and courtly love, ideals often strangely at odds with current social practice. *Courtesy* had several meanings. It was a technique for wooing and pleasing ladies with real or pretended respect; it was ordinary good manners; and it was a code of behavior in war and in private battles. Professor Sidney Painter quotes a splendid example from a *chanson de geste*. A noble cuts off his opponent's head in a duel, then piously lays the victim's sword and his own crosswise on the headless trunk. Thereat Emperor Charlemagne exclaims: "Ha! God, how courteous this duke is!" Professor Painter continues: "When the hero of a tale overthrows a villainous knight, he practically always spares his life and releases him on parole. No one attacks an unarmed man. Two knights never set upon one. Even bands of robbers who meet an adventuring knight are careful to assault him one by one." The code persists, even in fist fighting. No sportsmanlike brigand would hit below the belt or kick a man when he is down. But the modern gangsters of fact and the robustious heroes of spy fiction are not courteous.

Courtly love was one aspect of courtesy. Its origins are obscure. The romantic idealization of love and the beloved had no source in Roman or Germanic tradition. It came apparently from Islamic Spain, where women had a good deal of freedom and were often poets in their own right. It was there that a mystical doctrine of love as a holy passion, pure and uplifting, developed. Arabic literature is full of parted and thwarted lovers, totally faithful and devoted. Its poetry is mostly love poetry, foreshadowing the themes and styles of the French troubadours.

Courtly love compensated the medieval lady for the brutalities of marriage and recognized her existence as an individual. The lover, who by definition was not her husband, addressed her with the same vocabulary of adoration he used for the saints. He hoped, of course, for what was prettily termed the gift of mercy, but if this was not to be granted, he loved none the less ardently. For his lady's sake he sought to progress in merit, to purify his spirit. For her he was mighty in battle and in her presence, gay, witty, well dressed, well washed, cleansed of stable smell. He composed and sang love songs for her, and was always scrupulous to defend her honor. Honoring her, he respected all ladies and proclaimed their fame. In feudal idiom he was his lady's vassal and to her he rendered his homage.

The modern psychologist finds, of course, much more in courtly love than meets the innocent historian's eyes. The lover assumes a childlike or feminine attitude, with voyeuristic tendencies, complicated by memories of spanking in boyhood. "It appears," one psychologist writes on the subject, "that the characteristics of this unique woman are those of a mother image of infantile origin and that the lover's relation to her is under the spell of disguised childlike fantasies."

The home and school of courtly love was at Poitiers, in the court of the renowned Eleanor of Aquitaine, queen of Henry II of England. Toward the end of the twelfth century Eleanor presided over an actual Court of Love, wherein ladies and gentlemen judged questions of behavior, issued decisions, and composed a casuistic code for the guidance of others. Her daughter's chaplain, Andreas Capellanus, set down the results of their meetings in a treatise, De Arte Honeste Amandi (The Art of Courtly Love). True love, he says, must be free; it must be mutual; it must be noble, for a commoner could not experience it; it must be secret. If the lover meets his lady in public, he must treat her almost as a stranger and communicate with her only by furtive signs. But when he catches sight of her, his heart palpitates and he turns pale, and thus risks betraying his dear secret. He eats and sleeps very little. Clearly this true love is incompatible with marriage; "everybody knows that love can have no place between husband and wife."

Courtly love was obviously physical at bottom, and the humble adorer might suddenly revert to his character as the rampaging male. How far courtly love led to actual adultery is an insoluble problem. Plenty of troubadours celebrated their amorous victories, but the troubadours are very unreliable witnesses. At any rate, adultery in the swarming communal life of the castle was difficult, if not impossible. Sinful matings must have occurred mostly outdoors and must have depended much on the weather. One might find an uncomfortable opportunity on a dispersed hunt, and pilgrimages opened up possibilities. But on the whole it seems that courtly love was mostly a game, an intellectual diversion with little effect on moral behavior.

As a game it had amusing developments. At Treviso in 1214 was held a Court of Solace and Mirth. A Castle of Love was built, and defended by ladies against an assault by two rival bands of gentlemen from Padua and Venice, who used cakes, fruits, and flowers as missiles. But the mimic war turned into a real battle between the Paduans and the Venetians, and the police had to intervene to stop it. In Florence were brigades of young gallants, dressed in white, with their leader, a Lord of Love.

Courtesy and courtly love are expressions of a larger, looser entity that we call chivalry. This regulated the behavior of a gentleman according to fixed moral principles. It comprised the code of courtesy and the ideals of knightly conduct derived from feudalism and the ethical teachings of the church. Its perfect representative was a chaste, loyal warrior for religion, a defender of ladies' honor, a Galahad, a Percival. This ideal was supported by an enormous outpouring of literature: troubadour lyrics, verse romances, legends of King Arthur and his knights and of German folk heroes. Naturally, a countering antichivalric spirit developed, especially among the bourgeoisie. The knights and their pretensions were mocked in coarse popular fabliaux, in the social-conscious *Roman de Renart*, and in the thirteenth-century *Roman de la Rose*.

In time the chivalric code was modified, but it has never died. It set a standard for upper-class behavior, especially in the Victorian era. Our esteem for sentimental love is a medieval relic. "Women and children first" is a chivalric motto. When the *Titanic* sank and the gentlemen bowed the ladies into the lifeboats, they were "verray parfit gentil" knights. We may still see on illumined screens the knight, with a change of clothing and locale. He has gone Western, but still he is the dextrous cavalier, vaulting to his saddle, the mighty fighter for virtue, ill educated but possessed of a salty wisdom, worshipful, faithful, and tongue-tied in the presence of good women.

The proper medieval gentleman had many virtues. He was generally loyal to his feudal obligations and conscientious in the administration of justice. He was generous, particularly in bequeathing land and money to the church. He was sincerely religious, respectful of church authority, and faithful to his duties. He took his knightly vows seriously and seldom violated an oath or solemn promise, knowing that these are recorded in heaven and that the breach of an oath may be divinely punished as perjury. He could be sympathetic to lesser humans. "Courtesy to the poor is of a humble heart," said the thirteenth-century writer the Knight of La Tour-Landry, telling how a great lady bowed to a tailor. (Some reproached her; others praised her meekness.)

However, the gentleman's faults loom larger in retrospect than do his virtues. Pride of birth and class turned readily into arrogance; bravery, into foolhardiness. Many great battles were lost by the knights' disregard of orders, their refusal to wait for the command to charge. The story of the crusades is full of such splendid folly. The Templars especially were so eager to be always in the van that they got themselves killed for nothing but honor, and not much of that.

Generosity, much extolled by the minstrels who profited by it, became absurd display. When Thomas à Becket visited Paris in 1157, his train was like a circus parade. It included a traveling chapel, wagons with vestments, carpets, and bedcoverings, twelve horses carrying table plate, grooms and hawkers with hounds and gerfalcons, and on the back of each lead horse a long-tailed ape. The whole was guarded by armed men with fierce dogs on leashes. Display developed conspicuous waste, rivalry in destruction as in an Indian potlatch. One knight had a plot of ground plowed and sown with small pieces of silver. Another used precious wax candles for his cooking; another, "through boastfulness," had thirty of his horses burned alive. The result of such rivalry was that many or most nobles were perpetually in debt to usurers. If worse came to worst, they were sometimes forced to murder their creditors.

They were a rapacious crew, often merely out of economic necessity. The noble troubadour Bertrand de Born speaks for his class, rejoicing in the approach of war with its breakdown of law and order: "We'll soon seize the usurer's gold; there won't be a packhorse on the roads; no burgher will go without fear, nor any merchant heading for France. If you want to be rich you have only to take!"

Whereas the king's authority often protected the merchant, the family feuds of the nobles were beyond control. Revenge was regarded rather as an act of private justice than as a crime. The remotest members of a clan were bound by the obligations of the vendetta, which had its special home in Italy. Its history in the Middle Ages is largely one of family feuds that turned into wars. These ended either by the extermination of one party or by the intervention of the emperor or the church, imposing reconciliation and indemnities.

Our courteous, chivalric knights could readily become demons of brutality. The *chansons de geste* are filled with rolling heads, strewn brains, gushing bowels, baby spearing, and nun raping. Some part of this joy in deeds of blood must be literary, an appeal to the perverse spirit, as in the sadistic fiction recrudescent today. But much of the brutality was unquestionable fact.

123

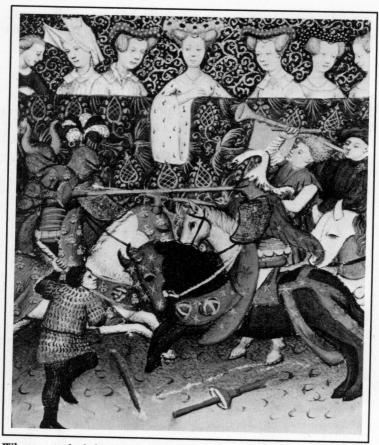

What was a knight to do when there were no wars to be fought for booty or revenge? The challenges of battle could nearly be matched in competitive jousting bouts. The knight could amuse himself and his lady by entering a tournament such as the one pictured here. I shall give none of the abundant examples, since I do not wish to abet what I would condemn.

Another contrariety in noble behavior was in the matter of sex. The adept of courtly love, fresh from sighing at his unapproachable lady's feet, could pause on his homeward journey to tumble a shepherdess in her meadow, a fresh-faced village girl under a hedge. The Moslems in Spain and Syria were shocked by the licentiousness of the French. The famous *jus primae noctis* (the lord's right to spend the first night with a peasant bride) may well be a fable. Nevertheless, the noble regarded his female serf as his chattel, to do with as he would. Often, no doubt, what he would was what she would; but if she defended her rustic honor and was then undone, neither she nor her family had any means of redress.

Such were some of the traits of the noble. He was a bundle of paradoxes—a romantic lover and a libertine, a gallant knight and a bloodthirsty brute, a devout Christian and a flouter of the elements of morality. But he shared his paradoxes with the rest of humanity.

The center of the noble's life was the castle hall. Here he held court, transacted affairs, entertained, and dined on trestle tables set up for each meal. When he had private business, he took his visitors into the bedroom.

In winter the castle was very cold. In the early period a fire was built in the center of the hall; the smoke found its way out through a small opening in the roof. The arrangement had the advantage that little heat was lost. And smoke was thought to be beneficial; it cured the ague and hardened the house timbers. Wall fireplaces and chimneys were uncommon before the fourteenth century. Piers Plowman speaks of "a chamber with a chimney" in which rich men dined. The favored gentry by the fire were nice and warm while the underlings in far corners froze. In the thirteenth-century French romance *L'Escoufle* Sir Giles, beside the fire, removes all his clothes except his drawers to scratch himself. (Fleas, no doubt.) Bedrooms rarely had a hearth. In bitter weather a small fire was built on the stone floor at bedtime, or one transported a brazier full of coals from the great hall.

People simply endured cold without complaint. They must have been tougher than we are. Their hands and feet must have been thermally conditioned, like those of the Syrian mountaineer who walks barefoot in the snow but muffles his face. The great stone churches were unheated; our ample clerical vestments were designed, in part, to keep the wearer warm. Yet one feels for the monk chanting in the drafty choir from midnight to dawn, and for the scribe writing or illuminating in the cloister's carrels in a temperature of about forty degrees. (It is true that the sedentary worker often had a *chauffe-mains*, a container with hot coals hanging at his side.) Fortunately there was generally plenty of fuel—wood, peat, and charcoal—and plenty of wool and furs for heavy clothing.

Lack of warmth was aggravated by lack of light. Windows were small and high, and were occupied by sheets of parchment or oiled cloth or paper. Glass windows were to be seen at first only in churches. Eventually domestic window glass became readily available, but it was thick, blurry, and bossed with lumps like bottle bottoms. (Clear, transparent panes did not come till modern times.) Glass was so precious that the owner might have the windowpanes removed, wrapped, and stored when he went away. There were always some to deplore the innovation. The Florence flood of 1333 was ascribed by clerics to God's wrath at the use of glass windows and other luxuries.

With the early winter dark one had recourse to torches of resinous wood, which were smoky and foul smelling, injurious to tapestries and decorations, and dangerous with their spurting sparks. Commonly candles were made of tallow, with wicks of reed pith or, eventually, of cotton. These had to be constantly trimmed with scissors. The burning fat gave off an acrid smoke and an evil smell. Beeswax candles were too expensive for any but church or royal use. The English king's regulations for 1136 specify the rights of high nobles to candle ends from the royal palace—four daily for one, twenty-four for another. Lamps were fairly common. These consisted of a wick or wicks of precious cotton floating in a bowl of vegetable or fish oil. They gave little light and much smell, but burned long. Night lamps to ward off demons were familiar objects, also portable lanterns with panes made of horn.

Medieval man had to live by daylight. At night he could travel only by the intermittent moon. Few trades could be carried on by artificial light. Winter in the north was the time of repose, of fireside diversions, of song and storytelling. It was also the time of hardship, perpetual chill, scanty, monotonous, vitaminless food, further restricted by the Lenten fast. So when spring came, it roused people to a pagan frenzy. After the harshness of winter, the sun shone blessedly down, sap flowed, as did the lusty blood. Most love poems were timed with the spring. Weather really meant something in those days.

To give some semblance of warmth, the great hall and the bedrooms were often hung with tapestries or embroidered hangings representing biblical or hunting scenes. Woven tapestries appeared in the fourteenth century. Overhead beams were sometimes painted; a common subject was the signs of the zodiac. The floor was strewn with rushes or straw, and could become unnecessarily foul in slovenly castles. Furniture was scanty—demountable tables and benches eased only by "bankers," cushions or embroidered cloths. Usually the noble host alone had a chair; hence our chairman is the person who presides at meetings. There were also some locked chests, often ornamented with iron scrolls. In these the lord kept his records and rarities; the lady, her silver and fine linen. In such chests the Norman kings of England transported on their tours a good part of the country's entire treasury.

Although most of the castle's occupants slept on the floor on straw pallets, the lord and lady had a wood-framed bed, corded with rope or leather, with curtains for privacy and a padded or feather mattress, bolster, pillow, linen sheets, and coverlets for comfort. The custom of sleeping in a half-reclining posture was common from Byzantium to Scandinavia. On retiring, men and women stripped, hung their clothes on a pole to protect them from dirt, dogs, rats, and mice, and donned, at most, a nightcap. Kings and queens are pictured naked in bed, wearing, however, their crowns. The chronicler Froissart, in the late fourteenth century, mentions a nightshirt as an innovation.

This rough inventory of a castle's contents needs much qualification, chronological and geographical. Luxury steadily increased through the medieval centuries, even during the grim days of the Hundred Years War. Byzantine palaces outdid those in the West, but the rich cities of Italy were not far behind. There the gentry were building high-towered town houses, frescoing the walls or hanging them with embroidered silk or gilded leather, and setting out majolicas, bronzes, ivories, and paintings made solely for the pleasure of the eye. The country castles became such villas as Boccaccio describes, with fountains and sculptures and flowery loggias embowered in sweet-smelling orange and lemon trees.

The clothing of gentlefolk was partly utilitarian, partly symbolic of class, status, and wealth, as all clothing is bound to be. The cleric wore his cassock; the physician, a purple robe and red gloves; the peasant, his blouse; the leper, a gray coat and scarlet hat; the harlot, a scarlet dress; the Jew displayed a circle of yellow cloth; the released heretic, a double cross. The gentleman's symbol was armor. As civilian dress he wore close-fitting garments, suitable for wear under a coat of mail. Chaucer's Knight on his way to Canterbury was dressed in a fustian doublet. discolored where his coat of mail had pressed. In winter the wellto-do sported a fur-lined jacket, over this a tunic, pulled over the head, and over all a cloak or fur mantle. The outer garments were sometimes slashed to reveal the materials within. Fashions changed constantly, and young men were very particular about the proper length and cut of their garments. In the fourteenth century there was a great vogue of short coats that barely covered the buttocks, and trousers so tight that the wearer could hardly sit. These, flaunting the codpiece, were regarded as shameful. They must at least have been very uncomfortable. Long trousers, or hose, combined breeches and stockings. They were supported by belts or were laced to the upper habiliments. The materials were the richest that the wearers could afford: brocades, silks, velvets, bright-colored, often parti-colored. The poorer gentry had to make the best of wool or leather or tow cloth made of coarse flax fiber.

On the subject of underclothing we are relatively ill informed. Cotton was introduced in France only in the twelfth century; it long remained a luxury article, out of reach of the poor. Linen was widely used; the fourteenth century has been called *le siècle du linge*, when men and women generally adopted the chemise. (We still speak of our linen when we mean our cotton or our nylon, and our lingerie is properly nylongerie.) Flax does not grow everywhere, and its transformation into linen is a slow and laborious process. Hemp was much used as a substitute; the thought of hemp shorts curdles the blood. Probably in the early Middle Ages most people did without underclothes. Cistercians wore no underclothing on principle, thus provoking many a scurrilous jest. What provision was made for the fouled bodies of the sick? For the needs of a mother in childbirth? For babies' diapers? Without dish towels how did one dry the dishes? History seems to give no clear answer. It reports merely that by the fourteenth century linen became so common that it supplied abundant rags to ragmen, who sold it to papermakers, who made possible general correspondence, the diffusion of learning, printing, the modern world.

Headdresses also indicated class and caste. The king wore his crown; the pope, his tiara; the bishop, his miter; the noble, a helmet; the squire and magistrate, a pointed hat; the rich landowner, a coif; the doctor, a hood and biretta; the plowboy, a round brimmed hat; the countryman, a cap; the Jew, a yellow pointed hat; the Saracen, a turban. In officialdom today headgear still marks duty and rank. And even in nonofficialdom the homburg, the beret, the bared head, express the individual's self-typing. Gloves were common in the north, even for the peasant at his outdoor labors. Nobles, bishops, and grand ladies had them embroidered and ornamented with jewels. A knight might bind his lady's glove to his casque as a sign of devotion. Gauntlets were part of the knight's equipment; they became symbolic and were used as pledges in law cases, or they were flung to the ground as a challenge to engage in combat.

While the commoner wore heavy boots or sabots, the gentleman preferred soft heel-less slippers. Fashion varied, but usually insisted that shoes be tight and very long, with pointed or even upward-curling toes. In fourteenth-century England fashionables chained their long toe points to their waists; they could not kneel for their prayers. In the thirteenth-century *Roman de la Rose* Love counsels the lover to buy such tight shoes that churls will wonder how he gets in and out of them. A century later, Petrarch, deploring amusedly his youthful vanities, recalled that his shoes would have crippled him completely, squeezing his bones and sinews out of shape, if he had accepted the styles of the moment. Chaucer's dandified parish clerk had his slippers pierced in the design of St. Paul's rose window, revealing his bright-colored socks.

Pockets were still unknown. Men carried purses slung over the belt. Handkerchiefs were a rarity. Richard II introduced these to England at the end of the fourteenth century and therefore was accounted effeminate. But jewels, for which the Middle Ages had an inordinate taste, were regarded as manly enough, as were gold chains and signet rings, which served a useful purpose in validating messages and documents. Cloaks were held at the shoulder by jeweled brooches and clasps, which fastened like safety pins. Clothes were kept in place either by such clasps or by ties. The button was strangely late in appearing. It originated apparently in China, where button and buttonhole on silk garments were protected by frogs. (There used to be in America sects of "hook-and-eye" Baptists, and there still is a group of Amish who abjure the button on the ground that it is not mentioned in the Bible.) The earliest reference to the button I have noted is in an account of the crowning of Baldwin of Flanders as emperor in Constantinople in 1204: "The golden buttons at the back and front of the tunic are undone, and when his chest is bare he is anointed. When this has been done, the buttons are refastened, he is dressed again in the pallium, and his mantle is clasped on his shoulder."

Dandies took the greatest care of their hair, curling it elaborately with hot irons and sometimes adorning it with flowers and garlands. Even in the eleventh century long hair was regarded as effeminate, and men generally wore their hair cut just below the ears. The round bowl cut, or pageboy style, is more frequent in historical movies than it was in fact. Hair styles—like clothing styles—varied from place to place. In the Bayeux tapestry Normans and English are distinguished by their hairdos, the English favoring long hair. In twelfth-century France there was a vogue for little tufted beards interwoven with gold threads.

W omen's dress also varied, but at a slower pace than today. A fine gown was nearly permanent. It appeared inventoried in the trousseau and again years later in the lady's will. In the meantime, as the wearer developed, it must have undergone a number of alterations. In general gowns were brightly colored, of Eastern or Italian materials, and were long and ample. In some times and places, as in fourteenth-century Avignon, bodices became very décolleté. Preachers pointed at the bared bosoms, calling them windows of hell. Such pretentious garments seldom appeared in the routine of castle life. The chatelaine then wore a simple homemade housedress of wool or linen over a long-sleeved undergarment, with one or more petticoats.

Above, Burgundian courtiers chatter with one another between dances at a ball. These medieval men and women are dressed in the latest fashions of their time. Their social rank and relative wealth were represented by the style and material of their clothing. She sometimes framed her face in a wimple; this is preserved in the coifs of nuns.

Women's headdresses and hair styles were often elaborate. In Italy and France girls wore their hair loose until marriage, then divided it in two tresses or raised it in a large chignon and added a bandeau or crown of flowers. Gold nets and circlets were popular, or a sprinkling of gold dust on the hair, or even jeweled coronets with pearl pendants. The tall pointed hennin, beloved of illustrators, appeared only in the fifteenth century. The Wife of Bath, a mere commoner, bore a coverchief weighing ten pounds—surely a poetic exaggeration. (She also sported a pair of tight, bright-red stockings.) In Italy blond hair was much prized, so ladies spent whole days bleaching it in the sun and wore crownless hats. Such a practice was said to damage the brain and imperil the soul. The use of hair dye and cosmetics, rouge and powder, was likewise reproved.

A hard problem was the cleaning of clothes, for the world was very dirty; chandeliers dripped wax, a hand clutching a morsel from the stew dripped gravy, wine poured by clumsy servitors could bespot the daintiest drinker. Dry cleaning was not invented till the middle of the nineteenth century. The medieval housewife removed grease stains by rubbing the material with fuller's earth moistened with lye, or by soaking it in warm wine for two days. She baffled moths by shaking and brushing all clothing regularly, displaying it to the sun, and packing it with bay leaves in a chest of cypress wood. She fought flies with flyswatters and sweet-smeared strings; she had mosquito nets and many devices for combating fleas. Nevertheless, household vermin abounded, as they did to our own times. The extermination of insect pests is one of the triumphs of civilization easily forgotten by the young, very few of whom have ever seen a bedbug or a louse.

Contrary to popular legend, medieval people loved baths. They probably bathed more than people did in the nineteenth century, says the great medievalist Lynn Thorndike. Some castles had a special room beside the kitchen where the ladies might bathe sociably in parties. Hot water, sometimes with perfume or rose leaves, was brought to my lord in the bedchamber and poured into a tub shaped like a half-barrel and containing a stool, so that the occupant could sit and soak long. In the cities there were public baths, or "stews," for the populace. Soap was probably invented in the Orient and brought to the West early in our era. This was a soft soap without much detergent power. Generally it was made in the manorial workshops, of accumulated mutton fat, wood ash or potash, and natural soda. Laundresses might also use a solution of lye and fuller's earth or white clay. They worked usually by streamside, rhythmically beating the material with wooden paddles. After the winter's freeze they had a great spring washing of the accumulations. It was on such an occasion in the *Merry Wives of Windsor* that Falstaff hid in the laundry basket. Hard soaps appeared in the twelfth century. They were luxury articles, made of olive oil, soda, and a little lime, often with aromatic herbs. They were manufactured in the olive-growing south, especially Spain; hence our Castile soap.

Shaving was difficult, painful, and infrequent, since the soap was inefficient and razors, which looked like carving knives and perhaps substituted for them at need, were likely to be old and dull. Even haircutting was disagreeable. Scissors were of the one-piece squeeze type, similar to grass trimming shears; they must have pulled mightily. Although by the thirteenth century a few aristocrats had toothbrushes, the toilet of the teeth was generally accomplished by rubbing with a green hazel twig and wiping with a woolen cloth.

Privies were set in recesses in the castle wall. There are examples of their discharging directly into the moat, but this disposition was rare for hygienic reasons. Since, of course, there was no toilet paper, a *torche-cul* or a curved wooden gomph-stick was provided in a basket.

No one in the castle knew surely what time it was. The Angelus ringing in the village church was a sufficient time signal for most people. Night and day were each divided into twelve hours measured between sunrise and sunset. Thus the length of an hour or minute varied every day and from one latitude to another. Water clocks were known from antiquity, but they were likely to freeze or evaporate.

During the early period glass was too rare to permit much use of hourglasses. Alfred the Great invented a set of standardsized candles calibrated to measure the passage of time. The monk whose responsibility it was to rouse the brothers for midnight matins calculated by the prayers recited, the pages read, or the candles consumed. If he was an hour or so off, probably no one minded. During the fourteenth century the mechanical clock became general in the form of gigantic town clocks, often with parading figures.

The castle's day began at dawn with morning mass, then breakfast. In Italy this was only a bite, but in England the gentry early demanded something substantial. The great event of the day was dinner, served at about ten A.M., after most of the lord's business had been transacted. It was announced by a trumpeter. Distinguished guests entered; the ladies rose and curtsied-with folded hands-and sat again. The lord held his guests' fingers for a moment; often a light kiss was exchanged. A washbowl and an aquamanile, a bronze water holder in the form of a grotesque animal, were brought to honored guests; everyone else washed his hands at a lavabo and dried them on a long towel, which was likely to become very wet and black. The convives fell into order of precedence-visiting clergy, visiting knights, the lord's family. They took their seats on a banquette at the wall side of the high table. They looked down at the lesser folk "below the salt," at tables perpendicular to the high table. The arrangement was that of an Oxford hall or of a club banquet anywhere. The chief table ornaments were a mighty silver saltcellar, a nef, or silver ship containing spices, sugar, and such stomatica, and a maple mazer, or wassail bowl. At the king's table everyone bowed to the nef on passing it, as to a holy monstrance. Each pair of guests shared a wooden bowl or trencheras Harvard students still did in the seventeenth century. Earthenware plates were little used in the north. The first reported in England arrived from Spain at the end of the fourteenth century, along with the first recorded shipment of oranges. The cups on the table were made of pewter, wood, or horn. The very rich had cups of exotic materials, coconut shell, gourds, ostrich eggs, agate, elaborately mounted. Guests were supplied with spoons, but were expected to bring their own knives. Forks were a rarity. Even in the fourteenth century the popes in Avignon had only a few, though these were of gold and crystal.

Dinner began with a blessing. The food was carried across an open court from the kitchen; it was never more than lukewarm. The servants, approaching from the unoccupied side of the high table, genuflected with their burdens. They might present a tender roast on its spit to a young gentleman-carver. But most of the food was minced or pounded fine; it was hard to cut meat at the table without an anchoring fork. The servants ladled thick stews onto chunks of bread in the bowls. A gentleman plucked out toothsome morsels with his fingers and offered them to his vis-à-vis with much gallant byplay. The two took wine from the same goblet—"leave a kiss but in the cup, and I'll not ask for wine." He did not need to ask; the cup was kept well filled. The strong spices tempted one to drink more than he had really intended. Table manners were formalized. Various "Bokes of Curtesye" adjure readers not to burnish bones with their teeth, butter bread with their thumbs, poke their fingers in eggs, wipe their knives or teeth on the tablecloth, spit across the table.

At the end of the long dinner the bread in the bowls was collected for the poor. Bones and other discards were tossed to the begging dogs, though this practice was discountenanced by arbiters of etiquette. Guests washed their hands again at the lavabo and went off to hunt, play vigorous games, or surrender to a nap. Supper, a lighter meal, came at sunset. This was the time for minstrelsy and sport. Then the seigneur checked his doors and defenses, made sure the sentinel was awake, retired, prayed, washed his feet, hung his clothes on a pole, put his folded shirt behind the bolster, and went to bed.

Medieval food implied a class distinction. The noble ate meat and white bread and drank wine; the peasant had porridge, turnips, dark bread, and in the north, beer or ale. In Germany there were actually codes of food for the different classes. Such distinctions are lost now that grand lady and proletarian push their carts in line at the supermarket, now that presidents serve wieners to heads of state. Still, pheasants, caviar, and champagne preserve some of the old aristocratic connotation.

Meat and fowl were served in great variety. All sorts of birds were eaten, from starlings to gulls, herons, storks, cormorants, and vultures. Animals were cut up and cooked immediately after killing, or they were salted for preservation. Pork was recommended as most resembling human flesh. Tender fowls and animals were roasted on spits, but most meat was boiled since rangy cattle, hard-running stags, and half-wild chickens were sure to be tough, rebuffing toothless elders. Pretentious party dishes were elaborate hashes in which the taste of a dozen strong spices dominated, especially pepper, mustard, and garlic. (The

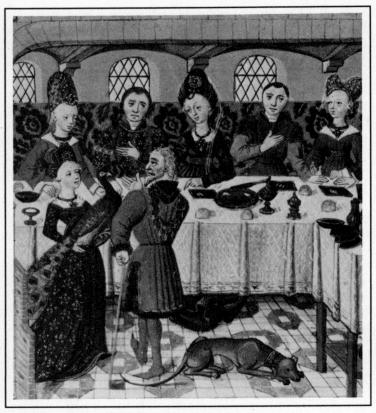

"It is not seemly that a lord should eat alone," states a medieval book of rules. Nobles loved their convivial feasts. This fifteenth-century picture illustrates a gathering of wealthy diners, evidently awaiting a meal that will include freshly roasted peacock.

French crusaders in Constantinople revolted the natives by their garlic breath.)

The meat-and-pastry diet induced skin troubles, digestive disorders, infections from decomposed proteins, scurvy, tooth decay. (The common cure for toothache was extraction; hence the old had only rare, treasured teeth.) The Lenten prohibition of meat was an excellent therapeutic measure. Fish was substituted; castles and monasteries had their own fishponds, in which villeins were forbidden to dip. Every kind of fish was eaten; dogfish, porpoises, seals, and whale were imported from the salt sea.

Most of our vegetables, except potatoes, tomatoes, and Indian corn, were known, but they were scorned as commoners' foods. Lentils and cucumbers were regarded as unwholesome. Our fruits were familiar, though they were smaller, wilder, and perhaps more flavorsome than they are today. Medical opinion counseled against eating them raw. They were often preserved in honey and cooked in pastry. Such desserts were costly because of the shortage of sweetening. But sugar was imported as a luxury from the twelfth century on. People delighted in rosy and violet-colored sugars from Alexandria and appreciated cakes, wafers, cookies, waffles, and jellies.

Much attention was given to the appearance of dishes. An artistic chef liked to serve a peacock fully feathered, with its tail spread. Or a swan with silvered body and gilt beak, swimming on a green pastry pond. Or a pasty, which, on being cut, released bewildered little birds; upon these nobles' falcons plunged. Or a sculpture of paste, jelly, and sugar, called a subtlety. Or some such novelty as a cockatrice, the head and forequarters of a piglet sewed to the body of a capon or vice versa. A great party given for the pope by two cardinals in 1308 was graced with a pastry castle containing a roasted stag, two edible trees bearing fruits and candies, a fountain spurting five kinds of wine. A new archbishop of Canterbury in 1443 enjoyed a subtlety representing the Trinity with Saint Augustine and Saint Thomas à Becket.

Italy had its own regime. The mainstay was a minestrone, variously confected with cheese, almonds, cinnamon, cloves. The modern pastas were in common use: macaroni, lasagna, ravioli. In Lombardy risotto and other rice dishes were common long before rice was known in northern countries. For drink the gentleman had only wine, often diluted with water or mixed with honey, ginger, and cinnamon to sweeten it. Water alone was regarded with justified suspicion. There were no hot drinks except mulled wine at festivities. Monks loved mead, honey and water fermented and scented with herbs. Distilled liquors were not commonly made before the end of the Middle Ages, though alchemists had long been practicing distillation.

After the evening meal the castle's population might assemble to watch a floor show, presented by traveling minstrels, jugglers, acrobats, or contortionists, and sometimes trained dogs or monkeys; or they might listen to a storyteller recalling high deeds of the past and faraway wonders. He would pause at thrilling moments to announce: "Whoever wants to hear more must open his purse." Or a jongleur, who had by heart a vast repertory of *chansons de geste* and poetic romances, would strike on his vielle the melody and chant an interminable tale, inserting from time to time a refrain tune, in which the audience would join. "Merry it is in halle to hear the harpe,/the minstrelles synge, the jongleurs carpe."

When they lacked a professional entertainer, the gentlemen and ladies amused themselves. They had a billiard, a kind of croquet without hoops, and a game resembling ninepins in which one tried to knock the pins over with a crooked stick, and a primitive form of tennis with a stuffed leather ball. They played games that have now become children's property-blindman's buff, hot cockles, ring-around-a-rosy. They danced, sometimes elaborately, as in the torch dance in which each participant carried a lighted taper and tried to keep the others from blowing it out. They were inveterate chess players; it is a pity that we have no record of their champions' games. They gambled at dice, justifying themselves with the example of the apostles, who cast lots to select a successor to Judas. Since Providence determines all things, dicing was called the game of God. Dicers would even gamble away their clothes. In Italy the communes licensed public dice shops, whose proprietors often employed shills or come-on men and rolled crooked dice. The game provoked violence, suicides, pacts with the devil. Losers threw stones at pictures of the Madonna, who had played them false. One man shot an arrow aloft against God; it returned covered with blood. Playing cards were probably not introduced

until the thirteenth century; they did not become common until printing could produce identical backs. (The queens and knaves on our cards were stylized representations of late fifteenth-century fashions.)

The greatest of noble sports was hunting. In the early days it was necessary for food supply, as on the American frontier, and was not a class monopoly. Later it was reserved for the gentry and developed the ritual it still keeps. Deer were the favorite quarry; every year eight bucks killed in Windsor Forest were laid on an altar in Westminster Abbey, to the blowing of the *menée* or *morte*. Ladies joined the hunt, riding astride, not, as normally, on sidesaddles. Hunting laws bore cruelly on the peasant. Henry II of England punished the killing of a deer by a churl as severely as the killing of a man; poachers were hanged or mutilated. The deer ravaged the peasant's crops with impunity, and the noble hunters might trample what remained. Though we sympathize with the peasant, we reflect that the restriction of hunting rights has certainly conserved many kinds of wild creatures.

Hawking was the noble's particular joy. His falconers were expert in the care, feeding, and training of his birds. King John of England specified that his hawks should feed on doves, chickens, and pork. Anyone who found a lost falcon and failed to return it was punished severely; the bird was allowed to eat six ounces of flesh from the culprit's breast. Knights and ladies carried their favorite, hooded, on the wrist and parked it behind them at meals. There are stories of bishops and abbots who brought their hawks to church, strapping them to the altar rail while they officiated. Some gentlemen sprinkled the bird with holy water before a hunt, asking the Virgin for a clear field. And some made pilgrimages to pray for the recovery of sick hawks.

Since the business of the knight was fighting, he practiced his trade in sport and play. He exercised constantly at fencing and horsemanship. He rode with his spear against a quintain, or manikin wearing hauberk and shield, and fastened to a post. Sometimes the manikin, sword in hand, revolved on a pivot so that it would spin around and smite the assailant on the back if it was not struck squarely. Or the horseman might try to catch a small ring with his spear tip. This is said to be the origin of the ring on a modern merry-go-round, which the rider tries to seize in the hope that it will be brass, entitling him to a free ride. The best game was the tourney, or mimic battle. Though its origins lie in the distant past, this war game came into its own only when private wars were more or less checked in the twelfth century. Then boredom suggested a substitute to fullblooded, meat-fed knights. Large parties gathered and divided into sides, usually on a territorial basis. At a signal from the herald they charged with leveled lances. Those who were brought down continued to fight on foot. Any sort of stratagem was permitted; the defeated could be pursued into the open country and captured. Once a knight yielded, he gave his parole to his captor, and afterward surrendered his horse and armor or a suitable money ransom. Squires dragged out the fallen, who were likely to be numerous. In one enormous tournament near Cologne more than sixty knights were killed.

The church opposed tournaments, which not only impugned its teachings but offered too attractive an alternative to the crusades. But papal and royal bans were ineffective; at most they could soften the procedures, turn the bloody battles into pageants. Thus in the later tourneys the number of contestants was limited; they fought with blunted swords and lances and aimed to seize the opponents' banners. Armor became heavier and more protective. Ladies attended, applauding the prowess of their knights, awarding the prizes.

Tourneys came to feature the joust, or clash of two knights. It was a game of skill, not of murder. The combatants fitted the spear, a dozen feet long and weighing perhaps twenty pounds, into the spear rest on the right breast. The two knights met at a slow canter. The idea was to strike the opponent squarely on the head or breast, parrying his thrust with one's shield while attempting to unhorse him. As armor was smooth and rounded and as one's hands were not free to guide one's horse, this was no small feat. The advantage was all on the side of the trained performer, the professional athlete, who could make a career of jousting. The famous William Marshal won twelve horses on one occasion; he and a companion took three hundred knights for ransom in a season.

Tournaments became festivals, with feasts and dances. They were attended by horse dealers, armorers, and harnessmakers, also by usurers, fortunetellers, and prostitutes. Many nobles avoided them because of the cost or from lack of confidence in their own prowess. Reluctant contestants arranged to have their spears made light and flimsy, to shiver at a touch. The tournament could even become a burlesque of itself, as at Acre in 1286, when knights jousted dressed as fine ladies and as nuns.

When all games ended, the knight brooded on his sins and made his peace with God. He built and endowed a chapel, and paid to have masses said forever for the rescue of his soul. For a fee he could be buried in a monk's robe. "The great liked to rest in a chapel or an underground vault or under the steps of the altar," writes the historian Geneviève d'Haucourt, "so that in a sort of posthumous penitence, they would be trampled by the feet of the priest. . . . If a Christian failed to gain admission into the church itself, he would ask to be buried beneath its walls so that the rainwater, blessed by contact with the roof of the holy edifice, would drip onto his tomb."

These nobles were the humble. Mostly, however, the great did not lose their pride in death. We see in a thousand churches their effigies clad in their best armor, sword at side, with their wives beside them and their dogs at their feet, ready to rise, equipped to demand their due at Judgment Day.

V An Age of Faith

An angel is shown announcing Christ's birth in this fourteenth-century tapestry.

God's house is threefold," wrote a French bishop. "Some pray in it, some fight in it, some work in it." Thus in the early Middle Ages the Christian world was neatly divided into three castes: priests, nobles, and common people. (The burgher class was still inchoate.) Preachers like to compare society to the human body: priests were the head and eyes; nobles, the arms and hands; commoners, the legs and feet. As the head of all mankind, the church claimed the right to direct and rule society, as it hardly does today except in certain pious polities, such as those of the Mormons or the Amish.

The church fulfilled many of the functions of the modern state. Church courts tried civil and criminal cases involving clerics, and their decisions on such matters as marriage, divorce, and bequests were binding and enforceable by local constables. The church alone controlled scholarship and book production; it alone cared for the poor, the sick, and the aged. It had jurisdiction over all students as well as over priests, monks, lay brothers, and a horde of "clerks" in minor orders, who enjoyed "benefit of clergy" with practically no obligations. The proportion of clerics to the population was perhaps ten times as large as it is today. The church was, in sum, more than the patron of medieval culture; it *was* medieval culture.

The pope ruled this mighty organization as God's vicar on earth. Possessing dominion over souls, some popes asserted their mastery over bodies as well, and over the earth from which bodies are drawn. They dreamed of a City of God wherein the pope, God's vassal, would anoint kings his vassals and bid them defend the faith.

Papal claims were both supported and impaired by possession of the Patrimony of St. Peter—the city of Rome and its surroundings—and the papal states, which extended across Italy. The popes could regard this territory as a kind of feudal demesne, paying part of the costs of their government. The papal lands were always badly administered, however, and they could not provide enough money to support the papal court properly. The popes, therefore, eagerly sought more territory. Asserting their primacy throughout the world, they played the role of Italian princelings at home, using spiritual weapons anathema, excommunication, interdict—against temporal rivals and actually declaring crusades against them. Thus they blunted the church's weapons, ranged themselves with ordinary mortals, and laid themselves open to mockery and shame. What land the popes gained was bought very dear, at much cost to their spiritual authority.

It was in the Middle Ages that the church formed the organization that it more or less keeps today. At its head was the pope, elected by the cardinals acting under divine guidance. The pope, in his turn, appointed the cardinals, making the system closed and self-perpetuating. The cardinals would nearly always elect one of their own number as pope. Originally the cardinals were merely the high clergy of the city of Rome and its environs. It was not until 1245 that they received their distinctive red hats; they adopted their characteristic red robes shortly thereafter. With their assistants the cardinals formed the pope's curia, or court. They could meet with the pope in consistory as a board of directors, but mostly they worked in committees or as supervisors of executive departments. The church's enormous correspondence was handled by the chancery, which drafted and issued all papal decrees, taking elaborate precautions against forgery. (But false bulls were rife, and were sometimes commissioned by unscrupulous bishops from unscrupulous scribes.) The papacy's financial bureau, the camera, ran a gigantic business, with money coming in from taxes imposed on all bishops and fees charged for decisions made by the papal court. Since the transport of gold from afar was difficult and dangerous, the camera developed a credit system in cooperation with Italian bankers.

A long with the rationalization of the church's governmental structure came the systematization of Christian doctrine. Many of the current beliefs and practices of the Roman Catholic Church were established in the Middle Ages. Transubstantiation was made a dogma in 1215; the number of sacraments was fixed at seven. The doctrine of the treasury of the merits of the church was proposed in the thirteenth century and confirmed in the fourteenth. One could, through prayer, good deeds, pilgrimage, or cash contributions, obtain an indulgence or draft on this treasury; it contained the excess virtues of Christ and the saints, which could be drawn upon by repentant sinners to relieve them of purgatorial pains. The Electors of Saxony piled up a credit of two million years against their time in purgatory. The Virgin, a minor figure in the New Testament, became an object of great reverence, chief intercessor with her son, almost his rival. The doctrine of her Immaculate Conception was first explicitly stated by Saint Bernard of Clairvaux in the twelfth century. Her cult was strengthened by the import from the East of the rosary with its litany of prayers addressed to Mary. Worship of the saints was much developed, for they are kind, whereas God is just, and justice is not kind to sinners. The most important saints' days were marked on the calendar with red letters, hence our red-letter days. The liturgy was revised, hardly to be altered until our own time. The church's teachings were masterfully codified in the thirteenth century by Thomas Aquinas, the Dominican monk, scholar, and saint.

In an age of faith tales of miracles abounded, and they were solemnly recounted from the pulpit and by the fireside. Eagerness to see wonders brought the wonders to life—bleeding statues, miraculous cures, resurrections, reversals of nature's laws. Men were not the only beneficiaries of the saints' intercession. A parrot, even, carried off by a bird of prey, spoke the familiar words of his mistress: "Sancte Thoma adjuva me (Saint Thomas, help me)," and Saint Thomas immediately released the parrot.

The powers of heaven were rivaled and often thwarted by the powers of hell. Life was an unceasing battle with the devil and his minions, who were always nearby, ready to pounce. After all, their home was directly underfoot, only a second's flight away. They too had their rights and obligations. Said Saint Francis: "The demons are our Lord's bailiffs, whom he hath set apart to exercise men." Satan could even befool mankind by assuming the form of Christ or of the Virgin. It was thought that insanity was caused by possession by an unholy spirit; the victim might be whipped, tortured, or burned to force out his impious inhabitant. One of the lower ranks of the clergy was that of the exorcist.

Men and women were not only the victims of the devil; often they were supposed to be his active agents. Having made a pact with the Evil One, they flew by night to horrid assemblies, or covens, where they coupled with demons without much satisfaction, for the diabolical members are icy cold. In return they were enabled to cast spells on their neighbors, rendering them impotent or causing them or their cattle to waste away and die. Since most of our information about witchcraft comes from confessions that were made under torture, we cannot be sure how reliable it is. No doubt some remnants of old country paganism persisted as an underground cult, and some angry, embittered men and old, hysteric women did believe themselves to be warlocks and witches. At any rate, the church and even wise Saint Thomas Aquinas accepted without question the existence of witchcraft. Joan of Arc was convicted of necromancy and burned as a witch in 1431.

Jews were also classed among the enemies of good Christians. Stories of the ritual murders of Christian children, committed by the Jews in following their hellish rites, received wide circulation. Perhaps these originated in the Jews' slave-trading activities in the early Middle Ages—a time when Jewish dealers may have bought children from poor parents and shipped them off to Moslem lands. (Unwanted children were often sent into the forest to die, as the story of Hansel and Gretel recalls; parents could easily explain their disappearance by blaming it on the Jews.) In Norwich Cathedral in England one can see a very apologetic plaque commemorating the boy William of Norwich, who in the twelfth century was said to have been stolen by Jews and crucified. In compensation he was made a saint.

Notable among church institutions was the cult of relics. The basis of the cult is reasonable and natural: when the soul of a holy man ascends, his body remains with us as a perpetual token of his stay on earth. His clothing, his intimate possessions, are reminders of him, impregnated with his spirit. Do we not treasure objects the beloved has touched and loved? Every historical museum is a reliquary; crowds stand humbled before George Washington's false teeth, Abraham Lincoln's stovepipe hat. The adoration of relics was legitimate, psychologically as well as canonically.

Relics were, and still are, required for the consecration of a new Roman Catholic church. Men signed treaties and took oaths upon relics. The knight carried them in his sword hilt, the merchant in a bag at his neck. Inevitably the relics acquired magical properties. Touching one was the best cure for disease.

The possession of relics was very profitable to a church, which could then become a shrine, a center of pilgrimage. The competition for superior relics was fierce. Baldwin II, emperor of Constantinople, sold for a large sum to Saint Louis one of

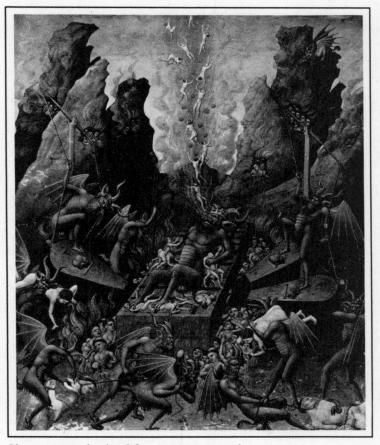

Sinners were destined for a grotesque and unforgiving hell, according to medieval theology. In this fear-inspiring depiction of the devil's eternity, the unfortunate sinners fall into a deep pit of torture and flames. Below, they suffer torments at the mercy of winged, horned demons. the greatest treasures of Christendom—the crown of thorns for which Saint Louis built the Sainte-Chapelle in Paris as a reliquary. The pious who were unable to acquire a relic as great might hope to have others associated with Christ: his swaddling clothes, one of his teeth, drops of his bloody sweat, a piece of bread chewed by him, the sponge offered him on the cross, a basket used at the miracle of loaves and fishes.

Inevitably, pious frauds and thefts abounded. The monks of Conques commissioned one of their number to steal a saint's body from Agen. The criminal inveigled himself into the monastery, and after ten patient years, managed to be appointed custodian of the relic, which he triumphantly carried off to Conques. At another time two monks purchased a complete Saint Sebastian in Rome; but they were cheated, for the corpse turned out to be only a Roman emperor. After it was installed with great pomp under their abbey's altar, it blew up like a bad egg. When Saint Thomas Aquinas fell ill and died in the monastery of Fossanuova, where he had stopped while on a journey, the monks decapitated him and boiled his body to make sure of keeping his bones. Saint Romuald of Ravenna, visiting France, heard that the people proposed to kill him, since he would be more precious dead than alive. He escaped by feigning madness.

Wandering friars and impostors in clerical dress sold pigs' bones as those of saints, slivers of the True Cross, and drops of the Virgin's milk at country fairs. Said San Bernardino of Siena: "All the buffalo cows of Lombardy would not have as much milk as is shown about the world." Because Saint Apollonia was considered especially effective in treating toothaches, Saint Apollonia's teeth abounded. Henry VI of England is said to have collected a ton of them. Said Thomas Fuller, a seventeenth-century divine: "Were her stomach proportionate to her teeth, a country would scarce afford her a meal." The multiplication of holy members was explained as a miracle, not beyond the powers of the saints. Voltaire, a suspect authority to be sure, counted six foreskins of Our Lord, to which barren women made pilgrimage.

Sober ecclesiastics, including the great Pope Innocent III, took alarm at the cult of relics and tried to bring it within reasonable bounds. At first they could do little to counter the vested interests of famous shrines and the need of simple folk for symbols of hope and comfort. Eventually doubt and skepticism increased, even among the devout. When the Reformation came, mountains of ancient bones were gleefully burned on bonfires.

Relics were a particular attraction for medieval pilgrims. The impulse to go on pilgrimage lies deep in the human spirit and stirs most often in springtime: "Whan that Aprille with his shoures soote/The droghte of March hath perced to the roote!" One yearns to see a place or thing long dreamed of, long adored. One feels, perhaps, the instinct of ancient nomads and migrants. Primitive pagans made pilgrimages to holy wells and trees; the Greeks traveled to visit the oracles of Delphi and Dodona. Among Moslems, pilgrimage to Mecca is a ritual obligation. The pious Protestant goes to the Holy Land to walk in the footsteps of Jesus; and throngs of Catholic pilgrims continue to visit the shrines of their faith.

When travel became reasonably safe in Europe, the church encouraged pilgrimages for the spiritual benefits they provided and sometimes as an alternative to punishment for misdeeds; a trip to the Holy Land ensured a troublemaker's absence for a year or two and very likely forever. The three great goals of pilgrimage were Santiago de Compostela in northwestern Spain, Rome, and Jerusalem. Along the route to the shrine of Saint James at Santiago, the Cluniac monks had organized hostels, a day's journey apart, complete with barbers and cobblers. At least two medieval pilgrim inns survive in England, having been in continuous service for about six hundred years—the George at Glastonbury and the George at Norton St. Philip.

The pilgrim was required to receive the church's blessing before setting out on his journey. He wore a robe of shaggy wool and a round felt hat. Sometimes he went barefoot and vowed not to cut his hair and beard until after his return. He carried a six-foot staff, with a hook for his water bottle and for a little bundle of necessaries. If he was headed for the Holy Land he wore a cross on his robe. Some pilgrims even had a cross branded or cut in their flesh. Those returning from Santiago sewed cockleshells on their hats; from Rome, a pair of crossed keys or vernicles, replicas of Saint Veronica's handkerchief; from Jerusalem, a palm leaf (they were then called palmers). Pilgrims to Canterbury received a flask containing a drop of the muchdiluted blood of Saint Thomas à Becket.

A pilgrimage could be very gay. On entering a town a party

formed ranks behind a bagpiper and marched through the streets, to the applause of bystanders. All sang and rang their little bells, which in England were called Canterbury bells. In the morning, like migrating birds, they gave a gathering cry, or assembly call, and started off. Along the road they sang hymns and holy songs, and told one another stories, as did Chaucer's Canterbury pilgrims. In the evening at the pilgrims' hospices the monks often provided diversion for their guests, chanting legends of the holy places and wonders located along the route. In exchange the pilgrims could give their hosts news of the great world.

And sometimes demons hovered above them on the march and suggested wanton songs to accompany the piper's tunes, and dances in churchyards, and lewd satisfactions in the hurlyburly of inns and nights under the stars.

The church and its teachings pervaded man's entire life. One could not strike a bargain, cut a finger, or lose a farm tool without invoking celestial favor. One was seldom out of sight of a church tower, out of hearing of a consecrated bell. It is estimated that in England there was a church for every forty or fifty households. The visitor today marvels at seeing an enormous, beautiful, ancient church, usually empty, alas, in every East Anglian hamlet. According to an eleventh-century chronicler, the world was "clothed in a white garment of churches." Love and pride built the parish churches, and love and pride found a transfigurement in the cathedrals. All people contributed to their building, giving labor as well as money, even harnessing themselves to the supply wagons. The ecclesiastical fund raisers were astute; they knew that by offering a little they could obtain much; thus they rewarded those who contributed generously toward the construction with indulgences or freed them from the strict observance of certain church laws. The "Butter Tower" of Rouen Cathedral was built largely with funds received for permission to eat butter during Lent.

The social services of the church were all-embracing and were, at their best, rendered in a spirit of loving charity that a state—the inheritor of many clerical functions—cannot legislate. According to canon lawyers, charity is a moral obligation; it is merely justice. The poor have a right to support from the community's property. The church maintained hospitals, leprosaria, almshouses, orphanages, and hospices along Alpine

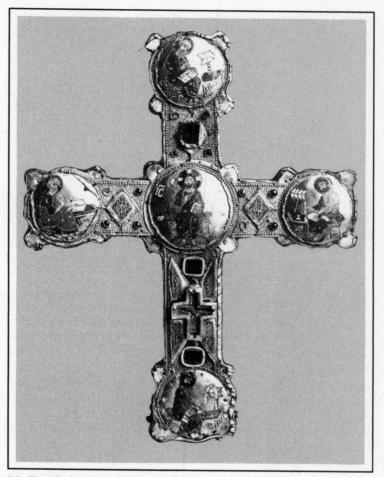

Medieval churches and shrines competed for collections of relics, which were objects touched or owned by martyrs or saints. With a good collection a church could turn itself into a profitable pilgrimage center. This decorative reliquary was donated by Frederick II in the early thirteenth century. passes. It fought the remnants of slavery, which lingered in Western lands; a London council in 1102 forbade "the ignoble trade whereby men are sold like beasts." The church ransomed prisoners and repatriated Christian slaves from Moslem lands. The orders of Trinitarians and Ransomers offered their own bodies to free those whose salvation was in danger. The Penitent Sisters of St. Magdalen reclaimed prostitutes. A kind of Travelers Aid Society succored pilgrims. A poor-relief system was decreed for every parish; the poor were entitled to one fourth of the tithes and one half of all other donations to the church. Often, however, the yield was disappointing.

The church also promoted economic welfare, helping to build and maintain roads and bridges. The bishop of Metz in 1233 ordered that the best suit of clothes of every person who died in the diocese be sold to pay for a bridge over the Moselle. This is the Pont des Morts, which still stands. Many monastic farms were models, introducing new crops and techniques, including the scientific breeding of cattle.

Hospitals abounded. In the High Middle Ages there were four hundred in England, and by the time of the Reformation, there were seven hundred fifty. Thirteenth-century Paris had twelve hospitals, with special maternity wards, and also a lazar house and an asylum for the blind. Generally they were supervised by Augustinian monks and nuns; the actual nursing was done by humble lay brothers and sisters, who had renounced the world to serve the unfortunate. Most hospitals were vast halls with partitions, such as the famous Hôtel Dieu at Beaune in Burgundy. They were brightened with flowers; their rooms were more cheerful than most modern wards are.

Supposedly no one was to be refused admittance unless he tried to bring in his hunting dogs and hawks. The rule of the Paris Hôtel Dieu read: "Receive the patients as you would Christ himself... treat each patient as if he was the master of the place." Upon admittance the patient was washed, and his clothes were disinfected in the lice room. He was bathed every morning, and his sheets were frequently changed. However, at crowded periods he was likely to be bedded with one or two companions. On his discharge his clothes were returned, laundered and patched. In short, hospital routine was much as it is today, with the addition of love and charity.

The church alone dealt in education. Many monasteries con-

ducted informal trade schools, teaching embroidery and goldsmithing for the making of church vestments and ornaments. Reading, writing, and elementary Latin were taught to youths who were being trained for careers as clerks, either as churchmen or government employees. Higher schools, attached to monasteries and cathedrals, prepared the students for admission to the universities. Although modern scholars may sneer at medieval latinity, the training produced a world of clerks who could converse at ease in Latin and write it with a fluency and vigor beyond the reach of our Classics majors. The training could also produce pedants, however. Petrarch met one who totally condemned Virgil for using too many conjunctions. When a tenth-century scholar, Gunzo of Novara, arrived nearly frozen at the monastery of St. Gall in Switzerland, his chattering teeth let escape an accusative case ending instead of an ablative. One of his hosts, the monk Ekkehard, expressed shock. Gunzo excused himself in a lengthy letter, listing twenty-eight such errors made by the best authors. It is pleasant to read that a hundred years later another scholar drastically corrected the carping Ekkehard's Latin.

The ecclesiastical hierarchy early became a class hierarchy. The bishops and high prelates generally came from the nobility; the parish priests, from the peasantry. Monks and friars were outside the class system, but in the early Middle Ages the abbots tended to be gentlemen, and the rank and file, commoners. The bishops were lords and must still be so addressed in England. They kept the pride of their noble background and their insistence on precedence. When a papal legate visited Westminster Abbey in 1176, the archbishop of Canterbury sat down in the seat of honor at his right. The rival archbishop of York, an old warrior, crowded into the same seat, "thrusting with the more, uncomely quarters of his body so that he sat down upon the lap of his own Primate," says a chronicler. York elbowed Canterbury with his sword arm, but "was ignominiously seized by certain bishops, clerics, and laymen, and torn from the Archbishop's lap, and cast upon the floor."

There were good bishops and bad. Many were learned theologians, conscientious in the discharge of their tasks, compassionate, even saintly. Their job was an exacting one, combining spiritual obligations and diocesan administration with political, feudal, and judicial duties. Some were ignorant. A bishop of Durham, consecrated in 1316, was scarcely able to read. When during the consecration ceremony he reached, after many promptings, the word *metropolitanus*, he gave up, gasping, "Let that be taken as read." Some were cynical self-seekers. A thirteenth-century bishop of Parma refused communion on his deathbed, saying he believed nothing of the Christian faith. Asked why he had accepted the bishopric, he replied, "Because of its riches and honors," and so died unabsolved. And some were frank scoundrels, like Bishop Matthew of Toul in France, who defied excommunication for eight years, murdered the ecclesiastic sent to replace him, stole the episcopal equipment and holy chrism, and built a castle from which he plundered his own diocese.

The bishop's administrative staff consisted of the dean and canons of the cathedral. These men were responsible for processions and festival celebrations, for the maintenance of the cathedral's fabric, and for the services—normally five on weekdays, seven on Sundays. In cooperation with an archdeacon and a rural dean or archpriest, the chapter also conducted the business of the diocese. This was very extensive and included many duties, such as the probate of wills, that have now been turned over to the state.

The chapter's subjects were the parish priests. Prosperous parishes were often occupied by younger sons of gentlemen, but most parish clergymen were baseborn. Pious parents had dedicated them to the service of the church and had paid the fee required by the local lord for their tonsuring. These men had some schooling, usually from the priest under whom they had served in their home village. For them a curacy meant an opportunity to wield some influence in the village and a release from some of the burdens that the other peasants bore. They had their own glebe, and worked with the other villagers in the fields. They were usually poor, particularly if their patrons carried off most of the tithes. Some kept taverns. Boccaccio's Don Gianni di Barolo hawked goods at country fairs to support himself.

Naturally these priests charged for their services, even for giving the sacraments. One priest demanded the baptismal robes of newborn infants; another carried off the bedclothes of a dying man to whom he had just administered extreme unction. Often they were as slovenly and filthy as the other peasants. The thirteenth-century Franciscan chronicler Salimbene tells of flyspecked hosts and ragged vestments. He relates the tale of a Franciscan friend who was called upon to say mass in a village church and had to borrow the incumbent's stole. It turned out to be a concubine's girdle, with a bunch of keys attached. These jingled comically as he turned to pronounce the *Dominus vobiscum*. Tales of priestly ignorance abounded. San Bernardino of Siena heard a Tuscan cleric reprove another for saying, "*Hoc est corpus meum* (This is my body)," when he elevated the host during mass. The proper form, he said, is: "*Hoc est corpusso meusso*." Appeal was taken to a third priest, who said he never bothered with the phrase at all; he just said a Hail Marv at the elevation.

Visitations by higher authority were infrequent, and the isolated parish priests could do about as they pleased. Often they contented themselves with saying mass, leading the singing, pronouncing exorcisms and cursings, and announcing news bulletins, lists of strayed sheep, or the penalties imposed by the manor court. Those who chose to preach recounted Bible sto-, ries and miracles, and told exempla, anecdotes with moral lessons, while the congregation laughed, wept, and interrupted. Priests made much of the torments that awaited sinners. Some were excellent dramatizers. In the Cluny Museum at Paris is a wooden crucifix from a twelfth-century village church. It contains a spring, connected by an iron rod to a pedal at the base, which the preacher worked with his foot, making Christ's head, eyes, and tongue move. The church's appeal to marvels and miracles encouraged the countryfolk's tendency toward superstition. The peasants might treat the sacred host as a charm: one peasant even crumbled it on his cabbages to keep off caterpillars.

People treated their church very familiarly, wandering in and out, talking and joking as if at market, or popping in to seal a solemn bargain. Since the edifice was usually the village's only capacious hall, it was used for town meetings, elections, and court sessions, and even for such useful purposes as the storage of surplus hay. Many young men attended services only to ogle the girls. It was in church that Petrarch fell in love with his Laura.

The churchyard was sometimes the scene of noisy celebrations, such as vintage festivals. These were the descendants of ancient pagan revels, and the ancestors of our socials, bazaars, and Sunday-school picnics. In England church-ales or scot-ales, parties in which every participant paid his scot, or assessment, were held as benefits. The taverns were closed, and booths were set up in the cemetery for the sale of bread and ale. The churchales were likely to end in unseemly brawls.

In the early Middle Ages the parish priests were generally married men. Church authorities carried on an endless battle to enforce celibacy for two main reasons—spiritual and practical. The spiritual reason was that the priest, by renouncing normal life and hope of posterity, gave secure evidence of total devotion to the church's unworldly ideal. He became a little more than human. The practical reason was that the celibate priest had no duty other than that of his priesthood. In effect, he married the church and gave all his fatherly love to his charges. Most societies, however licentious, have honored chastity, and above chastity, virginity. "Virginity alone can make men equal to angels," said Saint Thomas Aquinas. The worship of virginity carried many medieval men to pathological extremes—even to selfmutilation, for does not the Bible say: "Some have made themselves eunuchs for the kingdom of heaven's sake."

The papacy fought fiercely against clerical marriage. Priests' wives were reduced to the status of concubines, and by the end of the thirteenth century, even clerical concubines were rarely seen in western Europe. Sexual misdemeanors among the clergy were not thereby eliminated, as a mass of evidence shows. Salimbene reported that a hundred times he had heard Italian priests cite as a text from Saint Paul the words: "Si non caste tamen caute (If you can't be good, be careful)."

Monks, having taken a solemn vow of chastity, were the special prey of ranging demons, who were said to come at night in the form of voluptuous succubi. Saint Benedict's Rule, which most monasteries followed, prescribed as a defense against them hard outdoor work and a bland vegetarian diet, and not too much of that. Before retiring, the monks sang, and still sing, the Compline Hymn, *Procul recedant somnia*:

From all ill dreams defend our eyes, From nightly fears and fantasies; Tread under foot our ghostly foe, That no pollution we may know.

Yet all too often the unhappy monk awoke to realize that he had

been visited by a succubus. His best recourse then was a good lashing with the discipline.

Some account has already been given of the monastic orders. In them a young man with a true vocation was able to find a wide range of sacred careers. Some orders, especially the Carthusians, were cruelly austere; others inclined toward comfortable laxity. One could choose an ascetic order or a contemplative one or an order devoted to scholarship or preaching, missionary work or charity. Some promised the troubled youth the privilege of total and essentially egoistic concern with his own salvation. Others offered self-sacrifice in good works among lepers or prisoners. Many promised a high-walled refuge from a stormy and dangerous world.

Some of the monks were "children of the cloister," offered to God in babyhood by parents who already had a surplus of offspring. Others were chosen by the monks for their unusual promise, and were tonsured and educated within the walls. Knowing nothing of life outside, they readily took the irrevocable monastic vows when they came of age. Some, who knew that life all too well, gladly exchanged the expectation of toil and oppression for the holy, melodious peace of the monastery and a guarantee of salvation. Certain monasteries and many nunneries tried to keep an aristocratic tone by admitting only gentlefolk. Most commonly, however, the recruits were the offspring of freemen and burghers, youths who felt in their late teens an emotional upsurge, coupled with a revulsion against the world's futilities and falsities.

The beneficence of pious donors gave monastics many splendid homes and far-spreading lands to support them. They owned much of the wealth of Europe, and as a result were constantly involved in controversies over boundaries, revenues, rights, tolls, taxes, and usurpations by feudal lords and merchants and creditors. The orders competed constantly with one another, since they possessed, naturally, a kind of club or school spirit. The Cluniac monk Guyot de Provins saw no good in rival communities. He found Carthusian food appalling, and complained that the Cistercians thought only of acquiring land and money and that the monks of Grandmont were dandies, combing their beards in three coquettish braids. He considered the Hospitalers shameless beggars and scorned the Templars, who were forever getting killed. "I do not care to be killed," Guyot

The Benedictine monastery at Canterbury is mapped out in this twelfth-century plan. Extending along the top is the cathedral, with cloisters beside it. At far right is the long cellarium, or storage house. At a right angle to that is the refectory. The monks' necessarium, or latrines, are at bottom left. remarked, "I would rather pass for a coward and live, than be the most glorious of earth dead."

The typical monastery was situated in the open country or in a small town. The founders chose a site by a stream, to provide drinking and washing water, a fishpond and power for a mill, and also a sewage disposal system, often ingenious and very elaborate. The abbey church, with a long nave for processions, stood at the north of the monastery complex, with the sanctuary at the east, looking toward Jerusalem. South of the church, protected from chill winds, was the rectangular cloister, nicknamed Paradise. Here the monks strolled for exercise, or worked at stalls, located in the bays between the pillars, for writing and illuminating manuscripts. Opening on the cloister were the chapter house, refectory, a dorter, or dormitory, for monks and another for the lay brothers, and perhaps a warm library and scriptorium, or writing chamber. There was also a locutorium, or parlor, for conversation after dinner. At a little distance were the abbot's lodge, the infirmary, and the latrine, or necessarium.

The monk's day began with the service of matins, usually immediately followed by that of lauds. Theoretically these were celebrated promptly at midnight, although they were often postponed to two or three o'clock. These services could be very long, lasting until dawn. At Canterbury in the eleventh century they contained fifty-five psalms, which were to be sung by the monks, standing. This was too heroic for human endurance. Ordinary matins consisted of a chant, three anthems, three psalms, and three lessons, along with celebrations of local saints' days, anniversaries of benefactors, and so on. Usually there was time for a little sleep before the next office, prime at dawn.

Matins in the dark choir must have been very dramatic, with only a few wavering candles to illumine the lesson reader's book and reveal the high gloom of the choir, the outlines of cowled singers and carved saints. In the early days the monks had no lights for reading; they were required to know by heart both words and music of an enormous repertory of psalms, chants, anthems, and responses. Their feats of memory, taken as a matter of course, may seem phenomenal to us; but before reading came to be common, memory was trained from childhood. Illiteracy is by no means the same thing as benightedness. By the fourteenth century, however, thanks to the wider diffusion of wax candles and service books and the elaboration of musical notation, reading replaced memorization. Many medieval manuscript illustrations show a cluster of singers standing around a giant antiphonary. Candles were fixed above the choir stalls, and a favorite prank of the monks was the dropping of hot wax on the bald pate of a drowsing comrade below.

The monks, who had returned to the dorter for a few hours of rest after matins and lauds, were awakened at dawn by the brother on duty. They hurried to the lavatory for a wash, then to church for the service of prime. Then they proceeded to the chapter house for a business meeting, with orders for the day, reports, and discussions, and sometimes a sermon or public accusations and confessions or punishments, which included flogging. Then came private mass, or reading and working in the cloister until the third hour after sunrise, when the office of terce was said, and high mass. At midday came the office of sexts, and at last, dinner. After a brief period of recreation, the monk could retire to the dorter for rest until the office of nones, a short service; this was followed by work in the cloister or garden, vespers, and after twilight, compline and the Great Silence—and so, thankfully, to bed.

Such was life in one of the more rigorous monasteries devoted to the Opus Dei, intercession with God by praise and prayer. The schedule was based on the Benedictine Rule, which had been established in the sixth century as a guide to monastic life. Most monasteries relaxed the Benedictine Rule, however, for there was simply not enough time for the manual labor that the rule required. Though the monks in poorer foundations had to take turns doing kitchen work, in most monasteries duties were turned over to lay brothers and servants, cooks, bakers, brewers, barbers, tailors, and shoemakers. Farm management and accounting fell into the hands of professionals, who supervised the laborers-millers, smiths, shepherds, carters, fishermenwho worked on the monastic domain. Some of these workers were recruited from among fleeing serfs, whom the monasteries could hold against lordly claimants by putting a bell rope around the fugitive's neck. The monks' obligation of charity was fulfilled by the almoner. Every monastery had its alms scuttle for the poor. At Heisterbach in Germany a steer was killed daily, and its meat was distributed as alms. The monastery's property rights were sometimes relaxed in case of need. Thus at Rumersheim in Germany pregnant women were permitted to fish in the monks' brook; but they were allowed to do so only on the condition that they put one foot in the water and keep the other on land.

The monastery was required to receive and entertain monarchs and nobles on their travels. The appearance of a seigneur with his retinue and his horses, dogs, and servants could be a disaster to the house's economy. Isabella, queen of Edward II of England, left her pack of hounds at Canterbury for two years. King John, after a long stay with an enormous suite at Bury St. Edmunds, left as a parting gift only thirteen pence.

The monk with competence spent many happy hours writing or decorating holy books. He had the pleasure of making beautiful pages in fine calligraphy and at the same time of acquiring spiritual benefits, for Saint Bernard had said: "Every word that you write is a blow that smites the devil." As time went on, copying and illumination were taken over by professional scribes and artists, and the monasteries confined themselves to making service books.

The monk's gowns varied in cut and color with the order. For the most part the clerics were clad in garments of coarse material. They slept in their habits and stockings, ready to rise, put on slippers, and wend their way to the nocturnal offices. In every order some ascetics rejected all comfort for the body and went barefoot. Abbot Samson of Bury St. Edmunds wore a pair of haircloth drawers.

Normally the monks had but one meal a day, though a light supper was permitted in summer, and the English always demanded a breakfast of bread with ale or wine. Dinner in the less austere orders was usually substantial. In England it consisted of bread, cheese and egg dishes, beans, vegetables, cereals, and fish for both fasting and feasting. Oysters were a fast-day staple. They were no luxury; Chaucer speaks of something as being "nat worth an oistre." Poultry was classified as a fast food of aquatic origin since at the Creation "the waters brought forth abundantly, after their kind, and every winged fowl after his kind."

Many monasteries failed to adhere to this limited diet, however. The scholar Giraldus Cambrensis, visiting the monks of Canterbury in 1179, was offended by the great amount of food that was served them—sixteen dishes, tricked out with stimulating sauces and accompanied by beer, ale, claret, new wine, mead, and mulberry wine. He sneered at the monks of St. Swithin's, Winchester, who groveled in the mud before King Henry II because their bishop had suppressed three of their customary thirteen dishes. The king replied that in his court he was content with three, and so should the monks be. The Benedictine Rule forbade the consumption of meat, except by the sick. However, the prohibition was gradually relaxed by various devices. Sometimes half the monastery would report sick and enjoy special meat dinners in the infirmary. Gluttony was the darling vice of the monastics, and why not, indeed? They came ravening to table after a twenty-four-hour fast.

At dinner a lector read edifying selections from the lives of the saints or from other devotional books, though the monks' attention might be otherwhere. The brothers, forbidden to speak at meals, developed an elaborate sign language. At least a hundred signals have been recorded. Giraldus Cambrensis, at the Canterbury dinner just described, thought he was watching a stage play, with all the gesticulations and whistling that went on. Another scholar reports that when the monks were forbidden to communicate with their hands, they talked with their feet.

Lack of exercise, a starchy diet, and abundance of ale and beer induced corpulence and invited coronaries. To purge noxious humors and also to diminish lust, the monks were bled five or six times a year. This was a happy time. The men spent several days in the infirmary, relieved of all duties, sleeping, and eating meat. At this time, one monastic chronicler reports, "the cloister monks are wont to reveal the secrets of their hearts." Many monasteries possessed country retreats or rest hostels, where the religious were allowed to take decorous walks, though they were forbidden to hunt or vault hedges.

The professional disease of the cloistered monk is *accidia*, a spiritual sluggishness that may turn to black boredom, to melancholia. In hours set for meditation, and particularly after a heavy noontide meal, the hearty monk is assailed by the devil, the Midday Demon. He questions whether he has done well to renounce the world and its delightful temptations. To fight *accidia* the monk might seize any opportunity to go on a monastic errand or a pilgrimage, or to spend a term at a university.

Some never returned; they became wandering beggars, gyrovagues, and some, like Friar Tuck, joined brigand bands. Within the walls the monks were likely to burn with petty jealousies: one envious brother at the monastery of St. Gall cut to pieces with his penknife a rival's beautiful manuscript; others, maddened by the devil's wiles, hanged or crucified themselves.

Some zealots, for whom the communal life of the monks was insufficiently austere, became hermits or anchorites, obeying the impulse that always bids some to hide from the world. They might build huts in the wilds, dress in sheepskins, exist on the produce of their own garden and the gifts of poor peasants; or they might continue to serve humanity by settling at a ford or marsh or forest way to guide travelers. Some few, particularly women, had themselves walled in a cell with a window opening on a church.

Women's convents were smaller in number and population than those for men. Some recruits had a real vocation, like the thirteenth-century Italian lady the Blessed Angela of Foligno, who "mourned to be bound by obedience to a husband, by reverence to a mother, and by the care of her children." She prayed to be relieved of those burdens. Her prayer was granted. "Soon her mother, then her husband, and presently all her children departed this life." Thus by God's mercy she was enabled to enter a Franciscan house. Most nuns, however, were surplus or unmarriageable daughters of the noble and bourgeois classes. We need not commiserate with them for escaping the usual lot of a loveless marriage and the repeated bearing and loss of children. They seem to have had a very pleasant time, with no great austerity, in what have been called aristocratic spinsters' clubs. They occupied themselves with schooling girls and with fine needlework and embroidery; the opus Anglicanum-embroidered work produced in English convents-is still famous. They could possess private property; their habit was elaborate, corresponding to that of fashionable widows at the time of their order's foundation. Like Chaucer's elegant prioress, they could wear bracelets and brooches, keep pet dogs, and also birds and rabbits. They were allowed to dance and sing, and take long holidays, lasting even a year, for air and recreation. If they repined at their lot in life, they merely classed themselves with the great majority of people.

S imilar to monasticism in its ideal, very different in its operation, was the rule of the mendicant friars. Their great originator was Francis of Assisi—one of the few men who have transformed mankind's thought and behavior in their own and succeeding times. Books on Saint Francis are one long cry of adoration and love. Only rare cynics have ventured to sneer at him, calling pathological his desire to excel all men in abasement, and megalomaniac his words when in prison: "You will see that one day I shall be adored by the whole world." The cynics make only a thin piping in the general chorus. Everyone who knew Francis succumbed to his spell. His power was Christ-like, and it is still at work in the world.

The son of a well-to-do merchant, he was born in 1181 or 1182 in the Italian town of Assisi. As a young man he strove to outdo Assisi's other young men in conspicuous waste. Around the age of twenty-one, after a year's political imprisonment and a long illness, he heard the divine call. He made a pilgrimage to Rome, exchanged his fine clothes for beggar's rags, and stood all day before St. Peter's asking charity. One day while riding in the country he met a leper and turned away in repulsion. Then with a mingling of horror and humility he returned to kneel in the dust and kiss the leper's hand. Assisi thought him mad. His father, alarmed at his spendthrift charity, brought him before the ecclesiastical court. The bishop commanded him to surrender all his property. Francis, who had an excellent sense of comedy, stripped himself naked and handed his clothes to his father, announcing that thenceforth he would recognize no other father but God. The bishop took Francis, trembling with cold, under his mantle.

Thus Francis espoused his Lady Poverty. It was a very happy marriage. The mark of Francis and of Franciscanism is joy. Francis was an excellent singer and loved jolly French songs. Possessing no instrument, he accompanied himself by sawing with one stick on another. He named his followers the *Joculatores Dei*, God's Minstrels.

He soon had his disciples, an apostolic twelve, who imitated his example of renouncing all worldly goods. They built cabins of branches and made their own tunics of rough cloth of graybrown color that the Italians call beast color. They worked in the fields with the peasants. They would enter a town singing, and then preach repentance and the forgiveness of sins. Some of

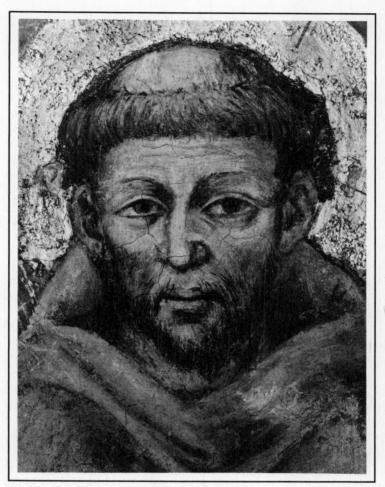

This portrait of Saint Francis, a detail of a painting by Cimabue, hangs in an Assisi church. Francis's reputation as a philosopher and a leader was nearly Christ-like. Late in life he retired to the mountains, where, it was said, he saw a vision of an angel nailed to a cross. At that moment the virtuous Francis discovered the stigmata on his own hands and feet and a wound in his side. their hearers were angry and threw mud at the preachers or tore off their clothes; some laughed and put dice in their hands and told them to play; and some were deeply moved. On the whole the clergy were mistrustful, as our own established churches once were at the indecorum of the Salvation Army. In 1210 Pope Innocent III met with Francis and his followers in Rome. He felt Francis' radiant power, and bade him and his disciples continue their work, but he had them tonsured against their will, to bring them under church discipline.

Thus encouraged, they carried their evangelizing message afar, particularly to Germany and England. Francis was certain that if he could only expound Christian truth to Moslems and infidels they would immediately be convinced of its validity. He joined a crusading army in Egypt, crossed to the enemy's lines, and bade the Moslem sentries to conduct him to the sultan. The soldiers were nonplussed, but concluded that anyone so simple and dirty must be a madman, whom Allah has instructed men to respect. They led Francis to the sultan, who listened to him with bewilderment and returned him courteously to the Christian lines.

The church authorities, being administratively minded, gently pressured Francis to establish a monastic rule that his disciples would follow. Francis hated rules; he was content to pray, preach, and sing. His order was most irregular; anyone could join, without a novitiate. The only requirement for admission was that he should give away all he possessed to the poor. Members of the order were called Friars Minor, for Francis had said: "Let the brothers always be less [minores] than all others." We call them mendicant friars because they lived mostly by begging, but in fact Francis expected his companions to work at any menial task they could before they asked for alms. He did not condemn property itself; he regarded it as a bond from which apostles should be free. He welcomed the support of laymen and laywomen, whom he invited to join a Brotherhood of Penitence. They had no rule other than the Gospel.

Every administrator will recognize that such disorganization will open the way to excess and calamity. Love dares not be free; it must be directed and channeled. The vast enterprise had to have a home office, a permanent staff, constitution, and bylaws. Administrators took the place of saints. The demon of property threatened Lady Poverty. The citizens of Assisi built a residence for the friars. Francis climbed to the roof and threw down the tiles. A few years later, when a church was being built to honor Francis, one of his followers, Brother Leo, smashed the offertory box. For this offense he was publicly whipped.

Francis became desolate and heartsick at seeing his holy anarchy made businesslike. He retreated to the mountains and spent his time in communion with God and nature. His love of wild beauty is one of his bonds with the modern spirit. He delighted in mountain views and would stare hour-long at brook waters. He required that every Franciscan monastery garden set aside a corner for flowers. His little sisters, the birds, and his little brothers, the beasts, would come trustfully at his call, and he would sing to them or preach them a sermon. This almost pantheistic identification with the universe is expressed in his "Song of the Creatures," or "Canticle of the Sun," one of the greatest poems ever composed.

In the last years of his life, after a period of ecstatic prayer on the mountain, Francis had a vision of an angel nailed to a cross. He then perceived on his own body the stigmata—dark, fleshy excrescences on hands and feet, as though made by piercing nails, and a wound in his side that occasionally bled. There can hardly be any question of the genuineness of these appearances. The only question concerns their cause. Petrarch, in the fourteenth century, suggested that they were due to a traumatic psychosis, although he does not use the words. Many, however, still find it easier to believe in miracles than in traumatic psychoses.

Francis died in 1226. In two years the giant basilica of Assisi was begun to house the bones of the man who in life abandoned a hovel because he heard someone call it "his." Because the Franciscan Order was growing at epidemic speed, the church was obliged to provide headquarters for the friars. To circumvent Francis' prohibition of ownership, the church found an argument. In a bull of 1230 the pope declared: "No one is considered to *own* what he merely *possesses*, so long as he does not in conscience *consider* himself as owner." The brothers could then possess without owning, and friends of the order, free to accept money, could "consider themselves" owners. To this argument Lady Poverty, who is no scholar, could find no answer. The brethren enjoyed all the advantages of wealth and had to bear none of its responsibilities.

At the same time the order became scholarly, its members

167

concerning themselves more and more with theological speculation. Francis distrusted book learning, and he assailed a follower who set up a school. "You wish to destroy my order. I desired and willed that in accordance with the example of my Lord my little brothers should pray more than they read." The reproved brother fell ill and took to his bed. A fiery, sulphurous drop fell from the sky and pierced his body and bed, and the devil carried off his soul—or so the story goes.

The order broke apart. The Spiritual Franciscans, the fundamentalists who remembered Francis, held to the original ideals. The great majority accepted the necessity for regularization, for learning and scholarship, for obedience to the pope. They remained mendicants, though a friar who might not touch money was often followed by a servant rattling a money box. It was said that people feared to meet a friar as they feared to meet a robber. But even the friars had to eat. They went into the world to save others' souls, instead of retreating from it, like the monks, to save their own. They fulfilled a social rather than a personal mission, and were the chief agents in the revival of religious vitality that took place throughout western Europe in the thirteenth century.

Co-workers and occasional rivals of the Franciscans were the Dominicans, named for their founder, Dominic of Caleruega in Spain. Different though he was in character, he was a devoted friend and ally of Saint Francis. He was an intellectual, a scholar, and an able administrator. Laboring for years to convert the Albigensian heretics, who flourished during the period in southern France, he recognized that a missionary must be more learned than his adversaries. He therefore obtained, a few years after Saint Francis had, permission to found a preaching order of mendicant friars, scholarly enough to contend effectively with the arguments of the heretics. Dominican friars were punningly termed *Domini canes*, "dogs of the Lord." They wore the white woolen robes of canons regular, with the black traveling capes of Spanish priests; hence they appear in art accompanied by black-and-white spotted dogs.

Dominic proposed to have a school in every Dominican center, with a higher academy in the greater monasteries, and a kind of graduate school in the leading cities to be associated with universities that were already in existence. The Paris school was set

Dominican monks acknowledged nine suitable ways of praying, two of which are shown here. At top, three monks in characteristic black and white robes are in their "attitude of contemplation" before the bleeding crucifix. Below, a prostrate monk kisses the ground. Other prescribed methods of prayer included genuflection, supplication, the performance of penance, and inclination (bowing the body low in humility). up around 1220, that of Oxford somewhat later. These became the intellectual centers of the West. They fostered cooperative enterprises, such as an encyclopedia of all knowledge, and they educated and sponsored the most profound philosophers of the time, most notably the Dominican Saint Thomas Aquinas.

Dominicans and Franciscans still keep the impress of the character of their founders. Dominicans are preachers, scholars, and writers, liberal in spirit, though stoutly orthodox. Franciscans are active workers in the world, democratic, poetic, inclined to the radical, and treasuring the holy joy of Saint Francis.

Like monks, most friars-Franciscans, Dominicans, Augustinians, and Carmelites-lived under a rule and wore distinctive habits. Their purpose, however, was to save others' souls. and only incidentally their own. They were generally evangelical workers among the proletariat of city and countryside, living by charity, returning regularly to their houses in the towns for rest and spiritual refreshment. Most of them were themselves of the lower class, and in their humility were warmly welcomed by the humble poor. They were accused, though unjustly, of communist teachings. Their writings and exhortations indeed contained social criticism, but this was incidental to their religious purpose of saving souls. The friars developed a colloquial, dramatic, revivalist style of preaching. They might produce a skull in the pulpit to terrify sinners, or they might conceal a confederate to imitate the cries of the damned or blow the Last Trump on a horn.

Though the friars were at first welcomed by the monks, they soon roused hostility. Their fervor attracted recruits from the old orders. Their ostentatious poverty contrasted with the great wealth of landholding monasteries. The friars were the favored confessors to the pious rich. They attracted charity and large bequests to the chagrin of other orders. They had open channels of communication to the popes, who were likely to show them every favor.

The friars became equally unwelcome to the parish clergy. With their new eloquence they emptied churches and diverted alms expected for parish use. A special grievance was that they heard confessions within a priest's territory. Villagers preferred confessing to a stranger rather than to a fellow villager, who might turn the information to his private advantage, who might be a babbler in his cups. For their part the friars accused the parish clergy of ignorance, worldliness, and neglect of duty. The hostility actually resulted in riots led by parish priests and in indecent squabbles, even over corpses at the graveside, disputed by priest and friar for the fee of soul scot.

Eventually the friars were injured by their own success. The wealthy gave them fine houses, noble churches, rich decorations. The upkeep of these possessions was costly, and almscollecting brothers were whipped to greater efficiency, encouraged to demand rather than to beg, with the privilege of pocketing any money they could collect after reaching a certain quota. Unworthy recruits took the cowl for personal profit. Little by little the friars lost their popular acceptance, and with it their own fervor and their material prosperity.

Wandering friars were not the only religious enthusiasts N seen traveling the highways. Long processions of flagellants were also a common sight. Self-flagellation with a whip, or discipline, to subdue the rebellious flesh was an old practice of monks and anchorites. In the thirteenth century public flagellation became a mania. Whole communities, both men and women, would set off on month-long tours, parading halfnaked through the towns, lashing their own and one another's backs. Their private penitence seemed to demand public display and applause. Says the Franciscan Salimbene: "All men, both small and great, noble knights and men of the people, scourged themselves naked in procession through the cities, with the bishops and men of religion at their head. ... Men confessed their sins so earnestly that the priests had scarce leisure to eat. . . . If any would not scourge himself he was held worse than the Devil, and all pointed their fingers at him as a notorious man and limb of Satan; and what is more, within a short time he would fall into some mishap, either death or of grievous sickness." In the following century the terrors of the Black Death inspired a revival of the flagellants' activities. They adopted a uniform, a long white gown and blue cloak, and a faith of their own: flagellation replaced penance; the Eucharist was held unnecessary, as was the mediation of priests between men and God. Such heretical beliefs brought the church's condemnation upon the flagellants.

The human spirit inclines readily toward heresy, arguing against imposed doctrine and challenging the institution that prescribes it. Early in the eleventh century began the burning of dissenters—peasants, clerics, and nobles—both in France and in Italy. There were many more victims in the following centuries. Dante's *Inferno* abounds in heretics for whose courage the poet betrays a reluctant admiration. In England in 1166 a cluster of people who rejected the sacraments were brought to trial. Says the chronicler William of Newburgh: "With their clothes cut off to the waist they were publicly flogged and with resounding blows driven forth from the city into the intolerable cold, for it was winter time. None showed the slightest pity on them and they perished miserably."

About 1170 Peter Waldo, a well-to-do merchant of Lyons, was inspired by reading Scripture and by tales of the lives of the saints to sell all that he possessed and give the proceeds to the poor. This was nearly forty years before Francis of Assisi espoused *his* Lady Poverty. Peter Waldo organized a group—the Poor Men of Lyons—who devoted themselves to preaching the Gospel in the vulgar tongue. The pope ordered Waldo to submit to church discipline. He refused, saying that his duty was to obey God rather than man. He was excommunicated; but he and his Poor Men continued to preach, accepting as true only what they found in the Bible. Persecuted, they sought refuge in the high Alpine valleys of Savoy and Piedmont. The extraordinary thing about the Waldenses is their survival. There is a Waldensian church in New York, and colonies in North Carolina, Argentina, and Uruguay.

The Waldenses were evangelical Christians; their contemporaries the Cathari, or the "Pure," were unmistakably heretics. Their beliefs derived originally from Persian Manichaeism, much modified by Greek gnosticism. The doctrine was dualistic: the Cathari believed that an everlasting war of good and evil is fought in our world, with the adversaries almost evenly matched. The good is spirit, represented by Christ; the evil is matter, the flesh, the property of the devil. The chief weapon of Satan is sexual desire. Marriage is regularized sin; and all that is born of the flesh is to be abjured, including meat and eggs. All bloodshed is wicked, whether performed by a soldier or decreed by a judge. Since nothing worse can be conceived than this world of ours, there is no purgatory and no hell. The body will not be resurrected; the pure soul will be joined with the celestial body, the impure will be reincarnated in animal form. The Cathari's horror of sex gave the orthodox excellent means of detection. The English monk Gervase of Tilbury tried to seduce a girl in a vineyard near Reims. She thrust him back, saying: "If I should lose my virginity, without doubt I should be everlastingly damned." He recognized from these words that she belonged to the impious sect. He denounced her; she was arrested and tried. Refusing to recant, she was burned, "neither sighing nor weeping nor lamenting."

Catharism flourished in Languedoc, under the benevolent eye of Duke Raymond VI of Toulouse. The Cathari preached openly, and even infiltrated high places in the church. Since the city of Albi was the heretic center, the adepts came to be called Albigenses. Orthodox churches stood empty; at one service the bishop of Albi and his chapter found themselves alone in the cathedral.

Stern measures were necessary to suppress the heretics. In 1208 Pope Innocent III proclaimed a crusade. The response was terrific. Crusades to the Holy Land had become very unpopular, offering much hardship and little reward. The Albigensian Crusade, practically at home, promised immense loot in this world and ample indulgences in purgatory. It appealed also to the old hostility of northern France toward the south.

To find and punish the heretics, the Inquisition was finally established in the year 1233, under the direction of the Dominicans. As its name suggests, it was an "inquiry" into men's faith. No one was safe. Even to have saluted a known heretic made one suspect. The accused person was not told the name of his accusers, who might be notorious perjurers or even murderers. Ignorant of the charges, without counsel, he had to defend himself by guesswork. If obdurate, the accused could be tortured along with any witnesses who favored him. But children below the age of puberty and aged men and women were tortured less severely than the robust.

The Albigensian Crusade succeeded in eliminating heresy. In the process it also wiped out the brilliant troubadour culture of Provence. People sometimes say that ideas cannot be stamped out by force. The Albigensian Crusade proves them wrong. Ideas can be stamped out by the elimination of everyone who holds the ideas. However, this is a very costly process. The Inquisition succeeded in those areas where it operated, but it also did the church immense harm. In the later Middle Ages the church suffered from a dwindling in spirituality and an increase in worldliness, or, to put it baldly, in official greed. During the Hundred Years War the needs of both church and state led to severe exactions on the peasantry. The collection of tithes was often brutal. Tithes took a tenth of all produce, even garden truck and milk. A farmer who deducted his working expenses before tithing damned his soul. Tithes were also an income tax on all personal earnings. Those who withheld something were punished by a "cursing for tithes": "We curse them by the authority of the court of Rome, within and without, sleeping or waking, going and sitting, standing and riding, lying above earth and under earth, speaking and crying and drinking; in wood, in water, in field, in town. Curse them Father and Son and Holy Ghost! Curse them angels and archangels and all the nine orders of heaven . . . the pains of hell be their meed with Judas that betrayed our Lord Jesus Christ, and the life of them be put out of the book of life till they come to amendment with satisfaction made! Fiat, fiat! Amen!" It is as if the Internal Revenue Service held powers of excommunication and eternal punishment.

Eventually the financial exactions of the church embittered the larger public. A sullen anticlericalism spread, aggravated by the failure of the crusades, by an angry conviction that the church had gulled the people, that God had left his soldiers in the lurch. The popular fabliaux, scurrilous comic tales in verse, are filled with mockery of the clergy, as are the songs of the wandering scholars, the Goliards. The clergy burlesqued their own ceremonies. At St. Rémy in France they made a procession to mass on Maundy Thursday, each trailing a herring on a string. The game was to tread on the herring in front and save one's own herring from being trodden. Some districts celebrated a festival of the ass, when an ass, grotesquely dressed, was led to the chancel rail. A cantor chanted a song in praise of the ass, and when he paused all responded: "He haw, Sire Ass. He haw!" On the Feast of Fools, a relic of the Roman Saturnalia, a cleric, elected dominus festi, was baptized with three buckets of water. The University of Paris complained to the king: "Priests and clerks ... dance in the choir dressed as women, or disreputable men, or minstrels. They sing wanton songs. They eat blackpuddings at the altar itself, while the celebrant is saying Mass. They play at dice on the altar. They cense with stinking smoke from the soles of old shoes. They run and leap throughout the church, without a blush at their own shame. Finally they drive about the town and its theatres in shabby carriages and carts, and rouse the laughter of their fellows and the bystanders in infamous performances, with indecent gestures and with scurrilous and unchaste words."

Disrespect for the church was rife. Citizens of Perugia burned the pope and cardinals in effigy. The excommunicated ruler of the Italian town of Forlì in his turn excommunicated the pope and curia, remarking: "Well, we are excommunicated, but for all that our bread, our meat, and our wine will taste just as good." Robbers broke into churches, stole the sacred vessels, made gowns for their doxies from altar cloths. In England citizens, incensed at financial exactions, fired and plundered abbeys. From this later period date the rubicund, wine-bibbing monks and jolly friars of persistent legend.

If one concentrates on the church's shortcomings, which are after all more striking and diverting than its quiet labors, one sees it as smug and somnolent, content with its daily routine, unadventurous. Nevertheless, the church continued to inspire its adepts with conscientious zeal. Many poor parsons, unregarded and unrecorded, did more than their duty to their parishes; many served knowledge and wisdom in school and scriptorium; many were vouchsafed moments of mystic illumination; many, by holy living and holy dying, preserved a model of Christian character—humble, chaste, obedient, charitable, filled with the consciousness of God and abounding in love.

VI Towns and Trade

The small but prosperous French town of Feurs is portrayed in this illustration as it appeared in the fifteenth century.

he manorial system, widespread in the West from Charlemagne's time onward, was not at first favorable to the development of agriculture and commerce. Manors tended to be self-sufficient; the economy was closed. People lived in their small world, in constant fear of the strange world beyond, from which came only evil. The best they could hope for was to endure; and they endured.

In the eleventh and following centuries things took a turn for the better. Life became more stable; population increased; new lands were brought under cultivation and old lands rendered more productive. New agricultural techniques were introduced. The power of legumes to nourish and revive exhausted soils was recognized, and the science of manuring developed—marl and ashes being employed in combination with animal manures. The quality of herds was improved by selection and crossbreeding. Flowing water was put to work, operating gristmills and providing power for forges. Windmills whirled on plains and uplands, and men even attempted, with some success, to construct tidal mills.

Wasteland, forest, scrub, and marsh were subdued by the plow. The English, French, and German countryside assumed the appearance it more or less has today. In the Po Valley the Alpine waters were tamed with the construction of impressive embankments, dams, reservoirs, and canals. Spain restored its ancient Roman irrigation systems. In the Low Countries the sea had stolen a large share of the best land in the years between 1000 and 1200 to create the Zuider Zee. In one of the most momentous engineering feats of history, princes, monks, burghers, and peasants joined to build the Golden Wall, extending from Flanders to Frisia, its great stones shipped to the Lowlands from Scandinavia and Germany. Dikes were built, and the polders behind them were purified with the aid of hand pumps and drainage canals. The work lasted for centuries; by the time it was over, land comprising half of the modern Netherlands and some share of Belgium had risen from the sea.

Trade revived, though it had never entirely disappeared, even in the darkest days. Venice built up a considerable seaborne commerce, supplying Constantinople with wheat, timber, salt, and wines, and bringing back Eastern luxuries. Constantinople also received furs, honey, wax, amber, hunting hawks, and slaves, from the far north, transported along the Russian rivers and across the Black Sea. Scandinavia sent its fish, timber, and furs to the West as well as to the East; Scandinavian products traveled by sea to Flanders, where they were exchanged for manufactured cloth. The difficulties of trade were great: journeys were costly and dangerous, currency was scarce and unreliable, and systems of distribution were undeveloped. But the profits could also be great, and brave men gambled that fortune or a kindly saint would bring them reward instead of disaster. The Continent wanted English tin and wool; England wanted German silver, Flemish cloth, and Italian luxury goods; everyone in the north wanted wine, a prestige drink with triple the alcoholic content of ale and beer. (The church stimulated trade in wine, by requiring its use in the Eucharist, and in olive oil, which was also obligatory for sacramental use.)

A new class appeared on the edge of feudal society: the merchants. Probably they originated among the landless men, escaped serfs, casual harvest laborers, beggars, and outlaws. The bold and resourceful among them, the fair talkers, quick with languages, ready to fight or cheat, became chapmen or peddlers, carrying their wares to remote hamlets. They were paid in pennies and farthings and in portable local products, such as beeswax, rabbit fur, goose quills, and sheepskins for making parchment. If they prospered, they could settle in a center and hire others to tramp the forest paths. Such was the career of the English Godric of Finchale, who rose from peddling to be a shipowner and entrepreneur, who journeyed to Denmark and Rome, and who ended by reforming and becoming a hermit and saint.

The merchants made the towns. They needed walls and wall builders, warehouses and guards, artisans to manufacture their trade goods, caskmakers, cart builders, smiths, shipwrights and sailors, soldiers and muleteers. They needed farmers and herdsmen outside the walls to feed them; and bakers, brewers, and butchers within. They bought the privilege of selfgovernment, substituting a money economy for one based on land, and thus they were likely to oppose the local lordling and become supporters of his distant superior, the king. Towns recruited manpower by offering freedom to any serf who would live within their walls for a year and a day. "Town air makes men free," the citizens said. Thus arose the bourgeoisie, proud, rich, energetic, and contemptuous of the feudal world that surrounded them.

The merchants dealt in anything that might turn a profit. Under public and clerical disapproval the slave trade had almost disappeared in western Europe, but still Venice and Genoa bought children in Russia and shipped them to Spain or the lands of Islam. The French, Spaniards, Swedes, and Germans mined iron; the English, tin; the Germans and Italians, lead and copper; the Germans and Austrians, zinc. The demand for gold and silver spurred geological exploration. English coal, unexploited since Roman days, was sent by ship from Newcastle to London, France, and Germany; hence it came to be known as sea coal. Salt, in short supply in the north, was brought by sea from salt beds in southwestern France and elsewhere, where the tidewater could be easily trapped under a burning sun. The fisheries demanded immense quantities for preserving herring and cod, the common food of common folk. (Since fish were not gutted before salting until the fourteenth century, many people preferred in place of salted fish, stockfish-cod, haddock, or such, which were split and then sun-dried without salt. The cook, on the other hand, had to pound stockfish for an hour with a hammer to make it edible.) Salmon, sardines, lampreys, whales, and dolphins were pursued in the northern seas; tunnies, in the Mediterranean. Freshwater fish and toothsome eels were usually reserved for the gentry and clergy.

As transportation became cheaper and more efficient, foods began to travel. England exported fish, cheese, and ale, and imported dried figs, dates, raisins, olive oil, almonds, and southern fruits, such as oranges and lemons, which were highly perishable and regarded as great luxuries. Provence and Spain had factories for making sugar, syrups, and preserved fruits, mainly for export. Italy produced pies, pizza perhaps, and sea biscuits to send abroad. The wine business was colossal. England imported from Bordeaux great quantities of wine, in casks, skins, or "hoses," leather receptacles that were shaped like a human leg.

The great international commerce was in textiles. The wool that was most prized came from England. Much of it went directly to Flanders for processing. The wool trade brought great prosperity to the English; the Lord High Chancellor in the House of Lords still sits on a woolsack, which symbolizes the nation's wealth. In both Flanders and England the wool was spun with spindle and distaff by women spinsters. Spinning was considered to be women's proper work; even at the world's beginning Adam delved and Eve span. The spinning wheel, probably an Indian invention, did not appear in the West until the thirteenth century, and then came quickly into general use. Once spun, the yarn went to weavers, who worked at home or in shops in the towns. Often two weavers sat side by side at a broad double loom, weaving "broadcloths." Next, the woven wool went to fullers, or walkers, who stamped on the cloth, shrank and compacted it, and removed grease with fuller's earth. Water-powered fulling mills, with tireless hammers, eventually replaced the stamping walkers. (The importance of the cloth trade is evidenced by the number of people named Weaver, Fuller, and Walker today; but for obvious reasons there are no Spinsters.) The material went then to the dyers; to fix the colors and give them brilliancy, alum was required, which came chiefly from the Aegean islands and was for centuries a Genoese monopoly. Finally the cloth was shipped to market by sea or in bulging bales on the backs of pack mules.

Italy as well as Flanders had a great garment trade. In Florence in 1306 there were three hundred workshops, with a gross revenue of a million florins. Their superb robes and gowns were frequently shipped to England, whence the wool had originally come. In 1391 a manufacturer in Bologna built a water-powered mill for spinning silk that is said to have put four thousand laborers out of work. Though one must distrust all medieval statistics, it is evident that technological unemployment is not new to our age.

Glassmaking was an ancient trade that had never been completely forgotten. Stained-glass windows began appearing in churches early in the twelfth century; a century later, alchemists used glass vessels, and in the fourteenth century the use of glass windows in houses became common. The Arabs made lenses in the eleventh century, and spectacles were introduced to Europe at the end of the thirteenth. Glass cups and household vessels were rarities until much later. Venice was the great producer of glass, but transport risks restricted its widespread use until local

The commercial life of the Grand Pont, the main bridge of medieval Paris, is seen in these two fourteenth-century illustrations. At top, a herd of sheep and a pig are brought to market; the melons arrive by boat. Below, another boat delivers a load of grain to the bridge's gristmills.

factories were established for its production throughout the West.

Many other industrial shops were set up during these years to make tile and brick, church bells, tanned leather, weapons, soap, paper, ink, paints, and varnish. Potteries naturally were widespread. They employed tools, designs, and methods that had not changed for millenniums and are still used today. But in many cases new needs and a new spirit of enterprise enabled people to break through the limits imposed by the old technology. Someone combined the crank-known since antiquitywith a connecting rod, thus enabling people to convert rotary motion into reciprocal motion and vice versa. This made possible the operation of many mills and factories. In the early days many tools were made of wood and were limited in strength and accuracy and subject to rapid wear. The use of steel for toolmaking made it possible to build a simple lathe and a screw for boring pump barrels and water pipes from solid tree trunks. The brace and bit replaced the bow drill, which had been in use since prehistoric times. At the end of the twelfth century William of Sens, architect of Canterbury Cathedral, constructed novel devices for loading and unloading ships and for hauling stones and cement. Albertus Magnus, in the thirteenth century, invented a blower for fires that was operated by steam. Since it was shaped like a human head, he and others were accused of possessing familiars that whispered secrets to them. Maybe they did; maybe they whispered the secret of steam power. And let us not overlook that pioneer of aviation Oliver of Malmesbury, who in 1065 made a glider on which he launched himself from a church tower. He was discouraged by the breaking of both his legs.

Technology came to the aid of seaborne commerce. The sternpost rudder, replacing the great steerboard or starboard hung overside, made it possible to construct large ships with a wide spread of sail. Maps and portolanos, or harbor charts, became available. The compass, originating, like so much else, in ingenious China, came into general use in the thirteenth century, and the astrolabe and quadrant somewhat later. Shipmasters were thus emboldened to affront the open sea.

When economics and politics permitted, international trade could now prosper. Venetian ships carried pilgrims, horses, iron, and timber to Palestine and brought back Eastern luxuries. Venetian merchants set up trading posts on the Black Sea, and some, like Marco Polo, went overland to China by the Great Silk Road, over the frozen plateau of Tibet and through the burning desert. Others made their way to China and India on Arab vessels. There were apparently a good number of Venetian businessmen living on the China coast. They were remarkable men, these merchants, willing to freeze and starve, ready to fight, to help a sailor at his tasks, to medicine a horse, to haggle in many tongues, fortified by their knowledge of materials, costs, and the state of European markets.

In the Mediterranean the Venetians, Genoese, and Pisans, not content with their Eastern trade, looked toward the beckoning West. By the end of the thirteenth century Genoa had organized a fleet that sailed annually for Flanders and England, and Venice soon followed its lead. The Atlantic route must have been opened even earlier, for Abbot Suger, describing the rebuilding of the abbey church of St. Denis about 1145, says that marble columns could be brought by sea from Rome and up the Seine to Paris.

Prudent shipmasters liked to keep close to the shore, to seek harbors for the night unless landward winds threatened, when the only safety lay on the open seas. Nevertheless, the Canary Islands and the Azores were discovered, or rediscovered, in the fourteenth century, probably by storm-driven sailors. At the same time Norman seamen were trading to the Ivory Coast and the Gold Coast, and by 1412 Englishmen were fishing off Iceland.

Oceangoing ships to carry heavy cargo—timber, salt, grain were broad, single-masted, and slow sailing. A large ship could carry a thousand tons of cargo, and a crusaders' transport could accommodate more than a thousand passengers with their equipment. The Venetians and Byzantines preferred to use oared galleys. These were speedy, making their way in calms and doldrums; but they were unmanageable in high seas, and they required a very large crew, sometimes more than two hundred men. In the fourteenth century a compromise model was developed, carrying sails, with oars for auxiliary power.

The profits of a long voyage might be large, but so were the chances of disaster, as the Merchant of Venice well knew. Capitalists therefore pooled their risks, forming companies to share profits and insure the craft and cargo against loss. Piracy was rife, both Saracen and Christian, and sailors often had to wield sword and ax. Chaucer's Devonshire Shipman, who knew every haven and estuary from Gotland to Spain, had no nice conscience; in any maritime controversy he drowned his adversaries if he could. The perils of shipwreck were aggravated along the English coast by the common law, which decreed that a wrecked vessel was forfeited to any finders unless a man or even a cat should escape alive. (All merchantmen were required to carry cats as rat killers.) Hence shore dwellers were very strongly tempted to make sure that no man or cat should escape from a wreck alive.

In general the overland trade routes followed the old Roman roads, whose stone pavements still serve the traveler here and there. The heaviest traffic was north-south, from France along the Riviera to Italy or on narrow zigzag mule tracks over Alpine passes, especially the St. Bernard, the Mont Cenis, and the Brenner. The St. Gothard route was opened early in the thirteenth century, with the construction of a sensational suspension bridge, the first in Europe.

With some exceptions, the roads were in deplorable state. Although landholders were concerned with maintaining local market-roads, and merchant companies, pious fraternities, and municipal and royal governments attempted to repair the main highways, the stone-paved Roman roads, made for marching men, deteriorated to mere gravel and dirt, easier on the tender feet of horses and pack mules. (The hard-surfaced road was a nineteenth-century introduction.) In wet weather the highways became muddy rivulets, or even rivers. Bridges were sometimes built by royal command or by religious fraternities, with the costs defraved by tolls. Nevertheless, one was often obliged to ford a dangerous stream. Once off the highway the traveler was in real trouble. There were no signposts, since the peasants did not need them, and few could have read them anyway. It was advisable to hire a guide who would know the way and its particular dangers. Our children's fairy tales recall the shuddering plight of the traveler benighted in the dark forest who chooses the wrong turning leading to an ogre's castle, or happily, the right turning toward an enchanted princess.

On the main highways the traffic was very heavy. Some historians assert that there was more displacement of persons in the

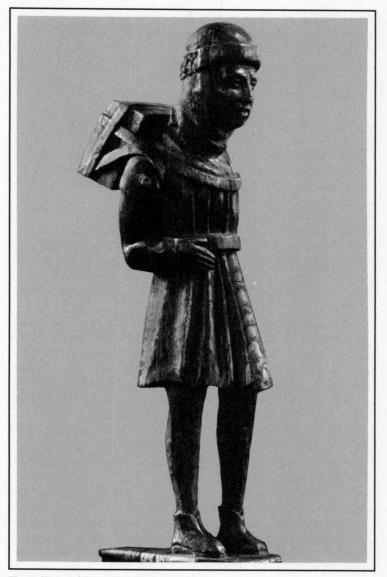

Traveling with packs of merchandise strapped onto their backs, peddlers, like the one in this wood carving, were a common sight on the roads of medieval Europe.

Middle Ages than there was in the settled village society of the nineteenth century. Everyone was on the roads: monks and nuns on errands for their community; bishops bound for Rome or making a parochial visitation; wandering students; singing pilgrims following their priests and their banners; papal postmen; minstrels, quacks, and drug sellers; chapmen and tinkers; seasonal workmen and serfs out of bond; discharged soldiers, beggars, and highwaymen; and sheep and cattle on their way to market, befouling the already foul highway. The gentry and the well-to-do traveled on horseback, caring for their own mounts or hiring fresh horses at relay stations. Everyone else went afoot, bespattered by the mounted men and scuffing through horse and mule droppings. Only rarely did one meet an oxdrawn cart carrying timber or stone for a castle, or lead for a church roof. The cost of heavy transport was prohibitive; it was reckoned that carting stone a dozen miles was as expensive as quarrying it, that the timber for Beauvais Cathedral cost four times as much to move as to fell. But as time went on and main roads improved, light horse-drawn carts began to replace pack animals.

Merchants traveled by preference in convoys or caravans, "with sword on saddle," according to an ordinance of the Emperor Frederick Barbarossa. They led a long train of pack animals, which were tended by hostlers and muleteers; it took about seventy beasts to carry the contents of a modern ten-ton truck. At night the party camped by the roadside while the animals grazed. A spirit of rollicking comradeship pervaded the expedition; the chief and his "brothers" were bound by an oath of fellowship, and on their return home they would often form a guild and meet to recall their hardships and adventures to the clink of cannikins.

On the highway all movement ceased at sunset. Gentlemen would seek out a castle nearby, where they were entertained, though sometimes with reluctance. Commoners found inns, notorious for their crowding, discomfort, dreadful food, and vermin. The poor were sheltered in the guesthouses of monasteries; the poorest—outcasts and outlaws—slept under the stars or the rain.

Although there were some attempts to establish postal service, generally one had to rely on couriers to carry letters. Petrarch sometimes kept his letters more than a year, waiting for a cleric or a merchant bound for the recipient's town. These men would carry a letter or a small package, for which they usually charged a fee. News was spread mostly by chance encounters and recorded also by chance. This is one reason why medieval facts and dates are often vague.

A mounted convoy or a good walker would cover from twenty to twenty-five miles a day, and travelers in a hurry could go twice as fast. In 1188 a courier brought a bull from Rome to Canterbury, covering about 1,200 miles, with twenty-five days to cross the Channel, and in 1316 news of Pope John XXII's election was carried over 800 miles, from Lyons to York, in ten days.

The security of the roads varied much, depending on the character and authority of the ruler through whose territory they passed. In general it was in the interest of the local lord to protect travelers, especially merchants, and draw a regular revenue from the tolls they paid. However, there are innumerable reports of robber barons and of highwaymen turning a quick and bloody profit. And, of course, war let loose official and semiofficial plunderers. In some regions the traveler also had to fear wild beasts. Boccaccio's characters were terrified of wolves and bears in the woods, only a few miles from Rome.

The merchants' usual destination was a trade fair. Most famous were the fairs held annually, in sequence, in the small cities of Champagne, where roads from all lands of Europe crossed. During the fairs the counts of Champagne guaranteed the merchants protection, and the church suspended regulations against usury, imposing maximum rates of interest. There was a twelve-day cloth fair, an eight-day leather, hide, and fur fair as well as fairs for the exchange of other products. Merchants of all countries transacted their business, and neighboring lords sent their stewards to buy a year's supply of weapons, textiles, spices, sugar. For amusement there were gambling taverns and primitive nightclubs, with even more primitive floor shows. Disputes were settled in special commercial courts, piepowder courts-for commercial travelers were called pieds poudreux. "dusty feet." Because of the variations and scarcity of cash. accounts were kept in the local currency, the silver livre of Troyes and Provins. At the fair's end a kind of clearinghouse operation was held, which often called for loans and credits from the money changers, or "bankers," so called from the

banks or benches on which they laid out their coins. (A "broker" was one who broached a cask of wine for sampling. And on this theme, *cheap*, as in Eastcheap, the London marketplace, was the English word for *market*, and *bon marché* was "goodcheap," or a bargain.)

With time the fairs and their traveling merchants yielded in importance to the great commercial cities, with their warehouses and permanent stocks. The merchant ceased to be a bold wavfaring adventurer and turned sedentary. He and his fellows formed a class at odds with the seignorial or clerical masters of the countryside. Greatest of the businessmen's cities were the communes of northern Italy. The Lombard and Tuscan communes, such as Milan, Florence, Siena, Bologna, were manufacturing and trading cities, associating all citizens, noble and plebeian, for defense, offense, and the pursuit of wealth. For their own support and protection these cities continually sought to expand. They were constantly at war with one another as well as with emperors and popes. Their magnificence dazzled visitors from the rude West. The Venetian republic, half embarked upon the Adriatic, waged war and made its own foreign policy with regard only to profit. It was a genuine city-state of the old Greek type. Genoa and Pisa were also great maritime cities, controlling Corsica and Sardinia, dominating the western Mediterranean, and sending merchant fleets to the Levant and southern Russia as well as to England and Flanders.

In the north famous commercial cities, such as Ghent, Bruges, Arras, and Cambrai, flourished in Flanders and neighboring Picardy. They had their guaranteed liberties, often gained and preserved by force of arms. The merchant guilds controlled municipal governments with little interference from king, bishop, or local lord. Artisans also had their rights, and serfdom disappeared. These cities had their own court system, which required proof based on the testimony of witnesses; to the businessmen the feudal principle of appeal to divine justice by means of a judicial duel or ordeal seemed absurd. Punishments for crimes against property were harsh and often picturesque, like nailing a thief's ear to a cartwheel, which was then set rolling. The great prosperity of these cities encouraged public works; roads, canals, and markets were built, and splendid guildhalls,

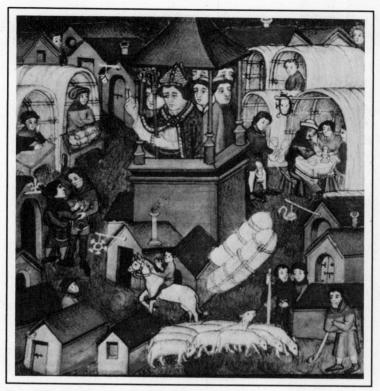

From all over Europe and the East, caravans of merchants converged on the great fairs. They brought so much wealth that both church and state granted the travelers special protection and privileges. The Lendit fair was held every year in June in a field just outside Paris. The bishop of Paris, who is seen here giving the fair his blessing, helped to increase attendance by exhibiting a piece of the True Cross. the delight and wonder of modern architects.

Paris, the natural commercial center of France, boomed. It was not, however, a free city, nor was it totally given to business, being dominated by the royal government, the church, and the university. In England all roads led to London. Its population is estimated at about 30,000 at a time when Venice, Milan, and Paris had over 100,000. In Spain Barcelona became very important, controlling inland trade and sending its fleets throughout the Mediterranean.

The case of Germany was special. Most of its large cities became self-governing in the twelfth century. But instead of competing fiercely among themselves as the Italian cities did, they eventually united in leagues, of which the most famous are the Hanseatic and the Swabian. The Hanse merchants of Lübeck and other northern seaboard cities developed overland routes to Italy, but the Hanse's chief business was water-borne. By around 1400 it had offices in one hundred sixty towns, and factories or compounds, with their own docks and warehouses, in London, Bruges, Bergen, and Novgorod. The league held a monopoly on the Norwegian fish trade, exploited Sweden's mineral and agricultural resources, and brought timber, tar, grain, butter, cheese, and bacon to Flanders and England. It dealt in everything, being, like the Hudson's Bay Company or the Dutch East Indies Company of later days, limited only by territory and not by type of merchandise. The league seldom used force to maintain its supremacy. It employed, instead, embargoes, boycotts, and commercial pressures, with which recalcitrant cities and even kings could be subdued. It did go to war, however, with King Waldemar of Denmark in the middle of the fourteenth century, capturing Copenhagen, and with it the monopoly of the Baltic fish trade. The Hanseatic cities loved monopolies, particularly the one that controlled the transport of Flemish cloth to Russia in exchange for furs. This trade promoted a steady infiltration of Russia by German traders and settlers, who penetrated even into the deep interior.

In the West most of the towns developed from episcopal or other church centers, or from burghs or bourgs, walled fortresses. The inhabitants therefore were called burghers or bourgeois. Other towns had their origins in trading settlements situated advantageously where roads met or rivers could be forded or crossed by ferry. These towns began to appear around the millennium, and two centuries later they abounded. Since the feudal system made little provision for trade and industry, the towns had to make their own place in society. Purchasing charters and freedoms from the landholders, they gained territorial immunity and became "legal islands" and sanctuaries. They did obeisance only to the king, and that with qualifications. Avignon, in a treaty of 1208, declared that it obeyed no one but God. The towns raised their own militia and spent about eighty percent of their revenues for defense—walls, moats, armaments. When night fell the burghers locked their gates and slept secure.

Kings and nobles came to recognize the profits in city realestate development and founded "New Towns" in their own territories, and especially in the wild borderlands of eastern Germany. They tempted settlers with promises of freedoms, tax exemptions, cheap land, and low rents. Their recruiting methods resemble exactly those of the big operators who, in the nineteenth century, transported whole provincial populations from Europe to the American West. These new towns, *villes neuves* or *bastides*, fascinate modern city planners, being laid out rationally, with streets on a gridiron plan, like Philadelphia, like any New City from Texas to Siberia.

Off the main traffic routes many medieval towns persist today, their spires and fortress towers rising above weedy walls. Unlike modern cities, they take naturally poses of beauty, show colors dimmed to nature's harmony. They rejoice the artist, from the medieval miniaturist to Maxfield Parrish. Apologetic for disturbing old ghosts, we walk the cobbled streets, gaze at the faded pride of their decrepit, nearly empty churches, at the merchants' mansions now serving as rickety inns or garages, at the pathetic pomp of fallen fortunes.

The typical town was a series of concentric rings, each marking a stage of growth. The innermost ring was the original stronghold; the outermost, the defensive walls. Intervening rings showed where walls had once stood, before being dismantled and replaced by boulevards. The plan of Paris today clearly shows the development. When the citizens decided to expand the town and build new walls, they left enough space to accommodate gardens, orchards, and vineyards, as a precaution against siege.

The market square was the town center. Here stood the great church, the town hall, the clock, and the market cross, which reminded the citizens that God was watching to punish any malefactor who might disturb the market's peace. Here too stood often the pillory, stocks, cucking stool for scolding women, gallows, and gibbet. (The Paris gibbet accommodated twenty-four; when a new occupant arrived, an old skeleton was thrown into a nearby charnel pit.) In the square the troops drilled, wandering actors performed, young men played a kind of mass football. This was the business center. Round about was the shopping area, often arcaded. In many towns, especially in Germany, a quarter was walled off for the Jews. This segregation was intended as much to protect as to humiliate them; often it was the rabbi who held the keys.

Each trade might have its separate street—Shoe Lane, Leather Lane—as it still does in Athens and the East. The shops were marked, not by lettered signboards, but by symbols—a barber's basin, a gilded boot, or for a tavern, a bush, though good wine needs no bush. The shops were narrow and deep, with a frontage that might be only six feet wide. Here the workmen plied their trades, where the light was best, where their work could be inspected and admired, and where they could exchange pleasantries with the passersby. (Window workers are now extinct; the last to go were the cigar rollers.) Artisans usually kept no stock; they worked only on orders. They would have been shocked by ready-made shoes and clothes.

The streets, except in the new towns, were narrow, irregular, with unexpected angles that record a householder's successful fight with the municipality. The street level was likely to rise above the house floors, for street repairs were made by dumping sand and gravel on old bases. Hence in many towns one steps down from the street to visit old churches. The streets were made chiefly for pedestrians, not for wheeled traffic. Paving was paid for by tolls imposed on carts entering the town; the tolls were graduated according to the weight and type of vehicle and its presumed injury to pavements, as our motorcar registration fees are. The highest rate was paid by carts with iron-rimmed or nail-studded wheels. The parking problem on market days was acute.

Houses were built flush with the street or overhanging it, marking the triumph of the owner over the general good. Building styles varied with local materials and conventions. In England and the north, houses were mostly of wood, with

The feudalism of the Middle Ages gradually began to change as towns grew and their new economies prospered. Medieval merchants began to discover their strength. A lively street of business is depicted in this French town scene from a manuscript. At work in their shops are, from left to right, the tailors, the furriers, the barber, and the grocer. thatched roofs that were very flammable. The frequent fires in London led, in time, to reconstruction, with tiled roofs and stone party-walls. Every burgher was enjoined to keep tubs of water ready. The city supplied hooks to pull burning thatch into the street, hence our hook-and-ladder companies. A common cause of fire was the custom of sleeping on straw mattresses beside the hearth. On the other hand, the times were spared the hazards of cigarettes and electrical wiring.

In the early centuries the houses had considerable yard and garden space in the rear, enough for maintaining a cow and a few pigs. But as the cities grew within their constricting walls, this open space was much encroached upon. The houses lacked air, light, and *confort moderne*; but people had little taste for privacy. They lived most of their lives on the streets, noisy indeed by day with pounding hammers, screaming saws, clattering wooden shoes, street cries of vendors of goods and services, and the hand bells of pietists summoning all to pray for the souls of the dead.

But at night reigned a blessed silence, broken only by the watchman rattling his iron-shod staff and crying, "All's well!" Nightwalking was prohibited after curfew, at about nine o'clock, as presumptive of ill-doing. There were, of course, no street lights or illuminated shop fronts.

Men met in taverns; women had their social hour when they fetched water from the public fountains, which, as in Perugia, could be the city's pride. All progressive cities had a municipal water system, but it was advisable not to drink the water straight. City water fed public bathhouses, which included sweat baths.

Efforts toward municipal hygiene could not prevail against old custom, which ruled that the street before a man's house was part of his domain. (A relic of this custom is the sidewalk café, which in Mediterranean lands may expand halfway across the road.) The medieval streets were unquestionably foul. Butchers slaughtered animals at their shop fronts and let the blood run into the gutters. Poulterers flung chicken heads and feathers into the streets. Dyers released noisome waters from their vats. City officials in Italy would throw the fishmonger's unsold fish into the street for the poor, to make sure it would not sicken honest purchasers. Pigs ran free as scavengers, and in London "genteel dogs," though not commoners' dogs, were allowed to roam at will. Flies settled down in clouds to their banquets, but few, besides Petrarch, complained. The walker, perhaps with a perfumed handkerchief to his nose, picked his way carefully, dodging the black mud thrown up by the squash of horses' hooves. And there was always a menace from overhead. Louis IX of France, Saint Louis, received the contents of a dumped chamber pot on his royal cloak. He dismounted and ran to the culprit's lair, finding him to be a student who had risen early to study. The king gave him a scholarship. (The king, of course, was a saint.)

Sewage disposal was an impossible problem. Only the big cities had sewers, which emptied into rivers below the laundry area. At Strasbourg malefactors were ducked where the sewer joined the river. Pollution of the streams became a serious concern; everyone agreed that something should be done about it. Street cleaning and the removal of wastes to rural dumps were usually left to individual householders, who were apt to toss their refuse over the city walls or abandon it just outside the gates. On the other hand, in a well-policed city like Paris the garbage man, "Maistre Fifi," called regularly. In The City in History Lewis Mumford points out that in the early Middle Ages, with a good deal of open land behind the houses and privies in the gardens, conditions could be as cleanly as in the idyllic American small town of the 1890s. The wastes were mostly organic matter, not tin cans, glass, and plastic; they decomposed, and enriched the soil. Mr. Mumford, who frowns upon modernity, even celebrates the remembered smells of horse and cow dung. "Is the reek of gasoline exhaust, the sour smell of a subway crowd, the pervasive odor of a garbage dump, the sulphurous fumes of a chemical works, the carbolated rankness of a public lavatory, for that matter the chlorinated exudation from a glass of ordinary drinking water more gratifying? Even . in the matter of smells, sweetness is not entirely on the side of the modern town; but since the smells are our smells, many of us blandly fail to notice them." True, but we should certainly have disliked their smells, and there is overwhelming evidence that they disliked them too. Some used a deodorizing charcoal in the privies. Edward III of England said that the York stink was worse than that of any other town he had smelled. Henry III's asthmatic Queen Eleanor was driven from Nottingham by coal fumes. In Westminster Palace the garbage was carried out

from the royal kitchen through the palace halls. It made the courtiers sick; and in 1260 an outlet was built in the kitchen.

The cities, fair or foul, were the natural habitat of the bour-L geoisie. Merchants or sons of merchants, an oligarchy of competence, they were forced to organize their agglomerations. They created from nothing a system of municipal administration for free men living crowded together. They elected their own town officials, mayor, and aldermen. (Aldermen are "elder men." They met at a dinner table, a board; hence the board of aldermen.) The educated bourgeoisie infiltrated the officeholding class, providing many lawyers, notaries, and accountants. Their power and abilities were recognized by kings, whom they entertained at dinner. In 1190 Philip Augustus of France took the unprecedented step of appointing six bourgeois to the council of regency during his absence on crusade. The bourgeois had a strong civic sentiment, which could expand, in time, to become a national sentiment, or patriotism. They had their own moral code of behavior, exalting both personal and business virtue. The idea gained ground that ability is measured by wealth, that the rich are the best and wisest men, and the poor are the worst.

The chief organization of medieval economy was the guild. The origins of the guild have been traced back to primitive Germanic and religious brotherhoods. The word first appears in Charlemagne's decrees. In Anglo-Saxon England the guilds, religious associations of men with similar mercantile interests, were established to provide mutual aid, protection, and good times.

At first there was one guild to a town, but as population grew and interests diverged, the guilds divided vertically and horizontally. Vertically they divided into the merchant-owners and the workers, employers and employees, rich and poor. Horizontally the original guild divided into craft guilds, each representing a particular trade. The craft guilds tended to subdivide. In England it took three craftsmen to make a knife: a bladesmith, a cutler for the handle and fitments, and a sheather. The purpose of the craft guild, like any trade union, was to promote the economic welfare of its members and guarantee full employment at high wages by restricting membership. It held a local monopoly of its product, discouraged competition among guildsmen, and suppressed scab labor. It regulated work procedures and hours of labor. It set wages, but maximum, not minimum wages. It standardized the quality and price of the product and opposed innovation. It forbade price cutting, overtime work, public advertising, overenergetic salesmanship, the introduction of new tools, the employment of one's wife or underage children. The guild's aim was regularization, the preservation of the status quo. Hence it failed to adjust to technological progress, which took place outside the guilds.

The craft guilds promoted discipline and solidarity among their members. Guilds owned property, had their own chapels in churches, contributed stained-glass windows to cathedrals. They cared for destitute members and for widows and orphans. They presented mystery plays; the plasterers staged the building of the ark; the wine dealers, the marriage at Cana; the fishmongers, Jonah and the whale and the miraculous draft of fishes; the bakers, the Last Supper. Even thieves, beggars, and vagabonds formed trade association in imitation of the guilds.

The vertical division within the guilds tended to diminish craft solidarity. Big business, or capitalism, was on the side of progress, favoring labor-saving inventions, cutting labor costs, importing cheap goods when available. The rich had separate interests from the poor and were tempted to exploit the rank and file. Hence industrial and social crises occurred. By the fifteenth century the scission was complete between those who could afford the rich, furred liveries of their companies and those who could not. So it is still. The livery companies of the city of London meet, magnificently robed, in their ancient guildhall to elect their lord mayor—whose functions consist only of ceremony and display—and to dine superbly well. They are the prosperous businessmen of the city, who have lost touch with their nominal trades. At this writing only one member of the Cordwainers' Company is in the leather business.

The moneymen invented the techniques of modern business. Double-entry bookkeeping was perfected in Florence in the fourteenth century, and remained unchanged till the twentieth. The burghers speculated in urban real estate and in the variation of prices on world markets. Rejecting the prevailing theory that every article had its "just" price, reckoned on costs plus a reasonable profit, they based prices on supply and demand. They formed "companies," or associations of investors, who shared profits and risks. They revolutionized the concept of money and credit.

In the early days money was represented by silver coins, always in short supply and subject to clipping and debasement. (In 1125 Henry I of England found ninety-four of his ninetyseven monevers, or mint officers, guilty of debasing the coinage; he had ninety-four hands chopped off and nailed to the exowners' office doors.) Coins were dangerous to transport and very heavy. The English pound was a pound weight of silver. In 1242 Henry III carried with him on a French campaign thirty barrels of money, each containing 16,000 silver pennies. The cash economy, generally current in the thirteenth century, developed into a credit economy. This depended on the existence of rich, permanent, trustworthy groups or banks that could deal in money, make loans against security, and exchange, for a commission, letters of credit that would be honored by associates in any commercial city. The system originated among the Arabs and the Byzantines; it was brought to a high point of efficiency by the Italians-Lombards, Venetians, and Florentines.

The business world would look familiar to a modern banker. Individuals and groups, especially Italian family groups, lent money to monarchs, monasteries, and lords against expectations of future income. Industrial loans were made for production purposes. King John of England used letters of credit to equip his envoys to Rome. A crusader could buy in London a draft on Acre, thus avoiding the burden and danger of carrying gold. Once disembarked, he would go to the Acre correspondent, who was informed of the draft by letter, and draw his money. Joint-stock operations began in Genoa in the fourteenth century. Insurance, especially marine insurance, was practiced; also reinsurance, or the subdivision of the insurer's risks.

Financial operations could be risky. Edward III of England raised money by issuing a short-term government bond, signed by him. He borrowed, exerting pressure, some 1,400,000 pounds from the great Bardi and Peruzzi houses of Florence. He then declared himself bankrupt, and the Bardi and Peruzzi were forced to do the same.

Interest rates could be terrific, as high as one hundred percent for a loan to an abbey in shaky financial state. On the other hand, the rate could drop as low as five percent. The normal is said to be around ten percent. This is not bad if one considers the risks of shipwreck, banditry, mortality, and repudiation. The church, on Scriptural authority, condemned all moneylending as usury; but clever canonists were able to prove that interest, properly regarded, is not interest but a service fee, an expense item, a penalty. The popes themselves did not disdain to borrow.

The power of the businessmen has a curious exemplification. The year began at Easter, anywhere from March 22 to April 25. This made an intolerable calendar for merchants, who required fixed dates for contracts and loans. For the beginning of their year they chose the minor Feast of the Circumcision, January 1, the date on which the Romans had also inaugurated their year. Business practice was transformed by the introduction of Arabic numerals, with the invaluable zero. (Try multiplying CCCLXXXVIII by XLIX without mental substitution.) The Arabic system was introduced into the West in the twelfth century; it immediately conquered the commercial world.

At the lower level the little people could pawn their household goods and borrow money from Italians, Cahorsins, or men of Cahors in France, and Jews. Small debtors had to pay dearly; the standard rate was forty-three and one-half percent. But the risks were also high, and enforcement of loan payments by the courts was difficult, if not impossible. The Jews, regarded as fair game by the general public, suffered most. Nevertheless, they prospered, through intelligence and astuteness and because authorities found them useful. Their personal relations throughout Europe and their clan-consciousness were of great advantage. "So long as Isaac of York trusted his brother Jacob of Marseilles," one historian has written, "and both of them trusted their cousin Joseph of Jerusalem, all three stood to make a profit if the clergy of York wanted to import a relic of the Virgin Mary from the Holy Land, or if a Yorkshire baron set off on a crusade. Isaac of York took the clergy's or the baron's silver; Joseph of Jerusalem bought the relic, or paid the baron's expenses when he arrived in the Holy Land. Jacob of Marseilles arranged for the carriage of the relic overland to York, and for the baron's accommodation on a ship clearing from Marseilles for eastern Mediterranean ports."

The Jews paid with humiliation for the right to transact business. They had to wear a visible mark, a yellow patch or a star of David, and a horned cap. At Toulouse they were obliged to

199

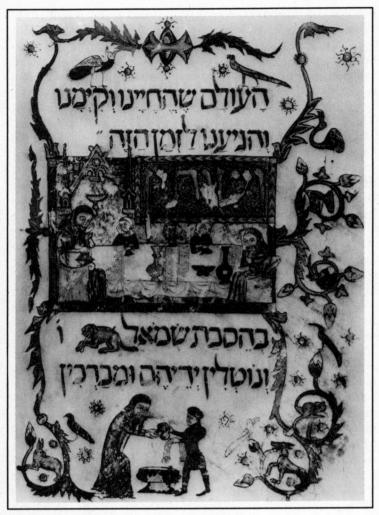

Despite their continuous persecution, Jews maintained their ancient traditions. The Haggadah illustration shown here, depicting a Passover feast, shows Jews looking quite unlike those seen in typical Christian portrayals. In Christian works they were shown as baleful enemies of society. send a representative every Good Friday to the cathedral to receive a resounding box on the ear. At Béziers the mob had the right to stone Jews' houses during Holy Week until the Jewish congregation, in 1160, annulled the right by a money payment. Every Jew passing the tower of Monthéry (which still stands, south of Paris) had to pay a half farthing; if he was carrying a Hebrew book, four farthings. During carnival at Rome the Jews were forced to run in the public lists. No wonder the proud Jewish spirit secreted bitterness enough to last for centuries.

All the business and industrial enterprise of the twelfth and thirteenth centuries suggests the erosion of feudalism, the rising power of money, the coming of capitalism. Medieval capitalism is hard to define; its beginnings are very obscure. Perhaps it dates from the eleventh century in western Europe, when money began to be dissociated from land and was put to work on its own. The means of production came into the hands of private entrepreneurs, who, as in Flanders, supplied the raw materials, supervised the manufacturing, and sold the finished product. The workers tended to become ill-paid employees, dependent on business cycles, theoretically free but living in virtual economic subjection.

"To be a free burgess," said a contemporary poem, "is to be in the best estate of all; they live in a noble manner, wearing lordly garments, having falcons and sparrow-hawks, fine palfreys and fine chargers. When the vassals are obliged to join the host, the burgesses rest in their beds; when the vassals go to be massacred in battle, the burgesses go to picnic by the river." On the other hand, chivalric literature treated burghers as avaricious and mean-minded, in contrast to the nobles, splendidly prodigal of their wealth. More popular writers regarded noble and bourgeois as equally acquisitive.

The bourgeois formed a separate class; in France, the third estate. They had their own traditions, code of behavior, and pride. They treated the nobles with a mingling of scorn, jealousy, and subservience. Especially in the Italian cities they were glad to marry their well-dowered daughters to poor nobles and assure their grandchildren of gentility. The nobles, on their part, despised and envied the burghers, who could often live better than they, who knew how to make their money fructify.

Toward the church-the second estate-the burghers were

both respectful and patronizing. They were pious enough in little things, interspersing crosses, sacred emblems, and prayers in their business accounts. Businessmen commonly opened on their books an account for Messer le Bon Dieu, Messer Domeneddio, or God, Esquire. In case of business failure, God's account was paid first. When a contract was signed, God was called in as witness and received God's penny. Businessmen were lavish in gifts to the church and in the endowments of "chantry priests" to say masses forever for their often bespeckled souls. They made handsome bequests for social services, for small debtors in prison, for lepers in lazar houses, for the mad, "goddes prisoners," in Bedlam (the London asylum of St. Mary of Bethlehem), and for municipal improvements, such as the piping of water to London prisons. It was expected that a proper burgher would leave a third to a half of his movable property for uses that would benefit the public and his own estate in the next world. Now the state takes over such functions by means of inheritance taxes. The judgment of the state is substituted for the decedent's, and the merit of voluntary well-doing is lost.

The church's relations with the burghers were ambivalent. The church disapproved of trading and money getting, which distracts people from their proper aim and leads to usury and other sins. Said Thomas Aquinas: "Business has a certain shameful character." And Gratian, the great canon lawyer: "A merchant can never please God. Or hardly ever." Nevertheless, the church generally protected the merchant, who responded with lavish gifts.

Toward the poor, the burghers' attitude was mixed. Successful men could be very harsh toward the unsuccessful, the shiftless, the dissolute. Yet the burghers felt a certain uneasiness about the distressed, and cautioned executors not to trouble the old and poor in collecting debts. They were taught by the church that the poor were blessed. They were also informed by revivalist preachers that they had offended against God's poor. San Bernardino of Siena told the merchants that the rich gowns of their daughters' dowries were most often "the fruit of robbery and usury, of a peasant's sweat or a widow's blood, of the very marrow of widows and orphans. Were you to take one of these gowns and . . . wring it out, you would see gushing out of it, a human being's blood."

The burghers played the business game hard. Many were

tempted to commercial offenses—fraud, forgery, breach of faith and contract. The petty bourgeois played their petty tricks, passing gilded copper for gold, giving short weight and poor quality, selling shoddy goods in the half-dark by flickering candlelight. A London baker was accused of installing a boy under his counter to reach up through a trapdoor and abstract some of the customers' dough under their very eyes. But the punishments in the merchant-dominated courts were often severe fines, mutilation, or amputation preferred to imprisonment, which was costly to the city.

As with the nobility, financial interest played a large part in marriage, though a fifteenth-century counselor urged a poor, meek wife in preference to a rich one. On the lower levels of bourgeois society a wife might help her husband in the shop and inherit it at his death. In that case she very often married the foreman and carried on the business. At all social levels she was in subjection, to her father, brothers, or husband. In many regions she could not inherit land, make a legal will, or testify in court. She was taught to walk demurely. The fourteenthcentury Ménagier de Paris, who wrote for his young wife a volume of instructions on household management, admonishes her: "As you go, bear your head straight, keep your eyelids lowered and still and look straight before you about four rods ahead and upon the ground, without looking nor turning your gaze upon any man or woman to right or left, nor looking up, nor glancing from place to place, nor laughing, nor stopping to speak to anyone in the road." If she disobeyed, she was well beaten for her good. Another fourteenth-century writer, instructing his maiden daughters, warns them of the fate of a certain disobedient wife. Her husband consulted a surgeon and made a deal for the mending of two broken legs. He then went home and broke both his wife's legs with a pestle, remarking that in the future she wouldn't go far to break his commandment.

However, we have only to recall the Wife of Bath to realize that a bourgeoise could get a great deal of fun out of life. Within her house, at least, she reigned, unless she had an uncommonly fussy husband like the Ménagier de Paris, that Goodman of Paris whose writings are more precious to the historian, perhaps, than they were to the wife.

The burgher's house might be anything from two or three narrow rooms over the shop to one of the haughty mansions

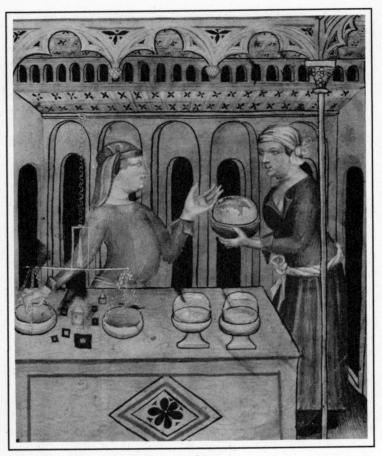

This illustration of a butter merchant displaying his goods is from a series of similar pictures depicting medieval food merchants. Chefs expanded their menus for the well-to-do burghers, whose appetite and life-style changed as their numbers increased and their wealth accumulated. that still stand in old towns of Germany and the Low Countries. As in the noble house, life was lived in the hall and its adjoining kitchen. The whole family was likely to sleep in one bedroom, the servants and apprentices finding place for their pallets where they might. In Chaucer's *Reeve's Tale* the Miller of Trumpington, obviously well-to-do, slept in the single bedroom with his wife, grown-up daughter, baby granddaughter, and two Cambridge undergraduates; from this arose one of the first bedroom farces. Normally the room contained, besides the beds, only the linen chest and a stool or two; but with increasing wealth, the housewife distributed gay cushions about and adorned her walls with hangings in stripes, dots, checks, or floral designs. There were no water closets, but some houses had a garderobe off the bedroom, with a chute to a pit in the cellar.

Fashions in women's clothing varied from year to year and from place to place, as did hair styles. In the prosperous Italian towns during the thirteenth century the women wore false hair, painted and powdered their faces, fasted and laced to improve their figures, wore scandalous décolletages. The church tried to impose the use of neckerchiefs and veils. Says the Franciscan Salimbene: "Women made veils of linen and silk, and drew the eyes of those that saw them still more toward wanton thoughts."

Elegance in dress was expressed more in materials than in cut. Not only the women but their husbands, so many of them in the cloth and garment trade, were connoisseurs of quality. Dress was a status symbol, says the historian Sylvia L. Thrupp: "Although the merchant had the eye of an expert for the intrinsic beauty of the color and texture of cloth, in the imagination of the age scarlet and other bright dyes and the smoothness and sheen of fine fur and the softer materials were associated with power and importance, drab colors and fabrics standing for poverty and insignificance. . . . Fourteenth-century magnates were resplendent in tunics of samite and velvet, silk-lined hoods trimmed with fur or gold-thread embroidery, and outer robes of purple or scarlet or green, furred with ermine, beaver, and marten. Their fingers sparkled with jeweled rings, their silken girdles were set off with taffeta bags and crystal-hafted knives, their hats were fur-trimmed, and their shoes variegated in color. On state occasions, following French fashions, they moved to the musical tinkle of little gold and silver bells sewed about their

hoods and sleeves. Even lesser merchants of the period wore silk, and their best robes were always furred." One may still see this magnificence in the London guildhall, with the lord mayor outshining all.

The merchants were likely to dine very well as merchants have always done everywhere. They had all our familiar meats, and small game in addition. Paris pastry cooks sold waffles, cakes, pies filled with fruit or chopped ham, chicken, eel, or soft cheese and egg, well peppered. In Boccaccio's burlesque Utopia, where they tie the vines with sausages, there is a mountain of grated Parmesan cheese, inhabited by people who do nothing but make macaroni and ravioli, which they cook in chicken broth and toss out for anyone to take. Boccaccio, a fat gourmet, smacks his lips over papardelle, ribbons of meat-seasoned pasta with Parmesan cheese, fritellate sambucate, elderberry pancakes, migliacci bianchi, white black-puddings, and other dishes that seem to be now forgotten. The recipes of the bourgeoisie sound much more tempting than the rich and pretentious meals of the nobility. Here are two examples from Eileen Power's translation of the instruction of the Ménagier de Paris, who undoubtedly had a critical finger in every pie:

"Stuffed Pigling: Let the pig be killed by cutting his throat and scalded in boiling water and then skinned; then take the lean meat and throw away the feet and entrails of the pig and set him to boil in water; and take twenty eggs and boil them hard and chestnuts cooked in water and peeled. Then take the yolks of the eggs, the chestnuts, some fine old cheese and the meat of a cooked leg of pork and chop them up, then bray them with great plenty of saffron and ginger powder mixed with the meat; and if your meat becometh too hard, soften it with yolks of eggs. And open not your pig by the belly but across the shoulders and with the smallest opening you may; then put him on the spit and afterwards put your stuffing into him and sew him up with a big needle; and let him be eaten either with yellow pepper sauce or with cameline [a kind of mustard] in summer.

"Pancakes in the Manner of Tournay: First, it behoves you to have provided yourself with a copper pan holding a quart, whereof the mouth must be no larger than the bottom, or very little more, and let the edge be of the height of four fingerbreadths, or a good three and a half. Item, it behoves to fill it with salt

butter and to melt, skim, and clean this and then pour it into another pan and leave all the salt and some fresh fat, very clean, in equal quantities. Then take eggs...take the whites away from half of them and let the remnant be beaten up, whites and yolks together . . . take the fairest wheaten flour that you can get and beat them together long enough to weary one person or two, and let your paste be neither thin nor thick, but such that it may run gently through a hole the size of a little finger. Then set your butter and fat on the fire together as much of one as of the other, until it boils; then take your paste and fill a bowl or a big spoon of pierced wood and run it slowly into your grease, first in the middle of the pan, then turning it about until your pan be full; and . . . then go on beating your paste without stopping, so as to make more crisps. And this crisp that is in the pan must be lifted with a little spit or skewer, and turned upside down to cook it, then taken out and put on a dish and the next must be begun; and all the time let someone be moving and beating up the paste unceasingly."

To make such appetizing dishes, the medieval cook had to contend with special difficulties. Milk was little used in cooking. Cow's milk was seldom available in winter; this was hard on small children. Animal fat for cooking was in short supply, for it was in great demand to make candles, soap, and axle grease; a pound of fat cost as much as four pounds of lean meat. Hence most food was boiled not fried—probably a good thing. Since there was no refrigeration, one had to be ever on the watch for a fish past its prime or a bad egg. (The young of today have never seen a rotten egg.) Danger lurked in made-up meats. A thirteenth-century Paris preacher tells of a customer who informed his butcher that he should have his sausages cheaper since he had been a faithful client for seven years. The butcher replied: "Seven years! And you're still alive!"

Enough of this. Clearly the medieval burgher led a comfortable and happy life, barring wars, uprisings, epidemics, and accidents. If one could be transported back to the Middle Ages, one might choose not to be a noble, with the burden of supporting one's pride and prestige by incessant battle, public and private. No one in his senses would choose to be a peasant. But the well-to-do burgher had the best of his world, and the best could be very good. The well-to-do always do well.

VII The Life of Labor

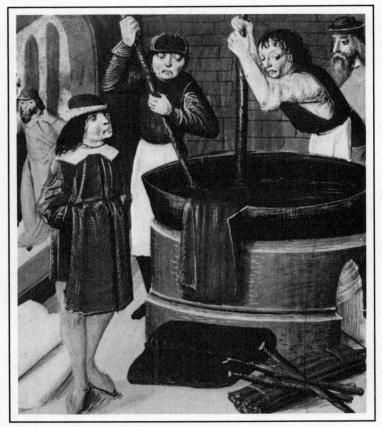

At a medieval dyehouse workers struggle over a hot vat, stirring material through dye. More the feudal system of a grant from a greater lord. The field and the physical form of a manor: a castle or great house and a village or villages surrounded by farmland. The manorial system can be defined as the exploitation of these lands and the government of their inhabitants.

The character of the manor varied greatly during a period of about five hundred years and over a territory extending from the Baltic to the Mediterranean. Even within a limited area, there might be wide divergences, for the nature of the terrain and the "custom of the manor" determined local rights and duties. One can hardly find a single manor at a specific time that can be called typical. However, we are best informed about the manorial system in northern France and in England during the early centuries of this millennium. With those places and times the following pages will chiefly deal.

The manor was divided into two parts: the land granted to the peasants, held and cultivated by them, under the lord's overriding rights; and the demesne, directly owned and exploited by the lord, and worked on a part-time basis by the same peasants. On a small manor the lord might oversee operations in person. On a large estate he would employ as general manager a seneschal, or steward, often a gentleman of his own class, trained as a guardian of noble rights and privileges. "The seneschal," writes the British scholar H. S. Bennett, "must know the size and needs of every manor; how many acres should be plowed and how much seed will be needed. He must know all his bailiffs and reeves, how they conduct the lord's business and how they treat the peasants. He must know exactly how many halfpenny loaves can be made from a quarter of corn, or how many cattle each pasture should support. He must for ever be on the alert lest any of the lord's franchises lapse or are usurped by others. He must think of his lord's needs, both of money and of kind, and see that they are constantly supplied. In short, he must be as all-knowing as he is all-powerful."

209

The seneschal might supervise several estates; he might also be frequently absent on his lord's errands. He would often employ a bailiff, or intendant, as farm manager. The bailiff was chiefly concerned with the lord's demesne. He assigned and supervised tasks, and usually kept the accounts, in Roman numerals and with the aid of tallies, notched sticks that provided him with a comprehensible record. These were often split in two to provide a receipt, which "tallied" when the halves were brought together. The bailiff was a free peasant, rough and tough; to him was ascribed the principle that "the churl like the willow sprouts the better for being cropped." He had many opportunities for small-scale graft; he was checked, however, by the seneschal and by the annual visit of the lord's auditors, if not by conscience.

In England the bailiff often had as his subordinate a reeve, who was himself a peasant. Sometimes he was imposed by the lord as a sort of foreman; usually he was elected by the serfs from their own number as a defender of their interests. He may have descended from the Anglo-Saxon elder, or head man, of a free village. One step down were certain minor agents: the beadle, or constable, who collected rents and fines, issued summonses, evicted delinquents; the hayward, or "hedge warden," chosen by the lord of the manor or elected by the villagers to lead the sowing and harvesting, to impound stray cattle, and to supervise hedging and temporary fencing around the hay meadows. The hayward's symbol of office was a horn, which he blew to give warning that cattle were invading the crops. Little Boy Blue was a hayward.

Within the village, which today looks so uniform with rows of nearly identical houses, a legal and social hierarchy prevailed. At the top was the parish priest, who might be a gentleman, but was most often a peasant among his own kind. He had his own land, the glebe or parson's close, and was often obliged to participate in the village's communal labors. He worked alongside the others, in smock and coarse boots, but he was treated with at least a modicum of respect.

The peasants, the commoners, fell into several groups. The freemen were legally privileged, and in England some of them, the franklins, held a good deal of land and received much consideration. Freemen owned their patches of land, and with the lord's consent, could sell or otherwise dispose of them. They could leave the manor, contract marriage where they pleased, put their sons into the church or send them off to be soldiers. The freeman felt some social superiority to the serf, but he actually possessed little economic superiority. All peasants lived in the same kind of house, wore the same clothes, ate the same food, suffered alike from the caprices of weather and soil.

The serfs were unfree, bound to the manor, but they held guaranteed rights to the land they worked. In England they were called villeins, and if they had a house rather than a cottage, they were termed house-bonds, or husbands. Their normal landholding was a virgate, about thirty acres. Legally they possessed nothing but their bellies-nihil praeter ventrem; all their property was lent to them by the lord, who in theory could sell them with their land, marry them to whom he pleased, separate their families. In practice, however, few lords, in England at least, would risk such highhanded procedures. It was understood that the villein's land was bound to him and he to it. He had no fear of unemployment. The lord's interest was to protect his workers and give them security in their jobs. The serf could, however, gain freedom by purchase, by marrying a free woman, by dispensation to enter the church, or by fleeing from home to live for a year and a day in a principal town or on a royal domain.

Both freemen and serfs supplied the village with specialists. The smith was essential to the economy, as the abundance of his offspring attests. He united physical strength with enterprise and ingenuity. He shod horses, made and repaired plowshares and other farm tools, also nails, knives, hinges, locks and bolts, and sometimes swords and other weapons. The miller, who has also begotten innumerable progeny, might prosper and live at ease, as we may judge from the evidence of surviving mills and from Chaucer's Miller of Trumpington, proud as a peacock, who carried an honorable sword. But millers, like the Miller of Trumpington, were ill regarded and accused of every kind of peculation, of giving short weight and taking an undue proportion of the grain for their pay. "What is the boldest thing in the world?" inquired the peasant in a riddle. "A miller's shirt" was the answer, "for it clasps a thief by the throat daily." The village might also be able to support a full-time or part-time carpenter. a shoemaker, a barber, a tavernkeeper; but there was seldom business for a shopkeeper.

Those who had trades acquired surnames—Shoemaker, Dyer, and so on. In the twelfth century family names became general and inheritable. Except in Scandinavia and eastern Europe, patronymics—Wilson, Johnson, Samson—were fixed. Many surnames indicated the bearer's hometown or a characteristic of his physique or his behavior.

The cottars, who occupied a cot or hovel as distinct from a house, were economically inferior to the freemen and serfs. Though they might possess a scrap of land, they lived by casual labor for daily wages. They herded cows and swine, helped in the strenuous days of harvest and planting, ditched and delved, guarded prisoners, carried messages. They were the odd-job men, the rural proletariat. Last of all were the slaves, who had no rights at all. But by the thirteenth century slavery had mostly disappeared from western Europe.

As long as the villagers were let alone, they could survive and even prosper. But all too often they were undone by incomprehensible wars. Abbot Suger of St. Denis tells a significant story. An upstart noble of Reims violated the king's domain. The king, Louis VI, fitly punished him by invading, plundering and firing, and depopulating his lands. "It was an excellent deed, that those who ravaged should be ravaged." The king's men "avenged by the ruin of the lands the injuries committed." Thus the culprit was punished by the death and destruction of many guiltless little people, to whom the holy abbot does not give a thought.

The ideal of the manor was self-sufficiency, as on the plantations and farms of early America. The ideal was not often realized; that is the drawback of ideals. Though the manors could feed, clothe, and house their inhabitants, they had to import salt for curing meat, iron for the smith to work, tar to medicine sheep scab. They paid for the imports with their small farm surpluses. The great difficulty was to find a market within reach, for the cost of transport rapidly wiped out profits.

The character of the manor varied with the soil and climate. In general its people lived in villages, partly for protection and sociability, partly to suit their system of husbandry. The village was, then, a kind of corporation for the exploitation of the land; it could make communal decisions about the choice of crops, the time of planting and harvesting. Each peasant held his por-

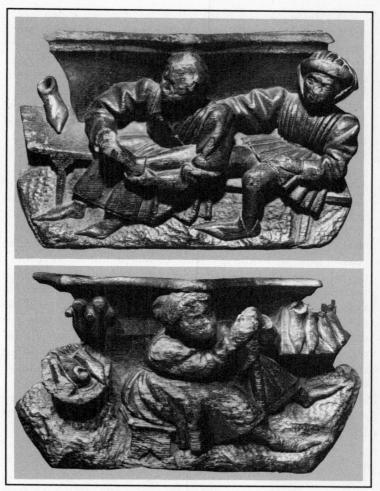

In these carvings from Rouen Cathedral's choir stall, French shoemakers diligently work on customers' shoes. Skilled laborers were uncommon in early medieval towns, since the peasants could handle most tasks themselves. But as time passed, more children were sent off to be apprentice workers, adding to the ranks of the skilled. tion of the arable and pasture land, and had his rights to the common and waste land. He contributed his share of labor and that of his family and his draft animals. His strips of property were small and often scattered, the product of many divisions among heirs. They were distinguished by stones or other landmarks, not by walls and permanent fences that would limit cultivation. The farm work was done cooperatively. This is the open-field system. It was equitable and efficient; it divided good and bad land fairly, saved the waste and expense of boundary walls, and promoted a healthy community spirit as well as many unhealthy disputes. It gave the small-scale farmer many of the advantages of large-scale operation. It discouraged sloth and sloppy farming, since all the villagers labored under their neighbor's eyes.

A constant menace to the farmer was the exhaustion of the soil. He knew that overworked fields would grow tired; like people, they need sleep and food. In England he could produce at best only about ten bushels of wheat per acre from a little more than two bushels of seed. (The present yield of wheat in England is well over thirty bushels per acre.) He did not in the early Middle Ages know the reason for soil exhaustion—the depletion of nitrogen by grain growing—nor was he aware of nitrogenous restoration by clover, alfalfa, legumes. He had no chemical manures, and his thin, underfed beasts produced all too little digestive bounty. He knew, however, that rest and a change of crops would restore fertility. He therefore developed the three-field system, a three-year rotation in the use of his land.

In addition to the arable fields, the normal village possessed common meadows for pasture. This "common" the New England town inherited. The village might also have access to wasteland, marsh, woodland, barren rock, and sand. Such areas furnished wood for fuel, building, and toolmaking, also clay and stone for house construction, fern and heather for bedding, sedge for thatching, wild fruits and berries for human food, and acorns and beechnuts for the pigs. These animals were thin, bony, and fierce. All but the few kept for breeding met their doom in the autumn; their flesh—the staple meat of the medieval peasant—was salted, and their skins used to make footwear, harness, belts, and wallets. Often the village adjoined the lord's private forest, reserved for his hunt. For a woodpenny the villager was entitled to what wood he could take "by hook or by crook," by reaching from the ground with a hooked pole. The peasant had also a kitchen garden of his own, a croft beside his home. Piers Plowman's croft contained beans, peas, leeks, parsley, shallots, small onions, potherbs, and cherries.

The agricultural system, if not enlightened, was adequate. The peasant feared innovations and experiments. He preferred to do things in the good old way. (Intimacy with the soil seems to breed conservatism, perhaps because the soil itself generally acts in the good old way.) The peasant may well have been justified in following old rules; he did not have the knowledge to risk experiments. He worked steadily and long, in every weather, but he seems to have taken his time. He was not driven to produce, since there was often no market for unusual surpluses. The ancient custom of the manor gave him some protection against exploitation. During the long dark of winter he hibernated; he lay fallow like his fields. If food was scanty, he slept, as did the Russian muzhik of yesterday. Usually he was content with his lot; he knew no better.

All the villagers followed the ritual of the farmer's year: in the spring plowing, sowing, and harrowing; in the summer weeding, manuring, sheep shearing, tending the lord's gardens, cutting and storing hay; in the autumn reaping the grain, threshing and storing it; in winter house repairing, toolmaking, and odd jobs. Regularly the villein was summoned by the bailiff to work on the lord's demesne, though his own fields might need seeding or his grain cutting. The serf commonly owed two or three days' work a week to his lord; the freeman, a freeholder, paid a rent instead, although some were obliged to render occasional services. There were some alleviations of this bond work. The custom of the manor might rule that the day's work should be short or that the serf might send an able-bodied son as his substitute. At peak periods the lord might claim boon services, with extra duties; but he often recompensed these with a fine dinner of meat or fish, with plenty to drink. When the day was over, the peasant might have the right to carry home as much hay as he could lift on a scythe handle. And any experienced steward, or bailiff, knew that he would get poor returns by driving his men too hard. They had to go at their own pace.

Each villager owed the lord rent for his house or cottage. It was reckoned in pennies, but usually paid in kind—a few hens

or a pig. There was also an annual egg fee; payment must have overwhelmed the manor house with eggs. Most vexatious to the peasant were the extra labor services, or *corvée*. He could be summoned to repair roads and bridges, to carry stone to build the lord's castle, and in time of war to bring supplies to the soldiers. He was also subject to the lord's exercise of special feudal rights, such as a levy to celebrate the coming of age of the lord's son, or *formariage*, a fee for permission to marry one's daughter outside the manor. Heriot and mortuary, the forfeiting of the serf's best possessions at his death, have already been mentioned. The enlightened cleric Jacques de Vitry called lords who imposed heriots "vultures that prey upon death... worms feeding upon the corpse."

A talmost every step the peasant found himself checked and blocked by some of his master's ancient rights. He was, as we have seen, obliged to patronize the manorial wine press or cider press, its bakeoven, its gristmill. There were severe penalties for possessing a quern, or hand mill. The peasant had to give the lord a hen for the right to keep chickens. He could not fish in the village brook or kill the deer that devoured his crops. Poaching was regarded as one of the most heinous crimes, as indeed it still is in England.

One of the lord's privileges was dispensing justice, for fines went into his own pocket. He was likely also to accept presents from parties to suits. The manor court was held, if weather permitted, in the open air, perhaps under a hallowed tree. The lord or his steward presided, and all peasants were obliged to attend or present an acceptable excuse. The presiding officer rendered summary justice and assessed penalties, but in serious cases a jury was assembled, as much to determine the custom of the manor as to decide an individual's guilt or innocence.

For small offenses public humiliation in the stocks or pillory was deemed sufficient. Often, however, fines and penalties were severe. The abbot of Crowland hanged a man who had stolen sixteen eggs. (For this the abbot was condemned; his impropriety lay not in the severity of the penalty but in seizing the thief off lands where he had no legal jurisdiction.) G. G. Coulton gives some hair-raising examples from Germany of harsh penalties, of which the least is the punishment for removing a neighbor's landmark. The culprit "shall be buried in the earth, with his head standing out, in the place where that landmark stood; and men shall take a new plow wherewith no man hath yet plowed, and harness thereunto four [oxen] which have never yet been used, and new harness to the plow, and these shall plow the field, and the buried man may help himself as best he can."

However, authorities had much difficulty in enforcing their judgments. Many convicted felons would escape and seek sanctuary; or they would submit to an ordeal in the hope that divine favor or good luck might give the lie to human justice; or they would put themselves "in mercy," appealing to the king's mercy, which might be lighter than a judge's rigor. In the English town of Lincoln in 1202 with, as the historian O. G. Tomkeieff has noted, "about 430 cases of crime, including 114 cases of homicide, 89 of robbery (often with violence), 65 of wounding and 49 of rape, only two criminals were hanged and between 20 and 30 outlawed. Most of the others put themselves in mercy and paid fines, while some managed to reach sanctuary in a church, whence they would be allowed to go into outlawry." Incidentally, these statistics of crime in the small city of Lincoln outdo anything our own lawless times can present.

A curious aspect of medieval judicial theory, recorded by the historian Friedrich Heer, is that "every object had its *ordo*, its own legal status, defended its own honor and was answerable for its own actions. Thus a sword which fell from the wall could be brought to account in court, so could cockchafer grubs which ravaged the fields (as in a trial at Basel as late as 1478), so could rats (there was a great rat trial at Autun around the middle of the sixteenth century), so could toads, witches, and bad neighbors."

Another curious aspect of medieval justice was the method of impressing dates and decisions on witnesses' memories, since written records were scanty or inaccessible. Boys who served as witnesses were solemnly cuffed and flogged to vivify their memory until old age. Coulton records that "Roger de Montgomery had thrown into the water his son Robert of Bellême, clad in a fur cloak of gris, in testimony and in memorial that the lordship of the abbot and his monks extended as far as that point."

The effort of the manor to be self-sufficient and the peasant's attachment to his soil made the village a restricted social unit, a closed group. A boy expected to till his father's land, to die in the house of his birth. A girl expected to marry within the

Woodsmen labor at their logs in the medieval forest, decoratively represented here in this Flemish tapestry. The men have set to work with saw and hatchet, while their hound stands guard, keeping trained eyes out for wild beasts that might lurk in the woods surrounding the work party. manor. Superfluous brothers and sisters were likely to remain, unmarried, in the household, though the males, at least, were often forced to migrate townward. Thus a strong localism developed, even a hostility toward rival villages outside the manor. Local customs, rites, turns of speech, special foods, marked the village. Few visitors came except carters, army draftees, and an occasional pilgrim. The world beyond their walking radius was as mysterious and terrifying as that Next World of which their pastor prated.

As with the nobles and the bourgeois, marriage was arranged by parents and was more dependent on landholding than on personal inclination, but this did not keep a maiden from peering into the fire on Christmas Eve to catch a glimpse of her future husband.

The two fathers bargained endlessly over the groom's settlement and the bride's dower. Marriage came early in Germany and France, but in England it was likely to be late, since the groom's father would not yield land to his son until he was almost ready to retire. The essential marriage ceremony took place at the church door, where the groom named the endowment he proposed and put gold or silver, with the symbolic ring, on a book, with pence for the poor. Our wedding ceremony preserves a remembrance of ancient troth-plightingwith the ring, the giving away by the father, and the public promise that "with all my worldly goods I thee endow." The church ceremony was followed by village merrymaking, with a feast, a bridal cake, and a bride-ale, which has become a "bridechampagne." The couple then retired to the groom's father's house, where the priest blessed the bed to the accompaniment of prehistoric comicalities.

The spouses sometimes tricked the marriage bed; many were well aware of planned parenthood. Said Bishop Alvarus Pelagius, in the early fourteenth century: "they [the peasants] often abstain from knowing their own wives lest children should be born, fearing that they could not bring up so many, under pretext of poverty; wherein they sin most grievously and live contrary to the law of matrimony." (Their betters set them the example. Countess Clementia of Flanders had three sons in three years. Fearing dynastic troubles, she contrived "by feminine arts" to avoid further childbearing. But God punished her by causing the death of her three sons.)

A peasant's house of the better sort might be surprisingly substantial. After all, many of them have lasted a good five hundred years-a record no modern ranch house is likely to equal. Its character depended on local materials. In the north it was commonly timber-framed, with walls of wattle and daub, clay reinforced with sticks. The roof was usually of thatch, steep-pitched and low hanging to shed rain. Thatch is an excellent insulator, but is highly inflammable; it harbors vermin and needs frequent replacement. In the south tile replaced thatch. The floor was of rammed earth covered with straw. Seepage, freezing and thawing, and the tread of muddy boots made it often very disagreeable and, surely, provocative of rheumatism. In early times the hearth was in the middle of the main room, and smoke escaped through doors or windows or louvers in the roof: later, hearths and chimneys became general. "Full sooty was her bower, and eke her hall," said Chaucer of a poor widow in the Canterbury Tales. She had at least her two rooms-bower. or bedroom, and hall. In Germany the tiled stove was common by the early eleventh century. It became a household deity; people told it secrets to fend off bad luck, as in the folktale of the Goose Girl. Some houses had extra rooms, as for elderly parents. Many had a built-on stable for the animals, which provided warmth, company, and familiar insects. There are innumerable such peasant houses in Europe today.

The poor, the hand-to-mouth cottars, occupied flimsier homes. There is a case of an aggressor's thrusting a spear through the wall of one cot to wound the occupant. Cots could be dismantled and moved with no great trouble. They were the trailers of the Middle Ages, and the occupants, similarly, were usually the disadvantaged, the landless.

Light came through windows, unglazed holes in the wall that could be closed with a shutter. Artificial light was provided by the hearth fire or by burning rushes soaked in resin; a onepound tallow candle cost a day's work and was too dear for ordinary use.

The necessary furniture was bed and board, still symbols of marital life. The bed might be big and sturdy enough for six, but the very poor had only stuffed pallets on the floor. The board was a trestle table flanked by benches or stools. Most peasants possessed a chest for finery and valuables. The betterto-do owned large wardrobes and regular chairs. The housewife had her domestic equipment—fire irons, a pot hanger, iron pots and skillet, a caldron, a washtub, bowls, jugs, and baskets, a besom, perhaps a cheese press and a kneading trough. The husband owned his tools—hoe, spade, ax, scythe, knife, shears, whetstone, a yoke for carrying buckets. With only a few differences, his possessions were those of a poor American frontiersman not so long ago. Winter was the time for making and restoring equipment. The men whittled, made wooden buckets, dishes, mugs, sabots, and wove baskets. The women spun, wove, repaired clothing, sometimes with thread made from nettles.

The peasant's clothing was homemade of local materials. His badge was the blouse or smock, a practical working garment of coarse tow cloth or wool, or in later times, linen. He wore short breeches and a cap, and in winter, a cloak or mantle, often of sheepskin. There seems to be a general rule that clothing shrinks and retreats inward; a gentleman's shirt drops its sleeves and hides as an undershirt; the blouse shortens its tail and becomes the modern shirt; the French *veste*, or coat, dwindles to a waistcoat; the wide cloak or mantle slims to be a topcoat. In some regions the peasant wore wooden shoes, which he removed on entering the house, as he still does. But most of the pictures show him wearing boots of heavy leather, felt, or cloth. He carried a knife or a dagger, a useful tool as well as a symbol of aggressive manhood.

The villager's diet was certainly limited and monotonous; but except in famine times, it was plentiful and nourishing. In England there was plenty of bread, made of wheat, rye, or barley, sometimes mixed with beans or peas. There was also no lack of cheese and curds, oatmeal cake or porridge, and herring. Meat, though a party dish, was by no means rare. At pig-killing time everyone could feast on pork. The eating of horseflesh, incidentally, was forbidden by the church since the horse does not divide the hoof nor chew the cud. The English and their children drank a watery ale, which intoxicated only the persistent. They made cider and fermented honey for mead or metheglin, which was sometimes spiced and medicated.

In France peasants lived mostly on bread, thick soups or stews, vegetables, and wine, or in the north, cider. The diet was usually fairly varied and abundant. Poor though they were, they took their food seriously. They kept fruit in straw, dried it in the sun, preserved it in honey, or cooked it in must of grapes or concentrated fruit juice—verjuice. They treasured old recipes; the Breton *far*, or pudding, is said to have descended from pre-Roman times. Italian countrypeople ate, as they do today, coarse bread, raw onions, boiled beans, raw turnips, garlic, and the inevitable pasta. In Germany the common folk lived on dark bread, oatmeal porridge, boiled peas, turnips, cabbage, sauerkraut, lentils, and occasionally, pork. They loved especially second cuts of pork with turnip greens.

These were lower-class diets. Said a noble poet: "Why should the villeins eat beef, or any dainty food? Nettles, reeds, briars, peashells are good enough for them."

No doubt the peasant, with his simple regime, was physically better off than the gentleman, ostentatiously gorging on meat, game, white bread, pastries, and wine. The curse and the terror of the underling was famine, resulting from wartime pillage or from crop failure, which smote the peasant, whereas the noble could live on stored supplies or on confiscations. The lean years were blamed on bad weather, demonic activity, or the merited anger of heaven. Probably they were also due to insect invasions and to epidemic plant diseases, unrecognized and unrecorded. When famine struck, it brought with it the excesses of desperation, resort to barks and grasses that merely exasperated hunger's pangs. A twelfth-century bishop of Trier was assailed by a starving crowd that refused his offer of useless money, seized his fat palfrey, tore it to pieces, and devoured it before his eyes. There are even reports of cannibalism; perhaps the folktales of ogres, of Jack and the Beanstalk, have some basis in fact.

The suffering peasant did not have a doctor to turn to, though one of his fellows might claim some skill as a bonesetter. He could appeal to a wisewoman, a part-time witch, learned in the properties of local herbs. She might possess a dead man's tooth, the touch of which was good for toothache. The castle hangman might offer for sale the boiled-down fat of a lately deceased felon. This was good for almost anything.

The peasant enjoyed many festivals and holidays, blending the Christian cycle with ancient pagan remembrances. The second of February, Candlemas, marked in England the resumption of tillage. Easter had its solemn dramatic celebrations and was followed by a week's holiday, of which our school Easter vacation is a relic. On May Day, traditionally, the cattle were put out to pasture while youths brought in hawthorn sprays, crowned a queen of the May, danced morris dances around a maypole. St. John's Eve, June 23, was celebrated with bonfires; on All Hallows' Eve the dead were released, to revisit their homes. The great Christmas holidays, the low point of the farming year, lasted twelve jolly days. This was a time of license, with the election of a Lord of Misrule, with a mummers' play, which portrayed the death and rebirth of a principal actor, thus reenacting the ancient mysteries of Adonis and Tammuz. In Italy a yule log was placed on the hearth on Christmas Eve and adorned with gifts and coins.

Peasants loved to dance, often in the very churchyard before the disapproving priest but amid the approving dead. Their dances, many of which survive, were performed to fiddlers' music, with chorused refrains. They had little of the sexual implications of modern dances. Monks and nuns did not always disdain to join in. There were ecclesiastical, professional, and trade dances. Along the shores of the Bay of Biscay wet nurses performed together, carrying their charges.

Thus the medieval peasants lived, familiar with the earth, responsive to its rhythms. Said Alvarus Pelagius, "Even as they plow and dig the earth all day long, so they become altogether earthy; they lick the earth, they eat the earth, they speak of earth; in the earth they have reposed all their hopes, nor do they care a jot for the heavenly substance that shall remain." The peasant aged rapidly and died young. His skin was hard and leathery, having been dried by exposure to all weathers and cured like a ham in the smoke of his home.

Although poor in material possessions, countryfolk usually had all they needed for the conduct of their lives; and poverty was held no crime. No one was imprisoned for begging or vagrancy until the late fourteenth century. The poor person who bore his lot patiently was holy; he or she had the best chance of eternal life beyond the grave. Peasants were ignorant, but not of the things they needed to know. They were learned in the ways of the soil and its creatures. If we should change places with them—*absit omen!*—we, with all our learning, would soon succumb under the weight of our ignorance. They were hard and cruel; they could laugh at others' pain, but they also could sto-

A prosperous French peasant approaches his wife, who stands posed in front of their cow, their home, and their well-kept farm buildings. The scene is an illumination from a fifteenth-century manuscript in which the couple and two infants enact the classical myth of Romulus and Remus. ically bear their own. Montaigne tells of dying peasants who sat in their own graves and scooped the earth over their bodies. Nor did all countrypeople lack pity and sympathy. Chaucer's Plowman loved his neighbor, and for the poor he threshed, delved, and dyked, refusing payment for Christ's sake. Peasants were violent, ready with fist and club, heedless of consequences, but so are most people who have little understanding of law, who must sustain their rights themselves. Peasants were greedy, sly, and vengeful; but they had a strong clan and family spirit, and they knew how to cooperate with their fellow villagers and to subordinate their own interests to those of the group.

Though they might suffer from the severities of a rapacious lord, they might also receive the understanding sympathy of a good master. There is a vivid—and significant—confrontation of gentleman and peasant in the thirteenth-century French idyll *Aucassin and Nicolette*. Aucassin is searching for his lost beloved in the forest. He meets a villein, "tall and marvelously ugly and hideous. He wore cowhide boots and leggings tied above the knee with a rough cord. He had on a reversible cloak, with both sides the wrong side out. He was leaning on a big club." Aucassin asks if he has seen any sign of Nicolette.

"What are you complaining about?" says the peasant, roughly. "I'm the one who has some right to complain. I was working for a rich peasant, holding the plow for a four-ox team. And three days ago I lost my best ox, Roger. I am hunting for him everywhere, and for three days I've had nothing to eat or drink, and I don't dare to go back to my village because they would put me in jail, for I have nothing to pay for the ox with. All I have in the world is what I have on me. I've got a poor old mother; the only thing she owned was a mattress, and they've pulled it out from under her, and now she is sleeping on nothing but straw. I'm more unhappy about her than about myself, for if I've lost today, I'll win tomorrow. So what are you worrying about?" Aucassin, who is a decent young gentleman, then gives the villein twenty sous with which to purchase a new ox.

Was the peasant's life, in general, tolerable? Or was he a wretched victim of oppression? Modern writers disagree. Some say that his lot was worse than that of the most downtrodden industrial wage slave, the least privileged sharecropper. Others judge him to have been better off than the typical English farm laborer of the nineteenth century. And some even assert that in many regions the peasant's general level of well-being was higher during the Middle Ages than it was to be again until our own enlightened times.

At least, the average peasant was in harmony with his surroundings. He would not have understood our woeful outcries about maladjustment and alienation, anguish and despair. He had his fixed place in the village community, an honorable role in his little society. He had a perfect unquestioning faith in God and the kindly saints. If he suffered man's injustice, he had only to wait a little for the hour when all wrongs would be righted for eternity. He could not judge the system into which he was born; it was as imperative as the cycle of the seasons, the cycle of life, toil, mating, decay, and death.

The discontented or the superfluous peasant might escape to the towns, thus beginning a population shift that has not yet abated. He would find himself at the bottom of a new hierarchy of rank and occupation. With luck and with the passage of a few generations the newcomers might make entry into the craft guilds and apprentice their sons to their craft. This was a considerable privilege; in England apprenticeship was restricted by a statute of 1405 to the sons of parents possessing land or rents of twenty shillings a year. Nepotism ruled, as it still does in certain craft unions.

The apprentice was bound for a term of years to a master, who engaged to teach him the trade's mysteries, to treat him as a good father would, to tend his spiritual and moral welfare, to beat him for his benefit. At the end of his term he took an examination and became a journeyman. A sincere journeyman would spend a few years wandering and working in other shops. He would then present his chef d'oeuvre, his masterpiece, to a committee, and after a final examination, would qualify as a master. With a little fatherly aid he might set up his own shop. He was still a small businessman, working side by side with two or three journeymen and as many apprentices. He was bound by the restrictive rules of his guild. A few ambitious contrivers managed to raise themselves into the rich capitalist group. But most masters, apparently, were contented with their security and achievement, and inclined rather to look down with scorn on lesser men than up with rancor at the great. As Henri Pirenne pithily puts it: "To security of existence corresponds a moderation of desires."

Pirenne describes the craft guild as "industrial Malthusianism." It guaranteed full employment for its members, but left too many workers outside. It tended to exploit consumers for the benefit of the guildsmen; it was unsuited to the rising industrial capitalism of the towns, especially in Italy and Flanders. It limited production and working hours, demanded extra pay for overtime work, forbade innovation and the invention of new labor-saving tools. (The modern parallels are obvious.)

English masons labored in winter from daylight to dark, in summer from sunrise to thirty minutes before sunset, with one hour off for dinner, thirty minutes for a nap, and thirty minutes for an ale break. Thus the mason's average working day was eight and three-quarters hours in winter, about twelve hours in summer. This seems long, but apparently the pace was slow and there were a good many days off for bad weather, holiday observances, and masons' courts, wherein trade disputes were settled. One might dwell at length on the routine of work in other trades. In many of them the changes have been small. A goldsmith or jeweler, for instance, still works in the medieval way except for the use of power tools and micrometric measurements. A fisherman has learned little new about catching fish. Even in those days fishing vessels might contain a well in which the catch could be kept alive for sale in the seaboard towns.

The demand for weapons, tools, and precious metals spurred a resumption of mining in the tenth century. Most of the old Roman mines had been abandoned during the Dark Ages. Operations were at first restricted to surface mining, with only a shallow penetration. The great enemy of the miner is water. Unless the pit can tap some underground escape route, surface water will drain into it and make work impossible. Because suction pumps are limited by the laws of physics to a lift of about thirty-four feet, technicians devised systems of bucket-hoists, endless chains with bailing cups and pumps in series, operated by horses and mules. They gradually ventured farther, with shafts more than six hundred feet deep and side galleries propped up to prevent the collapse of overbearing earth. The problems of ventilation were acute and were countered with blowing-machines. The exhaustion of oxygen gave workers headaches and often suffocated them. Miners were also the prey

of respiratory diseases, trench foot, and subterranean demons. Deep coal-mining presented the dangers of explosive coal gas, for the miners had to work with unshielded candles. In spite of all, the business of mining flourished. Companies for exploitation were formed, issuing certificates of ownership very like our stocks. The great game of mining speculation began.

In the industrial and commercial world women had their place. In fifteenth-century England and perhaps elsewhere, some few were apprenticed in the clothing trades. Others did very well in the silk business. Masters' wives commonly helped out in the shop, without pay of course. However, most women were outside the organized trades, doing their own housework or serving as domestics, tavernkeepers, ale brewers, home weavers.

Below the merchants and the guildsmen were the unskilled workers, the submerged, the obscure proletariat. We know little of them. They appear chiefly in criminal records and seldom in the voluminous documents dealing with property. They were simply the inevitable poor, whom, we are authoritatively assured, we shall always have with us. They were former serfs who had escaped to the towns in the hope of finding there a better life. They were the surplus sons of country freemen who had no expectation of land and were sent off to seek their fortunes with a father's blessing and nothing more. How often the situation recurs in the folktales-the grasping elder son with his inheritance and the noblehearted younger son with none! Some of these proletarians were representatives of the downward drift that takes place in all societies, incompetent journeymen, discharged soldiers with no pensions, gentlemen-alcoholics. Some of them were outlaws, fugitives from justice in their own country or another. They lived by odd and dirty jobs as porters, scavengers, street sweepers, or by pimping or charity. Or they might seize a promising opportunity for highway robbery, which, if unsuccessful, could bring them straight to the gallows. They were free, of course, but free only to look for work, honest or dishonest, and to go forever hungry and cold. Many a sturdy youth, newly debarked in the town, must have looked back with regret to the security of serfdom among his kinsmen and the companions of his boyhood.

These were the people we loftily term the rabble. Many of them found a sweated employment in the industrialized clothing trade, especially in Italy, Flanders, and England. They were dependent on trade conditions, on mysterious movements of demand, supply, international competition, depressions. They would assemble weekly at the jobbers' doors, hoping for a handout of materials that they would weave or work in their hovels for the barest living wage. It is curious that this piecework system in the clothing trade, with all its abuses, was exactly reproduced in New York and elsewhere little more than a half century ago.

As in New York, the workers, desperate and with nothing to lose, fought their employers with strikes, and the employers answered with lockouts. Industrial disputes engendered violence; discontent justified its actions by a primitive socialist theory. Unrest became political, and proletarians rebelled against royal and ecclesiastical authority. There were many such uprisings, led by the poor clothworkers, in the Low Countries, in Ghent, Bruges, Ypres, Lille, Douai. The protesters received sympathy and encouragement from the friars and popular preachers. In the "matins of Bruges" in 1302 the weavers bloodily established a revolutionary government and defeated a French punitive expedition at Courtrai. This action was known as the Battle of the Spurs, from the mass of golden spurs the weavers collected from dead knights on the field.

The peasant suffered from exposure and deforming toil: the L artisan's life was confining and sedentary. Some trades had their special afflictions, such as the woolworkers' anthrax and the painters' arsenical or lead poisoning. Physical injuries, now quickly repaired, might well be permanent; a cut might leave a lifelong scar. If a tooth ached, it was often extracted and gone forever. Eye trouble was very common - ophthalmia, trachoma, tumors, cataracts, blindness. The purblind King John of Bohemia contracted with a doctor to cure his cataract; the doctor failed and was sewn in a sack and cast into the Oder River. One is struck by the number of cripples, stumping or crawling, in medieval genre pictures. Some of the twisted limbs must have been congenital defects or the results of bad midwifery. The legless and handless were often the product of legal mutilation; the sinning hand of a thief might be punished by separating it from the body. Amputation was the usual method of dealing with a

compound fracture or with a spreading infection, and it was not unlikely to spread infection further.

Qualified physicians and surgeons were scarce and were apt to confine their practice to the rich and noble. Although medicine suffered from its slavish obedience to classical and Arabic authority, the achievements of surgery were remarkable. Trepanning was common because of the prevalence of head wounds and fractured skulls sustained in battles and tourneys. Operating for hernia, cancer, and gallstones was frequent. Surgeons performed cesarean sections, treated hemorrhages with styptics and ligatures, broke and reset badly joined bones, put fractured limbs into plaster casts. Although it is often said that medieval doctors had no idea of antisepsis, they cauterized wounds and dressed them with old wine, strong in alcohol, and with sterile whites of newly broken eggs, and soothed them with balmy dressings. They practiced an at least partial anesthesia, putting patients to sleep by holding to their noses sponges soaked in opiates, mandragora, and the drowsy syrups of the East. Plastic surgery was performed in the fifteenth century; noses, lips, and ears were built up by skin grafts. Trusses were common, and esophagus tubes were used for artificial feeding.

Physicians, who were learned scholars, felt themselves to be a cut above the surgeons, who were manual workers. Since the surgeons were all too few to meet human needs, most of the operations fell into the hands of barber-surgeons. It took the surgeons centuries to break their association with barbering. Even in eighteenth-century Germany an army surgeon had to shave the higher officers.

Dentistry fell in the province of the general medical practitioner, although there were some specialists, called dentatores. Dental science was inherited from the Arabs, who had made impressive advances in theory and practice. The practitioners possessed a wide variety of tools—scrapers, forceps, elevators, saws, files, and cauteries. They removed decay, filled cavities, strengthened loose teeth with metal ligatures, made artificial teeth of ox bone and other materials. Gold fillings are mentioned in the fifteenth century. All medieval writers believed that decay was caused by tiny worms in the teeth. The belief is not absurd if one renames the worms bacteria. Enlightened dental treatment was available only to the very rich; the poor could resort to a tooth drawer in his booth at a fair or market.

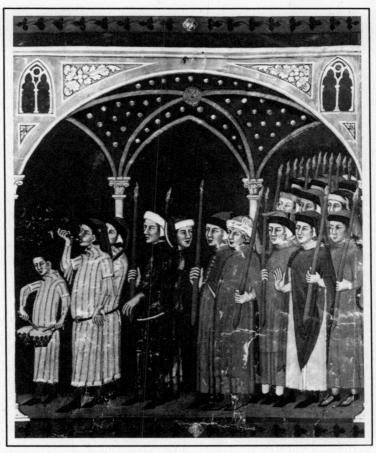

The notaries of Perugia, Italy, are portrayed here marching together, carrying lighted candles. These proud and respected members of the town oligarchy are taking part in a procession on Candlemas Day. The trumpeters and the drummer, at left, precede this privileged group.

Incomprehensible diseases afflicted town and country alike. Dysentery was very common, also epilepsy, malaria, influenza, diphtheria, scurvy, and typhoid and other contagious fevers. A curse of certain times was St. Anthony's fire, a torturing disease that blistered, gangrened, deformed, and killed its victims. This may have been an aggravated form of erysipelas, or it may have resulted from the poisoning of cereals by the ergot fungus, the base of modern LSD and very probably the cause of the great plague of Athens in the fifth century B.C. The village baker could thus be responsible for poisoning a whole community. Smallpox raged for a time; it may have been introduced by returning crusaders. Skin diseases-scabies, scrofula, impetigo-were rife as a result of faulty diet, inadequate hygiene, and irritating clothes, such as hemp shirts and dirty furs. On the other hand, medical historians record small incidence of tuberculosis, cancer, and venereal disease. Only later came polio, typhus, cholera, yellow fever, sleeping sickness, syphilis, and the chronic bronchitis of smog-ridden cities. Acute alcoholism and delirium tremens were uncommon, thanks to the absence of distilled liquors.

The insane were kindly treated, in general, and were allowed to run at large or to dwell in almshouses without constraint unless they should prove dangerous. Since usually they were presumed to be inhabited by evil spirits, they were treated by clerical exorcists, who sought to identify the inhabitant and cast him forth. This is the method of psychoanalysis, itself somewhat diabolistic.

Leprosy was endemic in the early days, especially in Anglo-Saxondom. It flourished again in the twelfth and thirteenth centuries; possibly the crusaders reimported it from Syria. The Office of the Seclusion of a Leper was terrible; it symbolized his living death. He played the role of a corpse. Kneeling under a black pall, he heard mass; then the priest spaded earth on his feet, saying: "Be thou dead to the world, but alive again unto God." Hospitals, operated by greathearted clerics, received many victims; others were permitted to live in solitary retreats and to walk the roads, wearing a black costume with white patches and a tall scarlet hat, and signaling their approach with a wooden clapper. The leper was forbidden to enter a church, mill, bakehouse, tavern, or assembly, to wash in a spring or stream, to touch anything he wished to buy. He was ordered to keep to leeward of anyone he might address. Compassionate public opinion allowed him many privileges, such as the right to take a handful of grain from the sacks set out for sale in the market, or to take a cheese or a fish from every cartload, or even a horse from the annual horse fair. Perhaps as a result of enforced isolation, leprosy declined in the fourteenth century.

Let us turn from this doleful theme to the gaieties of the sturdy townsman in health. He loved sports and games more than did his country cousin, to whom physical exercise was no relief from the daily routine. Most cities had their playing fields, whither journeymen and 'prentices' resorted on holidays, and students and young clerics joined the fun. The bishop of London complained in 1385 of ballplaying within and without St. Paul's, to the damage of windows and sculpture. Sportsmen practiced archery and played a kind of baseball, with a bat and leather ball. Bowls goes back at least to the thirteenth century and is probably even older. The game of tennis is very ancient; there is a story in the Arabian Nights of a king who was killed when he wielded a poisoned racket handle. Court tennis evolved in the twelfth or the thirteenth century. One will remember that in Shakespeare the dauphin sent Henry V a present of tennis balls. Since, of course, rubber was unknown, the balls were very hard, even lethal. At Elford in Staffordshire is the tomb of a boy who is shown holding a tennis ball with which he was accidentally killed. The football was an inflated pig's bladder, usually leather covered and sometimes containing rattling peas or beans. A game of football resembled a civil war, with the lads of different quarters trying to drive the ball, with feet and hands, to opposite town gates. Any number could play; there were no rules, but many casualties. In the fourteenth century the English kings repeatedly forbade it. Golf was reported in the Low Countries and in Scotland in the fifteenth century.

Many of the sports, such as bullbaiting and bearbaiting by dogs, might be too savage for modern taste, though we accept the public sadism of prizefighting and bullfighting and the blood served as a condiment in half our movies. In twelfth-century London, schoolboys brought their fighting cocks to class on Shrove Tuesday and staged battles to the death, with their master as referee. Italy had an evil cat game. A man bare to the waist, with his head shaved, entered a cage with a cat and tried to kill the cat with his teeth, without using his hands or losing his eyes. (It is to the credit of the students at the University of Bologna that they booed this spectacle.)

The townspeople also had the pleasure of watching the mystery plays, which developed step by step from the church ritual. Eventually the representation was taken over by the community, with as many as five hundred actors, mostly guildsmen. A wide multiple stage was built in the public square. The sacred story was reenacted with many amplifications, including comic interludes.

No doubt the townworker's greatest solace was drinking, talking, and gambling in his friendly tavern. There he could rub shoulders with his fellows in animal warmth and ease. The unventilated atmosphere was noisome, with the sweat of bodies and the reek of ancient, uncleaned clothes, but at least there was no tobacco smoke. The drink of the country was always cheap, and no one dared to tax it. In England every inn brewed its own ale—this was women's work—and then put out an ale-stake, a pole with a branch or bunch of leaves at the end. Its appearance was a signal for the official aleconner or aletaster to make a test. If he found the drink below standard, it was forfeited and the tavern closed. We do not find this custom in France; the patrons were competent to judge their own wine.

Life in a medieval tavern was not very different from that in a pub or bistro today. Probably the conversation would sound familiar to any modern bartender. Piers Plowman, who was present, can give us an authentic report, in a modern adaptation by J. F. Goodridge.

One Friday Gluttony was on his way to church to make confession, when he met Betty the ale-wife. She asked him where he was going. " 'To Holy Church,' he replied, 'to hear Mass and go to Confession; then I shan't commit any more sins.'

" 'I've got some good ale here, Glutton,' she said. 'Why don't you come and try it, ducky?'

" 'Have you got hot spices in your bag?'

" 'Yes, I've got pepper, and peony-seeds, and a pound of garlic—or would you rather have a ha'porth of fennel-seed, as it's a fish-day?'

"So Glutton entered the pub, and Great Oaths followed him. He found Cissie the shoemaker sitting on the bench, and Wat the gamekeeper with his wife, and Tim the tinker with two of his apprentices, and Hick the hackneyman, and Hugh the haberdasher, and Clarice, the whore of Cock Lane, with the parish clerk, and Davy the ditcher, and Father Peter of Prie-Dieu Abbey, with Peacock the Flemish wench, and a dozen others, not to mention a fiddler, and a rat-catcher, and a Cheapside scavenger, a ropemaker and a trooper. Then there was Rose the pewterer, Godfrey of Garlick-hithe, Griffiths the Welshman, and a crew of auctioneers. Well, there they all were, early in the morning, ready to give Glutton a good welcome. . . .

"Then Clement the cobbler pulled off his cloak and flung it down for a game of handicap. So Hick the hackneyman threw down his hood and asked Bett the butcher to take his part, and they chose dealers to price the articles and decide on the odds....

"Then there were scowls and roars of laughter and cries of 'Pass round the cup!' And so they sat shouting and singing till time for vespers. By that time, Glutton had put down more than a gallon of ale, and his guts were beginning to rumble like a couple of greedy sows....

"He could neither walk nor stand without his stick. And once he got going, he moved like a blind minstrel's bitch, or like a fowler laying his lines, sometimes sideways, sometimes backwards. And when he drew near to the door, his eyes grew glazed, and he stumbled on the threshold and fell flat on the ground."

VIII The Life of Thought

An astronomer with an astrolabe is assisted by a clerk and a mathematician.

he culture of a given time and place is a product of inherited tradition, of the recovery of lost or obscured forms of thought, of innovation. Such seeds, fertilized by prosperity, tended by leisure, and warmed by the sun of peace, may produce an abundant bloom. Most commonly the bloom is brief, as was that of the Carolingian Renaissance. Its soil was too thin; its roots pithless.

For nearly three hundred years, from the ninth century onward, cultural growth in western Europe was all but arrested. In the church some few learned to write good Latin, and in the monasteries fewer still, bold or bored, opened the old books of brooding wisdom and copied them down. We are ill informed of the spirit's life in those days, but evidently the cultural calamity was due less to ignorance than to incuriosity. Men were not ignorant of the things they needed to know—practical agriculture, weaponmaking, the strategies of survival; and they had no interest in rediscovering the speculations of ancient sages. If we censure them for their neglect, we might well ask ourselves when we have last read Cicero and Virgil through.

With the eleventh century came an economic recovery, a slackening of tension in Christian Europe. The Scandinavian invaders were absorbed, the Islamic thrust checked. New orders in the church, especially the Cluniacs, provided islands of peace and security. The struggle for existence continued, but men could now hope for something more than mere existence. Here and there they could find leisure for contemplation, for the arousing of curiosities about the human past as well as about their personal destinies in another world.

In all these gloomy years two names stand out: Alfred the Great, king of Wessex, and Gerbert of Aurillac. Alfred, still beloved in English legend, lived at the end of the ninth century. Not only did he organize Anglo-Saxondom and triumphantly fight the Danish invaders, he also translated into his own language a number of Latin classics, notably the sixth-century *Consolation of Philosophy*, by Boethius. He fostered an Anglo-Saxon literary culture, superior to that of the Continent, but doomed to extinction after 1066. Gerbert, who flourished in the latter half of the tenth century, left his monastery in southern France and went to study in Spain. He returned to head the

237

cathedral school of Reims and to tutor the future German Emperor Otto III. He liberalized his school's curriculum, resuscitating such ancient authors as Virgil, Horace, Terence, and Juvenal. He explained the mathematical basis of music by means of vibrating strings of various lengths. Deft-fingered, he constructed a clock marking the hours, a hydraulic organ, and an armillary sphere, illustrating the earth and the orbits of the planets around it, and the revolving heaven of the fixed stars. He reintroduced the abacus, making quick calculation possible. Naturally he was regarded as a magician; he was said to have manufactured a head of brass that told him of the future. It said to him: "You will be pope!" And, in fact, he was elected pope as Sylvester II. But beware of necromancy, which tricks its devotees! He died soon after his elevation, and he is said to have repented on his deathbed for selling his soul to the devil.

After the death of Charlemagne, organized schools were almost entirely lacking. We are so used to equating education with schools that we may forget that schools are merely a convenient, economical method of group or mass education. In primitive societies a child is educated by association with his elders in work and play. Plenty of great thinkers, from Socrates to Pascal, Rousseau, and Mill, never went to a regularly constituted school.

The monasteries, with their insistence on the correct singing and chanting of the sacred offices, commonly supported song schools to train young choristers. They had to learn to read the Latin script and needed enough Latin grammar and vocabulary to sing with proper expression and emphasis. This was not difficult in a convent where Latin was the language commonly used. Most graduates took orders, and no doubt many improved their opportunities for private study. The monastery schools, then, were properly vocational. So were the cathedral schools, for each bishop was supposed to provide for the training of secular priests.

In later times, with the increasing demand for literacy, song schools or chantry schools became widespread. Chaucer speaks of "litel clergeon, seven yeer of age," who learned "to singen and to rede, as smale children doon in hir childhede." The pupils chanted in unison phrases given out by the teacher. They learned their letters from an alphabet arranged in the form of a cross, a christcrossrow—hence our crisscross. This might be contained in a paddle-shaped hornbook, parchment protected by a transparent layer of horn. They practiced writing on slates or wax tablets; paper was far too expensive for them. As soon as possible they were initiated to Latin. Secular schools, a few of which had survived from Roman times, also began to increase in number as the demand for elementary education outgrew the facilities provided by churches and monasteries. Many were intended for the children of the burghers and were oriented toward commercial education, with emphasis on arithmetic and foreign languages. Noble boys were trained by tutors; and girls were occasionally sent to school in convents.

Some few of the early cathedral schools carried education from the first steps through the higher levels. Of these "grammar" schools the most celebrated through the twelfth century was the cathedral school of Chartres. The curriculum followed the Roman model. Its seven arts were divided into the trivium and the quadrivium. The trivium was regarded as superior to the quadrivium. The trivium consisted of grammar, rhetoric, and logic (or dialectic); it cultivated the appreciation of Latin classics, correctness and elegance in writing Latin prose and verse, and the systematic conduct of thought and reasoning. The quadrivium was composed of arithmetic, geometry, astronomy, and music. The mathematical studies of the quadrivium were, of course, very elementary, and the astronomy was closely tied to astrology. At Chartres medicine was also taught, although it consisted of no more than the transcription of ancient authorities. But at least the school at Chartres was concerned with profane knowledge; its excellent teachers inspired many to look for instruction to nature and the external world.

Instruction in the grammar schools was chiefly oral, for generally the teacher had the only copy of the text. Enormous feats of memorization were required. Learning to think—and forget—would have seemed a waste of class time. The hours were long, with no provision for school sports. The fare was poor; the punishments, severe. For any misbehavior, such as speaking one's native tongue, *vae natibus*—"woe to the buttocks!"

The course terminated with public exercises. In twelfth-century London the scholars of several schools met in churches to dispute logically and demonstratively in syllogisms. "Some," a contemporary observer wrote, "disputed for show, others to trace out the truth. Cunning sophisters were thought brave scholars when they flowed with words." Boys recited their own Latin verses and contended about the principles of grammar and the rules of moods and tenses.

In the late Middle Ages schools tended to free themselves from direct church control. The first institution to do so in England was Winchester, established in 1382. Some years later, Eton became the first public school—"public" in the sense that students were accepted from everywhere, not merely from the neighborhood.

In the twelfth century the progress of learning, the increase of scholarly subject matter, and the demands of ambitious students caused universities to develop from certain large and favored schools or from mere coagulations of disciples about a distinguished teacher. The word *universitas* means no more than "the corporation." Its first recorded appearance is in a letter of Pope Innocent III in 1208 or 1209. The first university was at Salerno in Italy, followed by others at Bologna, Paris, Montpellier, and Oxford. They gained a relative independence from their local bishops and put themselves under the control of the pope, who was likely to be more liberal than the bishops and was at least much farther away.

The universities taught the trivium and quadrivium, plus the natural sciences as Aristotle had described them. These studies corresponded to our course in arts and sciences, and were regarded as liberal studies, preparatory to professional training in theology and philosophy, the specialties of the northern universities, and in medicine and law, which were specialties of the south.

The first universities needed little organization or administration since there were no trustees, regents, presidents, deans, or university buildings. Entrance requirements and age limitations were vague. Petrarch matriculated at Montpellier when he was twelve years old. The students were grouped by faculties. At Paris and elsewhere those studying in the faculty of arts were further divided into nations, according to their origins. Students lived in cooperative rooming houses and boarding clubs, which attracted endowments from the benevolent and became the colleges of Paris, Oxford, and Cambridge. At Bologna the students held control of their university, hired and fired professors, fined them for unexcused absences or lateness, for wandering from their subject, and for dodging difficult questions.

The boys are playing school in this medieval illustration, and they have allowed one of their number to act as the powerful teacher. Seated above the others, he wields the dreaded palmer, a stick with a flat wooden disk on the end that was used for swatting the palms of young misbehavers. Bologna was a guild of students; elsewhere the universities were guilds of masters. The professors were very proud. They taught from a kind of throne and wore noble insignia, gowns, toques, long gloves, gold rings. They asked the prestige accorded to knights and tried to make their posts hereditary. They were likely to go far in courting popularity and enrollments, for they were paid by student fees, and they had, after all, no tenure, pensions, or grants. When members of the mendicant orders invaded the universities in the thirteenth century, they met with great hostility, for they lived on charity and taught for nothing.

The typical scholastic day began at five or six A.M. The students assembled for class in rented rooms or halls, or in churches. They sat on hard benches or on the straw-covered floor, taking notes with styluses on wax tablets. The professor read some standard text, then expounded and commented on it, then, usually, permitted criticism and discussion by the students. Pedagogic methods have not changed much. But with books scarce and expensive, there was little opportunity for supplementary reading, term papers, individual investigation. Classes were adjourned at ten for dinner (as was the custom at Oxford until the eighteenth century) and were resumed for the afternoon. Most students were in bed by eight or nine.

A feature of university instruction was the disputation. A promising student, prompted usually by his professor, would propose to defend against all comers a more or less bold thesis in the field of his studies. All other exercises were canceled, and a large band of students and also eminent visitors attended. It was a "clerical tournament," a sporting spectacle in the intellectual realm, with the professor acting as the challenger's second and trainer. A spirited defense was hailed with shouts of applause.

The disputation was a trial run for the award of the master's or doctor's degree. In the guild organization the student entered as an apprentice. After a period of trial he became a *baccalaureus*, bachelor, similar to a journeyman-artisan. At the end of seven years he took his master's degree and gave a specimen lecture, as the artisan presented his "masterpiece." He was then crowned with a master's cap. Cambridge had a remarkable test for a candidate for the Master of Grammar (or Master of Education) degree. A beadle presented him with a birch rod, a palmer, or small bat for smacking palms, and a boy in need of correction. The candidate demonstrated his skill with birch and palmer, then paid the boy fourpence for his pains, figurative and literal, and gave another fourpence to the beadle.

The new master was then formally admitted to the guild of teachers. He took an oath of obedience to the university statutes and to its officers; he was seated in the master's cathedra; a volume of Aristotle or another appropriate book was placed in his hands; he was invested with a ring to evidence his marriage to learning; he was solemnly kissed by his new colleagues. He then invited his examiners to a banquet, a custom that has regrettably lapsed. In Italy if he was wealthy, he gave a ball; in Spain, a bullfight. It is reported of one stingy initiate that "the people invited to his banquet were so poorly fed that they did not even desire to drink." But see the consequence: "He opened his course with novices and hired listeners."

The students were mostly poor, ambitious, and serious. Many were bright novices sent by hard-pressed monasteries; they had to beg, "to sing Salve Regina at rich men's doors," as Thomas More says. Or they worked for their keep. Roger Bacon tells of a boy who served for two years and found no one to teach him a word. But some were well-to-do and could afford fine clothes, soft beds, and tavern dissipation. There were no organized sports; many games, including marbles, including "leaping and singing," were forbidden. The compressed spirit occasionally burst forth in violence, in battles between students of different nations and in wars of town and gown, such as the Great Slaughter at Oxford in 1355, when many on both sides were killed. At Bologna one student was assaulted by another in class with a cutlass and the offender was fined for wasting the time and money of the serious scholars. At Leipzig it was against the rules to wound a professor with a stone or to throw a stone and miss the target or even to pick up a stone with an antiprofessorial intention.

Most of the student amusements were harmless enough. In Germany the hazing of freshmen, the *beani*, "to purge them of their rusticity," evoked this statute in 1495: "Each and every one attached to this University is forbidden to offend with insult, torment, harass, drench with water or urine, throw on or defile with dust or any filth, mock by whistling, cry at with a terrifying voice, or dare to molest in any way whatsoever, physically

243

or morally... any who are called *beani*, who come to this town and to this fostering University for the purpose of study."

Surely there is room here for a thirteenth-century Paris joke. Some students were frequented in their lodging by a friendly cat. "He eats here free," they said. "Make him join in the dice game." They contrived to make him roll the dice; he lost. They then tied a bill for a quart of wine to his neck and sent him home. The owner returned him with the money and a message: "Don't let him shoot dice anymore. He can't count good." This must be the first shaggy-dog story.

Such student gamesters were the idlers, the ne'er-do-wells, who sang:

Le temps s'en vient Et je n'ai rien fait; Le temps revient, Et je ne fais rien. (Time passes on and nothing I've done; Time is repeated, and nothing I do.)

While their industrious companions labored in the hope of good jobs in the church or at noble courts, these students drank and wenched and sang in taverns the songs preserved in the *Carmina Burana*, such as *Meum est propositum / In taberna mori* ("It's my firm intention/In a barroom to die"), defiant songs of love and wine, with an overtone of melancholy, of defeat. These were the rebels, escapees from the ordered life of society, for the universities were producing an oversupply of candidates for worldly posts, creating an intellectual underworld of dropouts and beats. They lived as shysterish tutors and schoolmasters, as jongleurs and buffoons, as beggars and petty thieves. François Villon, Master of Arts of the University of Paris, is their exemplar and spokesman.

For the most part the students and their teachers were animated by a passionate desire for learning. For them man's enemy was not so much the devil, the old Tempter, as ignorance. "Man's exile is ignorance; his home is knowledge," said the twelfth-century Bishop Honorius of Autun. And Saint Anselm of Canterbury: "I do not seek to understand that I may believe, but I believe that I may understand." They sought understanding in the works of profane as well as sacred authors. Such curiosities scandalized many of the devout. In Cluniac monasteries a monk who wished to read a heathen book had to indicate the fact by scratching his ear, "as dogs are wont to do, for it is not unjust to liken a heathen to such an animal." But familiarity with ancient authors inculcated a humble respect for the classics, manifest in art as well as in letters. In church sculptures the apostles were gowned in Roman togas. People began to collect classical antiques. The Roman Senate in 1162 decreed that anyone who injured a Roman column should be punished by death. This spirit of loving respect for the past contained the seeds of humanism.

With the classical revival came a rediscovery of Aristotle. Much of the Organon, with its six treatises on logic, was already known, in a sixth-century Latin translation by Boethius. By the twelfth century the major works of Aristotle and other philosophers passed from Greek to Arabic—often by way of Syriac and thence to Latin, either directly or through intermediate translations into Spanish or Hebrew. Much was lost or misinterpreted on the way. As one of the most eminent of medieval translators, Adelard of Bath, observed, "an authority has a wax nose that can be twisted this way or that." But on the whole the fidelity of the final product to the original is said to be remarkable.

Aristotle, "the master of those who know," as Dante called him, possessed one of the greatest minds in intellectual history, perhaps, indeed, the greatest. He proposed a complete system explaining the universe. But the mechanistic Aristotelian system conflicted with the church's system, for Aristotle made no provision for the exercise of free will, for the intervention of deity, for miracle, for revelation. Hence the Last Judgment of human souls disappears, along with salvation and punishment; and God is left without much to do in his world.

The dangers to orthodoxy in Aristotle caused him to be repeatedly banned by the church. Niggling critics pointed out his mistakes; one interpreter reported having seen two lunar rainbows in a year, whereas Aristotle says they occur only twice every fifty years. Petrarch said: "I am anti-Aristotle whenever Aristotle is anti-common-sense." Common folk called him a devil's child, who got his wisdom by stealing Solomon's secret book in Jerusalem. They told how he had so ignobly loved a light woman that he went on all fours, saddled, bestridden, and whipped by the triumphant doxy.

But Aristotle's intellectual eminence could not be denied, nor could his teachings be dismissed by any church pronouncement. The rationality of science and the constancy of the world's behavior had to be accepted, although one might reject the philosopher's mechanistic outlook.

The works of Aristotle led scholars to the study of dialectic, which is both a subject matter and a scholastic method. Dialectic is no more than a formalized logic based on Aristotle and developed by means of syllogism. According to our contemporary R. W. Southern, the student "learned to classify the type of valid argument, to detect the causes of error and to unmask the process of deception. Once more he found that, instead of the bewildering variety which met the casual inquirer, the types of valid argument are strictly limited in number and can be classified on a simple principle. . . Logic was an instrument of order in a chaotic world. . . . The world of nature was chaotic a playground of supernatural forces, demoniac and otherwise, over which the mind had no control. . . But logic, however obscurely at first, opened a window on to an orderly and systematic view of the world and of man's mind."

Logic gave people a new understanding based on faith. One was no longer required to accept without question. One observed, defined, classed, understood by rational deduction. One reinforced dogma, explaining apparent contradictions by well-conducted reason. The use of reason was exalted as a method of securely apprehending divine truth. "Faith must not be blind," people said.

In their speculations the new thinkers fell upon the question of universals, which had occupied Plato and Aristotle, and on which they differ radically. The world is made up of individual realities, proper nouns. My automobile, a proper noun, exists; it is a reality. But does the automobile, a collective noun, exist? It is a universal, a concept, an ideal. We cannot picture it; representing all automobiles, it is no automobile in particular. Can we therefore say that it exists?

To the question there are two answers. The realists replied: "Certainly the ideal automobile exists—in God's mind; man merely builds approximations of the ideal. The fact that we can conceive of the perfect automobile proves that the ideal is a reality." The second answer is that of the nominalists. They replied that universals are merely names, semantic conveniences, useful assumptions. Actually there is no such thing as an automobile in general. When we pass from collective to abstract nouns, the case becomes clearer. What of Justice, Beauty, Truth? There is no proof that they exist as entities independent of men's minds.

The question of universals was angrily argued through several centuries, and it still produces a lethal crop of learned studies. Was the question really so important, or is it one of those subjects that have become important only because philosophers and historians have talked so much about them? The quarrel was, in fact, important because of its implications and extensions. If, as the nominalists maintained, only particulars exist, what of the mystical body of the church? Instead of a reality, is it merely a convenient designation for the sum of Christians? What of the Trinity? How can three be one and one three? Do these words define a reality or are they just words? Nominalism took on an ominous smell of radical thought—of heresy.

Indeed, the quarrel about universals continues, under other names. Science tends toward nominalism. Popular usage, treating abstractions as real existences, prefers realism. When Mussolini proclaimed that the state does not exist for man, but man for the state, he propounded the realist view. When a person dies for communism or for capitalism, he might well salute realism with his last breath.

A compromise between the two views was found by Peter Abelard in the early twelfth century. According to the philosopher Maurice de Wulf, Abelard argued that "although there exist only individual men, although each one is independent of the other in his existence, the mind nevertheless possesses the general notion of humanity which belongs to each of them; but this form of generality is a product of our conceptual activity and does not affect the real existence."

Abelard was one of the most fascinating personalities in a time that was inclined to suppress or disregard personalities. In intellectual history he remains an example of a mighty intellect; and in popular remembrance, a symbol of the great lover, although like other great lovers, he was more than a bit of a cad. Around the age of twenty he appeared in Paris, defied and confuted the

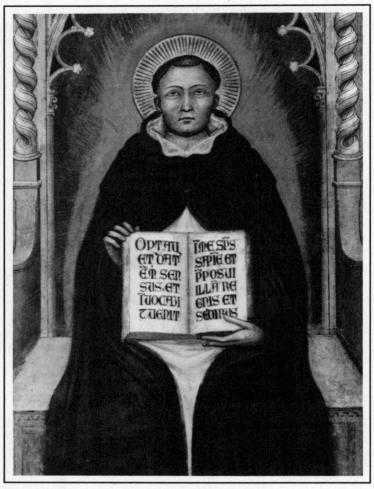

This portrait of Thomas Aquinas holding the Bible depicts the philosopher, theologian, and poet in a glow of saintly status. Aquinas systematized Catholic theology, seeking to reconcile reason, revelation, and faith. He taught that the three must work together. He was a student of Albertus Magnus, the first medieval scholar to apply Aristotle's philosophy to Christian thought of the time. learned doctors, and soon opened a school of his own. His popularity was immense, except among the teachers who found their classrooms deserted. He was nicknamed the Indomitable Rhinoceros. He fell in love with the learned and beautiful Héloïse, niece of a canon of Notre Dame. She bore him a son, who was pedantically christened Astrolabe. The angry canon seized and castrated Abelard, who had then no recourse but to enter a monastery, while Héloïse, at his insistence, became a nun. She wrote him beautiful, passionate letters expressing her love and longing, unquenched by her vows and by her lover's misfortune. (One historian points out that she was enabled to write at length because as abbess she could raid the convent's store of parchment.)

Abelard made important contributions to philosophy, to logic and ethics. His most influential book was *Sic et Non* (Yes and *No* or *On the one hand and on the other*). It is a list of apparent contradictions in the Bible and the Church Fathers, with suggestions for harmonizing the conflicting statements. Abelard also did something for the emancipation of women. As Friedrich Heer has written: "Abelard elevated Mary Magdalen, the patron saint of women sinners, above the militant saints of the feudal Middle Ages, and so initiated a Magdalen cult. . . . Abelard sought out the youth and the women of Europe, calling on them to think boldly and to dare to love with passion. . . . " And finally, his personal influence made the Paris Left Bank, the Montagne Sainte-Geneviève, the intellectual center of Paris and the Western world.

Abelard's chief enemy was that mighty battler for the Lord, Saint Bernard of Clairvaux. Bernard repudiated human reason as a means for the attainment of divine truth. He was an intellectual anti-intellectual. He bade his clergy flee the Babylon of the Paris schools in order to save their souls—"You will find more in forests than in books. Woods and stones will teach you more than any master." He represented that distrust of science, philosophy, and speculative intelligence that still agitates some earnest believers. Bernard brought Abelard to trial for heresy; but Abelard played his trump by dying before Rome could render a decision.

The scholastic method of Abelard and his colleagues was to dominate philosophy and theology for many years. Scholasticism—as one modern scholar has pointed out—is "essentially the application of reason to revelation." It accepts the words of Scripture and the inspired authorities without question, but clarifies them by reason. The mystery of the Trinity, for instance, is of its very nature incomprehensible, but—scholastic philosophers maintained — its import can be rendered clearer by enlightened analysis. Thus reason has the right to treat of the holiest arcana of the faith. The method of scholastic philosophy fell into the form of a disputation; a question was proposed, the arguments pro and contra stated, and a balance struck between them. This method was adopted by Thomas Aquinas in his *Summa Theologica*. Many years later, it reappeared as Hegel's thesis, antithesis, and synthesis. It is still a familiar method, essentially that of our law courts.

The scholastic method encouraged subtlety, intellectual agility, a sharpening of scholarly wits. It provoked a rage for philosophy, which occupied the schools at the expense of humanistic and scientific studies. Compromising by nature, it did not lead to the discovery of great final truths. It led, rather, to aridity, spiritual casuistry, and, with its ever more fine-spun distinctions, to absurdity. But it has left its mark even on our language. As G. G. Coulton writes: "When we hear from the lips of an ordinary laborer such a sentence as 'it ain't the *quantity* of the food I object to, but the *quality*,' that man is drawing a necessary distinction more easily and familiarly than many educated Romans could have done in Cicero's day."

The freedom of scholastic speculation and the consolations and securities of faith were brought together in the doctrine of the two truths: there is a philosophical truth, dependent on reason, and a theological truth, independent of human reason and superior to it. No matter if these two truths appear to conflict, they cannot actually do so, for they dwell in different orders of reality and are incommensurable. Thus a scientist or philosopher is free to reach whatever conclusions he may, and practice the faith without an intellectual tremor. This compromise of the two truths is not unknown today.

The truths of faith and reason were magnificently brought into accord by Thomas Aquinas in his *Summa Theologica*. Six hundred years after Aquinas's death, in 1274, Pope Leo XIII formally declared the book to be the basis of theological study in the church. A school of Neo-Thomists still flourishes.

Aquinas has been termed a moderate realist. He accepts the

faith, as it was given to us by Christ, the church, and the fathers. Reason, God's gift to man, must necessarily confirm the truths of faith; if it fails to do so, it has somewhere gone astray. Aristotle, "the philosopher," has offered us our logical method and our best statement of the achievements of reason without faith. Aquinas, therefore, gives us an endless series of questions on dogma, with the arguments for and against. He summons Aristotle as an expert witness. He then states the resolution, and finally, explains away apparent objections. Apologist though he is for Christian orthodoxy, Aquinas gives wide scope to reason, allowing it to rule to the limits of experience and knowledge, and thus he encouraged philosophy to seek larger freedoms.

As Aquinas organized and codified theology, others performed the same task for law. There are two kinds of law—that of custom and that of edict or, as we say, common and statute law. Common law, depending on remembered precedent, varied from province to province, almost from village to village. Except perhaps in England, its customs were too incoherent to be useful in the narrowing world. The church and the lay rulers demanded uniformity. Said Pope Urban II in 1092: "The Creator hath said: 'My name is Truth.' He hath not said: 'My name is Custom.'"

Statute law fell into two categories-canon and civil. Canon law dealt with the body of papal bulls, canons, and pronouncements, and with the edicts of other ecclesiastical authorities. These were masterfully organized and interpreted by the monk Gratian in his Decretum, compiled around 1140. Its proper title, Concordia Discordantium Canonum (Concordance of Discordant Canons), displays its purpose: to assemble, elucidate, and harmonize the often contradictory canons of the church. Gratian and his many successors created a new course of study and a new profession, that of canon lawyer. Canon law held three jurisdictions: over persons, that is, all clerics; over subjects or issues, such as church organization and administration, and property, marriages, wills, vows, pledges, and contracts resting on good faith; and over sins-heresy, schism, perjury, usury, and such crimes as sex offenses. Thus a whole system of church courts existed beside the civil courts.

The organization of civil law began with the rediscovery of the Roman Emperor Justinian's *Corpus Juris Civilis* in the eleventh century. The church looked askance at Justinian's code,

251

based on imperial rather than papal authority. But the demand for civil lawyers, which it inspired, was too great to resist. Rulers needed their advice and paid them well. The new universities, particularly Bologna, offered professional training in the law, conferred degrees, and promised entry into a very lucrative profession.

Science, or the effort to gain knowledge of the physical universe by systematic observation and investigation, awoke in the early twelfth century. The school of Chartres first attempted to explain our world in terms of natural causes. "The great idea . . . which made possible the immediate expansion of science from that time," the historian of science A. C. Crombie has written, "was the idea of rational explanation as in formal or geometrical demonstration; that is, the idea that a particular fact was explained when it could be deduced from a more general principle." This great idea had been that of Aristotle and the Greeks. "Their bent of mind was to conceive of science, where possible, as a matter of deduction from indemonstrable first principles." Medieval science was regarded as a branch of philosophy rather than as a separate study. Indeed, physics was termed natural philosophy almost to our own times.

The authority and impulse for the new study of science came with the translations of Greek and Arabic writers: Aristotle first, of course, and then Euclid and Ptolemy and many Arabic and Jewish physicians. The European imagination was captured. Scholars realized that the physical world was no mere ugly training camp for the soul, it was the Creator's masterwork. The thirteenth-century encyclopedist Vincent of Beauvais introduced his tremendous *Speculum Majus* with the words: "I am moved with spiritual sweetness toward the Creator and Ruler of this world, because I follow him with greater veneration and reverence, when I behold the magnitude and beauty and permanence of his creation."

These concepts led soon to the ideas of testing generalizations by observation and of creating situations to be studied experimentally. Albertus Magnus, a thirteenth-century Dominican philosopher who performed experiments on plants, asserted: "Natural science does not consist in ratifying what others have said, but in seeking the causes of phenomena." At the same time Robert Grosseteste, a Franciscan, chancellor of Oxford University, and bishop of Lincoln, propounded a systematic theory of

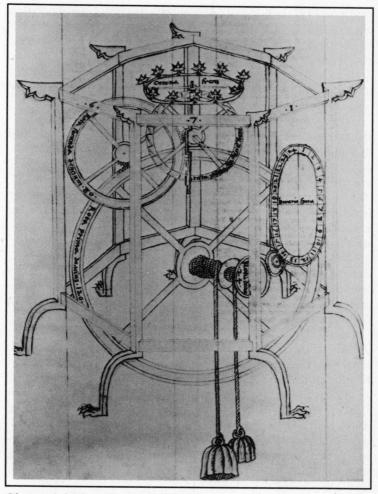

Giovanni de' Dondi, a fourteenth-century professor of astronomy, made this design of a clock. The astronomy of Dondi's day was similarly based on a system of revolving rings. According to accepted theory, the earth existed motionless at the center of the universe, while ten skies revolved around it, one for each of seven planets, the firmament, and two crystalline heavens. experimental science. He wrote on astronomy, mathematics, physics, and optics, and proposed a theory that light energy is the basis of physical phenomena. A. C. Crombie calls him "the real founder of the tradition of scientific thought in medieval Oxford and, in some ways, of the modern English intellectual tradition." He was also an eminent theologian who knew Greek well and had some knowledge of Hebrew.

Grosseteste's disciple at Oxford, the Franciscan friar Roger Bacon, has gained a wider reputation than his master. He held that all natural phenomena are the results of force acting on matter and that force is invariably subject to natural law. He upheld experimentation, believing that results reached "by argument" should be tested in practice. Bacon was a dreamer; he prophesied the coming of mechanical transport on land and water and in the air, and of a world ruled by a technocracy of supermenscientists. In the meantime he suggested "crusades of learning" to the Moslem lands to win the Saracens over to Christianity by impressing them with European knowledge. Bacon was a very fascinating figure, but modern writers are inclined to downgrade his scientific achievements in comparison with those of Grosseteste.

The development of science was long held back by the crudity of mathematics, and especially by the inadequacy of Roman numerals for calculation. The appearance of Arabic (really Hindu) numerals in the twelfth century enabled scientists as well as merchants and bankers to do their work. Trigonometry was also introduced in the twelfth century. Valuable astronomical instruments were borrowed from the Arabs—the quadrant, cross-staff, and astrolabe, which was used by the Arabs to determine the hours of prayer and to find the direction of Mecca. Chaucer compiled a treatise on the astrolabe, probably for his son, a freshman at Oxford.

Some work was done in physics and mechanics at Paris and Oxford. We are told of experiments in magnetic attraction being conducted in the thirteenth century. In geology Albertus Magnus speculated on the origin of fossils. Experimental botanical gardens served the medical schools, and herbals were written. The exploration of biology consisted mostly of useful observations of animal life, but Frederick II's *On the Art of Hunting with Birds* enters the realm of science, with its studies of birds' anatomies, habits, migrations, mechanisms of flight. Much scholarly attention was devoted to alchemy, which developed into chemistry. Its ancestry lies in ancient times. Greco-Roman Egypt practiced distillation to make mercury, arsenic, sulfur. The Arabs provided handbooks on metallurgy, glassmaking, pyrotechnics. The alchemic theory states that all matter is composed of mixtures of the basic elements; that gold is the noblest and purest substance; that metals may be transmuted by altering the mixture of the elements; that baser substances may be transmuted into nobler ones by means of a quintessence or fifth element or philosopher's stone. It remained only to discover the philosopher's stone. The effort encouraged investigation, experimentation, and the establishment of chemical science.

The alchemists have been abundantly mocked, and unjustly, for their successors have now apparently discovered the quintessence, the philosopher's stone. Simply rearrange the nucleus in your atoms.

We have already spoken of the practice of medicine. During the long dark years it was hardly more than folk medicine, in the hands of herbalists, bonesetters, and witches. Monasteries would appoint one of the monks to be leech; some tenth-century English leech-books are still preserved. Medical science in the West began with the import of Greek and Arabic texts, especially the works of Galen and Avicenna, in the eleventh century. Salerno in Italy established the first medical school. It seems to have been astonishingly enlightened. After Salerno, medical schools were organized at Bologna, Montpellier, and elsewhere. The advance of medical science was hampered by too slavish respect for the classical and Arabic authorities. Nevertheless, practice often outdistanced theory, as in surgery, hospitalization, and the treatment of contagious diseases by quarantine. Preventive medicine was understood; Venice had a public health commission as early as the year 1377.

With the intellectual activity of the High Middle Ages, the barbarism of earlier times dwindled, if it did not disappear. The level of general culture rose. Reading and writing became common accomplishments. When San Bernardino preached in Siena in the early fifteenth century, a woolworker took down his speeches with a stylus on wax tablets in a self-taught shorthand. As scholarship ventured forth from the monasteries, it became also the property of laypeople, such as Dante and Chaucer. Cer-

Medieval science was closely associated with the occult and was viewed with superstition. This schematic image of a spherical world envisions men marching around the earth.

tain princely courts piqued themselves on their encouragement of learning. Knights and ladies met in literary salons to listen to poetry and to discuss questions of chivalrous behavior. Even the bourgeoisie showed their appreciation of literature and poetic style. Educated women, bluestockings, were no longer a rarity. The wife and daughters of Giovanni d'Andrea, fourteenth-century professor of law at Bologna, were celebrated for their learning; a daughter is said to have lectured for her father when he was ill. But she taught from behind a curtain in order not to distract the students by her beauty.

The new culture was cosmopolitan. It had its common language, the easy, unpretentious Latin of the time, and its common classics, pagan and Christian. The clergy were at home everywhere; scholars, scarcely burdened with baggage, were constantly on the move. The crusades gave men a taste for travel and adventure. "Even in time of war," writes the French historian Henri Daniel-Rops, "it never occurred to the governments of belligerent countries to arrest enemy aliens and throw them into concentration camps. Foreign travel was not hedged about with ridiculous complications of passports, exchange permits. . . Pilgrims could visit any country to pray to their favorite saint. . . War did not prevent merchants traveling with their commodities to the international fairs."

A public, a cultural milieu, existed, which was necessary to the writer, whether bard or scholar. He must possess an inner compulsion, true; but he must also talk of his work and read bits to sympathetic ears. Without external encouragement—which could sometimes become very strong—the world's literary and scholarly store would be scanty indeed. "Publish or perish" is nothing new; at the University of Bologna a professor was required to present his yearly disputation for publication and was heavily fined for dereliction.

The writer at work was a favorite subject for artists. The writer, warmly gowned, sits at a sloping desk, with a stand above or at his side for reference books. Before him is a fair sheet of paper or parchment; at hand an inkhorn, a goose quill, and a penknife to keep it sharpened and to scrape out the inner fuzz; also a stick of lead and a ruler to make guidelines and margins for the page, a scraper for erasing errors and pumice to clean sheets and a bear's or goat's tooth to polish parchment; and wax and seal to attest genuineness, for a man's signature had

257

then no legal standing; also, perhaps, an hourglass and a charcoal brazier for warming the fingers and drying ink. A dog or cat sits on the floor, watching with admiration.

The great agent of enlightenment was paper. It originated in China about the first century A.D., journeyed slowly westward to the Near East, and entered Christendom by way of Spain in the twelfth century. Improvements were made in methods of manufacture. Unlike papyrus and parchment, paper was both durable and cheap. For the first time a merchant could afford to keep detailed accounts, an ordinary man could write a letter at small cost, a scholar could take ample notes and give free rein in his books to his natural garrulity.

In place of paper, pen, and ink, a writer might use slates and chalk for temporary notes, or a stick of soft lead (the woodcased graphite pencil lay far in the future), or a stylus on wax or ivory tablets, readily erasable. One of Chaucer's friars, selling masses for the dead, wrote the names of his clients on

A peyre of tables al of yvory, And a poyntel polisshed fetisly [neatly]... And whan that he was out at dore anon, He planed awey the names everichon.

In the early days bookmaking was an occupation of the more scholarly monasteries. The scribes developed some national calligraphic styles, as in Ireland. Most common was the Carolingian minuscule, originated during the Carolingian era and still in use in the twelfth century. The monks had plenty of time and worked chiefly for spiritual reward; they were free to adorn and illuminate their pages to their hearts' content. Their finest products were intended to be church and royal treasures rather than serviceable books. The demand for books that arose with the new enlightenment took bookmaking out of the cloister and into the commercial world. A class of professional copvists, mostly laymen, appeared on the edges of the new universities. Their numbers were large, their business good. One early fifteenth-century bookseller in Florence had forty-five copyists at work, supplying Cosimo de' Medici and other wealthy bibliophiles. The copyists formed their own guild, setting rates of pay and hours of work, regulating competition, forbidding advertisement and allurement of customers, even by blowing one's nose significantly. The guild acquired its own demon, Titivillus, whose business was to induce scribes to make mistakes. The copyists worked fast, commonly using swiftly written Gothic minuscule, with an abundance of abbreviations that are torture to a modern reader. They finished a book with a great sense of relief (as who does not?), and often closed with a personal note. For instance: *Explicit hoc totum;/Pro Christo da mihi potum*. ("The job is done, I think;/For Christ's sake give me a drink.")

A lengthy book or an illustrated one was, of course, very expensive. It took at least a year for a man to write a complete Bible; no ordinary priest could afford one. A distinguished private library would contain only a few dozen books. On the other hand, small Books of Hours, breviaries, and school books were mass-produced and were surprisingly cheap. (One wholesaler ordered four hundred copies of a popular university manual.) Few students bought books; they rented them from stationers, as today they expect to sell their texts at the end of term to the secondhand man.

Lavpeople as well as clerics were allured by the joys of authorship. The professional writer, the homme de lettres, appeared. A few, such as Dante and Petrarch, had university training; most had their education from life. They made no direct profit from their works, though Boccaccio, who was always broke, rented his manuscripts to copyists. The writers' reward came from their celebrity and intellectual distinction, which brought them church livings or free lodging and gifts from princes or nobles. Thus the first female professional writer, Christine de Pisan, supported herself and her children at the French court in the early fifteenth century. The literary life was hard. One published a book by offering it to a noble patron or by giving a party and reading the text aloud. Then it fell into the public domain. To sell one's thoughts was considered ignoble. Copyright did not exist, nor the sense of literary property. Others copied one's book, changed it at will, made their own additions, and the poor author might be forgotten; he joined the great army of the Anonymous. Plagiarism and even forgery were not taken seriously. The great eleventh-century archbishop of Canterbury, Lanfranc, forged nine documents to prove Canterbury's primacy over York. The papal curia rejected them because they bore no seals and "did not at all savor of the Roman style."

But nothing deters the writer. Medieval literature is massive

259

in its abundance; and much more has been lost than preserved. It is rich in variety, profound and subtle in thought, artistic in expression. In the beginning poetry rather than prose was the dominant form, for poetry was the normal expression of the literary impulse before writing came to confuse culture. Long after the book appeared, literature was heard rather than read. Even the solitary reader voiced the words. In the fourth century people were amazed to see Saint Ambrose of Milan reading to himself without making a sound.

The two great developments of early medieval literature were the transfer from oral to written form and the formation of vernacular literatures in competition with Latin. With the transfer to written form, literature became visual and private, with a loss of sound and music and with a loss of the critical check that auditors make on a minstrel. The solitary author ceased to know whether he was capturing or boring his audience. But the transfer to written form permitted the reader to stop and think; the author could venture much deeper into his own thought. What he lost in form he gained in substance.

The rise of the vernaculars to literary respectability is most evident in Anglo-Saxondom and the Nordic countries, where Latin was never securely imposed. *Beowulf* and the Norse sagas were unaffected by the Latin tradition. In the south the Romance languages took their own courses, and Latin became incomprehensible to the unlearned. At the same time the Romance tongues, enriched by their inheritance from Latin, gradually became suitable for the expression of difficult and subtle thoughts.

The achievements of medieval literature in many languages and through many centuries cannot easily be summarized in a few pages. One can hardly do more than name some of the permanent types or genres and recall some of the great familiar names.

The epic began as oral or folk literature. It is a natural product of most primitive societies, a tale of heroes sung by a bard. Long-forgotten poets worked it into fixed artistic shape, into a rhythmical pattern congenial to the language and music of a particular people. Eventually it was written down, to become a model for later, more sophisticated writers.

The folk epic flourished among the Celts, Germans, Russians,

Poles, Czechs, Serbs, and Bulgarians. The Anglo-Saxon Beowulf was written about 700. The bards of Ireland and Wales chanted their epics in the eighth century, though these were not written down till much later. The Scandinavian Eddas and sagas date from about 900 onward. Spain's great epic, the Poem of the Cid, was composed about 1140. But most important for their impress upon the world were the epics of France and Germany.

In France they are known as *chansons de geste*, songs of high deeds. These date mostly from the twelfth century. They combine history and legend, and express the noble ideals of heroism, fidelity to honor, feudal loyalty, and love of the homeland. Although they did not follow the strict form of the classical epic, they were by no means folk poetry but artistic productions, composed by poets, usually unidentified, called trouvères in the north and troubadours in the south. The *chansons* were passed on to jongleurs, who chanted them, in a ritual singsong, to audiences in castle halls.

The first and best of the chansons de geste was the Song of Roland, the national epic of France, composed about 1100 by an unknown trouvère, perhaps a monk. It tells the story of an actual event—the defeat of Charlemagne's rear guard at Roncevaux in the Pyrenees in 778. Roland, the commander, is portrayed as the idealized hero of feudalism—fearless, mighty in battle, utterly faithful toward his master and his friends, pitiless toward treachery, and respectful but not cringing before God. But he has his tragic flaw, the pride that forbids him to summon aid until it is too late and his army is destroyed. The character drawing is sharp, the storyteller's art most admirable.

In Germany the great epic is the *Nibelungenlied*, a retelling of old Germanic legends, written by an unknown Austrian poet around 1200. It is a savage and bloody tale of the adventures of Siegfried, packed with incident and emotion, told in a rushing, full-voiced style. It ends with a general holocaust of the cast. It seems to have been divinely destined to be staged to Wagner's music.

The epics expressed the noble attitudes and values of the early Middle Ages. They celebrate fighting and hardihood, and have little to say of love. The few women who appear are likely to be bloodthirsty brutes like Kriemhilde, Siegfried's frightful wife. But new generations appeared, more cultured, more sophisticated than the old. They found the endless spearings, beheadings, body bisections a bore. They asked for something more subtle: recognition of human problems, stories of love. Their demands were met by the romance of chivalry, the *roman courtois*, or, simply, the novel.

The romances of chivalry were tales of love and adventure, in verse or prose. Directed toward an audience of nobles, they glorified the aristocratic way of life and contained long descriptions of luxury, furniture, accessories. They exalted women, who were the poets' patrons and their most responsive public. They exalted also the institution of courtesy, a code of morals and ideals for gentlemen and ladies. Most of all they exalted love, "the origin and foundation of all that is good."

The romances of chivalry began in northern France in the twelfth century and spread to all the Western world. They took as their background themes stories of old Rome and of Charlemagne's court, and especially the Celtic tales that filtered in through Brittany and England. These tales dealt with the knights of the Round Table at the court of King Arthur, who was, in fact, a British Christian chief of the fifth century. The primitive Celtic literature had the character that persists in Yeats and other modern Irish writers: love of the fantastic and marvelous; blurring of the natural and supernatural; acceptance of magic, wonder, fairies, witches, and talking beasts, trees, and fountains as commonplaces; an underlying brooding mystic melancholy; the idea of love as a tragic destiny; wild, soaring poetic diction, transforming the speech of simple men. This spirit was preserved in the reworkings of Continental writers.

Perhaps the best Celtic tale is that of the desperate, doomed love of Tristan and Iseult, several times retold in France and also, most notably, in Germany around the year 1210 by the poet Gottfried von Strassburg. Religion and mysticism enter especially in the various romances of the Holy Grail. These present the ancient theme of the quest, which paralleled the actual experiences of the crusaders. As in Wolfram von Eschenbach's Parzival, written early in the thirteenth century, the quest represented the soul's struggle to find its own fulfillment. A late flowering of the Arthurian stories in England was Sir Thomas Malory's Morte d'Arthur (1469).

By the late Middle Ages writers were seeking other themes and manners. Boccaccio's *Fiammetta* (c. 1343) is a short prose novel about contemporary life. We might call Chaucer's *Troilus*

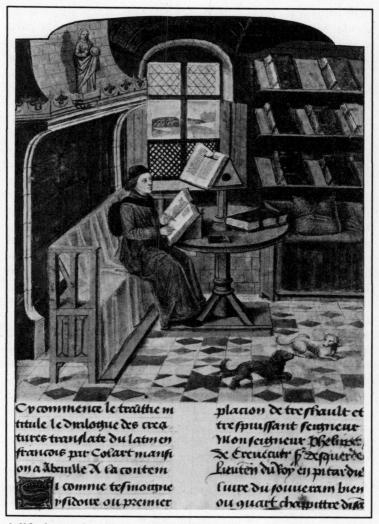

A life devoted to literary and philosophic study was a gracious and honorable pursuit mainly followed by churchmen. In this scene, a medieval scholar, with manuscript at hand, spends a thoughtful afternoon in his library.

and Criseyde a novel in verse. The short story was not an abridged novel but a separate genre. Its roots lie deep in the past, in the winter's tales told around many a humble hearth. Our fairy tales have many medieval remembrances, with their poor charcoal burners in the menacing woods, their familiar beasts, their wicked lords and imprisoned princesses, their trolls and witches and goblins, their magic and wonder. Many of the stories came from Greece and the East, passed on by the words of many mouths. Though adapted to Western milieux, they are still recognizable. Buddha, the bodhisat, became Josaphat; there is, or was, a church of St. Josaphat in Palermo.

In France many of these old wandering tales emerged in the twelfth century as fabliaux. These are written in jingling verse and were intended for recitation by jongleurs in the marketplace. They reflect bourgeois backgrounds and values, and pour mockery on arrogant nobles, stupid peasants, lecherous clergy, and deceitful women. However coarse and cruel they are, the fabliaux often display an excellent narrative art, and can even seem comical.

The short story became unmistakably an art form with Boccaccio's *Decameron*, written around 1350. In Boccaccio can be seen the general principles of plot structure, characterization, and conduct of narrative accepted by the popular short-story writer today. Boccaccio was followed by Chaucer, whose *Canterbury Tales* (1387–1400) are not only supreme examples of storytelling but are revelations of everyday medieval life.

The lyric poem emerges from the universal impulse to sing and dance and recite pleasing words in rhythmical patterns. The earliest surviving medieval lyrics are already sophisticated, with fixed arrangements of line length, stanza division, syllable stress, and rhyme. The origins of the lyric forms are very obscure. Perhaps they descend from Roman popular balladry, from long-lost soldiers' songs, or from Celtic or German originals; and certainly there were influences from the Arabic and Hebrew poetry of Spain. At any rate, the early Latin hymns— *Stabat Mater, Dies Irae*—were rhymed and accented, in contrast to the quantitative scansion of classical Latin poetry. By the twelfth century accented verse and consistent rhyme schemes were common in the secular Latin songs of the vagabond monks, called Goliards.

The Provençal lyric appeared in the eleventh century. From

the very first it was subject to elaborate conventions, in themes and forms. No doubt many of the conventions were brought to Provence by bilingual or trilingual Catalan minstrels, who knew the Spanish and Arabic songs of the Iberian peninsula. The troubadours of Provence abounded: we know the names of almost five hundred. They made two tremendous innovations in Western literary history. They invented-or borrowed from Arabic-the impassioned love lyric, brief and intense, expressing adoration of the all-virtuous, all-beautiful lady. This has been ever since the standard type of the lyric. Secondly, the troubadours, despising the easy and obvious, invented a set of exacting fixed forms, and delighted in ambiguities containing double, triple, decuple meanings. Their trobar clus, closed poetry, esteems obscurity as a merit in itself and requires devoted labor on the part of the reader. Hermetic verse was, a few decades ago, again the joy of our poets and critics.

The troubadours wandered far and inspired others to write in their own languages, thus founding national literatures. In the Sicilian court of Frederick II, in the early thirteenth century, the cultured monarch presided over a band of poets writing in Sicilian Italian, using some Provençal forms and inventing others of their own, including the sonnet. The impulse to write in the vernacular spread through Italy. Saint Francis called himself God's minstrel; his noble "Canticle of the Sun" is in every heart. A group of Tuscan poets, including Dante, developed the *dolce stil nuovo*, picking up the old Platonic theme that human love reflects the divine. The theme finds its summation in Dante's praise of Beatrice.

In Germany, from the twelfth century, the troubadour example inspired the minnesingers. These poets, of whom the chief is Walther von der Vogelweide—a singing name in itself—exalted women and love, and celebrated nature and religion. In England the Middle English lyric shows the influence of Latin, French, and Provençal. Of the few examples that have survived, everyone knows "Sumer is icumen in," though not everyone recognizes its little indelicacy.

The early history of the European drama is very obscure. What went on in those gigantic outdoor theaters of Gaul and Africa? Surely the managers did not produce the tragedies of Seneca, and probably not the comedies of Plautus. No doubt traveling troupes of mimes put on vaudeville shows, with improvised or traditional scenes; but there seems to be no positive evidence of this. During the long dark times, with the abandonment of cities and the difficulties of travel and assembly, the mimes may have disappeared entirely. But in the twelfth century their place was taken by the jongleurs.

Modern drama stems directly from church ritual. Early in the Middle Ages dramatic dialogues were inserted into the church services to celebrate the great festivals, Christmas and Easter. Then the scene was transported from the church's interior to its entrance, where the actors found in the church porch a readymade raised stage, with two or three doors for their entrances and exits and a backdrop of sculptured saints. (Saint Francis enacted the Nativity in a stable, with live animals.) Then multiple stages were erected in marketplaces, with a series of sets ranging from paradise to hell's mouth. Profane intrusions, with everyday realism, were permitted. Thus Noah's wife was shown as a comic scold, Mary Magdalen as a bar girl. Demons provided slapstick comedy; they wore horns, forked tails, and horrid masks, and circulated in the audience, prodding their friends and enemies. By the fifteenth century the plays, called mysteries, developed into enormous community enterprises, lasting as long as forty days. Then they perished by their own excesses, by a shift of taste, and by the disfavor of religious reformers.

Outgrowths of the ecclesiastical drama were miracle plays and moralities, most noteworthy being *Everyman*, which is still occasionally revived. From the comic passages in the mysteries came the farce and the interlude, a primitive musical comedy. Troupes of professional actors began to travel the roads in high wagons, with a dressing room below and a platform stage above; and the modern theater was born.

Meanwhile, the genres that lie on the edge of creative literature were defining their aims and forms and producing their share of masterpieces. The writing of contemporary history was spurred by the universal curiosity about the crusades. Froissart presents us with an entrancing record of the latter days of chivalry. Marco Polo's book about his travels revealed a new world to the people of the West. In the field of biography Joinville's *Life of Saint Louis* stands supreme, along with the anonymous *The Little Flowers of St. Francis.* Devotional literature was primarily speculative and didactic, but the current of mysticism produced a series of splendid imaginations, from the works of Saint Bernard of Clairvaux to the Imitation of Christ.

The crown of medieval literature is Dante's Divine Comedy. It must be found in every list of great books, on every five-foot shelf. It is the greatest Catholic poem, as Paradise Lost is the greatest Protestant poem. It is a personal confession, an exhortation to virtue, a science-fiction story of a journey through the hell of sin and purgatory of reformation to the heaven of salvation, and an encyclopedia of current philosophical, theological, and scientific thought, the whole fitted into a frame of magnificent poetry. The Divine Comedy surpasses the Middle Ages; it was written for all ages. It is an eternal book.

IX The Artists' Legacy

Medieval artists rarely won personal acclaim and were seldom the subject of pictures. In this rare exception the artist, a woman in fact, is painting her self-portrait.

he pictorial art of the Middle Ages is the product of the creative impulse, which sought original expression, but inevitably conformed to ancient conventions, those of Rome and Byzantium, those of indigenous populations, and those brought by invaders and immigrants from the East.

A powerful influence on early Western art was exerted by the Scythians, pre-Christian nomads of the Asian and Russian steppes. Possessed by a rage for decoration, they covered their utensils and tattooed their bodies with elaborate stylized plant and animal designs. The flowing plants of Scythian work and the animals gnawing one another and blending with the plants, so unclassical, so Oriental, return in Romanesque and Gothic ornament and illumination. The devouring dragon haunts the early Middle Ages. Even in remote Scandinavia the stave-churches interweave their snarls of plants and creatures, and sprout their dragons from the eaves; and the Viking longships carry dragons at the prow.

Another influence on medieval art came from the Celts. Examples of the earliest types of Celtic design are found in Ireland-clasps, cups, jewelry, ornamented with free-flowing plant patterns, checkerboards, crisscrosses, dots, carefully bound by an edge or border. The Celts in Ireland and on the Continent loved color; they set bright stones in their ornaments or used brilliant enamels within raised edges of metal-cloisonnerie. They sometimes inserted grim little human faces in their designs. Such sculptured heads appear life-size in some of the early Celtic remains in France, and later peer out from the cornices and capitals of Romanesque art. Like much medieval decorative detail, the scrolly plants of jewelwork are usually à jour, that is, pierced to reveal a background of space. Some of the metalwork and jewelry present patterns that apparently originated in Persia and the Near East. The early Celtic taste influenced twentieth-century art nouveau.

Of early Germanic work not a great deal remains beyond earrings, brooches, belt clasps, cups, and such small objects, precious things easily carried, easily hidden, and no less easily lost for later times to find. They are commonly decorated in a zoomorphic style, naturalistic in origin but tending to form a pattern of conventionalized animal and bird forms. Scandinavian remains are similar to those of the Germans and are much more abundant.

The Germanic, or Nordic, taste came to England and Ireland with the Anglo-Saxons in the fifth century and again with the Danes and Norsemen to influence, without submerging, the native taste. The influence of both German and Celtic traditions is evident in the elaborate carved stone crosses, called Celtic crosses, decorated with plaitwork patterns, made of interwoven strap forms or similar knotwork.

A triumph of blended styles appears in the magnificent Irish manuscripts, such as the seventh-century Book of Durrow and the late eighth- or early ninth-century Book of Kells. The manuscripts are written in a Roman script, modified to suit traditional Celtic taste. The fantastically elaborate ornament, networks of endless curves, spirals, interlaced scrolls, straps, and knots, animal and plant forms, derives from both Celtic and Germanic models. The hierarchical human figures are recognizably Byzantine. The styles betray a remarkable resemblance with contemporaneous Coptic decoration. The art historian James Johnson Sweeney alleges a direct connection between the artists of early Christian Ireland and those of the Coptic monasteries of Egypt.

Anglo-Saxon art early became conscious of itself. A remarkable school of Christian sculptors flourished in England as early as the eighth century. These produced the decorated stone crosses that still stand, forlorn, by the sites of ancient churches. Much later, in the tenth century, a cluster of illuminators and graphic artists appeared in the south of England, centered in the Benedictine monasteries of Winchester. Their specialty was line drawing, particularly of human figures, rendered realistically in action. Their style was generally based on classical rather than on Celtic or Scythian forms. The Anglo-Saxons were also master goldsmiths and embroiderers.

On the Continent and to some extent in England the remains of Roman buildings and decorations gave early medieval people a constant subject for wonder and an eventual stimulus to imitation. The continuance of the Roman tradition was most manifest in church architecture. According to the sixth-century chronicler Gregory of Tours, the French pilgrimage church of St. Martin of Tours was a vast basilica on the Roman model, adorned richly with paintings and carvings. Roman decoration persisted—the scroll patterns, the flowering capitals, the repetitive themes of the moldings. The ever-present Roman example never lost its authority. French stonecarvers imitated Roman capitals and pilasters in the eleventh and twelfth centuries. The porch of Notre-Dame-des-Doms in Avignon might be mistaken for Roman work.

In both architecture and art the influence of Byzantium was paramount. The Byzantine taste was established in Rome at the time of the barbarian invasions, and it continued to exert its power through the centuries. In architecture Byzantium replaced the Roman dome, an engineering feat itself, with a loftier, graceful, sheltering dome set on cantilevered pendentives. Later, it contributed the dome raised on a drum and the use of multiple domes and apses. Thus Byzantium made monumental Western architecture possible.

In art Byzantines presented the West with glittering elaborations of ancient mosaics, atmospheric with their gold or blue backgrounds, the inspiration for Gothic stained glass. Byzantium gave its love of rich, Oriental color, which found a ready response among less sophisticated people and came to imbue all medieval art. And Byzantium imposed its method of representing sacred figures-stylized, formal, otherworldly, remote. An image of a saint was not an evocation of reality, it was a holy object in itself, a magic-working ikon. It had, therefore, to conform to tradition, with no intrusion of the artist's fancy. As the art historian Arnold Hauser says, Byzantium conceived that "art should be the expression of an absolute authority, of superhuman greatness and mystic unapproachability." The Byzantines preferred flat, shadowy, spiritualized forms, caring little for the organic life of flesh and blood, for the characteristic, the individual. The subjects, whether saints or emperors and their officials, are presented full-face, confronting the spectator, inducing humility. Arnold Hauser continues: "Christ is represented . . . as a king and Mary as a queen; they wear royal and costly robes and sit reserved, expressionless, and forbidding on their thrones. The long row of apostles and saints approaches them in slow and solemn rhythms, exactly like the Emperor's and Empress's train in court ceremonies."

Byzantine examples, Roman remains, and the traditions of the indigenous populations and of the barbarians combined to make a west European taste. An opportunity for its expression was given in the late eighth and early ninth centuries by the peace and prosperity of Charlemagne's reign. Not much remains of the era's architecture except the tomb chapel that Charlemagne built for himself at Aachen and consecrated in the year 805. In an earnest effort to be Roman he had a Byzantine design and plan copied, and augmented it with a fortresslike facade, towers, and projecting porch-the whole executed with a German massiveness. The structure forecasts the Romanesque style. Carolingian church architecture was adapted to suit current needs. In abbey churches great size was necessary to accommodate festival processions and pilgrim throngs. The choir was enlarged to provide for the increased number of singing monks. Chapels for favorite saints were set around the apse, and a crypt arranged for the relics of the church's patron saint. The walls were adorned with frescoes, painted panels, mosaics, stained glass, picturing biblical events and lives of the saints, and intended to instruct as well as to delight the aesthetic sense. "A picture is a kind of literature of the illiterate," churchmen said.

Of Carolingian graphic and plastic art little is left except carved ivory panels and manuscript illustrations. These show an admirable freedom of invention and a certain tendency to return to classical realism in the treatment of ornament and the human figure. Most notable is the Utrecht Psalter, done around 820, with line drawings by some nameless, accomplished, and original artist.

During the troubled ninth and tenth centuries, when Viking bands raided the West and local princelings raided one another, building almost came to a standstill—except in Germany during the brief Ottonian Renaissance of the tenth century. Most construction was of castles and protective walls. Whatever churches were built were fortresses. They had a defensive, unwelcoming look. Their exteriors were grim and unadorned; but within, one could find security and the promises of religion.

With the relative peace of the eleventh century came a great resurgence of architecture, with art as its handmaid. The "white robe of churches" that covered Europe is still our wonder and delight. The growth of old towns and the founding of new ones warranted the erection of gigantic cathedrals and churches. Misled by modern church attendance and nonattendance, we may judge the towns overchurched. But if half of a town with a population of five thousand attends high mass on Sunday, a big

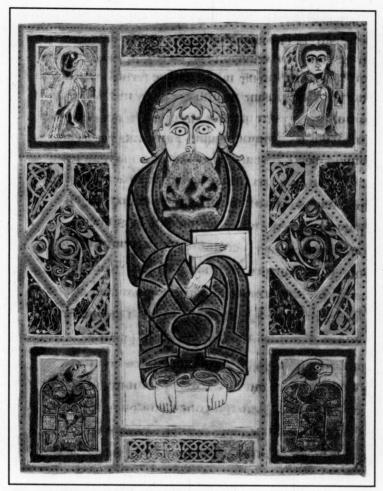

The art of the Dark Ages often displayed a decorative ebullience that seems more pagan than Christian. This page from an eighthcentury Irish gospel book depicts Saint Mark and the four evangelists. It is adorned with animal symbols, scrolls, and spirals, which also appear on artifacts of the Celts and of the barbarian Germans.

edifice is necessary. No doubt many rural areas were overbuilt with churches as a result of local rivalries. But in their time these churches were justified, and not by parochial pride alone. The only stone buildings in their region, they were likely to serve also as refuges against attack. Their uplifted towers or steeples gave the traveler his direction, their bells marked the hours of labor and repose, their decorations offered the poor peasant his one glimpse of a world of beauty and imagination.

Art was almost entirely religious. Sculpture existed only in the church; painting had no other patron in the early Middle Ages. The noble's dark, smoky hall was no place for art. But the church had been designed to display mural paintings, stained-glass windows, and an altar bright with glittering gold and stones. Art and architecture were a single unit; only later did they take separate courses. (It is curious today, with all our wealth, our builders cannot afford the decorative beauty customary in the relatively poor Middle Ages.)

Conscious symbolism governed medieval representation. Grammar, for instance, was pictured as an old woman with a knife and file to operate on students' mistakes. Rhetoric was an imposing woman whose dress was ornamented with the figures of speech. Conscious symbolism inundates our own lives. An arrow points the way to an exit or a public toilet, though an actual arrow is a rarity in our experience. Unconscious symbolism is even more pervasive. The medieval church may have taken the cruciform shape in order to supply additional space for the congregation in the transepts or to provide more side altars or bear the lateral thrust of the central tower. But the unconscious symbol is there, of Christ on the cross. His head is the chancel, surrounded with a diadem of little chapels; the doors are his pierced hands and feet. The church itself is a symbol of aspiration, with its spire pointing toward heaven.

The great European style of the late eleventh and the twelfth centuries is Romanesque, a well-chosen word meaning "sort of Roman." The Romanesque church descends directly from the Roman basilica. This was a large rectangular meeting hall or law court, terminating in a rounded apse, which contained a raised platform for the emperor or presiding magistrates. The upper part of the high nave, the clerestory, was pierced with windows. Side aisles, under a sloping roof below the clerestory, were set off by a single or double row of columns. This structure was readily transformed into a church by enlargement of the apse to contain the chancel and altar and by extension of the adjoining part of the building sideways, making a transept and giving the whole plan the form of a cross.

The Romans had bequeathed the medieval builders two devices for enclosing large spaces: the barrel vault, which is a half cylinder of masonry resting on the side walls, and the cross vault, which consists of two barrel vaults intersecting at right angles. The weight of this stone vaulting, thrusting downward and outward, demanded solid walls and massive columns or piers for support, and buttresses against the walls to strengthen them and counter the pressures from above. Windows, doors, and colonnades were round-arched. The structural requirements sometimes eliminated the clerestory and permitted little light to enter. The general effect was one of solidity, permanence, and gloom, but this was lightened by the brilliant cluster of candles on the shining altar, God's tabernacle and resting place. In the choir the singers' voices rose and rebounded from the stone ceilings with amazing resonance. The acoustic properties, presumably, were not mathematically calculated, but foreseen by experience.

In Romanesque churches, sculpture was always subordinated to architecture. It was usually in relief and was painted in bright colors, though it retained the feeling of the stone block or molding, its matrix or womb. Sometimes on doors and porches elaborate decorative schemes were devised. The sculptors of capitals were permitted much play of fancy. In general we may call their art expressionistic; except during the Carolingian period, it made little effort toward realism. It admitted exaggeration and distortion in order to gain its emotional effects. In Romanesque sculpture damned souls have a certain dignity, saints are spiritualized ascetics. (Christianity has no fat saints, no Buddhas.) Christ appears as king, seldom naked and suffering on the cross. The Madonna is the queen of heaven, not the sorrowing mother. The figures are commonly posed side by side, symmetrically, as in nineteenth-century portrait photographs. Action and movement are formalized, stylized.

Romanesque painting, whether wall frescoes or manuscript illuminations, or the rare glass of the time was flat and linear, with modeling suggested but used primarily as a pattern. The colors of the frescoes that remain are predominantly simple earth pigments, yellow, red, and black. The vegetable colors, such as blue from madder, have faded. The illuminators used a greater range of jewel-like coloring, with gold leaf added. Mostly they dealt with sacred subjects, but some amused themselves with animal drawings and with lively scenes from everyday life.

Romanesque, indeed all medieval painting and sculpture, was what is now called literary. It was illustrative, descriptive, telling a story, sometimes in sequences like a comic strip. It was not intended to be of independent interest; it was supplementary to architecture, to the written word, and to the voice of the preacher.

A rchitecture is always a compromise between needs and means. At the end of the eleventh century, an era of progress, the needs became evident—to build bigger churches for the assembling throngs and hence to replace massive masonry by lighter construction. The means that the architects discovered for dealing with these needs constituted the triumphant new style—Gothic architecture. The four elements of the new style are the pointed arch, the rib vault, the flying buttress, and the triforium, or arcade above the columns of the nave or choir. All these elements developed from the late Romanesque. The combination made a magnificent machine for worship.

The pointed arch, or ogive, came originally from the East. The Arabs used a great variety of arches, more for decorative than structural purposes. Besides the ogive, they contributed the horseshoe arch and the ogee, and the compound, the cuspate, and even the flattish forms used in late Gothic. They interlaced round arches, thus creating with the overlap a series of intervening pointed arches. The pointed arch was known in the West during the Romanesque period; the originality of the Gothic architects was in using it for cross-vaulting.

In the Romanesque cross vault, the lines of intersection are called groins. After a strengthening stone rib was applied to these groins, builders came to construct the ribs first, filling in the area between them with thin panels of stone. Then came the idea that a rib could begin at the base of a pier and go up it, curving to a junction with another rib; this suggested the clustered pier and the pier with applied ribs. The ribbed vault could be used to cover all sorts of irregular areas, and it could be raised to a considerable height. And since the thrust of the superimposed weight extended down through the ribs to the piers, the walls between the piers served no structural purpose and could be replaced by windows, affording more daylight for clerics and worshipers. The weight of stone roofs, which were now being used instead of wooden ones, pressed upon the piers and tended to push them outward. The piers were, therefore, shored up from outside by massive buttresses, and as even these were insufficient to contain the thrusts, flying buttresses were built to receive the push of the roof's ribs at the point where they met the walls.

The result of these innovations was to make a kind of stone skeleton, or exoskeleton, as the biologists say, outside the organism. The fat columns, ponderous arches, and wide wall-surfaces of Romanesque disappeared. The church interior ceased to be dark, a "penumbra peopled with flames," and became flooded with daylight. In many churches the decoration of the interior was confined almost exclusively to the glorious color of the windows. It was the exterior that was adorned, with towers, steeples, architectural fantasies, gargoyles, carved porches, statues in their niches.

The character of a great Gothic church is to be soaring, open, spiritual, defiant of earth's gravity, reaching to heaven, not because of, but "in spite of the stone," as the art historian Wilhelm Worringer has said. There were, however, national as well as local and individual differences. In Italy Gothic style seems often no more than a pattern imposed on the Romanesque, for in that sunny land the builders retained their sheltering walls. deep arcades, and small windows. In Spain the Moorish taste persisted, influencing the style and plan of many churches. Seville Cathedral, the biggest and widest of all Gothic cathedrals, is built on the foundations of an old mosque; its famous Giralda Tower was the mosque minaret. Spanish ornament is particularly rich and varied. Many churches have ornamental iron grilles-characteristic of Spain-separating the choir from the nave. French Gothic always retained something of the classical feeling of an envelope of continuous mass and structure, and a unified plan dominating ornament. German Gothic tended to be more soaring and ecstatic, nervous-looking and tenuous. Germany and the Low Countries constructed in the Gothic style a great many secular buildings, markets, guildhalls, town halls,

English churches favor an exceptionally long nave for processions and a massive square tower over the crossing of nave and transepts, in place of the Continental steeple. In Syria the crusaders followed French styles, but often their structures had flat roofs to make terraces for relaxation in the evening cool. But all Gothic tended to grow steadily more vertical, freer and more varied in structure, less severely geometrical, until the shapes of ribs and tracery seemed to flow upward as did the plant scrolls of the early Celtic artists.

The first tremors of Gothic architecture were felt in France about 1100. At that time the pilgrimage church of Vézelay was built, with domical cross-vaulting, to permit a high clerestory. Shortly afterward a narthex, or covered entrance porch, with pointed, though not ribbed. cross vaults. was added. Gothic elements may be discerned in the twin abbeys erected by William the Conqueror and his wife in Caen, in the English cathedral of Durham, and elsewhere. Around 1140 the illustrious Abbot Suger of the Benedictine abbey of St. Denis, just outside Paris, built the first great, unmistakably Gothic church. The first Gothic cathedral was that of Sens, begun at about the same time. In the following century eighty cathedrals and five hundred large Gothic churches were constructed in France alone. Gothic soared to literally dizzy heights. The crest of the Beauvais choir roof is 224 feet from the ground. The north tower of Chartres stands 375 feet high, that of Strasbourg 466 feet, of Ulm 525 feet. (The Ulm tower, designed in the fifteenth century, was completed from the original plans in the nineteenth.) Such heights were not to be achieved again until the nineteenth century, with the building of the 550-foot Mole Antonelliana in Turin and the Eiffel Tower in Paris. Some of the cathedrals are vet uncompleted; Goethe said they are uncompletable since they are in the process of endless development. Gothic bloomed again as Victorian Gothic in the nineteenth century and as "Girder" Gothic in the twentieth. At this writing it is out-offashion, partly because it is too difficult and expensive to build. But Gothic is not yet dead.

Romanesque sculpture had specialized in the ornamentation of moldings, tympanums, and capitals. Gothic architects lost interest in capitals, which interrupt the flow of lines from floor to vaulted roof. Their pleasure was rather in figure sculpture, putting saints in exterior niches and representing sacred dramas, as of the Last Judgment, in the porches. The interior displayed splendid tombs and memorials. The sculptors' mood was realistic. They observed and imitated nature, presenting free-standing, three-dimensional figures, with a continuous progression of planes. Foliage and other details became ever more hollowed, undercut, and tenuous. The figures, far from being the formalized types of the old Byzantine tradition, were individual, recognizable characters. Most of the work was not usually done in place, but in the comfortable warmth of the masons' lodge at the site.

A notable example was the great gilded statue of the Archangel Michael, which crowned the abbey church of Mont-Saint-Michel. He served as a weathervane and turned on his base, forever holding out his sword in defiance of the storm. (He must have turned on very delicate bearings. What were they like? Who lubricated them and how?) The monks believed that if he should ever be cast down, the abbey would be smitten as well. The statue was struck by lightning in 1788, and very soon afterward, the revolutionists banished the saint and his devotees from their home.

In the early Middle Ages only a saint was permitted a sculptured tomb. But proud kings and nobles demanded the privilege of saints—hence the profusion of marble knights and ladies recumbent in Gothic churches. The later artists, seeking realism, caught the look of their subjects in life. Eventually portrait statues and sculpture moved from the church to decorate the ostentatious castles of the nobility.

Gothic painting sought vainly to attain the realism of sculpture, for such an achievement requires an understanding of perspective, foreshortening, and modeling in light and shade, to turn three dimensions into two and create an illusion of depth. In the High Middle Ages the walls of castle halls were sometimes painted with scenes of history and chivalric adventure. Time and damp have destroyed them. Manuscript illuminations have survived in great number, however. The art of illumination tended toward naturalism and displayed great technical competence. Manuals for illuminators reveal a high proficiency in the purifying, grinding, and mixing of colors. By the thirteenth century the artists permitted themselves fanciful landscape backgrounds and free compositions. They represented emotions,

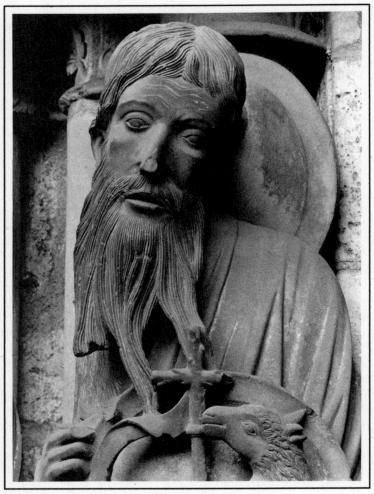

Medieval sculpture was primarily of a religious nature, since most of it was intended to decorate church facades, altars, and tombs. The thirteenth-century carving of John the Baptist shown here adorns a portal of Chartres Cathedral. such as grief, in the postures and facial expressions of their figures. Illuminators in the fourteenth century delighted in grotesqueries and profuse ornament, rendered in rich color. Anonymous though the artists were, we can recognize the personal touch of these many gifted masters, creating beauty for the glory of God.

The particular triumph of Gothic painting was stained glass, which told the stories of the Christian faith in colored sunshine. *Stained glass* is a bad term, for the color was infused into the glass, not stained on its surface. It is sometimes said that the art is now a lost one, that we cannot reproduce the blues of Chartres. However, the twelfth-century German Benedictine Theophilus gives detailed directions in his *De Diversis Artibus* (On the *Different Arts*) for designing and making stained glass. He reveals that glassmakers were pilfering and grinding up ancient mosaics to get some of their best colors.

A large cathedral might contain ten thousand figures, pictured in glass within and in stone without. It was a school of sacred history and of dramatized theology. It was as well a public art gallery, a concert hall, and sometimes a library. It was designed to answer most of man's spiritual needs, in this world and the next.

The cathedral artists were well aware of the merits of their work and of their own merits. They expected the faithful to respond with increased faith and ardor. Wrote the monk Theophilus to a pupil: "Animated, dearest son, by these supporting virtues, you have approached the House of God with confidence, and have adorned it with so much beauty: you have embellished the ceilings or walls with varied work in different colors and have, in some measure, shown to beholders the paradise of God, glowing with varied flowers, verdant with herbs and foliage, and cherishing with crowns of varying merit the souls of saints. You have given them cause to praise the Creator in the creature and proclaim Him wonderful in His works. For the human eye is not able to consider on what work first to fix its gaze; if it beholds the ceilings they glow like brocades; if it considers the walls they are a kind of paradise; if it regards the profusion of light from the windows, it marvels at the inestimable beauty of the glass and the infinitely rich and various workmanship. But if, perchance, the faithful soul observes the representation of the Lord's Passion expressed in art, it is stung with compassion. If it sees how many torments the saints endured in their bodies and what rewards of eternal life they have received, it eagerly embraces the observance of a better life. If it beholds how great are the joys of heaven and how great the torments in the infernal flames, it is animated by the hope of its good deeds and is shaken with fear by reflection on its sins."

The building of a suitable house for God stretched people's imaginations and abilities to the utmost. First came the idea, the inspiration, which hardened into purpose, which sought and found the means to bring the great achievement into being.

Abbot Suger of St. Denis happily recalled the process that resulted in the first truly Gothic church. His old Romanesque basilica, containing a nail from the Crucifixion and a piece of the crown of thorns, was so popular a bourn of pilgrimage that on high holy days men and women were trampled and nearly suffocated. Suger decided to enlarge and rebuild his church, taking advantage of new methods of construction, which he could have seen at Vézelay. He proposed to bring columns from Italy by sea, along the Atlantic coast and up the Seine. But just in time a deep ancient quarry was discovered in nearby Pontoise. "Whenever the columns were hauled from the bottom of the slope with knotted ropes, both our own people and the pious neighbors, nobles and common folk alike, would tie their arms, chests, and shoulders to the ropes and, acting as draft animals, draw the columns up; and on the declivity in the middle of the town the diverse craftsmen laid aside the tools of their trade and came out to meet them, offering their own strength against the difficulty of the road, doing homage as much as they could to God and the Holy Martyrs." On one occasion seventeen persons - some of them weak and disabled, and the rest mere boys-miraculously pulled up a column, a feat that would have baffled a hundred strong men. The next problem was to find rafters, long, straight, and stout enough to support the roof, which was evidently to be of wood. The abbot was assured that none were left in the whole Paris region. Taking no one's word, he went himself to explore the dense woods, and in nine hours discovered twelve tall, straight trees, exactly the number required. For, as he points out, God grants all things according to weight and measure. With the aid of geometrical and arithmetical instruments the lines of the new structures were brought into harmony with the old, and many new windows poured light into the interior. Gifts arrived from all Christendom. And when the main arches were in place but not yet cemented together, the devil, who has much authority over weather, sent a frightful storm, mighty enough to blow down stone towers and wooden bulwarks. But a bishop, celebrating mass at the altar, defeated the tempest by pointing at it the arm of Saint Simeon, so that the storm "was unable to damage these isolated and newly made arches, tottering in mid-air, because it was repulsed by the power of God."

The success of St. Denis inspired most of the bishops of France with the desire to build cathedrals in the bold new style. The first step was to raise money. In each town the bishop, canons, and local magnates set an example of liberality; the king was always good for a handsome donation. Then a regular campaign was mounted. The pope granted indulgences to generous givers. Fund raisers were given a banquet (now it is called a kickoff dinner); they then ranged the diocese, armed with relics and employing advanced campaign techniques: rousing moral fervor, reporting miracles, promising unearthly rewards or penalties, and appealing to such human failings as pride, rivalry, shame, and fear. Individuals and groups were offered special recognition: thus at Chartres nineteen trade guilds contributed windows. The smallest gifts were not disdained. "The cathedral of Paris was largely built with the farthings of old women," said a contemporary prelate. Not only old women; it is said that the prostitutes' guild of Paris offered a window or a chalice for Notre Dame. It was decided that the gift could be accepted, but would receive no publicity.

An architect, or master mason, was engaged. He surveyed the site and drew plans and elevations of his projected church. The ridiculous legend has been spread that the cathedrals were built without plan, according to each day's inspiration. The existence of detailed plans at Reims, Strasbourg, and Siena gives the lie to this story. The architect sometimes presented a model, as did Giotto when he proposed to build the campanile in Florence. The architect was a man of substance and consideration. He was well paid and often received a house and other perquisites. It used to be said that he worked only for God's glory and not at all for his own; but in fact he carved his name on the fabric whenever possible. He designed the detail as well as the overall structure, using for his drawing wooden boards, plaster slabs, or slates, as parchment was usually far too expensive.

Commonly there was no contract builder; this task was also the architect's. He employed a clerk of the works for supervision. The architect had an enormous corps of workers, well over a thousand for a cathedral. Of these the elite were the masons. They were of two sorts: The rough masons, who cut, laid, and mortared the heavy stones, and the freemasons, who carved the "free" stone for the vaultings, window traceries, and ornamental sculptures. Their task was a delicate one, permitting no mistakes or second thoughts. There were many other artisans—carpenters (for the arch frames, choir stalls, and furniture), glaziers, metalworkers, painters; and also the unskilled workers—mortarmen, barrowmen, hod carriers.

The stone came from quarries, which in France were never far distant from the building site. It is estimated that from 1050 to 1350 France quarried more stone than did ancient Egypt for the pyramids. The Caen limestone of Normandy, which takes the chisel as a caress, was shipped in great quantities to England. To save transport expenses, much of the stone was roughcut at the quarries, according to the architect's specifications. The actual construction of walls, vaults, and towers was a technological feat of the first order. The mounting walls bristled with scaffoldings, made of roped poles and saplings, for sawed or handhewn planks were scarce and costly. The stones were hoisted into position by windlasses, pulling ropes over pulleys attached to temporary jutting beams. (The slots for the beams are often still visible.) The lifting of the stones by successive stages to the top of a 450-foot tower was a triumph of hand-power engineering. The construction techniques for a vault over the side aisles or the central nave must have derived from the building of arched bridges. Wooden frames were set up, resting on the piers. Then the ribs of carefully cut stones were set on the wooden frames and cemented together. The space between the ribs was filled with thin-cut stone or sometimes with rubble. Then the wooden centering was removed, to be used again in the next section of the vaults, and the underside of the vault was plastered. It was a daring and hazardous operation; any miscalculation was likely to end in disaster. The crash in the year 1284 of the Beauvais Cathedral vault, which had stood 157 feet from the floor, has not ceased to echo.

The workers were strictly unionized. Though zealous amateurs occasionally joined in to make cathedral building a communal enterprise, volunteer labor was not generally welcomed. There is a story in one *chanson de geste* of a pious soul who worked on a church only for pennies; the professional workers killed him. (But the fishes of the Rhine bore his body downstream, ringed with lighted candles.) The masons, most of whom were migrants, lived and worked in "lodges" near the edifice. (The word was revived, together with the mason's symbols, the T-square and compass, in modern Freemasonry. True, the mason-builders met often in solemn conclave, probably on company time, to regulate trade uses and abuses, but there seems to be no evidence of rituals or of esoteric practices among them. Only later did they develop secret grips and other recognition signs.)

The craftsmen, skilled artisans, were laymen, though monks and lay brothers sometimes lent a hand in the building and upkeep of their abbey churches. The fine arts-sculpture, painting, and illumination-were in the beginning the occupations of the clergy alone, but these too fell more and more into the hands of nonclerical professionals. Socially these artists did not rank very high. They were paid artisans' wages; their guild was sometimes a branch of the saddlers' guild. The public esteemed them no more than any other worthy craftsmen. Dante lauded two thirteenth-century illuminators; one of his first commentators marveled that he should thus immortalize "men of unknown name and low occupation." But "thereby he giveth silently to be understood how the love of glory doth so fasten upon all men indifferently, that even petty artisans are anxious to earn it, just as we see that painters append their names to their works." But even if the artist did not receive the adulation that was to be his in later times, we need not spend overmuch pity on him. He was better off than his cousins at the plow or in the workshop. He had full-time employment, decent pay, and jolly companionship; and he had the satisfaction of seeing his work not merely applauded but worshiped. When he watched the clustered groups kneeling before his Virgin or his saint, he must have felt that his handiwork was approved in heaven.

The great Gothic style of the thirteenth century changed and developed. It was succeeded in France by the Flamboyant style-so called for its flamelike window tracery-and in England by the Decorated Gothic, which was in turn succeeded late in the fourteenth century by the Perpendicular style. These styles are exaggerations and complications of thirteenth-century Gothic. They are marked by daring developments in design, by the ogee or double-curving arch, by multiple-centered arches, by profusion of fanciful ornament, by consummate constructional dexterity. Historians are likely to be very commiserating toward these late Gothic works, calling them overdecorated, theatrical, even degenerate, after "the monumental stateliness and idealized nobility of the thirteenth century." The historian J. Huizinga says that "the flamboyant style of architecture is like the postlude of an organist who cannot conclude." Less sophisticated or more flamboyant observers are nonetheless permitted to admire the Rouen Cathedral, or the florid constructions of Flemish cities, or the miraculous fan vaulting of Henry VII's chapel in Westminster Abbey and of King's College Chapel, Cambridge.

The calamities of the mid-fourteenth century interrupted the builders, especially in France. The Black Death arrived in 1348 to kill perhaps half of the population of Europe. It swept through the crowded dorters of the monasteries and put an end, for a time, to pilgrimages. The first English invasion of the Hundred Years War came in 1346; ravaging bands sacked French churches and towns. France lacked money, skilled workers, and incentive to build or even to repair.

While France surrendered to discouragement and apprehension, other countries, less afflicted, resumed building in late Gothic styles. The Low Countries, especially, displayed their pride in magnificent municipal buildings. Such are the pompous town halls of Brussels, Bruges, and Louvain. We recognize in them the laicizing of architecture. The impulse to build passed from the bishops and clergy to the rich bourgeois and patrician businessmen, such as the Medici in Florence. These erected their imposing town houses in the north, their palazzi in the south. They commissioned opulent tombs and hired the best artists to decorate their chapels and paint their portraits. They bought art for their pleasure and with an eye to profit. (There was a regular art market in Avignon.) The vogue for portraits and decorated

The results of the evolution from Romanesque to Gothic style are visible in this photograph of the cathedral at Bourges, in France. An intricate system of arches and pillars, aided by the flying buttresses outside the walls, supports the high central vault of this thirteenth-century structure. interiors was a very nice thing for artists. Instead of standing on a scaffold before a church wall, they could sit at ease in a studio and paint an altar triptych or a flattering picture of a patron and his wife, dressed in the finest of their finery.

In Italy a new spirit was formed, inspired by fourteenth-century humanism, the desire to emulate the intellectual achievements of ancient Rome. Rich men collected classical art; architects studied Roman buildings, with a view to imitation. The first clear break with Gothic tradition came with the mighty 300-foot-high dome of Florence Cathedral, built between 1420 and 1434 by Filippo Brunelleschi, architect, sculptor, engineer, mathematician, and goldsmith, an unmistakable Renaissance man.

Much earlier, in the opening years of the fourteenth century, Italian painters were struggling toward a new technique. Duccio, Simone Martini, and other Sienese strove for realism. The Florentine Giotto is hailed as the father of Renaissance art. With skillful foreshortening he obtained a three-dimensional effect, and thus an illusion of reality.

In the following century appeared the great Flemish painters: Rogier van der Weyden, Hans Memling, the brothers Hubert and Jan van Eyck, and the rest. They brought to art not merely the new technique of oil painting but a remarkable realism in portraiture and in the rendering of household interiors, fabrics, and reflected light. Bourgeois themselves, they responded to the demands of their bourgeois patrons, who dealt in fine goods and wanted them honestly reproduced in paint. This realistic art gives us precious documentation on the background of medieval life. It continues to enchant the museum wanderer, though Michelangelo once said it should appeal only to children and old women.

Art in the declining Middle Ages was not content to picture life realistically; it went beyond death to contemplate the body's decay. A favorite theme was the dance of death, wherein grinning Death comes to take hands with proud ladies, with kings, rich merchants, magnificent prelates, and so on down to the peasant torn from his plow. The dance of death was limned on church and cemetery walls and in the block prints that began to circulate among the common folk in the fifteenth century. Whereas earlier Christian art had expressed serenity, hope, heaven's promise, fifteenth-century religious art stressed suffering and horror. Christ hung tortured on his cross, the crown of thorns pressing on his brow, the wound in his side dripping blood. The vivid martyrdoms of the saints seem intended not so much to arouse pity and admiration as to appeal to perverse imaginations. Modern writers are inclined to find in this gruesome art an indication that the fifteenth century, a period of discouragement, war, and dwindling faith, was obsessed with death. It would be well not to push this conclusion too far. In the first place, the century is marked by recovery and revitalization as well as by despair; in the second place, there is plenty of cheerful art to set against the *memento mori* style; and in the third place, art is not always a very accurate representation of the moods of ordinary life.

Music is said to be universal. Everybody sings or tries to. The people of antiquity made music one of the seven liberal arts that constituted the educational curriculum. The early Christians inherited the Jewish chants of the synagogues. Echoes of these persist, as in the elaborate pitch variations of Christian church music. At first the Christian congregations sang in chorus or antiphonally; later, choirs of superior singers performed.

The ecclesiastical style settled into the form of plain chant, also called plain song or Gregorian chant. Pope Gregory the Great did not invent the plain song, but he encouraged it, as opposed to other singing styles, and he supported a *schola cantorum*, or "singing school," to train boys in rendering it. Plain song depends entirely on the words of the text; it is a free recitative in the major key of C. All the notes are approximately the same length and are sung in unison. It is a very simple and effective style; it has lasted nearly two thousand years.

Harmony is implicit in the effort of men's and women's differing voices to sing the same tune and make pleasant variations on it. Harmonic schemes appeared in the eighth century or shortly after. They came perhaps from Celtic or Germanic sources. The voices sang the same melody, with intervals of a fourth, a fifth, or an octave; thus a performance in four parts was possible. In the ninth and tenth centuries came the sequence and the trope. In the church service it was the custom to vocalize elaborately the last *a* of the Alleluia; these elaborations became independent melodies. The sequence was a set of words composed to fit them. The trope began as a verbal formula inserted between the words or phrases of the liturgy, as between Kyrie and eleison; it developed into lengthy additions, even entire poems. These additions and freedoms made independent composition possible, and they called for a method to record and preserve them.

Music notation was originally merely a set of small marks, a sort of shorthand, written above the words to indicate the rise and fall of the voice and changes in emphasis, without specifying the duration of the notes or the exact pitch. Only in the eleventh century was the staff of parallel horizontal lines invented to indicate pitch. At the same time the notes were named—ut, re, mi, fa, so, la, from the opening syllables of the successive lines of a familiar hymn: Ut queant laxis/Resonare fibris....

To keep voices singing in harmony under control, it was necessary to distinguish the duration of the notes and group them in time units. This is mensural music. Notes were recorded, in the twelfth century, with black squares and diamonds on little poles. The modern form of notation came in around 1600.

The influence of secular music on church music was obviously great, but it remains very obscure. Literature gets written down, architecture stands in stone, art in paint, but music is blown away on the wind. Very few early folk songs, words or music, have been preserved. Our knowledge of secular music begins with documented troubadour melodies and the Goliard songs of the twelfth century. Their range is narrow; they betray an evident affinity with both folk music and church styles.

Medieval people must have been practiced singers. Countryfolk had not much to do on dark winter evenings but sing and tell stories, and many of their stories were couched in ballad form. People sang while they danced, for instruments were clumsy and dear, at least in the early Middle Ages; and probably people sang while they worked together, as sailors did until yesterday. Troubadours and minnesingers composed music to fit their words, and performed to the accompaniment of a fiddle or a small harp. Gentlemen learned to sing as a matter of course, either in their courtly education or at school. At Winchester College the subjects for scholarship examinations were reading, Latin grammar, and singing.

People loved music and honored the singer. Brother Salimbene, that engaging thirteenth-century Franciscan, gives us a couple of case histories of musical friends, which reveal something of singers' styles and composers' methods. Brother Henry of Pisa "was skilled . . . to write music, to compose most sweet and delightful songs, both in harmony and plain-song. He was a marvelous singer; he had a great and sonorous voice, so that he filled the whole choir; but he had also a flute-like treble, very high and sharp; sweet, soft, and delightful beyond measure. . . . Having heard a certain maidservant tripping through the cathedral church of Pisa and singing in the vulgar tongue,

If thou carest not for me, I will care no more for thee,

he made then, after the pattern of that song, words and music of this hymn following:

Christ divine, Christ of mine, Christ the King and Lord of all.

Moreover, because when he . . . lay sick on his bed in the infirmary of the convent of Siena, he could write no music, therefore he called me, and I was the first to note one of his airs as he sang it. . . .

"The second air of [his] words, that is, harmony, was composed by Brother Vita of the city of Lucca, and of the Order of Friars Minor, the best singer in the world of his own time in both kinds, namely, in harmony and plain-song. He had a thin or subtle voice, and one delightful to hear. There was none so severe but that he heard him gladly. He would sing before Bishops, Archbishops, and the Pope himself; and gladly they would hear him. If any spoke when Brother Vita sang, immediately men would cry out with Ecclesiasticus, 'Hinder not music.' Moreover, whenever a nightingale sang in hedge or thicket, it would cease at the voice of his song, listening most earnestly to him, as if rooted to the spot, and resuming its strain when he had ceased; so that bird and friar would sing in turn, each warbling his own sweet strains."

In the twelfth century appeared the descant, or an ornamental variation above the plain song; this developed into counterpoint, and this, by the fourteenth century, into a complicated polyphony, or part singing. People sang madrigals and rounds, such as

Simone Martini was one of several Italian artists whose work showed the beginning of Renaissance style. Together with the famous Duccio, Martini strove for threedimensional effect in his portraits, unlike the flat works of the Dark Ages. The artist painted this pair of musicians playing double flute and mandola. "Sumer is icumen in," a six-part round written shortly after 1300. In the fourteenth century music came into its own. Philippe de Vitry published his Ars Nova, which introduced new rhythmic procedures and complex harmonic arrangements. Laypeople were able to make a career as composers and performers. Every prince and cardinal had his musical staff and *cappella*, his private orchestra. Especially in northern Italy a public of musical connoisseurs existed, stimulating composers to seek subtle, tenuous effects. Technical mastery and the conquest of difficulties were recognized and applauded.

Early music was primarily vocal, with instruments used only for accompaniment. The organ, known to the ancients, appeared in France in the eighth century. According to Professor Grout, it was "a raucous and somewhat unmanageable instrument." The organist operated it by pulling out stops. At Winchester in the tenth century was a famous organ with four hundred pipes and twenty-six bellows; it filled the church with an enormous indistinguishable roar. By the thirteenth century the organ, played from a keyboard, was much used in the choir to accompany masses.

The harp was apparently born in Ireland or Britain; before the ninth century it reached the Continent, where it was called "the English zither." Other early instruments were the vielle, prototype of the violin, and flutes and shawms, trumpets, bagpipes, drums and tambourines. Later came lutes, psalteries or triangular metal-stringed zithers, monochords or double basses, hurdygurdies, and other inventions. The earliest compositions for instruments alone date from the thirteenth century. These were performed at courtly functions. We hear of a fourteenth-century concert by an orchestra with thirty-six kinds of instruments.

Thus in music, as in literature, art, and architecture, the Middle Ages formed new aesthetics and applied them to artistic production with novel means and techniques. Their achievements were tremendous; but in each field they seem to have come to a natural stopping-point. Involved, fine-spun conceits in literature, flamboyant architecture, and the music of *Ars Nova* proceed from the same fundamental taste, a refinement that threatens to turn and destroy itself. By the end of the fifteenth century people were seeking something still newer. What they sought, and what they found, was Modern Times.

X End of an Era

The funeral cortege of King Charles VI moves outside the gates of Paris.

reflective European of the year 1300 would have been entitled to look on his world with a good deal of satisfaction. Progress during two centuries had been constant, even, if one came to think of it, amazing. The land was dotted with new towns and cities, secure behind their walls. adorned with noble churches, and filled with comfortable homes. Spacious castles offered amenities for the gentry and refuges for countryfolk in case of trouble. Food was cheap and plentiful, as a result of intensive agriculture. Business was good: the roads and seaways were usually open. A burgher in Scotland or Sweden could order wines from his favorite French vineyard, dress his wife and himself in Oriental damasks and brocades, and flavor his foods with spices from the world's extremities. He could send his promising son to a university, where the boy would find great freedom to speculate and argue, within, of course, the reasonable limit set by the faith. The kings had more or less settled down behind borders determined by race and language; they had, in general, gained power enough to keep their turbulent nobles in check. Islam was rolled back in Spain and. southern Italy; Christendom extended from Slavic eastern Europe to Greenland. The long disaster of the crusades had ended and had been succeeded by a booming trade with the East. The reflective European might have concluded, with Voltaire's Babouc: "Si tout n'est pas bien, tout est passable (If all is not well, all is at least tolerable)."

It is true that the nobility had lost much of their independence to their kings and much of their wealth to the rising bourgeoisie. The feudal system had been weakened, and with it the old chivalric principles. The clergy were torn by dissension, especially by the rivalries of secular priests, monks, and friars. The bourgeois, increasingly prosperous, purchased estates and gained titles and married their daughters into the nobility. Rulers—in the Mediterranean lands at least—chose their advisers and executives less from the lords and high prelates and more from competent civil servants of undistinguished birth. In France there appeared the *noblesse de robe*, magistrates and government officials, with the gown not the sword as the mark of their eminence. In Italy, especially, class-consciousness was much infringed. Boccaccio tells of a baker who invited the pope's ambassadors to drink wine; in return he was asked to dinner with the most honorable citizens. Petrarch was superbly entertained by a literary goldsmith. Dante, who piqued himself on his nobility, was a member of the apothecaries' guild.

The peasants, borne on a rising tide of prosperity, were probably better off than they would be again for centuries. Many were able to buy their liberty and become landowners. Louis X of France freed all the serfs in 1315 on the grounds that according to natural law every man is born free. (However, he made the serfs pay for their freedom.) Slavery, to be sure, was not extinct. In theory it was confined to non-Christians; in practice slave traders did not inquire closely into the faith of their captives.

The happy times, or relatively happy times, could not last. Population increase turned into overpopulation, as we may infer from the subdivision of landholdings into ever smaller units, from the effort to exploit marginal lands, from the growth of towns, with their hungry, rebellious proletariats. England's population rose from about 1,100,000 in 1086 to an estimated 3,700,000 in 1346. Bad weather brought famines; a very ugly one afflicted Europe from 1315 to 1317. There was, of course, no governmental organization of famine relief, no system for arranging and financing the movement of surpluses from areas of plenty to those of want. Sharp corn factors, especially those who were also millers, hoarded grain, holding it for high prices. The church did its best with almsgiving, but in famine country the church was nearly as poor as its charges. When the starving found a store of food, they were likely to eat so ravenously that they died.

During hard times industrial production in the towns was seriously curtailed, and many workers were thrown out of their jobs. The equilibrium of supply and demand was upset. Governments discovered inflation. They could not, of course, print bank notes, but they could reduce the amount of gold and silver in their coins. Base metal showed through, as it does in our quarters and dimes. The poor, unable to comprehend economic theory, blamed their increasing poverty on the machinations of the great and proposed to better their lot by killing their masters.

In France, ravaged by the Hundred Years War, the rebel mood showed itself in town and country. In Paris the Estates General of 1355, led by the provost of merchants, Etienne Marcel, made revolutionary demands to control the national finances and hence the kingdom. Marcel turned demagogue, courted the mob, invented the famous phrase "the will of the people," and also the liberty cap of red and blue. But as happens so often, the rebel defeated his own purposes by his exorbitance. In July 1358, Marcel was assassinated.

In the countryside discontent turned readily to violence. "We are men formed in Christ's likeness, and we are kept like beasts," said the peasants. They responded to the excesses of a highhanded lord with worse excesses. Their procedure was to break into a manor house, drink the choice wines, murder the hated bailiff, and burn the house with its rent rolls and records. Then the neighboring lords and often the king himself would send punitive troops, whose atrocities would outdo those of the peasants. The most famous uprising was the *Jacquerie*, which began in the Beauvais region in 1358, when men were killed if they did not have the horny hand of the toiler.

Italy had its share of troubles. In Florence the *Ciompi*, common workmen, seized power and ruled with surprising moderation for four years, from 1378 to 1382. In Rome in 1347 the lowborn but well-educated Cola di Rienzo rebelled against the nobles and church authorities, and attempted to reestablish the ancient Roman republic. But he promised the mob more than he could deliver, and eventually the Romans removed his head and hung the rest of him by the feet from a balcony of the Colonna Palace. (Mussolini admired Cola and proclaimed him a proto-Fascist; and history decreed that he too should hang by the feet, though only at a Milan filling station.)

English villeins also learned the delights of riot and plunder. Unpopular abbeys were pillaged and burned. In London in 1326 the mob beheaded the city's bishop and left him naked in the street.

England's great social protest was the Peasants' Revolt of 1381, which approached the dimensions of a revolution. The times were filled with war, plague, suffering, and anger. Although there was a shortage of labor as a result of the plague, the lords were declining to increase wages. The serfs demanded freedom and refused their feudal duties. A golden-voiced priest, John Ball, ancestor of all social-conscious clerics, preached to assembled throngs from the text: "When Adam delved and Eve span, who was then a gentleman?" He shouted: "Ah, ye good people, the matter goeth not well to pass in England, nor shall not do so till everything be common, and that there be no villeins or gentlemen, but that we may be all united together and that the lords be no greater masters than we be. What have we deserved or why should we be thus kept in serfdom? We be all come from one father and one mother, Adam and Eve." He is said to have nominated himself for the post of archbishop of Canterbury, and he promised to liquidate all religious houses and distribute their possessions. Other natural leaders sprang up to be the prophet's generals, among them Wat Tyler and Jack Straw.

In June 1381, three ragged armies converged on London, which fell as easily as the Bastille was to do four hundred years later. The invaders seized and beheaded the archbishop of Canterbury, the lord treasurer, and other officials. As these were dragged off, says the contemporary Thomas Walsingham, "a most horrible shout arose, not like men's shouts, but worse beyond all comparison than human cries, and most like to the yelling of devils in hell." The insurgents' program, according to the certainly prejudiced reports of their enemies, was to expel all clergy, with the possible exception of the friars, to seize the lands of the nobles and gentry, putting them to death, together with all government ministers, lawyers, and judges. They proposed to behead all foreigners and anyone who could write a letter.

However, the rebels protested their loyalty to the king, fourteen-year-old Richard II. He consented to come to a parley. Surrounded by city officials, the king rode into the open square of Smithfield. Wat Tyler, also mounted, met his monarch there and greeted him with swaggering insolence, shaking his hand and addressing him "comrade," calling for beer, rinsing his mouth in peasant style "in a very rude and disgusting fashion." This was more than the king's gentlemen could endure. They dragged Wat Tyler from his horse, and one of the royal squires stabbed him to death. In the moments that followed, the king's party gained the upper hand, and the peasant army was dispersed.

In the country and towns the rioters had been attacking manor houses and abbeys, to burn charters, leases, and court rolls. Says Walsingham: "They punished by beheading each and all who were acquainted with the laws of the country.... They

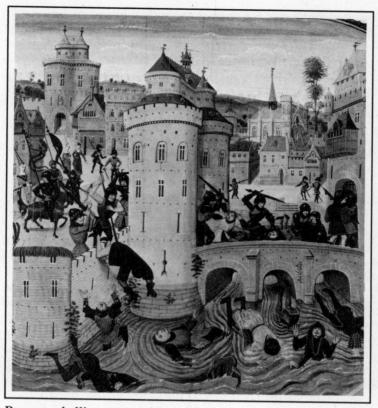

Peasant rebellions erupted in several corners of fourteenth-century Europe. Overpopulation and famine turned workers into desperate fighters. In a weakened postwar France the most famous uprising, the *Jacquerie*, was violent but brief. In this illustration the nobles hunt down and massacre the mob of peasant insurgents. were eager to give old records to the flames and lest any should for the future make new ones they put all such as were able to do so to death. It was dangerous to be recognized as a clerk and such as were found with an inkhorn by their side seldom escaped their hands... The memory of ancient things having been lost the lords would not in the future be able to vindicate any kind of right against them."

Violence wounds its own cause. The rebellion rapidly disintegrated. John Ball and other leaders were executed, and their severed heads displayed on London Bridge. Amnesty was granted the followers on the condition that they disband and return to their homes. The uprising had followed a normal sequence: discontent; the appearance of compelling leaders to focus the discontent and propose alternatives; an onrush to the seizure of power; brief, bloody, drunken domination; failure of constructive purpose; reaction of the conservative, propertied classes with their weapons and troops; and a white terror to match the red terror.

These uprisings reveal a revolutionary spirit menacing to social stability. But it is easy to overrate their importance. They came but rarely in the course of two centuries, and they struck only in a few scattered regions. People might grumble and threaten; not many would ever join together to turn discontent into violent action. The system of social and political control, imposed by authority and accepted by custom and habit, was too strong for the rebel mood. Revolt is abnormal; the historian's first duty is to recognize the normal.

During these later years of the Middle Ages the spiritual health and authority of the church declined. For it the thirteenth century ended badly. In 1292 the cardinals could not settle on a pope; they split into factions and fought in the street. After two years they elected a simpleminded monk as Celestine V, partly on the grounds that in the presence of Pope Gregory and his court he had hung his cowl on a sunbeam. Celestine was terrified by a conviction that his elevation was a demon-inspired dream and also by the traffic noise of Rome, as many have been since. The story went that Cardinal Benedetto Gaetani, rigging the new pope's cell with a speaking tube, encouraged him to abdicate, addressing him in the commanding tones of an angel. The story is no doubt a fabrication; but Celestine did abdicate, wherefor Dante lodged him in hell. Cardinal Gaetani succeeded him as Boniface VIII and arrested his predecessor, who died soon after, in prison.

The arrogant Boniface reasserted the doctrine of papal supremacy over all Christendom. In 1300 he proclaimed the first papal jubilee. He appeared on parade wearing the imperial insignia. The two swords of spiritual and temporal dominion were borne before him, and heralds cried: "I am caesar! I am the emperor!" He also added a second circlet to the papal tiara, to signify his double authority. (The third circlet, implying preeminence in heavenly matters, came a little later.)

The king of France during this period was Philip IV, "the Fair" or "the Handsome." When he attempted to impose a tax on the French clergy, Boniface retorted with the famous bull Clericis Laïcos (1296), forbidding any kings or princes to tax clerics without papal consent and ordering the clergy subject to such taxes to defy their rulers. Philip then forbade the export of money and valuables from France, thus grievously reducing papal revenues. He sought to strengthen his position by assembling, in 1302, for the first time, the Estates General, representatives of the nobility and clergy and the bourgeoisie, or third estate. Thus a monarch appealed for popular support, recognizing the bourgeoisie as a social and political unity, with a right to share in the making of national decisions. The entire assemblyincluding the clergy-sustained the king. Boniface demanded instant submission from France, using the famous phrase: "Outside the church is no salvation." He threatened to depose the French king. Philip then sent a commando band to Italy, headed by a vengeful lawyer whose grandfather had been burned as a heretic in Languedoc. The party, aided by the Colonna family of Rome, seized, manhandled, and imprisoned the old pope, who died soon after of shock and shame. Dante, who opposed papal claims to temporal power, reserved for him a niche in hell that he would occupy upside down, the fire raining on his feet.

Philip, now in control, engineered, in 1305, the election of a French pope, Clement V. Instead of proceeding to Rome, the new pontiff established himself in Avignon and appointed a retinue of French cardinals, all of whom preferred Avignon to the pestilential, riot-prone Holy City. Thus began the Babylonian Captivity of the papacy, which lasted until 1378.

The French popes of Avignon, in their immense, mournful

palace, bear a bad name, though some of them were sincere, learned, pious, and efficient. A good pope must have more than familiar virtues, however, if he is to command the devotion of Christendom. The Avignon popes were sympathetic, at the very least, to French interests. As managers of the world's largest business organization they were more concerned with administration and money raising than with spiritual uplift. But the system was permeated with corruption. A petitioner began by tipping the palace guards and paid graft for every advance of his case. All judgments and decisions were influenced by money payments. The church rewarded with indulgences, notes payable in the next world, and punished with excommunications, which were invoked even against poor people whose taxes were overdue.

The church's greatest revenues and greatest disputes came from ecclesiastical appointments. An everlasting controversy with lay rulers raged over the right of appointment to bishoprics and abbacies. Bishops and abbots, as church officers and administrators of landed property, still had a dual allegiance, still were part of two systems—clerical and feudal. The rights to immense revenues were involved. Quarrels over appointments were endless and were rarely conducive to the spiritual health of the local populations.

The Babylonian Captivity was followed by the Great Schism. Since Rome, the Holy City, bore a prestige no other city could match-its very name booms like a bell-Pope Gregory XI returned there in 1377. When he died a year later, the cardinals, physically threatened by the Roman mob, elected an Italian pope. Most of them then fled, voided their action, and elected another pope, or antipope, who returned to the vacant palace at Avignon. Soon Christendom was treated to the painful spectacle of rival popes playing politics, anathematizing and excommunicating each other, mounting crusades against each other, and resolutely insisting on exclusive rights to the church revenues. God's will in the matter was not discernible. In 1398 the German emperor conferred with the king of France and the Avignon pope, Benedict XIII, on the problems of the papacy. "The Emperor, Wenceslas," Professor Coulton writes, "was a confirmed drunkard, and could do no business but quite early in the morning. The King, Charles VI, was seldom sane, but there was most sense in him later in the day when he had eaten and drunken. The Pope (or anti-Pope), sober and sane enough in other ways, was less sane politically, less able to listen to reason where his own power and dignity were concerned, than either the drunkard or the lunatic." Two years later Emperor Wenceslas was deposed for various good reasons, including the roasting of his cook on a spit for having spoiled his dinner.

The French clergy, disgusted with Benedict XIII, voted a "subtraction of obedience." This action presumed that a national church could affirm or deny allegiance to the pope at will. In 1409 a majority of the cardinals, in outrage, held a council at Pisa, where they enounced the conciliar theory that a council has authority even over popes. They deposed both popes as heretics and elected a third, Alexander II, who promptly died. Then they elected another, John XXIII. Although he had begun his career as a captain of mercenaries, John was unable to overcome his two papal rivals, who rejected the council's order to resign. (The church does not recognize him as a legitimate pope; hence another Pope John in the twentieth century could assume the same number.)

The Council of Pisa was followed in 1414 by the more famous Council of Constance. This council declared itself supreme and enjoined all three popes to abdicate. Two of them accepted the decree; the third, irascible Benedict XIII, retreated to a mountain fastness in Spain, whence he poured forth a stream of acrimonious and unregarded bulls. The Council of Constance, in 1417, elected a new and worthy pope, Martin V, who did his best to reassert papal authority.

For a full century the church had exhibited to the world a spectacle of disunion, intrigue, incompetence, and corruption in place of the spiritual and moral leadership for which people longed. Rome became a byword and a hissing among all nations. Boccaccio could tell, to applause, the story of the Jew who, during a visit to Rome, was converted to Christianity on the grounds that a religion that could survive the villainies of its representatives must be the true one. The spirit of the Reformation was already abroad. Instinctive reformers, angry men, muttered so loudly that their words became audible.

John Wycliffe, born about 1320, was an eminent theologian at Oxford. He was tempted to dangerous thoughts, which were aggravated by the shameful farce of the Great Schism in 1378. This seemed to him to belie God's guidance of his church. Wyc-

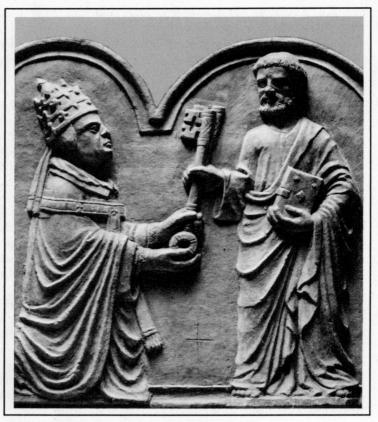

Pope Urban VI, shown here receiving the keys of Saint Peter, was an Italian and a reformer. His election to the papacy in 1378 split the church in two; he soon alienated the French cardinals, who declared his election invalid and set up an antipope. For the next forty years two lines of popes existed: Urban and his successors in Rome and their opponents at Avignon. liffe was choleric and fearless; he began uttering radical criticism of Rome's claim to supremacy and of Catholic doctrine. The Bible, he said, contains all that is necessary for salvation. Since the Bible does not recognize a distinction between priests and bishops, the Roman hierarchy is abusive and the pope is Antichrist. The church has no right to interfere in civil government: all priests are subject to secular laws. Wycliffe further denied transubstantiation and proposed to abolish confession, penance, pilgrimages, the use of holy water, the veneration of relics, prayers for intercession of the saints and of the Virgin. He burst out against ecclesiastical wealth: he treated even the friars as demonic. But this is heresy! This is Protestantism more than a century before its time! Wycliffe was forced out of the university. He devoted himself to translating the Vulgate into English and to enlisting "simple" priests to spread his opinions. The English authorities were, at the very least, tolerant of his views.

Wycliffe established no formal party, but he found many sympathizers with his anticlericalism, his insistence on the right of individual judgment, and his demand for free access to the Scriptures. His followers, called Lollards, which may mean "babblers," abounded among the lower clergy and the artisan class, who were natural dissenters. They called images idols, and the Virgin Mary a witch. They mocked the mass; a Wiltshire knight purloined a sacred host, ate one piece with oysters, one with onions, one with wine, without rebuke from on high. The Lollards were relatively unmolested, but in the early fifteenth century Henry IV insisted that heretics should be properly burned. Lollardry disappeared from view. It went underground, to emerge again with the Reformation.

Wycliffe's ideas were borne afar, to seed and sprout in the mind of John Hus, a Bohemian preacher in Prague, dean of the faculty of philosophy and rector of the university. His views, comporting the right of every man to seek his faith in Scripture, were very welcome to the independent Czechs and became the doctrinal principle of a political rebellion against foreign overlordship, which included papal authority. Hus was summoned to the Council of Constance, condemned, and despite a safeconduct, burned — for a promise to a heretic is invalid. His immolation was followed by the Hussite Wars, which ended with the triumph of the pope and the emperor in 1436. However, certain concessions were wrested from the papal government, certain local practices of piety authorized, and John Hus remained, as he is today, the hero-martyr of the Czech Protestants.

It must have seemed, in the early fifteenth century, that the church had gained a dominance that would endure for eternity. The outward manifestations of heresy were suppressed; the faith was codified by the councils; the dissensions of the Great Schism were ended; papal authority within the church was again unchallenged. Nevertheless, these were years of an ending, not of a beginning, years of convalescence from a century of plague.

The spiritual plague was accompanied and outdone by the physical plague, the Black Death. In October 1347, a convoy of twelve Genoese galleys, believed to have come from the Crimea, limped into Messina, guided by dying men. "In their bones they bore so virulent a disease that anyone who only spoke to them was seized by a mortal illness and in no manner could evade death," says a contemporary chronicler. The authorities ordered the ships out of harbor, but too late. The Messinans fled, spreading the disease throughout Sicily and in early 1348 to the Italian mainland and France.

The plague, which still lingers dormant, biding its time, was recently analyzed by the World Health Organization of the United Nations. It is caused by bacilli dwelling in the blood of a certain flea. The flea's stomach becomes blocked; it cannot feed normally. It fastens by preference onto the black rat, trying to feed; it inserts its pricker repeatedly into its host's skin, and because of its blocked stomach, regurgitates the plague bacilli into the wound. When the rat dies, the fleas seek food elsewhere, choosing humans if rats are unavailable.

The infection may take three forms: bubonic, pneumonic, or septicemic. In the bubonic plague the bacilli in the bloodstream settle in the lymph glands. They act against the walls of the blood vessels, producing hemorrhages, dark patches that eventually cover the entire body, and the tongue turns black; hence the term *Black Death*. Under the arms and in the groin appear swellings and carbuncles, the buboes that give the plague its correct name. Sufferers from the bubonic form of this disease occasionally survive, but most die within three days. In the septicemic form, the blood is fatally infected. The pneumonic form causes gangrenous inflammation of the throat and lungs, resulting in violent pains in the chest, vomiting and spitting of blood, and a foul smell. Victims of the pneumonic form almost always die; fortunately death comes to them very quickly.

As the plague advanced from town to town—for the ratfilled, unclean cities suffered worst—normal life ceased. Physicians' remedies were powerless; priests feared to approach the dying and administer the last rites. The doors stood open, and no one dared or cared to enter and rob. Criminals released from jail and ignorant peasants imported from the mountains threw the dead in great common pits, with a curse for viaticum. At sea, ships, manned only by dead sailors, drifted derelict.

Boccaccio has left a memorable description of the plague's ravages in Florence. Many a man, he writes in *The Decameron*, dined heartily with his friends on earth and supped with his ancestors in paradise. People avoided one another. Brother abandoned brother; parents, children. Shame was forgotten; women negligently exposed their bodies to servants. "People cared no more for dead men than we care for dead goats." Peasants neglected their farms, thinking only of enjoying what they had. Animals, crying for the milker, wandered unchecked through the wheat. Sheep and hogs caught the disease, and like humans, died. The authority of laws, human and divine, and the bonds of family love almost vanished. Many of the unstricken, like Boccaccio's jolly immortal band, retreated to a country shelter and spent their days feasting, dancing, and telling funny stories.

The plague traveled north, lying dormant, with its fleas, during the winter and resuming its march in the spring. It spread throughout Europe, reaching England in August 1348, and then attacking Scandinavia and Russia. It gradually relented, but reappeared, with diminished violence, in 1361 and other years. The Great Plague of London in 1665 was a recurrence of bubonic plague.

No one knows how many died in the Black Death, for medieval statistics were very emotionally compiled. But when we read that many villages were totally wiped out, that the papal authorities counted 1500 dead in three days in Avignon, that five cardinals, 100 bishops, and 358 Dominicans succumbed in the same city, that at the end the Franciscan losses numbered 124,434, we may credit the specificity and accept the general conclusion that a third to half of Europe's population died. This was the greatest calamity ever visited on the Western world. The immediate results of the plague were worse than those of any war. A traveler would find whole villages tumbling into ruin, yielding to the assault of the elements. The countryside was noisome with dead animals. The contemporary chronicler Henry Knighton reported five thousand sheep rotting in one pasture. For a time, he says, the fear of death ruled all men's thoughts, and no one cared for profits in the doomed world.

This state of affairs could not last long. As the plague receded and as the survivors looked again to a terrestrial future, prices rapidly rose to balance the scarcities. A pair of shoes cost as much as fourteen pence, says Knighton in horror; a reaper demanded at least eightpence a day and food, a mower twelvepence. (The normal wage had been a penny a day.) Governments vainly issued decrees fixing prices and wages. The workers were well aware of their power. They secured the abolition of some feudal services; if a local landowner tried to enforce the official wage scale, the laborers could always migrate and find employment elsewhere, with no questions asked. Whole villages secured their corporate liberty. Great numbers of serfs bought freedom, to develop into a class of yeomen-farmers, an agrarian middle class. In general the peasantry realized their power, as evidenced by the uprising of the French Jacquerie and by the English Peasants' Revolt.

To the clergy the Black Death dealt a cruel blow. Conscientious priests, administering the last rites, ensure their own. Many monasteries were completely wiped out. Petrarch's brother Gherardo, a Carthusian in the monastery of Montrieux, near Marseilles, tended his brother monks and buried them one by one; in the end only he and his faithful dog were left alive. (Dogs generally were more faithful than people.) The friars in particular, caring for the cities' sick, suffered appalling losses. But during the reconstruction period the monastic orders recruited too many unfit, who were eager to share the wealth of the abbeys. Says Henry Knighton: "A very great multitude whose wives had died of the plague rushed into holy orders. Of these many were illiterate and, it seemed, simply laymen who knew nothing except how to read to some extent."

A most woeful sequel of the plague was the persecution of the Jews. Since it is our nature to blame our misfortunes on the wickedness of others, people accused the Jews of a gigantic plot to destroy Christendom by poisoning the water supplies. There

The plague and the bitter Hundred Years War destroyed perhaps half of the European population. The horrors of pain and death were therefore never far from people's minds. This image of Death in its dark triumph was made in the fifteenth century. may be this much color in the accusation: the Jews, so conscious of hygiene, presumably refrained from using insanitary wells and polluted river water. But the populace demanded a blood sacrifice and refused to note that the Jews died of the plague as did the Christians. Horrible pogroms took place in southern France, Spain, Austria, Poland, and especially in Germany. Two hundred Jews were burned alive in Strasbourg. At Speyer the Jews were massacred, and their bodies were sent down the Rhine in empty wine barrels. In Esslingen the Jewish survivors assembled in the synagogue and cremated themselves. But at Schaffhausen and perhaps elsewhere, enlightened authorities protected the Jewish inhabitants from the black plague of fanaticism.

As if plague were not enough, war came to afflict the Western world. By the fateful year 1348 the kings of England and France had already initiated the war that was to last a century more. The great Hundred Years War was dynastic and territorial. The rules of succession to the French throne were unclear; the kings of England could make a reasonable claim to the monarchy. The French, who would have no foreign master, changed the rules to permit the accession of Philip VI, the first of the Valois kings, in 1328. In that year Philip intervened in troubled Flanders and for a time was recognized as that country's sovereign. Edward III of England, threatened with confiscation of his vast holdings in southwestern France, submitted to Philip and did him homage.

The war formally began in 1337, when Edward reasserted his claim to the French throne. For some years the war was prosecuted with little enthusiasm. Then in July 1346, Edward invaded France, landing an expeditionary force at St. Vaast on the northeastern shore of the Cotentin Peninsula of Normandy, only a few miles from the sites of the Allies' landing beaches in the second World War. The army probably numbered about fifteen thousand men. It was novel in composition. Instead of heavyarmored knights with their horses, so hard to transport across the stormy Channel, the soldiers were mostly mobile lightarmored infantry and archers. The archers carried the mighty longbow. The army made its way, looting and burning, through unhappy villages—Valognes, Carentan, St. Lô, which many Americans have reason to remember. Caen, which had

neglected to build proper defenses, was captured after a sharp fight. King Philip, with a large army, lay in wait near Paris. He offered to fight King Edward on a battlefield of the invader's choosing. This was a chivalrous challenge, but Edward had other ideas. He succeeded in repairing a broken bridge across the Seine at Poissy, dodged Philip's army, and headed northeast for the safety of Flanders. Hotly pursued by Philip, the English reached the Somme below Abbeville and in the nick of time found a ford passable at low tide. The army waded across, protected by covering fire from the archers. Philip's main army arrived just as the tide had risen to block their passage. Edward took up a strong position near the village of Crécy, on the edge of a small plateau, with his flanks protected by thick woods. There he disposed his men in two strong bodies of infantry, with the bowmen thrown well forward between them and on either flank. The soldiers had time for a good rest.

Philip's pursuing army, outnumbering the English by at least three to one, came up the narrow road from Abbeville. The mounted knights, lusting for battle, were well in advance. The foot soldiers, weary from a difficult march under the hot August sun, were strung out in a long disorder. When the French discovered the English position, they attempted to form on a rise opposite the English, but the battle line, crowded by troops constantly arriving from the rear, turned into a confused mass. The king himself had great difficulty in reaching the battle.

Philip sent forward a corps of Genoese crossbowmen to traverse the ground between the armies and engage the English. But they had the evening sun in their eyes, they had to shoot uphill, and they were outranged by the English archers. The English, as the historian C. W. C. Oman has noted, "shot so fast and close that it looked as if a snowstorm were beating upon the line of Genoese. Their shafts nailed the helmet to the head, pierced brigandine and breast, and laid low well-nigh the whole front line of the assailants in the first moment of the conflict. The crossbowmen only stood their ground for a few minutes; their losses were so fearful that some flung away their weapons, others cut their bowstrings, and all reeled backwards up the slope which they had just descended."

And King Edward produced from his carts his secret weapon—mysterious iron tubes about five feet long. These were charged with a black powder and ignited. They fired balls of iron and stone, about three inches in diameter. The belching flame of the guns, their thunderclap explosions, and the hurtling balls seemed to the French a diabolical magic.

The mounted French knights, in a fury, slashed their way through the retreating crossbowmen and charged up the slope. But the hail of English missiles brought them down in a mass of rearing, screaming horses. Among the heaps of their own dead, the valiant French charged again and again; very few reached the English line and none penetrated it. The flower of French chivalry fell; the heralds later reckoned 1,542 lords and knights, including dukes and counts, among the fallen.

The battle of Crécy was one of the decisive battles of the world. It meant the crippling of French power for a century and the beginning of English preponderance in world affairs. Militarily it marked the beginning of the decline of the cavalry and the introduction of the use of explosives in the field. Missile warfare-the use of mechanical weapons from the longbow to the cannon-diminished the importance of hand-to-hand conflict with swords, axes, and lances, mere extensions of the human arm. Personal gallantry yielded to the astute choice of defensive positions. The noble knight, essentially an amateur, was brought down by the professional soldier. War became a business, a rather dirty business. It was conducted by contract armies, recruited anywhere without concern for nationality. The knights themselves fought no longer from feudal obligation and lovalty but for advantage. Their dream was to capture and hold some noble for an enormous ransom.

The dreadful war dragged on, the background to human life in France for a hundred years. But not only France suffered. The period was one of warfare and upheaval throughout the West. Terror was a normal condition of existence. We are told that pigs learned to run for shelter at the sound of the alarm bell (a fine example of the conditioned reflex). The new professional soldiers had no liking for pitched battles; they preferred devastation and plunder, until in the end there was little left to plunder and devastate. Impoverished German knights in particular made a trade of war—indeed, they had no other. "Duke" Werner von Urslingen was conductor, *condottiere*, of a band known as the Great Company, which operated in Italy. He adorned his doublet with the words, in silver: "Duke Werner, the enemy of pity, of mercy, and of God." His system, worthy of the Mafia, was to invade a peaceful region, rob, burn, rape, and kill. Then he would call his demonstration to the attention of the capital city and demand a tremendous fee for passing on—or else! Thus he obtained vast sums from Siena, Perugia, Florence, and Bologna. Bertrand du Guesclin used the same shakedown on the pope in Avignon. But with one another the *condottieri* were inclined to live and let live.

The plague brought only a momentary respite to war. One might have thought that universal destruction would have sickened rulers with blood. But if death is invited to the dance, he is the last to leave. There seems never to have been a lack of soldiery to lend death a hand. Henry Knighton tells us that the Scots, not yet touched by plague, assumed that the avenging hand of God had inflicted it upon the English alone. They therefore assembled to invade England. Alas! God's vengeance was indiscriminate. In a very brief time five thousand Scots were laid low. The rest, both sick and well, headed for their homes. Then those English who had escaped the plague by God's favor caught up with the Scots and slew those that pestilence had spared.

In the war between England and France, the English had the best of it, thanks to competence and luck. The battle of Poitiers, in 1356, was a repetition of Crécy. The French, with a great superiority in numbers, were defeated by the English tactical dispositions. The French king, John the Good, was captured and held for a colossal ransom. Again at Agincourt, in 1415, the army of Henry V, outnumbered at least two to one, trampled in the mud a weary, hungry, ill-commanded French force. By this time gunpowder was in general use, but mostly for siege and field artillery. Small arms were still heavy and unreliable.

There were indeed islands of relative security in Europe. Chaucer's pilgrims seldom mention the war. Spain and Portugal were scarcely affected; northern Germany, Switzerland, Scandinavia, held themselves aloof. Even in France there were, according to one estimate, sixty years of nominal truce out of one hundred sixteen war years. There were bright interludes, as in 1389, when Isabella of Bavaria came to Paris for her coronation, and fountains spouted wine, and tapestries were hung along the streets of her progress.

In the general distress the duchy of Burgundy prospered. In the late fourteenth and in the early fifteenth centuries a succes-

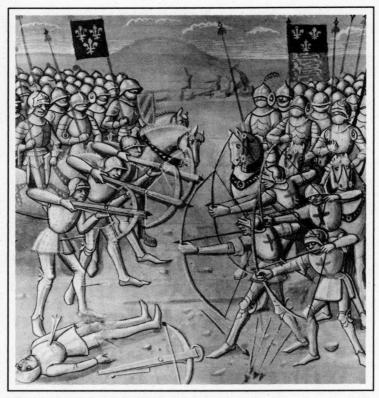

The battle of Crécy, in 1346, was one of the early disasters the French would face in the Hundred Years War. As seen in this painted miniature of the arduous battle, the French military, at left, fell to their British opponents. Despite their superiority in numbers, the French could not endure the slings of the English longbowmen. sion of powerful dukes extended their territory, by conquest and astute marriages, to include Brabant, Flanders, and most of Holland. They challenged the power of France and England. In their courts, at Dijon and elsewhere, they patronized the arts. Their architects developed the sumptuous Burgundian Gothic; their painters and sculptors worked in a realistic style that informs us of the aspect of medieval life. Philip the Bold (1342–1404) was a collector, connoisseur, lover of fine clothes, furs, jewelry. Philip the Good (1396–1467) was a great art patron. Since, in fact, he was far from good, he might have been more accurately termed Philip the Dilettante.

France was less fortunate than Burgundy. The journal of a Paris burgher complains in 1421 of extortionate taxes and high prices. "Every day and every night one heard everywhere in Paris only pitiable outcries, because of the cost and scarcity of everything. I doubt if the lamentations of Jeremiah the Prophet were more keen when the city of Jerusalem was entirely destroyed and the children of Israel were led to Babylon in captivity; for night and day men and women kept crying: 'Alas, I die of cold, of hunger." The good citizens established refuges and soup kitchens, but these were never enough. The poor ate garbage that pigs scorned, raw cabbage cores, grass. In the hospitals the dying were heaped with the dead. In 1439 ravenous wolves devoured fourteen people in the region between Montmartre and the Porte St. Antoine, and attacked shepherds in preference to sheep. In 1444 a great company of thieves and murderers camped outside Paris, seizing animals for food and people for ransom. The countryside was a waste of abandoned fields and burned villages, sometimes occupied only by wild boars. The smiling fields of Normandy were a tangle of briars and thickets. Roads were untended, bridges broken, river channels choked, harbors silted. Gangs of écorcheurs et chauffeurs, "skinners and footwarmers," roamed the country, looting whatever had been overlooked by the armies, extorting "protection money," and burning and flaying those who did not pay up. The only security was within the guarded walls of the large towns and cities, and often the only cultivated area lay within eyeshot and earshot of the watchmen in the towers. But not all the cities escaped. "The Black Prince" captured the city of Limoges in 1370; irritated by its resistance, he had three hundred inhabitants-men, women, and children-executed.

France's woes derived largely from the incompetence of its lamentable rulers. Charles VI succeeded to the throne in 1380. at the age of twelve. He was not very bright at best, and in 1392 he became definitely insane, although he did enjoy lucid intervals. He died at last in 1422, and was succeeded by his son Charles, the dauphin or crown prince, feeble in body and mind. He was very dubious, as were others, about his own legitimacy. He was held practically captive by a band of villainous advisers in his gloomy castle of Chinon in Touraine. They kept him poor, made him wear wet, worn-out boots and repair his old coats. His dominions dwindled till they embraced only central and southeastern France. Hence he was known as the king of Bourges, and more commonly as the dauphin. According to French tradition, he could not become king until he should be consecrated with the sacred chrism in the cathedral of Reims. And Reims was held by the hostile Burgundians.

Then occurred a miracle, or the nearest thing to an attested miracle in recorded history.

In the Lorraine village of Domremy, not very far from Nancy, Bar-le-Duc, and Chaumont, dwelt a farmer, Jacques d'Arc. Domremy had a fairy tree and fountain and a certain reputation for witchcraft. Jacques's daughter Joan worked in the harvest fields, guarded the beasts at pasture, and did women's work. "For spinning and weaving," she said proudly at her trial, "put me up against any woman in Rouen." She was illiterate, though in time she learned to sign her name. She was a very good girl and very pious; she insisted on taking communion every month. At thirteen she began to hear voices and see visions of Saint Michael, Saint Catherine, and Saint Margaret. Saint Michael told her of the great pity that was on the land of France. Aware of a prophecy that France in its greatest extremity would be restored by a virgin from the Lorraine marches, she vowed to preserve her virginity forever. (Virginity was regarded with superstitious awe, perhaps because there was so little of it.) The voices told her that she must come to the aid of the king of France, assure him of his legitimacy, and raise the siege of Orléans.

In May 1428, when she was sixteen or seventeen, Joan visited the captain of the nearby fortress of Vaucouleurs and told her story. The skeptical captain sent her home, but in the following February she returned and so impressed him that he detailed six men to conduct her to the dauphin in Chinon. The journey across France, through hostile country, took eleven days. The party moved often by night and slept side by side in the woods by day. For security and convenience Joan wore men's clothes. "I would never have dared make advances to her," testified one of her companions, "and I say upon oath that neither did I have for her desire nor carnal notion."

On her presentation at Chinon, the dauphin, forewarned, dissimulated himself in the throng, but Joan recognized him and made him her obeisance. The dauphin was delighted, but suspected necromancy; he sent her to Poitiers, where she was examined by a clerical commission. They found in her "no evil, but only good, humility, virginity, piety, honesty, simplicity." Her virginity was attested by two noble ladies. The dauphin was completely won over.

He presented her with a suit of armor, and his kinsman the duke of Alençon gave her a horse. She went out to the meadows and galloped a-tilt, lance under arm, spearing imaginary enemies. This is about the only playful moment recorded of her grim life.

Joan assured the dauphin of his legitimacy, that he was true king of France, and she insisted that she should lead the royal army to the relief of Orléans. The city, on the north bank of the Loire, had been under siege by the English since the previous October. They had built a ring of small forts around it and were waiting comfortably for starvation to do their work for them, with no fear of the dauphin's demoralized troops. Joan was therefore able to enter the city with a convoy of supplies, without much opposition. She sat her white charger with ease and grace. Before her was borne her white standard, pictured with two angels, each holding a lily of France. Leading the revivified citizens, she issued forth to attack the English forts one by one. "I was the first to place a scaling ladder on the bastion of the bridge," she testified at her trial. The English, decisively defeated, raised the siege and marched away.

The capture of Orléans was not only an evidence of Joan's brilliant, instinctive generalship, it was the greatest possible morale-builder for the French. The news spread through the countryside that supernatural aid had come to rescue them. Once more they were animated by the will to fight. Joan now followed the second behest of her voices. She must make the dauphin lawful king by having him anointed in Reims, in accordance with French custom. Her army fought its way through Auxerre, Troyes, and Chalons-sur-Marne to the holy city, and there, on July 17, 1429, the dauphin was duly consecrated.

Joan then turned on Paris. The campaign was hampered by the new king's indecision—or cowardice. In the attack Joan was wounded in the thigh by a crossbow bolt. (A plaque on the Café de la Régence in the Place du Palais-Royal marks the spot.)

The war died down during the winter, following normal military practice. No one likes to fight in cold weather. On May 23, 1430, Joan, coming to the relief of Compiègne, was captured by Burgundians, and after a time, sold to the English. Charles made no effort to save her.

In January 1431, she was brought to trial in Rouen before an ecclesiastical court, dominated by the English, on charges of witchcraft, magic, impurity, wearing men's clothes, and recalcitrance to the church. The judge was Bishop Cauchon, a tool of the English, who hoped to get the archbishopric of Rouen as his reward. The purpose of the trial, apparently, was not to discover truth and administer justice but to sway public opinion by condemning Joan as a witch and crediting her victories to the devil. She was allowed no advocate or defender; the text of the trial record was truncated and falsified; her published act of abjuration is a forgery. Nevertheless, Joan's honesty, her sharp wit, her courage in facing the vindictive accusers in their awesome robes, shine through the moving record. At length, after nearly five months of relentless questioning, though without judicial torture, she was broken down. She signed an abjuration and then retracted it. This made her a relapsed heretic, for whom there can be no forgiveness.

On May 30 Bishop Cauchon pronounced her guilty, but instead of remitting her to a civil court—for the church courts cannot condemn to death—he handed her over to the English army. The English brought her to the Old Marketplace of Rouen to be burned. She asked for a cross; an English soldier made one of two sticks and handed it to her. She received it devoutly, kissed it, and clasped it to her bosom. A well-wisher brought a cross from St. Sauveur's Church and held it before her eyes as she died. Her last word was "Jesus," which she uttered more than six times. No one could fail to be reminded of the Crucifixion. The spectators, including the soldiers, wept. A secretary of the English king said: "We are all lost, for we have burned a good and holy person." Her ashes were thrown into the Seine to avoid their use in sorcery.

Bishop Cauchon, who was denied his archbishopric, was consumed with hatred. He continued to befoul Joan's memory and punished anyone who expressed sympathy for her.

By burning Joan, England alienated French public opinion and ensured its own defeat. France made a lasting truce with the Burgundians. King Charles entered Paris in 1436, Rouen in 1449. Normandy, all northern France, Bordeaux, and Bayonne were recaptured. Of all its Continental possessions England retained only Calais. In 1453 the Hundred Years War was over.

Two years later, at the appeal of Joan's mother and two brothers, her case was reopened. In this trial of rehabilitation she was declared innocent of all the charges against her. In 1920 she was canonized.

What can a historian say of this almost incredible tale of an illiterate peasant girl who altered the course of history, who daunted kings, who outgeneraled generals, who rose above human capacities, to sainthood? Was Joan an agent of divine purpose, or does she illustrate the extraordinary secret powers of the human spirit?

The answer depends on our judgment of Joan's voices. Were they real or false? If Saint Michael, Saint Catherine, and Saint Margaret actually spoke to Joan, a miracle occurred. Deity, then, intervenes in human affairs, aids its favorites, rewards and punishes people's actions. This is much the easier explanation. It eliminates the question of natural law, of possibility and impossibility. It admits the direct evidence on the basis of an *a priori* theory.

But if the voices were false, they were the products of a hysteric imagination, disturbed by puberty troubles, by an endocrine upset. One theory is that she suffered from tuberculoma, or bovine tuberculosis, which affected the temporosphenoidal lobe of the brain, perhaps causing an incipient brain tumor. Joan's religious hallucinations were, of course, no bar to intellectual power and to practical good sense. The pathology of genius does not deny genius. No miracle took place, for a miracle defies the great nexus of cause and effect in the world and by

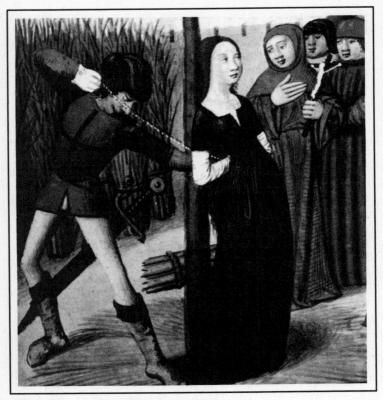

The tragedy of Joan of Arc occurred at Rouen, where the heroine was tried for witchcraft and heresy. Her judges made certain she would be convicted, and King Charles did nothing to save her. With a cross before her eyes Joan was burned at the stake. definition violates the rule of natural law. There are no miracles. Joan was simply mistaken about the character of her voices. They came from within, not from without. They were hallucinations, though not delusions. There is a third possibility—that she deliberately lied to further her purposes or merely to attract attention. Every reader may choose according to the cast of his mind and in the light of his experience.

At any rate, whether God-inspired or self-inspired, Joan saved France. She restored the spirit and morale of the country, gave the French the will to fight the English, eventually to expel them, establish the French kingdom, and bring the hundred and more years of war to an end.

It was a futile war. It achieved little except destruction, misery, and death. "One stands amazed, when one compares the enormous efforts put forth with the insignificance of the results obtained," says Henri Pirenne. The war left behind not only material and physical ruin but a neurotic, morbid, sick mood that readily turned to hysteria. Flagellant processions and outbursts of mass mania were common. Art and literature were preoccupied with the body's decay and the soul's promised tortures.

The European spirit, the ideal of Christendom's unity above all nations, faded and gave place to angry nationalisms. Joan of Arc with her cry of "France for the French" incarnated the new spirit. Patriotism was conceived not in France alone but in England, Scotland, Bohemia, Hungary. Racial hatreds, as of the Germans and Slavs, were justified and embittered. Feudalism remained as a picturesque social code, no longer as a working system of government and administration.

Out of the wreckage the sovereigns gained power. The Hapsburgs held the German office of Holy Roman Emperor as a family right. In Italy tyrants took over the free cities, or communes. They lived in perpetual fear of poison, surrounded by exiles, astrologers, artists, and writers.

The rulers steadily sapped the independence and importance of the nobles, and deprived them of their ancient rights, especially that of waging private wars. German nobles were likely to live in two or three rooms of their dilapidated, comfortless castles, amid cows and chickens instead of men-at-arms. Kings brought the higher gentry to court, encouraged them to spend their days in elaborate, meaningless formalities and festivities. The church's lands were wasted, its tithes went uncollected. Monasteries were half empty, often abandoned outright. No new orders were established; zeal seemed dead. The Avignon papacy, the Great Schism, the quarrels of councils and popes, encouraged anticlericalism, though, except in Bohemia, there was not much questioning of the church's doctrine and the priest's sacramental powers.

On the other hand, the bourgeois, accustomed to living by their wits rather than by force, made a handsome recovery. They supplied the monarch with legal advisers, administrators, and bankers; they helped replace the old economy based on land with a money economy. Some of them did extremely well, like Jacques Coeur, an entrepreneur with vast and varied interests, whose house in Bourges is a splendid example of medieval domestic architecture. (But in the end his magnificence undid him; he was falsely accused of treason, and after a term in jail he died fighting the Turks.) The big businessmen reorganized maritime transport, built countless ships, dug mines, erected silk, textile, and paper factories, gunsmitheries, glassworks. The great printing industry began. Agricultural villages were transformed into factory towns. The state undertook to protect and foster commerce. British merchants were everywhere, from Alexandria to Reykjavík. In favored regions the burghers lived well. We can see their comfortable homes in Hildesheim and Rothenburg and other still-medieval towns.

The peasants and workers suffered most from the wars and the troubles. Class lines were sharply drawn; a distinct working class, a proletariat, took form, from which it was very difficult to rise. In England the enclosures of common lands for sheep farming drove many displaced peasants into the towns. In Germany, we are told, forty-four percent of the villages in Hesse were deserted. A curious German development was that of the Vehmgericht, a kind of Ku Klux Klan designed to keep the peasants in order by stump trials and exemplary hangings. The sullen resentment of the little people was repressed, to burst forth in such uprisings as the Peasants' War in Germany in the following century.

As Europe struggled to reconstitute itself, a lowering storm gathered in the East. In the late fourteenth century the Tartar Tamerlane overran Mesopotamia, northern India, and even Muscovy, marking his passage with pyramids of skulls. The Ottoman Turks crossed the Dardanelles, captured Adrianople, and defeated the Bulgarians, Bosnians, and Serbians at Kossovo in 1389. Sultan Bayazid, or Bajazet, known as Lightning, swore that he would not rest until he should feed his horse at the altar of St. Peter's in Rome. However, the Turkish invasion was held back by the Hungarian hero János Hunyadi.

In 1453 the Turkish Sultan Mohammed II attacked Constantinople. In a remarkable siege operation Mohammed broke into the city. The Emperor Constantine XI died fighting bravely. Constantinople died with Constantine as it was born with the first Constantine. The city became Istanbul. The great church of Santa Sophia was transformed into a mosque, though it still bore its dedication to Divine Wisdom; the Christian Empire of the East was turned into the Ottoman Empire; a piece of Europe was added to Asia.

This was the twenty-ninth of May 1453. It is one of the hingedates of history. It is commonly taken to mark the end of the Middle Ages and the beginning of modern times. The date is an arbitrary one, but so are the other dates proposed. It will serve; clearly something familiar was ending, something new beginning.

Tt was the end of a great age. In consonance with the rhythms Lof history, the age began in a period of stagnant misery, ascended through struggle to a stage of mighty vigor and achievement, and relapsed again into stagnation. The metaphor of an individual's progress from infancy to maturity to senility is inevitable and entirely justified. The comparison can be carried further; the Middle Ages bequeathed to its child, modernity, a richer inheritance than it had received at birth. The Middle Ages accomplished mighty things in architecture and the arts, in literature, in learning and wisdom. The period added grace and beauty as well as mere comfort to the art of daily living. It initiated industrialism and capitalism, concepts containing unimagined unreleased forces. There was much of socialism in the guilds, of communism in the monasteries. The Middle Ages prepared the humanism that was to flourish with the Renaissance, the religious free thought that was to make the Reformation. It developed the spirit of discovery that was to expand man's geographical, material, and spiritual universe.

Our judgments of the Middle Ages as a whole must be rela-

tive to our assessment of our own age. It was an age of superstition; and so is ours, though the superstitions are different. It was an age of needless pain and death; but it did not inherit the medical learning of enlightened centuries. Life was short, dangerous, and doomed; but it still is. It was a cruel age, callous toward suffering, merely diverted by people's contortions in agony. It felt little sympathy and pity; it had small respect for human life. We shudder at its tortures, judicial mutilations, blindings, beheadings. But our own cruelties are impersonal mass cruelties from which we can avert our eyes—air-bombings, genocides, the starvation of peoples.

There is much in the Middle Ages that we may admire and even envy. Society as a whole was fixed and stable, and within it most people could find contentment. They knew the rules imposed by civil authority and the church. They were not assailed by futile questionings and anxieties. Probably their mental health was better than ours. An English yeoman, a German burgher, an Italian craftsman, could lead a rewarding if unexciting life. Those who asked something more could pursue honor, join a crusade, die nobly in battle for their liege lord. Or they could renounce the world, practice asceticism and mortification of the flesh, count on a sure reward in heaven. People's faith was secure; they had a sense of closeness to God and the saints. And the saints, at least, were close to people, only a few miles or yards overhead, ready with miracles, attentive to prayers, grateful for offerings, totally occupied with people's welfare.

Medieval people had a sharp feeling for the beauty of the physical world, which they tried to match with their own creations. Encouraged by the romantic writers of the nineteenth century, we too find in the life of castle, cathedral, and beetling hilltop towns a poetic refuge from an industrialized world. Our imagination makes of the Middle Ages a wonderland, peopled by gallant knights and fair ladies, troubadours and magicians, saints and demons.

Our imagination does not play us entirely false. The world was strange and beautiful to medieval people; they had only to open their eyes to it. They were conscious of the marvel and wonder environing ordinary life; they could apprehend beauty in accesses of rapture.

There is a fine passage in the chronicle of Salimbene of Parma that renders the medieval experience of beauty an almost mystical experience. He describes his own enchanted moment and casts the enchantment upon his modern reader. Along with a lay brother he was begging alms in Pisa: "We came upon a certain courtyard, and entered it together. Therein was a living vine, overspreading the whole space above, delightful to the eye with its fresh green, and inviting us to rest under its shade. There were also many leopards and other beasts from beyond the seas, whereon we gazed long and gladly, as men love to see strange and fair sights. For youths and maidens were there in the flower of their age, whose rich array and comely features caught our eyes with manifold delights, and drew our hearts to them. And all held in their hands viols and lutes and other instruments of music, on which they played with all sweetness of harmony and grace of motion. There was no tumult among them, nor did any speak, but all listened in silence. And their song was strange and fair both in its words and in the variety and melody of its air, so that our hearts were rejoiced above measure. They spake no word to us, nor we to them, and they ceased not to sing and to play while we stayed there: for we lingered long in that spot, scarce knowing how to tear ourselves away."

Strange and fair was their song; still strange and fair is the song of the Middle Ages.

About the Author

Morris Bishop, born in 1893 in Willard, New York, was one of the world's most lucid and knowledgeable commentators on the Middle Ages. He was also a biographer, a translator, and a masterful author of light verse. Among his best-known works are Champlain: The Life of Fortitude, The Life and Adventures of La Rochefoucauld, Petrarch and His World, and The Best of Bishop: Light Verse from "The New Yorker" and Elsewhere.

Bishop completed his undergraduate and graduate work at Cornell University. He remained there for much of his life, teaching Romance languages and literature, writing books (which include histories of the university he loved so well), and contributing to periodicals such as *The New Yorker* and *Horizon*. A historian and a poet, he reveals in his various writings a love for literature. This dedication extended beyond his own work. Recognizing a gifted writer in the unknown Vladimir Nabokov, Bishop helped find a teaching position for him at Cornell in 1948, long before the Russian-born novelist won acclaim.

Morris Bishop died in 1973 at age eighty.

Picture Credits

Title Page: Dr. M. J. Waring

Table of Contents: Bodleian Library, Oxford

- 6: Bibliothèque Nationale, Paris
- 11: Dumbarton Oaks, Washington, D.C.
- 14: Giraudon/Art Resource, New York
- 19: Iran Bastan Museum, Istanbul
- 24: Bibliothèque Nationale, Paris
- 29: Staatsbibliothek, Berlin
- 32: National Museum of Iceland
- 37: Antivarisk-topografiska arkivet, Stockholm
- 40: The Pierpont Morgan Library, New York
- 43: Musée d'Aquitaine, photo by J. M. Arnaud, all rights reserved
- 46: Bayerische Staatsbibliothek, Munich
- 53: By Gracious Permission of Her Majesty the Queen, Crown Copyright
- 57: Giraudon/Art Resource, New York
- 60: Collection Kofler Truniger, Luzern
- 63: The British Museum
- 68: The Vatican Library, Rome
- 76: Universitätsbibliothek, Heidelberg
- 79: The Pierpont Morgan Library, New York (top and bottom)
- 84: The British Museum
- 89: The British Museum
- 93: Bibliothèque Nationale, Paris
- 97: Öesterreichische Nationalbibliothek, Vienna
- 103: Bibliothèque Nationale, Paris
- 108: Bibliothèque Nationale, Paris
- 113: Giraudon/Art Resource, New York
- 117: The British Museum

- 124: The British Museum
- 131: Bibliothèque Nationale, Paris
- 136: Ville de Paris, Musée du Petit Palais
- 142: By courtesy of the Board of Trustees of the Victoria and Albert Museum/Theatre Museum
- 147: Giraudon/Art Resource, New York
- 151: Giraudon/Art Resource, New York
- 158: Masters and Fellows of Trinity College Cambridge
- 165: Alinari/Art Resource, New York
- 169: The Vatican Library, Rome (top and bottom)
- 176: Bibliothèque Nationale, Paris
- 181: Bibliothèque Nationale, Paris (top and bottom)
- 185: Royal Commission on the Historical Monuments of England
- 189: Bibliothèque Nationale, Paris
- 193: Bibliothèque Nationale, Paris
- 200: The British Museum
- 204: Bibliothèque Nationale, Paris
- 208: The British Museum
- 213: Rouen Cathedral
- 218: Musées des Arts Décoratifs, Paris
- 224: Bibliothèque Nationale, Paris
- 231: Biblioteca Augusta, Perugia
- 236: Bibliothèque Nationale, Paris
- 241: Bodleian Library, Oxford
- 248: Alinari/Art Resource, New York
- 253: Bodleian Library, Oxford
- 256: Bibliothèque Nationale, Paris
- 263: Österreichische Nationalbibliothek, Vienna
- 268: Bibliothèque Nationale, Paris
- 273: Stiftsbibliothek, St. Gallen
- 280: Bildarchiv Foto Marburg/Art Resource, New York
- 287: Jacques Boulas
- 292: Alinari/Art Resource, New York
- 294: Bibliothèque Nationale, Paris
- 299: Bibliothèque Nationale, Paris
- 304: Leonard von Matt
- 309: Staatliche Museen, Berlin
- 314: Musée d'Arsenal, Paris
- 320: Giraudon/Art Resource, New York

INDEX

Italic page numbers refer to illustrations and captions.

A

Aachen (Aix-la-Chapelle), Germany, 19, 23, 26, 272 Abacus, 238 Abbeville, France, 311 Abbeys. See Monasteries Abelard, Peter, 247-50; and heresy, 249; Sic et Non (Yes and No), 249. See also Héloïse Acre, 103, 141, 198; fall of (1291), 105; and Richard I, 62, 88, 102 Adam, 297-98 Adelard of Bath, guoted, 245 Adrianople, 323 Adriatic Sea, 52, 62, 188 Aegean Islands, 104, 180 Africa, 52, 105, 265-66 Agincourt, France, Battle of (1415), 85, 114, 313 Agriculture, 7, 34, 42; barbarian improvements of, 32; manorial, 177, 209-16; monastic, 74, 152; Moslem, 22 Aix-la-Chapelle. See Aachen Alamanni, 16 Alaric, king of the Visigoths, 13 Albertus Magnus, 182, 252 (quoted), 254 Albi, France, 173 Albigenses, 168, 173. See also Catharism. Albigensian Crusade, 173 Alchemy, 138, 255 Alcuin, 27 Alençon, duke of, 317 Alexander II, pope, 303

Alexandria, Egypt, 137, 322

Alexius Comnenus, emperor, 91, 94–95

- Alfred (the Great), king of England, 33–34, 133, 237
- Alps, 21, 30, 47, 49, 51, 74, 150– 52, 184
- Ambrose, Saint, 260

Andrea, Giovanni d', 257

- Angela of Foligno, 163
- Angers, France, 87
- Angevin dynasty, 59, 62-64. See also Anjou
- Anglo-Saxons, 41, 237; art of, 237, 270; literature of, 237, 260–61; Norman Conquest of, 52, 54–58; settle England, 13, 15, 58–59. See also Danes (Vikings)
- Anjou, France, 59, 61
- Anselm, Saint, quoted, 244-45
- Antioch: fall of (1268), 105; siege of (1098), 95–96
- Apollonia, Saint, 148
- Apulia, 52
- Aquinas, Thomas, Saint, 42, 145, 148, 156 (quoted), 170, 202 (quoted), 248, 250; Summa Theologica, 250
- Aquitaine, 66
- Arabic numerals, 107, 199, 254
- Arabs. See Moslems
- Architecture, 26, 44, 192–94, 270–88 passim, 287, 315, 322, 323; Byzantine, 18, 22, 271; early Christian, 270, 272, 274, 288; Gothic, 276–88 passim, 287, 385; Moorish, 277; Moslem, 22; Renaissance, 288; Roman, 270–75, 288; Romanesque, 274–82, 287. See also Art; Painting; Sculpture
 Aristotle, 240, 243, 245–46, 248,
- 251–52; Organon, 245 Arius and Arianism, 12, 14
- Armenians, 99

Arms and armor, 6, 39, 79, 93, 139–40, 310–13, 314. See also Gunpowder; Warfare

- Army. See Warfare
- Arras, France, 188
- Ars Nova, by Philippe de Vitry, 293
- Art, 26, 28, 42, 268, 269–93 passim, 315, 321, 323–24; Byzantine, 18, 22, 270–71; Celtic, 273; early Christian, 35–36, 270–71, 273, 288–89; German, 273; Gothic, 269–87 passim, 315; Irish, 273; Moslem, 21–22, 276; Renaissance, 286–88; Roman, 7, 269–72, 275; Romanesque, 269–82 passim. See also Architecture; Painting; Sculpture
- Art of Courtly Love, The, by Andreas Capellanus, 121
- Arthur, king of the Britons, 15, 122, 262
- Asia, 38-39, 322-23
- Asia Minor, 97
- Assisi, Italy, 164, 165, 166-67
- Astrolabe, 236, 254
- Astrolabe (son of Abelard and Héloïse), 249
- Astrology, 239
- Astronomy, 236, 238, 239, 253, 254
- Athanasius and Athanasianism, 12, 16
- Atlantic Ocean, 183, 282
- Attila the Hun, 13
- Aucassin and Nicolette, 225 (excerpt)
- Augsburg, Germany, Council of, 49
- Augustine, Saint, 8, 137
- Augustinians, 152, 170
- Austria, 62, 102, 179, 310
- Autun, France, 9
- Auxerre, France, 318
- Avicenna, 255
- Avignon, France, 130, 191, 286, 307, 313; Notre-Dame-des-Doms, 271; papacy in

("Babylonian Captivity"), 134, 301–3, *304*, 306, 322 Azores, 183

B

Babylon, 315 "Babylonian Captivity." See Avignon, papacy in Bacon, Roger, 243, 254 Bagley, J. J., quoted, 114-15 Bailiffs, 210, 211, 215, 297 Baldwin I, emperor, 130 Baldwin II, emperor, 146-48 Baldwin of Boulogne, king of Jerusalem, 95 Balkans, 28 Ball, John, 297-98 (quoted), 300 Baltic Sea, 100, 190, 209 Banking: Italian, 144; rise of, 107, 187-88, 198 Bannockburn, Scotland, Battle of (1314), 66Barbarians, 8-39 passim, 11, 269-71. See also names of individual tribes Barcelona, Spain, 190 Bar-le-Duc, France, 316 Bathing, 132-33, 194 Battle Abbey Church, England, 56 Battle of the Spurs (1302), 229 Bavaria, 23, 117

- Bayazid (Bajazet), sultan, 323
- Bayeux tapestry, 56, 86, 130
- Bayonne, France, 319
- Beatrice Portinari, Dante's poem to, 265
- Beaune, France, 152
- Beauvais, France, 297; cathedral, 186, 278
- Becket, Thomas à, 123, 137, 149; canonized, 61; and Henry II, 61; murder of, 60, 61
- Beer and ale, 135; English, 178– 79, 221, 234–35. See also Food; Wine

- Belgium, 13, 26, 177–78. See also Flanders; Low Countries
- Benedict XIII, pope, 302-3
- Benedictine Rule 10, 12, 74, 99, 156–57, 160, 162
- Benedictines, 20, 158, 270, 278
- Benedict of Nursia, Saint, 10, 74
- Bennett, H. S., quoted, 209
- Beowulf, 190
- Bergen, Norway, 190
- Bernardino of Siena, 148 (quoted), 155, 202 (quoted), 255
- Bernard of Clairvaux, Saint, 75, 161 (quoted), 249 (quoted), 267; and Abelard, 249; described, 75; promotes second crusade, 100
- Berners, Lady Juliana, 115
- Berry, duke of, 113
- Bertha, queen of the Franks, 23
- Beziers, France, 199
- Bible, 28, 79, 161 (excerpt), 248, 249–50, 259, 272, 305
- Biology, 254
- Biscop, Benedict, abbot of Wearmouth, 21
- Bishops, 10, 14, 18, 20, 26, 27, 36, 72, 114, 139, 152, 153–54, 186, 189, 238, 240, 283, 286, 297, 302
- Black Death, 171, 286, 297, 306– 10 *passim, 309*, 313. *See also* Diseases; Famines
- Black Sea, 30, 178, 183
- Blanche of Castile, 102
- Bloch, Marc, quoted, 111-12
- Boccaccio, 128, 154, 187, 206, 259, 295–96, 303; The Decameron, 264, 307; Fiammetta, 262
- Boethius: Consolation of Philosophy, 237; translation of
- Organon, by Aristotle, 245
- Bohemia, 47, 321
- Bologna, Italy, 180, 188, 313; University of, 42, 234, 240, 242, 243, 252, 255, 257
- Boniface, Saint, 20, 21 (quoted)

- Boniface VIII, pope, 300, 301(quoted); Clericis Laïcos, 301
- Book of Durrow, 270
- Book of Kells, 20, 270
- Books and bookmaking, 257-59; monastic, 12, 28, 35, 38, 237
- Bordeaux, France, 18, 31, 179, 319
- Born, Bertrand de, 77-78

(quoted), 123

- Bosnians, 323
- Bourgeoisie, 21, 42, 44–45, 78, 110, 143, 157, 177–207 passim, 204, 264, 286, 288, 295, 324; amusements of, 192, 201; and church, 201–2; described, 190–91, 201, 295, 322; in Estates General, 301. See also Capitalism; Guilds; Merchants; Towns
- Bourges, France, 322; cathedral, 287
- Brabant, 314
- Brenner Pass, 184
- Bridges. See Transportation
- Brittany, 15, 54, 262
- Brooke, Christopher, quoted, 17– 18
- Bruce, Robert, 66
- Bruges, Belgium, 188, 190, 229, 286
- Brunelleschi, Filippo, 288
- Bruno, Saint, 74
- Brussels, Belgium, 286
- Bulgaria, 261, 323
- Burgundians, 12, 13, 16, 315, 318, 319. See also Burgundy
- Burgundy, 13, 30, 73, 152, 314– 15. See also Burgundians
- Bury St. Edmunds, England, 161
- Byzantine Church, 98, 104
- Byzantine (Eastern) Empire, 22– 23, 51–52, 198; art and architecture of, 127, 269, 270, 271, 279; and crusades, 90–107 *passim*; described, 17–18; end of, 322–23; warfare, 90–91, 164

Byzantium, 30, 51. See also Constantinople

С

- Caedmon, 36
- Caen, France, 278, 284, 310
- Caernarvon Castle, Wales, 87
- Cahors, France, 114, 199
- Cahorsins, 199
- Calais, France, 319
- Calendar, 199
- Calligraphy, 19
- Cambrai, France, 188
- Cambrensis, Giraldus, 162
- Cambridge, England, University of, 240, 242–43; King's College Chapel, 286
- Canary Islands, 183
- Candles, 34, 42, 127, 159–60, 220, 275
- Canon law. See Law, canon
- Canossa, Italy, 49
- Canterbury, England, cathedral of, 61, 153, *158*, 182, 187, 259; Becket and, *60*, 61; monastery, *158*, 159, 161–62; pilgrimages to, 128, 150
- Canterbury Tales, by Geoffrey Chaucer, 128, 129, 150, 161, 183–84, 205, 211, 225, 238, 262–64; excerpts, 149, 238, 258
- "The Canticle of the Sun," by Saint Francis of Assisi, 167, 265
- Canute, king of Denmark, 54
- Capellanus, Andreas, The Art of
- Courtly Love, 121 (excerpt)
- Capitalism, 197; primitive, 45; rise of, 183, 201, 227, 323
- Cardinals, 144, 300-301
- Carentan, France, 310
- Carmelites, 170
- Carmina Burana, 244. See also Goliards
- Carolingian dynasty. See France, Carolingian dynasty

Carthage, 13

- Carthusians, 157; founded, 74
- Castel Sant' Angelo, Rome, Italy, 50
- Castles, 42, 75, 84, 113, 209, 272, 279, 295, 324; described, 86– 88, 125, 127; life in, 118–19, 125–27, 134–38; Norman, 58; in warfare, 86–90
- Catharism, 172–73. See also Albigenses; Albigensian Crusade
- Cathedrals, 42, 150, 324; construction of, 150, 272–88 *passim*; organization of, 154; schools, 27, 153, 237–38, 239. See also names of individual cathedrals
- Catherine, Saint, 316, 319
- Catholicism. See Church of Rome
- Cauchon, Bishop, 318-19
- Celestine V, pope, 300-301
- Celibacy, 72, 156-57, 172-73
- Celts: art of, 269–70, 278; literature of, 260, 262, 264; music of, 289
- Centula St. Riquier Monastery, France, 27
- Chalons-sur-Marne, France, 318
- Champagne, France, 187
- Chansons de geste, 123, 138, 261, 285
- Charlemagne, emperor, 19, 23–30 passim, 34, 47, 120 (quoted), 196, 238, 261, 272; coronation of, 25; described, 23; Palace School, 27–28
- Charles III (the Simple), king of France, 33, 37
- Charles VI, king of France, 294, 302–3, 316
- Charles VII, king of France: crowned, 316–18; and Joan of Arc, 316–19, *320*
- Charles the Great. See Charlemagne
- Charterhouses, 73–74. See also Carthusians
- Chartres, France, cathedral of, 278, 280; school, 239, 252;

stained-glass windows, 281, 283

- Chaucer, Geoffrey, 128, 129, 150, 161, 205, 211, 225, 238, 254, 258, 262, 264, 313; Canterbury Tales, 128, 129, 150, 161, 184, 205, 211, 220 (excerpt), 225, 238, 258 (excerpt), 264;
 - Troilus and Criseyde, 262, 264
- Chaumont, France, 316
- Children's Crusade. See Crusades
- China, 12, 18, 39, 130, 182, 183, 258
- Chinon, France, castle of, 317
- Chivalry, 42, 77, 121–23, 124, 262, 266, 279, 295, 312. See also Courtly love
- Christ. See Jesus Christ
- Christianity. See Church of Rome
- Church of Rome, 37, 143-75 passim, 266-67, 301-3, 324; and celibacy, 72, 156-57; and crusades, 90-107; Eastern schism, 92, 102, 104; and feudalism, 114, 302; Great Schism, 301-3; and heresy. 171-73, 247, 249, 251, 305-6; and Holy Roman Empire, 45-51, 69-70, 71; and Irish church, 20; and law, 251-52; missionaries, 20; organization of, 10, 143-44, 153-54; and reform, 72-75; rise of, 10, 12; and trade, 152-53. 187-88, 198, 201-2; and welfare, 19, 150-53. See also Bishops; Cardinals; Cathedrals; Friars; Monasteries; Monks; Nuns; Papacy; names of individual religious orders
- Cicero, 237, 250
- Cimabue, 165
- Ciompi, the, 297
- Cistercians, 67, 128, 157; founded, 74–75
- Citeaux, France, 74
- Cities. See Towns
- Clarendon, Constitutions of, 61

Clement V, pope, 301

- Clocks, 26, 44, 134, 238, 253
- Cloth. See Textiles
- Clothing: Anglo-Saxon, 35; of barbarians, 16; of bourgeois, 180, 186, 205–6, 295; clerical, 126, 129, 161, 163, 168; of Jews, 128, 129, 199; of nobles, *108*, 128–30, *131*; of peasants, 128, 129, 210–11, 220, 221; of women, 35, 128– 32, 205
- Clovis I, king of the Salian Franks, 14, 16–17
- Cluny, France, monastery of, 91, 149, 157, 237, 245; founded, 36, 73–74
- Coeur, Jacques, 322
- Cologne, Germany, 140
- Columba, Saint, 20
- Columban, Saint, 12, 20
- Commerce. See Trade
- Common Law. See Law, common
- Commons, House of (England), 65
- Communes, 138, 188; described, 51. See also Towns
- Compiegne, France, 318
- Compline Hymn, 156 (excerpt)
- Conques, France, monastery of, 148
- Conrad III, emperor, 101
- Consolation of Philosophy, by Boethius, 237

Constantine I (the Great), emperor, 10; Donation of, 22–23

Constantine XI, emperor, 323

Constantinople, 13, 17–18, 51, 137, 177–78, 323; and crusades, 94, 97, 101, 102, 104, 130; siege of (1453), 323

- Convents. See Monasteries
- Copenhagen, Denmark, 190 Copts, 270
- Cópis, 270
- Córdoba, Spain, 22 Corfu, island of, 52
- Cornwall, 15
- Corsica, island of, 188

- Cotentin Peninsula, France, 310
- Cottars, 212, 220
- Coulton, G. G., quoted, 112, 216– 17, 250, 302–3
- Councils: of Clermont, 92; of Constance, 303, 305; of Nicaea, 12; of Pisa, 303
- Courtly love, 119-21, 262. See also Chivalry
- Courtrai, Belgium, 229
- Crafts. See Guilds
- Crécy, France, Battle of (1346), 311–12, 313, *314*
- Credit system, 144, 187, 197–99. See also Currency
- Crimea, 306
- Crombie, A. C., quoted, 252, 254
- Crusades, 42, 80, 89, 90–107 passim, 93, 97, 103, 122–23, 137, 140, 257, 262, 278, 295, 324; Children's, 104–5; Frederick II and, 69–70, 105; origin of, 90–92; first (also Peasants'), 42, 91–100; second, 100–101; third, 101–2; fourth, 102, 104. See also Albigensian Crusade
- Currency, 18, 187, 197–98, 201, 296, 308, 322; scarcity of, 8, 9, 17, 21, 109, 178. See also Credit system Czechs, 261, 305–6

D

- Dalmatia, 102 Damascus, 71, 82, 101 Damietta, Egypt, 105 Dancing, 223, 307. See also Sports and pastimes Danegeld, the, 33 Danelaw, the, 33 Danes (Vikings), 31, 33, 34, 41, 237. See also Vikings Danes and Denmark, 54, 178, 190, 237, 270
- Daniel-Rops, Henri, quoted, 257

Dante, Alighieri, 22–23 (quoted), 245 (quoted), 255, 259, 265, 267, 285, 296, 301; Divine Comedy, 78, 172, 267; The New Life, 265

- Danube River, 13, 26
- Dardanelles, the, 323
- Davis, William Stearns, quoted, 82
- Dawson, Christopher, quoted, 50
- Death, dance of, 288
- The Decameron, by Boccaccio, 264, 307 (quoted)
- Decretum, by Gratian, 251
- Delphi, Greece, 149
- Dialectics, 239, 246. See also Philosophy; Scholasticism; names of individual philosophers
- Dijon, France, 74, 315
- Diseases, 8, 106, 116, 137, 162, 228, 229–33, 255. *See also* Black Death; Famines
- Divine Comedy, by Dante, 78, 172, 267
- Dnieper River, 30
- Dniester River, 30
- Dodona, Greece, 149
- Domesday Book, 38, 58
- Dominic, Saint, 168
- Dominicans, 145, 168, *169*, 170, 252, 307; and Franciscans, 169, 170; and Inquisition, 173; origin of, 168, 170; schools of, 168, 170
- Domremy, France, 316
- Dondi, Giovanni de', 253
- Douai, France, 229
- Drama, 265–66; miracle plays, 266; mystery plays, 197, 234, 266
- Dublin, Ireland, 20, 33
- Duccio, 288, 292
- Durazzo, Albania, 52
- Durham, England, cathedral of, 278
- Dvina River, 30

Eastern Empire. See Byzantine Empire Eastern Orthodox Church. See Byzantine Church Edessa, 95; fall of (1144), 100 Education, 77, 237-59 passim, 263, 289, 290; Carolingian, 27-28; cathedral schools, 27, 153, 237-38, 239; Dominican schools, 168, 170; grammar schools, 238-40, 241, 290; of nobles, 119, 239, 257, 290; Roman and secular, 239; song schools, 238, 289. See also Universities Edward ("the Black Prince"), Prince of Wales, 88, 315 Edward (the Confessor), king of England, 54-55 Edward I, king of England, 53 Edward III, king of England, 195, 198, 310-11 Egypt, 21, 68, 255, 270, 284; and crusades, 102, 105, 166

- Einhard, quoted, 23
- Ekkehard von Aura, 153
- Eleanor of Aquitaine, 62, 121; and second crusade, 101
- Eleanor of Provence, 195
- Ely, England, cathedral of, 59
- Emma of Normandy, 54
- England, 21, 30, 38, 41, 42, 77, 97, 127, 129, 130, 134, 184, 192, 195, 196, 240, 251, 254, 293, 305, 313, 315, 321, 322, 324; under Alfred the Great, 237; under Anglo-Saxons, 20, 33–36, 41, 52–58, 196; art of, 36, 270, 284, 286, 293; and Black Death, 307, 313; and church, 20, 64, 150, 155–56, 166, 172, 175; Danes (Vikings) in, 33–34, 41, 54; under Edward I, 65–66; and France, 310–19 *passim*; under Henry II, 59–62; under

Henry III, 65; and Ireland, 61; under John, 62, 64-65; literature of, 36, 260, 261, 262, 264; manorialism in, 114, 209-26 passim; Norman Conquest, 52-59, 57, 80; population of, 58, 59, 296; under Richard I, 62, 101-2; Romans in, 15-16; trade, 34, 45, 177-203 passim, 322; under William I, 58-59, 86. See also Hundred Years War; Peasants' Revolt English Channel, 15, 30, 55, 187, 310 Eschenbach, Wolfram von, Parzival, 262

- Esslingen, Germany, 310
- Estates General, 296-97, 301
- Ethelred (the Unready), king of England, 54
- Eton School, England, 240
- Euclid, 252
- Eve, 297–98
- Everyman, 266
- Eyck, Hubert and Jan van, 288

F

- Fabliaux, 174, 264
- Fairs, 187-88, 189, 257
- Famines, 44, 221–22, 296, 299. See also Black Death; Diseases
- Farming. See Agriculture
- Festivals and holidays, 20, 222– 23, 231, 266
- Feudalism, 10, 17, 26, 58, 84, 109– 15 passim, 113, 262; and church, 72, 114, 302; decline of, 90, 114–15, 201, 295, 308, 312, 321; explained, 109–10, 112, 114, 209; and trade, 190–91, 193. See also Fief; Manorialism
- Feurs, France, 176
- Fief, 109–11, 116, 209. See also Feudalism

- Fishing, 35, 112, 137, 160–61, 178, 179, 183, 190, 227
- Flagellants, 171, 321
- Flanders, 62, 104, 178, 286, 310, 315; textiles, 178–87 passim; trade, 45, 178–90 passim, 201, 227. See also Belgium; Low Countries
- Florence, Italy, 115, 121, 188, 197, 198, 258, 288, 297, 307, 313; cathedral, 288
- Food, 66, 127, 134–37, 179, 295, 315; of barbarians, 16; of bourgeois, 204, 206–7, 295; of monks, 74, 75, 161–62; of nobles, 134–37, 136; of peasants, 211, 214–15, 221–22. See also Beer and ale; Wine
- Forlì, Italy, 175
- Foucher de Chartres, Historia Hierosolymitana (History of Jerusalem), 96–98 (excerpt)
- France, 11, 16-17, 18, 21, 22, 36, 41, 42, 44-45, 60, 66-69, 77, 87, 110, 117, 125, 128, 130, 132, 148, 196, 201, 205, 206, 237, 283, 284, 295, 296, 299, 313, 315-16, 321; and Albigenses, 168, 173; art of, 28, 44, 45, 67, 269-93 passim; Avignon papacy, 301-3; and Black Death, 306, 310; Carolingian dynasty, 23-28, 109, 237, 258; and crusades, 91-107 passim, 97; and England, 61-62, 310-21 passim; literature of, 42, 44, 45, 66, 67, 259, 261, 262, 264, 265; under Louis IX, 67, 69; manorialism in, 209-26 passim; Merovingian dynasty, 16-17, 18; under Philip IV (the Fair), 78, 100, 301, 310; under Philip Augustus, 66-67; trade, 177-202 passim, 193; Vikings in, 30-33, 37. See also Hundred Years War; Jacquerie, the; Joan of Arc

- Francis of Assisi, Saint, 164–68, 165, 170, 172, 265, 266; The Canticle of the Sun, 167, 265; death of, 167; the Little Flowers of Saint Francis, 266; quoted, 145, 164, 168
- Franciscans, 67, 163, 252, 290, 307; and Dominicans, 168, 170; and monasticism, 166, 170; origin of, 164, 166. See also Francis of Assisi
- Franks, 7, 13, 14, 16–17, 18; and crusades, 91–105 passim; Merovingian dynasty, 16–17, 21. See also France, Carolingian dynasty
- Frederick I (Barbarossa), emperor, 101, 186 (quoted)
- Frederick II, emperor, 68, 69–72, 70 (quoted), 151, 265; and crusades, 68, 69–70, 105; described, 69, 71; On the Art of Hunting with Birds, 71, 254
- Friars, 148, 153, 164–71, 298; and Black Death, 307–8; and clergy, 170–71, 295; described, 170. See also Monks; names of individual religious orders
- Friars Minor. See Franciscans
- Friesland, 45. See also Holland; Low Countries; Netherlands
- Frisia, 177. See also Holland; Low Countries; Netherlands
- Froissart, Jean, 77 (quoted), 78, 88 (quoted), 127, 266
- Fulbert, Canon, 249
- Fuller, Thomas, quoted, 148

Furniture. See Houses and furniture

G

Gaetani, Benedetto. *See* Boniface VIII Galen, 255 Gaul, 9, 13, 16, 21, 22, 38, 265 Genghis Khan, 105 Genoa, Italy, 51, 90, 99, 311;

trade, 179, 180, 183, 198

Gerbert of Aurillac. See Sylvester II

- Germany, 14, 18, 20, 23, 25–26, 28, 29, 30, 42, 44, 45, 47–51, 77, 100, 115, 135, 166, 196, 205, 219, 220, 222, 243, 310, 312, 321, 322, 324; art of, 28; and crusades, 94, 101, 104–5; and England, 62; and Frederick II, 69, 70; literature of, 260–61, 262, 264, 265; trade, 178–79, 190–91. See also Holy Roman Empire; names of individual tribes
- Ghent, Belgium, 188, 229
- Gherardo (brother of Petrarch), 308
- Gibraltar, 30
- Giotto, 283, 288
- Glass, 42, 133, 180, 182, 255, 322.
- See also Stained glass
- Godfrey of Bouillon, 93
- Godric of Finchale, 178
- Godwinson, Harold. See Harold II
- Goethe, 278
- Goliards, 174, 264, 290. See also Carmina Burana; Music; Poetry
- Goodridge, J. F., adaptation of *Piers Plowman*, by William Langland, 234–35
- Goths. See Visigoths
- Grammar, 23, 239-40
- Grande Chartreuse, La, 74. See also Carthusians
- Grandmont Monastery, France, 157
- Grand Pont (bridge), Paris, France, 181
- Gratian, 202 (quoted); Decretum, 251
- Great Council of England. See Parliament
- Great Schism, 301-3, 306, 322
- Greece, 7, 9, 13, 21, 28, 39, 104, 264
- Greenland, 30, 33, 295

Gregory I (the Great), pope, 10, 20

- Gregorian chant, 289
- Gregory VII, pope, 48–50, 52, 60; investiture controversy and, 48–50
- Gregory IX, pope, 69, 70
- Gregory XI, pope, 302
- Gregory of Tours, 270
- Grosseteste, Robert, 252, 254
- Grout, Donald J., quoted, 293
- Guesclin, Bertrand du, 313
- Guilds, 18, 188, 196–97, 206, 277, 283, 296, 323; craft, 196–97, 213, 226–27, 228, 258–59, 285; and drama, 197; in education, 242–43; merchant, 196; origin of, 196
- Guiscard, Robert, 50, 52
- Gunpowder, 90, 311, 312, 313

Gunzo of Novara, 153

Guyot de Provins, 157–59 (quoted)

Η

Hadrian's Wall, 13 Haggadah, *200*

- Hagia Sophia. See Santa Sophia
- Hair styles, 130, 132, 205
- Hamburg, Germany, 31

Handwriting: Carolingian minuscule, 28, 258; Gothic minuscule, 28, 259; Roman majuscule, 28

Hanseatic League, 190

Hapsburg dynasty, 321

Harold II (Godwinson), king of England, 54–58, 57

- Harold III (Haardraade), king of Norway, 55
- Harun al-Rashid, caliph, 26
- Hastings, Battle of (1066), 55–56, 57, 58
- Haucourt, Genevieve d', quoted, 141
- Hauser, Arnold, quoted, 271 Hauteville, Tancred de, 52

- Hawking, 119, 139; On the Art of Hunting with Birds, by Frederick II, 71, 254
- Hay, Denys, quoted, 77
- Heer, Friedrich, quoted, 217, 249 Hell, 147
- Héloïse, 249. See also Abelard, Veter
- Henry (the Young King), 62
- Henry II, emperor, 46
- Henry IV, emperor, 48, 52; investiture controversy and, 48– 51
- Henry VI, emperor, 62
- Henry I, king of England, 198
- Henry II, king of England, 59, 61 (quoted), 62, 63, 121, 139, 162; and Becket, 60, 61; common law, 59, 61; and France, 61–62; and Ireland, 61
- Henry III, king of England, 65, 195, 198
- Henry IV, king of England, 305
- Henry V, king of England, 313
- Henry VI, king of England, 148
- Henry VII, king of England, 286

Henry VIII, king of England, 64 Henry of Pisa, 291

- Heresy, 171–73, 247, 251, 318; and Peter Abelard, 249; Albigensian, 168, 172, 173; Arianism, 12; and Bernard of Clairvaux, 75, 249. See also Inquisition; Joan of Arc; Philosophy; Theology; Witchcraft
- Heriot and mortuary, 112, 216
- Hesse, Germany, 322
- Hildesheim, Germany, 322
- Historia Hierosolymitana (History of Jerusalem), by Foucher de Chartres, 96–98 (excerpt)
- Hohenstaufen, house of, 71–72
- Holland, 45, 313, 315. See also Low Countries; Netherlands
- Holy Land. See Palestine
- Holy Roman Empire, 46, 321; conflict with papacy, 47, 48– 51; under Frederick II, 69–72;

under Henry IV, 48–50; origin of, 47; under Otto I, 47; under Otto III, 47. *See also* Germany

- Honorius, bishop of Autun, quoted, 244
- Hospitalers. See Knights Hospitalers
- Hospitals, 45, 255, 315; described, 152
- Houses and furniture: of bourgeois, 42, 192, 194, 203, 205; church, 126; after fall of Rome, 9; monastic, 74, 75, 126, 127; of nobles, 115, 116, 117, 125, 126, 127; of peasants, 34, 42, 211, 212, 220-21, 224
- Hugh the Iron, 105
- Huizinga, J., quoted, 286
- Humanism, 245, 250, 288, 323
- Hundred Years War, 114, 127, 174, 286, 296, *309*, 310–19, *314*. *See also* Joan of Arc
- Hungary, 28, 30, 102, 321, 323
- Huns, 12-13, 15, 39
- Hunting, 23, 112, 118, 119, 139
- Hunyadi, Janos, 323
- Hus, John, 305-6
- Hussite Wars, 305-6

Ι

- Iceland, 20, 30, 33, 72, 183
- Illumination, 19, 224
- India, 18, 39, 183, 322
- Indulgences, 144-45, 302
- Industries, 296; early, 34, 190; Moslem, 22; rise of, 44, 45, 180, 182, 201, 322, 323
- Innocent III, pope, 64, 105, 148, 240; and Albigenses, 173; and fourth crusade, 102; and Saint Francis, 166
- Inquisition, 173
- Investiture controversy, 48–51 Iona, 20

Ireland, 30, 33, 109, 261; art of, 269, 270; church of, 20; and England, 61; Scottish tribes in, 13

Isaac Angelus, emperor, 102

Isabella, queen of France, 117, 313

- Islam. See Moslems
- Istanbul. See Constantinople
- Italy, 9, 10, 13, 18, 28, 30, 41, 45, 49, 50, 51, 109, 115, 123, 127, 132, 134, 137, 138, 164, 188, 190, 194, 201, 205, 222, 240, 243, 255, 282, 295, 297, 301, 312-13, 321, 324; art of, 277, 286, 288; and Avignon papacy, 302; and Black Death, 306; and Charlemagne, 23, 25; and Frederick II, 69, 70, 71; literature of, 71, 265, 266, 267; and Lombards, 22, 23; Normans in, 41; and papal states, 22, 143-44; trade, 177-203 passim, 227

J

- Jacquerie, the, 297, 299, 308
- James, Saint, 149
- Japan, 109
- Jeremiah, 73 (quoted), 315
- Jerusalem, 21, 91–106 passim, 93, 246, 315; and Frederick II, 70; pilgrimages to, 91, 149; recapture by Moslems (1187), 101; and Richard I, 62, 101, 102; siege of (1099), 88, 96, 98
- Jesus Christ, 10–12, 37, 46, 142, 144, 145, 148, 149, 251, 271, 274, 275, 289, 297, 318
- Jews, 67, 129, 146, 199, 201, 252, 289, 303; and crusades, 94, 98; persecution of, 200, 308, 310; and trade, 199
- Joan of Arc, 67, 316 (quoted), 317 (quoted), 319, 320, 321; burned, 318–19; canonized,

319; trial of, 318; and witchcraft, 146, 318; wounded, 318

- John, king of Bohemia, 229
- John, king of England, 62, 63, 64; Magna Carta and, 64, 65
- John III (the Good), king of France, 313
- John VIII, pope, 36
- John XII, pope, 36, 47
- John XXII, pope, 187
- John XXIII, antipope, 303
- John of Salisbury, quoted, 77
- John the Baptist, 280
- Joinville, Jean de, Life of Saint Louis, 67-69 (excerpt), 266
- Jongleurs, 138, 244, 261, 264–65. See also Minnesingers; Minstrels; Troubadours
- Justice. See Law
- Justinian, emperor, Corpus Juris Civilis, 251

K

Kent, England, 35

- Kerak, castle of, 101
- Kiev, Russia, 30
- Knighthood, 17, 77–85, 110–41 passim, 146, 262, 310–11, 324; decline of, 312; dubbing, 78; origin of, 77. See also Arms and armor; Nobility; Warfare
- Knighton, Henry, 308 (quoted), 313
- Knights Hospitalers, 157; founded, 99
- Knights of Malta, 100
- Knights of Rhodes, 100
- Knights of St. John of Jerusalem, 100
- Knights Templars, 123, 157; founded, 100

Koran, 19

Kossovo, Albania, 323

Krak des Chevaliers, 105

L

Lancaster, duke of. See John of Gaunt Lanfranc, archbishop of Canterbury, 259 Langeais, France, 86 Langland, William, Piers Plowman, 125, 215, 234 Languages, 250, 295; Anglo-Saxon, 34; Arabic, 51, 52, 69, 99, 245, 252, 254-55; English, 7, 305; French, 33, 44, 67-69; Greek, 20, 21, 23; Hebrew, 245; Irish, 20; Latin, 15, 153, 237-39, 245, 257, 259-60, 290; Provençal, 66; Spanish, 245; Syriac, 245 Languedoc, 173, 301 La Tour-Landry, Knight of, quoted, 122 Lateran Council (Second), 72 Laura (Petrarch's), 155 Law, 64, 65, 71, 187–88, 202–3, 240, 305, 308, 321-22; Anglo-Saxon, 35; canon, 143, 150, 251; civil, 251-52; common, 59, 61, 184, 251; Roman, 7, 15 Leo I (the Great), pope, 13 Leo III, pope, 25 Leo IX, pope, 52 Leo XIII, pope, 250 Leon, Spain, 41 Le Puy, bishop of, 94 Levant, 91, 188 Liberal arts, 239-40, 289. See also Education; Universities Life of Saint Louis, by Jean de Joinville, 67, 266 Lille, France, 229 Limoges, France, siege of (1370), 88, 315 Lincoln, England, 217 Lisbon, 97 Literature, 27-28, 38, 42, 44, 45, 75, 107, 255-67, 289-90, 321, 323; Anglo-Saxon, 237,

260; bourgeois, 122, 257, 264; Byzantine, 17, 18; Celtic, 260-62, 264; chivalric, 119-20, 122, 257, 262; English, 34, 36, 262, 264; French, 44, 45, 120, 259, 261-62, 264-66; German, 260-62, 264; Greek, 18; Hebrew, 264; Italian, 71, 265-66; Latin, 15, 27, 28, 119, 238-39, 259-60, 264-65; Moslem, 22, 120, 264-65; Provençal, 173, 264-65; Scandinavian, 261; Spanish, 120, 261, 264-65; vernacular, 259-60, 265. See also Chansons de geste; Drama; Fabliaux; Goliards; Poetry; names of individual authors Little Flowers of Saint Francis, The, 266 Logic. See Dialectics Loire River, 86, 317 Lollards, 305 Lombards, 12, 22, 23, 25, 188, 198. See also Lombardy Lombardy, 21, 47, 51, 137, 148. See also Lombards London, England, 55, 56, 59, 62, 179, 188–89, 194, 197, 202, 206, 239, 297, 307 London Bridge, England, 46, 300 Lords, House of (England), 180 Lorraine, 30, 316 Louis VI, king of France, 212 Louis VII, king of France, 62, 100, 101 Louis IX, king of France, 40, 67, 69, 118, 146, 148, 195; and crusades, 105; described, 67; quoted, 67-69 Louis X, king of France, 296 Louvain, Belgium, 286 Low Countries, 16, 45, 177, 205, 229, 233, 277, 286. See also Belgium; Holland;

Netherlands Lübeck, Germany, 190

Lyons, France, 172, 187

M

Macedonia, 7, 28, 104 Magna Carta, 64-65 Magyars, 28, 30, 36, 38, 47 Main River, 26 Mainz, Germany, 26 Malory, Sir Thomas, Le Morte d'Arthur, 262 Manorialism, 27, 109, 111-12, 177, 209-29 passim. See also Feudalism Manuscripts, 12, 20, 28, 29, 35. 159, 160, 161, 237, 224, 258, 285 Marcel, Etienne, 296-97 Margaret, Saint, 316, 319 Margaret of Provence, 67 Mark, Saint, 273 Marozia, 36 Marriage: of bourgeois, 201, 203, 217, 219; Cartharism and, 172-73; church and, 143; clerical, 72; of nobles, 115, 116, 118, 203, 219; of peasants, 211, 217, 219. See also Celibacy Marseilles, France, 99, 105, 308 Marshal, William, 83, 140 Martel, Charles, 18, 22 Martin V, pope, 303 Martini, Simone, 288, 292 Mary, 271, 275, 285, 305; cult of, 12, 145 Mary Magdalen, 249, 266 Masons, 100, 227, 279, 283-85 Mathematics, 236, 238-39, 252, 254 Mayors of the palace, 17, 18 Mecca, 149 Medici, Cosimo de', 258 Medici family, 286 Medicine, 222, 229-30, 232, 239-40, 252, 255; and Black Death, 306-7. See also Hospitals Mediterranean Sea, 18, 21, 30, 90, 95, 179, 183, 188, 209

Memling, Hans, 288 Ménagier de Paris (Goodman of Paris), quoted, 203, 206-7 Merchants, 9, 30, 51, 146, 177-90 passim, 189, 193, 196, 204. 206, 228, 295-96, 322. See also Bourgeoisie; Trade Merovingian dynasty. See France, Merovingian dynasty Merowig, 17 Merry Wives of Windsor, by William Shakespeare, 133 Mesopotamia, 322 Messina, Italy, 379 Metz, France, 152 Michael, Saint, 316, 319; statue of, 279 Michelangelo, 288 Milan, Italy, 39, 51, 82, 188; population of, 190 Milvian Bridge, Rome, Italy, 10 Mining, 179, 227-28, 322 Minnesingers, 265-66, 290-91, 293. See also Jongleurs; Minstrels; Troubadours Minstrels, 123, 138, 260, 265. See also Jongleurs; Minnesingers; Troubadours Mohammed, 18, 70 Mohammed II, Sultan, 323 Monasteries, 20, 21, 27, 29, 31, 36, 38, 73-75, 152-53, 156-63, 164, 186, 286, 322, 324; and Black Death, 306; described, 10, 12, 156-63, 166; and feudalism, 114; influence on crusades, 91; and learning, 12, 29, 143, 152-53, 238, 255; and manuscripts, 12, 20, 28, 29, 35, 159, 160, 161, 237, 258, 285; and reform, 73-75. See also Friars; Monks; Nuns; names of individual religious orders Mongols, 13, 16, 39, 85 Monks, 20, 21, 27, 28, 73–75, 137, 152, 153, 223, 272, 279, 285; daily life of, 29, 74-75, 159-60; described, 12, 138-44

passim, 175; and friars, 166, 170–71, 295. See also Monasteries; Nuns

- Montaigne, 223-25
- Mont Cenis Pass, 49
- Montesquieu, 8
- Montpellier, France, University of, 240, 255
- Montrieux, France, monastery of, 308
- Mont-Saint-Michel, France, abbey church of, 279
- Moors. See Moslems
- More, Thomas, quoted, 243
- Morte d'Arthur, Le, by Sir Thomas Malory, 262
- Moselle River, 152
- Moslems, 7, 69–71, 125, 129, 146, 149, 152, 254–55; art of, 19, 276, 277, 278; conquests of, 18, 30, 41, 237; and crusades, 89, 91–107 passim, 93, 97. 103; in Italy and Sicily, 30, 41, 51, 52, 69, 295; learning of, 18, 22, 70, 71, 180, 198, 230, 252, 254–55, 264, 265; in Spain, 13, 18, 25, 41, 120, 125, 295; trade, 18, 179, 180, 198
- Mumford, Lewis, quoted, 195 Music and musicians, 23, 238, 292, 324; ecclesiastical, 12, 21, 159–60, 238, 289–91; notation, 159–60, 290; secular, 290, 293. See also Goliards; Minnesingers; Troubadours

Mussolini, Benito, 247, 297

Ν

Nancy, France, 316 Naples, Italy, University of, 57 Navarre, 41 Navigation, 97, 322; Byzantine, 90, 183; developments in, 44, 182–84, 186; Italian, 51, 90, 182-83; Viking, 30, 31, 33.

- See also Transportation
- Nazareth, 70
- Netherlands, 177. See also Holland; Low Countries
- Newcastle, England, 179
- New Life, The, by Dante, 265
- Nibelungenlied, 261
- Nicholas of Germany, 104
- Nile River, 105
- Noah's wife, 266
- Nobility, 25, 35, 36, 41, 45, 108, 109-41 passim, 186, 201-2, 262, 264, 272, 274, 279; amusements of, 131, 135, 136, 139-40; decline of, 295, 321; described, 115-19; and feudalism, 109-16; and manorialism, 209-29 passim; private wars, 77-80, 116, 123
- Norfolk, England, 33
- Norman Conquest. See Normans, in England
- Normandy, 37, 41, 52, 54, 55, 61– 62, 284, 310, 315, 319. See also Normans
- Normans, 110–11, 127, 130, 183; in England, 41, 52–59, 57; in Italy and Sicily, 41, 50, 52. See also Normandy
- Northmen. See Vikings
- Norway, 33, 55
- Norwich, England, 88; cathedral, 146
- Notre Dame Cathedral, Paris, France, 249, 283
- Notre-Dame-des-Doms, Avignon, France, 271
- Nottingham, England, 195
- Novgorod, Russia, 190
- Nuns, 184-85, 223, 249;
 - described, 163; in England, 163

0

Odoacer, 8 Oliver of Malmesbury, 182

- Oman, C. W. C., quoted, 311
- On the Art of Hunting with Birds, by Frederick II, 71, 254
- Orleans, France, 66, 316–17; siege of, 316, 317
- Otto I (the Great), emperor, 30, 36, 47
- Otto III, emperor, 47, 238
- Ottoman Empire, 323
- Ottonian Renaissance, 272
- Oxford, England: cathedral, 59; University of, 170, 240, 242– 43, 254, 303
- Oxford, Provisions of, 65

\mathbf{P}

- Padua, Italy, 121
- Painter, Sidney, 119, 120 (quoted)
- Painting, 268, 272, 274–76, 281, 288, 292. See also Art; Stained glass
- Palermo, Sicily, 52, 69
- Palestine (Holy Land), 42, 62, 91– 107 passim, 149, 182
- Papacy, 22, 25, 36, 68, 300–306; in Avignon ("Babylonian Captivity"), 134, 302–3, 322; founded, 10; Great Schism, 302, 306; organization of, 143–44
- Papal states, 143–44; Donation of Constantine, 22
- Paper, 239, 257-58, 322
- Paris, France, 31, 38, 45, 66, 123, 148, 155, 181, 183, 189, 190, 195, 244, 247, 249, 282–83, 294, 296, 311, 313, 315, 318; population of, 190; University of, 168, 174, 240, 244
- Parliament (England), 53, 65
- Parma, Italy, 49, 154, 324
- Parzival, by Wolfram von Eschenbach, 262
- Passover, 200
- Patrick, Saint, 20
- Pavia, Italy, 51
- Peace of God, 73

- Peasants, 7, 34, 35, 42, 107, 109, 174, 184, 207, 224, 264, 299, 308, 322; daily life of, 42, 44, 209–29 passim; feudal services of, 111–12, 113, 114, 209–19 passim, 307; and freedom, 35, 114, 178–79, 210– 12, 226, 295–96, 308. See also Jacquerie, the; Ciompi, the; Peasants' Revolt
- Peasants' Crusade. See Crusades
- Peasants' Revolt, 296-300, 308
- Peasants' War, 322
- Pelagius, Alvarus, quoted, 219, 223
- Penitent Sisters of St. Magdalen, 152
- Pepin the Short, king of the Franks, 22, 23
- Persia, 172, 269
- Perugia, Italy, 175, 194, 231, 313
- Peter, Saint, 10, 22, 49, 55
- Peter the Hermit, 94, 95
- Petrarch, Francesco, 129, 153, 155, 167, 186, 195, 240, 245 (quoted), 259, 296, 308
- Pevensey, England, 55
- Philip II (Augustus), king of France, 44, 62, 64, 66–67, 196; and third crusade, 101
- Philip IV (the Fair), king of. France, 78, 301; and Templars, 100
- Philip VI, king of France, 310
- Philip the Bold, duke of Burgundy, 315
- Philip the Good, duke of Burgundy, 315
- Philosophy, 22, 42, 240, 245–51; in France, 44, 45; theology and, 247, 248, 249–51. See also Dialectics; Scholasticism; names of individual philosophers
- Picardy, 186, 188, 219, 234, 257, 270, 278, 282, 305, 313

Picts, 13

Piedmont, 172

- Piers Plowman, by William Langland, 125, 215; excerpt, 234-35
- Pilgrimages, 12, 21, 91, 99, 100, 139, 146, 149–50, 151
- Piracy, 21, 41, 184
- Pirenne, Henri, 106; quoted, 226-27, 321,
- Pisa, Italy, 51, 183, 188, 291
- Plague. See Black Death
- Plantagenet, Geoffrey, 59
- Plato, 246, 265
- Plow, 16
- Poetry, 38, 71, 257, 258–67 passim; English, 36. See also Chansons de geste; Goliards; Literature; names of individual authors
- Poissy, France, 311
- Poitiers, France, 18, 66, 121, 313, 317; Battle of (1356), 114
- Poles and Poland, 261, 310
- Polo, Marco, 107, 183; The Book of Marco Polo, 266
- Poor Men of Lyons, 172
- Population: and Black Death, 286, 306–8, 309, 310; of clerics, 143; decline of, after fall of Rome, 9; increase in Middle Ages, 41, 42, 92, 177, 296, 299
- Portinari, Beatrice. See Beatrice Portinari
- Portugal, 313
- Po Valley, Italy, 177
- Power, Eileen, translation of writings of the Ménagier de Paris, 203, 206
- Prague, Czechoslovakia, 305
- Priests, 10, 12, 72–73, 153, 238, 259, 297–98, 305, 307–8; described, 154–56, 174– 75, 210; and friars, 170–71, 295
- Proletariat, 45, 208, 218, 228, 322
- Protestantism, 50, 100, 149, 306
- Provence, 66, 179; culture of, 173, 264–65

Provins, France, 187 Ptolemy, 252 Pyrenees, 16, 18, 62, 261

R

- Ransomers, order of, 152
- Raymond II, prince of Antioch, 101
- Raymond VI, duke of Toulouse, 173
- Raymond of Agiles, quoted, 98
- Reeves. See bailiffs
- Reformation, 149, 303, 323
- Reims, France, 16; cathedral, 212, 283, 316, 318; school, 237– 38
- Relics, cult of, 12, 31, 51, 146–49, 151, 189, 282, 305
- Remigius, bishop of Reims, quoted, 16
- Renaissance, 288, 323
- Reykjavik, Iceland, 322
- Rhine River, 13, 16, 26, 45, 285, 310
- Richard I (Lion-Hearted), king of England, 62 (quoted), 63, 82; and crusades, 62, 88, 101–2, 103
- Richard II, king of England, 129; and Peasants' Revolt, 298
- Rienzo, Cola di, 297
- Roads. See Transportation
- Roger I, count of Sicily, 52
- Roger II, king of Sicily, 52
- Roland, 261. See also Song of Roland
- Rollo, 33, 37
- Roman de la Rose, 122, 129
- Roman de Renart, 122
- Roman Empire, 11–39 passim, 199; culture of, 7, 10, 12, 15– 16, 27–28, 66, 227, 245, 269– 71, 275–77, 288; fall of, 8–12, 11
- Rome, Italy, 8, 10, 12, 13, 21, 22, 25, 30, 41, 48, 50, 51, 143, 144, 148, 149, 164, 166, 179,

- 184, 186–87, 201, 245, 260, 297, 300–302, *304*, 305, 323; and Frederick II, 71; Goths in (410), 13; sack by Vandals (455), 13. *See also* Roman Empire
- Romuald, Saint, 148
- Romulus and Remus, 224
- Romulus Augustulus, 8
- Roncevaux, Spain, 261
- Rothenburg, Germany, 322
- Rouen, France, 44, 72, 316, 318; cathedral, 150, *213*, 286; trial of Joan of Arc at, 318–19, *320*
- Runciman, Stephen, quoted, 98, 104
- Runnymede, England, 64
- Russia, 28, 30, 178–79, 188, 190, 260–61, 269, 307, 322–23

S

- St. Bernard Pass, 184
- St. Denis, France, abbey of, 183, 278, 282–83
- St. Gall, Switzerland, monastery of, 38, 153, 163
- St.-Germain-des-Prés, Paris, France, 38
- St. Gothard Pass, 184
- St. Jago. See Santiago de Compostela
- St. Lô, France, 310
- St. Martin of Tours, France, 270; church of, 270; monastery of, 27
- St. Peter's Basilica, Rome, Italy, 25, 30, 164, 323
- St. Vaast, France, 310
- St. Valéry-sur-Somme, France, 55
- Sainte-Chapelle, Paris, France, 148
- Saladin, 101-2
- Salerno, Italy, 52; University of, 240, 255
- Salimbene of Parma, 154–55; quoted, 156, 171, 205, 290– 91, 324

- Salt, 34, 51, 134, 177, 179, 183
- Samson, abbot of Bury St.

Edmunds, 161

- Santa Maria Maggiore, church of, Rome, Italy, 12
- Santa Sophia, church of, Constantinople, 18, 104; becomes mosque, 397
- Santiago de Compostela, Spain, 149
- Saracens. See Moslems
- Saragossa, Spain, 82
- Sardinia, island of, 188
- Saumur, France, 113
- Savoy, 172
- Saxons, 7, 23, 47–48. See also Anglo-Saxons; Saxony
- Saxony, 47, 48
- Scandinavia, 30, 41, 45, 58, 109, 127, 212, 237, 307, 313; art of, 269–70; literature of, 260; trade, 177. See also Danes and Denmark; Norway; Sweden; Vikings
- Schaffhausen, Germany, 310
- Scholasticism, 249–51. See also Abelard, Peter; Aquinas, Thomas, Saint; Philosophy; Theology
- Schools. See Education
- Science, 22, 236, 246–47, 250, 252–55, 256; in France, 44; and Frederick II, 69, 70–71
- Scot, Michael, 70
- Scotland, 20, 33, *53*, 70, 233, 295, 321; and England, 64, 65–66, 313
- Sculpture, 36, 71, 269–86 passim, 280; Byzantine, 279; Gothic, 278–79, 281–82, 286; Roman, 270–72;

Romanesque, 274-76, 278

- Scythians, 269-70
- Seine River, 183, 282, 311, 319
- Seneschals, 209
- Sens, France, 114, 278; cathedral, 278

Serbs, 261, 323

- Serfs, 9, 20, 35, 189, 209–29 passim, 296–98, 307–8; described, 211–12. See also Peasants
- Seville, Spain, cathedral of, 277
- Ships. See Navigation
- Sic et Non (Yes and No), by Peter Abelard, 249
- Sicily, island of: and Black Death, 306; and Byzantines, 51; and Frederick II, 69–71, 265; under Moslems, 41, 51; Normans in, 41, 52
- Siena, Italy, 115, 255, 288, 291, 313; as commune, 188; cathedral, 283
- Simony, 72-73
- Slavery, 12, 21, 34, 35, 50, 51, 105, 146, 152, 178, 212, 296; decline of, 179; under Romans, 8, 9
- Slavs, 12, 28, 41, 47, 100, 321
- Smithfield, England, 298
- Solingen, Germany, 82
- Somme River, 311
- Song of Roland, 25, 261
- Southampton, England, 88
- Southern, R. W., quoted, 246
- Spain, 13, 133, 134, 149, 168, 177, 237, 243, 258, 303, 310, 313; art of, 277; literature of, 261, 264, 265; Moslems in, 13, 18, 25, 41, 120, 125, 277, 295; reconquest, 41, 91; trade, 179, 190; Visigoths in, 13
- Speyer, Germany, 310
- Spiritual Franciscans, 106, 168. See also Franciscans
- Sports and pastimes: in towns, 233, 243-44
- Stained glass, 180, 197, 271, 272, 274, 275, 277, 281, 283. See also Glass
- Stamford Bridge, Battle of (1066), 55
- Stephen II, pope, 22
- Stephen of Blois, 95
- Stephen of France, 104
- Stone Age, 7, 38

Strasbourg, France, 195, 310; cathedral, 278, 283
Strassburg, Gottfried von, 262
Straw, Jack, 298
Suger, abbot of St. Denis, 183, 212, 278, 282 (quoted)
Summa Theologica, by Saint Thomas Aquinas, 250

- Swabian League, 190
- Sweden, 179, 190, 295. See also Scandinavia
- Sweeney, James Johnson, 270
- Switzerland, 20, 38
- Sylvester, bishop of Rome, 22
- Sylvester II, pope (Gerbert of Aurillac), 47, 237–38
- Syria, 9, 71, 88, 106, 107, 125

T

- Tamerlane, 322
- Tapestries, 117, 142, 218. See also Bayeux tapestry
- Tartars, 322
- Technology: ancient, 7; barbarian improvements of, 38–39; development of, 42, 44, 159, 180, 182, 197, 284
- Templars. See Knights Templars
- Teutonic Knights, 100
- Textiles, 128–29, 130, 132, 178– 90 passim, 322; English, 34, 45, 178–80; Flemish, 178–80, 190; Italian, 180; wool, 34, 45, 51, 74, 178–80
- Thames River, 59
- Theology, 20, 147, 240, 281; and philosophy, 246–47, 248, 249–51
- Theophilus, quoted, 281-82
- Thomas à Becket. See Becket, Thomas à
- Thor, 32
- Thrupp, Sylvia L., quoted, 205–6 Tibet, 183
- Tithes, 152, 174, 175, 322
- Toledo, Spain, 82
- Tomkeieff, O. G., quoted, 217

- Tools: ancient, 7, 38, 39, 182; medieval, 34, 38, 39, 42, 44, 86–87, 182, 227
- Toul, Bishop Matthew of, 154
- Toulouse, France, 199
- Touraine, France, 316
- Tournaments, 76, 124, 140-41
- Tours, France, 18
- Towns, 15, 176, 178–95 passim, 296, 315, 322; Byzantine, 18; decline of, 9, 19, 34; described, 9, 190–95; Moslem, 22; revival of, 42, 44, 45, 178–79, 188, 190–91, 193, 213, 272, 295; self-government in, 188, 190–91, 196, 231
- Trade, 177-206 passim, 185, 295, 322; Byzantine, 177-78, 182-83; church and, 188; decline of, 9, 21; English, 34, 178, 180, 183, 188, 190; Flemish, 178, 180, 183, 188, 190; French, 179, 181, 184, 187, 188; German, 178, 190; Italian, 51, 177, 178, 179, 180, 182, 183, 184, 188; Moslem, 183; Norman, 183; revival from eleventh century on, 42, 44, 45, 75, 107, 177-91, 189, 193; Roman, 8, 9, 178; Russian, 178, 188, 190; Scandinavian and Viking, 30, 178, 190; Spanish, 179, 190
- Transportation, 9, 45, 178–86; bridges, 26, 56, 110, 181, 184, 216, 315; roads, 21, 45, 110, 184, 186, 187, 192, 194, 216, 315. See also Navigation Trinitarians, order of, 152
- Tristan and Iseult, 262
- Troilus and Criseyde, by Geoffrey Chaucer, 262, 264
- Troubadours, 120, 121, 122, 173, 261, 265, 290, 324. See also Jongleurs; Minnesingers; Minstrels; Music
- Troyes, France, 13, 187, 318 Truce of God, 73

- Turks, 85; Ottoman, 104, 322–23; Seljuk, 91, 92, 94, 95, 96, 100 Tuscany, Italy, 188
- Tyler, Wat, 298; and Peasants' Revolt, 297, 298

U

Ulm, Germany, cathedral of, 278

Universities, 42, 75, 168, 170, 240–44; founded, 57, 240; professors in, 240, 242, 243, 244, 257; students in, 42, 240, 242, 243, 244, 295. See also Education

Urban II, pope, 91, 92 (quoted), 94, 251 (quoted); and crusades, 91–94

- Urban VI, pope, 304
- Urslingen, "Duke" Werner von, 312–13
- Utrecht Psalter, 272

V

Valla, Lorenzo, 23 Valognes, France, 310 Valois dynasty, 310 Vandals, 12, 13 Vassalage, 26, 33, 53, 77, 110-11. See also Feudalism; Knighthood Vaucouleurs, France, 316 Vehmgericht, 322 Venice, Italy, 115, 121, 255; and Byzantium, 51; and fourth crusade, 102, 104; population of, 190; trade, 51, 115, 177-90 passim, 198 Veronica, Saint, 149 Vézelay, France, church of, 100, 278, 282 Vikings (Danes), 30-35, 32, 36, 37, 38, 237, 272; art of, 37,

269, 270. See also Scandinavia Villon, François, 244 Vincent of Beauvais, Speculum Majus, 252 (excerpt) Virgil, 153, 237, 238 Visigoths, 8, 12, 13, 14, 16 Vitry, Jacques de, quoted, 216 Vitry, Philippe de, Ars Nova, 293 Vogelweide, Walther von der, 106, 265 Volkhov River, 30 Voltaire, 70, 148, 296

W

Waldemar, king of Denmark, 190 Waldenses, 172 Waldo, Peter, 172 Wales, 15, 53, 86, 87, 261; England and, 64, 65-66 Wallace, William, 66 Walsingham, Thomas, quoted, 298 Walter the Penniless, 94 Warfare, 6, 11, 77-78, 79, 80-86, 114, 116, 122-23, 312, 313, 314, 324; Roman, 8, 9; strategic, 80-82, 86, 88, 90, 310, 311-12, 313; Viking, 30-33. See also Arms and armor; Castles Wells, England, cathedral of, 59 Wenceslas, emperor, 302-3 Westminster Abbey, London, England, 55, 139, 153, 386 Westminster Palace (England), 54, 195-96

Weyden, Rogier van der, 288

William I (the Conqueror), king of England, 54–59, 57, 80, 82, 86, 278; crowned, 58; quoted, 55 William of Malmesbury, quoted, 94

William of Newburgh, quoted, 172

William of Norwich, 146

William of Posquères, 105

William of Sens, 182

Winchester, England: abbey, 270; college at, 240, 290

Windsor, England, 64

Wine, 135, 138; church and, 178; trade, 34, 51, 177, 178, 295

Witchcraft, 145–46, 262; Joan of Arc and, 146, 318

Women, 21, 249, 265; Anglo-Saxon, 35; bourgeois, 42, 194, 201, 203, 205, 257; noble, 42, 115–18, 119, 120–21, 129, 130–32, 139, 261, 262; peasant, 234; proletarian, 228, 234
Wool. See Textiles
Worms, Germany, Concordat of, 100

41 41

Worringer, Wilhelm, 277

Wulf, Maurice de, quoted, 244 Wycliffe, John, 303, 305

Y

York, England, 55, 153, 187, 195, 259 Yorkshire, 33 Ypres, Belgium, 229

Z

Zara, Yugoslavia, 102 Zuider Zee, 177